PRIVATE LIFE AND PRIVACY IN THE
EARLY MODERN LOW COUNTRIES

EARLY EUROPEAN RESEARCH

VOLUME 19

Series founded by Andrew Lynch and Claire McIlroy with the Australian Research Council Network for Early European Research, and now directed by The University of Western Australia Centre for Medieval and Early Modern Studies.

General Editors
Jacqueline Van Gent, University of Western Australia
Kirk Essary, University of Western Australia

Editorial Board
Tracy Adams, University of Auckland
Emilia Jamroziak, University of Leeds
Matthias Meyer, Universität Wien
Fabrizio Ricciardelli, Kent State University Florence Center
Juanita Feros Ruys, University of Sydney
Jón Viðar Sigurðsson, Universitetet i Oslo
Nicholas Terpstra, University of Toronto

Previously published volumes in this series
are listed at the back of the book.

Private Life and Privacy in the Early Modern Low Countries

Edited by

MICHAEL GREEN *and* INEKE HUYSMAN

BREPOLS

British Library Cataloguing in Publication Data
A catalogue record for this book is available from the British Library.

© 2023, Brepols Publishers n.v., Turnhout, Belgium.

All rights reserved. No part of this publication may be reproduced,
stored in a retrieval system, or transmitted, in any form or by
any means, electronic, mechanical, photocopying, recording,
or otherwise without the prior permission of the publisher.

ISBN: 978-2-503-60444-2
e-ISBN: 978-2-503-60445-9
DOI: 10.1484/M.EER-EB.5.132216

ISSN: 2295-9254
e-ISSN: 2295-9262

Printed in the EU on acid-free paper.

D/2023/0095/15

Table of Contents

List of Illustrations 7

Abbreviations 12

The Low Countries, Private Life, and Privacy 13
Michael GREEN and Ineke HUYSMAN

**'For my Personal Use': Notions of Privacy in
Egodocuments from Early Modern Amsterdam** 27
Michael GREEN

**Inward Dignity: The Liberated House in Simon Stevin's
Architectural Knowledge System as an Indication of his
Early Modern Conception of 'Privacy'** 63
Heidi DE MARE

Privacy in Seventeenth-Century Dutch Cabinet Painting 99
Jørgen WADUM

**'Au couvert, sans estre vues': Aspects of Privacy
in the Residences of Charles de Croÿ (1560–1612)** 121
Sanne MAEKELBERG

**Huygens at Home: Constantijn Huygens
(1596–1687) on Privacy in his Poem *Dagh-werck*
(*The Day's Work*) (1627–1638)** 145
Ad LEERINTVELD

**Withdrawn and Secretive: Privacy among
Portuguese Jews in Early Modern Amsterdam** 173
Tirtsah LEVIE BERNFELD

Private Life in Wartime: Captured Letters from 1672 197
Judith BROUWER

***Bibliotheca Furliana,* 1714:**
The Public Sale of a Private Book Collection 225
Hanna DE LANGE

Sociability and Privacy: The Eighteenth-Century
Extended Homes of the Amsterdam Elite 247
Freek SCHMIDT

Balancing between Mother and Wife:
The Private Correspondence of
Stadtholder Willem IV of Orange-Nassau 273
Fayrouz GOMAA and Ineke HUYSMAN

Index locorum 305

Index nominum 307

List of Illustrations

Figure 0.1. 'Zones of Privacy', Mette Birkedal Bruun, 2019. 17

Figure 1.1. Anonymous, *Plattegrond van Amsterdam (Ground Plan of Amsterdam)*, *1726–1750*. Print. Rijksmuseum Amsterdam, inv. no. RP-P-AO-20-55-2. 28

Figure 1.2. Dirck van der Koghen, 'Almanach 1681', title page with an engraving of Amsterdam's exchange. Amsterdam, CAA 15030, inv. 94939. 33

Figure 1.3. Dirck van der Koghen, 'Almanach 1681', month of January. Amsterdam, CAA 15030, inv. 94939. 34

Figure 1.4. Dirck van der Koghen, 'Almanach 1681', January engraving. Amsterdam, CAA 15030, inv. 94939. 34

Figure 1.5. Dirck van der Koghen, 'Almanach 1681', month of January, detail of two comets. Amsterdam, CAA 15030, inv. 94939. 38

Figure 1.6. Adriaen Jansz. van Ostade (1610–1685), *Interior of a Schoolroom*, Haarlem, 1666. Oil on canvas, 22.4 × 18.9 cm. 41

Figure 1.7. Arent van der Meersch, 'Almanach Anno 1744'. Amsterdam, CAA 15030, inv. 442. 44

Figure 1.8. Arent van der Meersch, 'Almanach Anno 1744', fragment. Amsterdam, CAA 15030, inv. 442. 47

Figure 1.9. Arent van der Meersch, 'Almanach Anno 1744', fragment. Amsterdam, CAA 15030, inv. 442. 48

Figure 1.10. Jan Hendrick Hermans, 'Geheim Boeckje begonnen in 't Jaer 1716 en der eenige gevallen van te vooren geschiet voor mijn Jan Hendrick Hermans', 1716, title page. The Hague, Royal Library of the Netherlands, shelf mark 78 H 68. 50

Figure 1.11. Daniël Stopendaal (possibly), *Gezicht op de Oude Kerk te Amsterdam* (View onto the Old Church in Amsterdam), *1685–1726*. Print, 171 × 174 cm. Inv. no. RP-P-AO-23-6-1. 51

LIST OF ILLUSTRATIONS

Figure 1.12. Jan Hendrick Hermans, 'Geheim Boeckje begonnen in 't Jaer 1716 en der eenige gevallen van te vooren geschiet voor mijn Jan Hendrick Hermans', 1716, pp. 58–71. The Hague, Royal Library of the Netherlands, shelf mark 78 H 68. 52

Figure 1.13. Anonymous, after Jan Veenhuysen, *Nieuwe Kerk te Amsterdam* (New Church in Amsterdam), Amsterdam, 1695–1699. Print, 124 × 147 cm. Inv. no. RP-P-1903-A-24101. 56

Figure 2.1. Simon Stevin, *Drawing of the house*. Included in Hendrick Stevin, *Materiae Politicae. Burgherlicke Stoffen*, Leiden 1649. 66

Figure 2.2. Simon Stevin, *Fourth form of a block of burgher houses*. Included in Hendrick Stevin, *Materiae Politicae. Burgherlicke Stoffen*, Leiden 1649, p. 28. 70

Figure 2.3a. Vitruvius, *Greek house, gynaikonitis* (wing with housing for women). 75

Figure 2.3b. Vitruvius, *Greek house, andronitis* (wing with housing for men). 75

Figure 2.4. Andrea Palladio, *Greek house*. 76

Figure 2.5. Simon Stevin, *Greek house*. 77

Figure 2.6. Simon Stevin, *Ground drawing of the Princely house*. 78

Figure 2.7. Vitruvius, *Italian house*. 80

Figure 2.8. Hendrik Stevin, *House model*. 81

Figure 2.9. Philips Vingboons, *House of Nicolaes van Bambeeck* (1650), Colveniers burgh-wal (Kloveniersburgwal), Amsterdam. 86

Figure 2.10. Philips Vingboons, *House of Pieter de Mayer* (1655), Fluwele Burgwal (Oudezijds Voorburgwal), Amsterdam. 87

Figure 2.11. Simon Stevin, *First ground drawing*. Included in Hendrick Stevin, *Materiae Politicae. Burgherlicke Stoffen*, Leiden 1649, p. 61. 89

Figure 3.1. Hendrick Goltzius, *Perseus and Andromeda*, inscribed 'Henricus Goltzius. inuent & Sculptor. A° 1583', engraving, 19.8 × 14.4 cm. Rijksmuseum Amsterdam. 102

LIST OF ILLUSTRATIONS 9

Figure 3.2. Rembrandt van Rijn, *Andromeda*, oil on panel, 34 × 24.5 cm, The Hague, Mauritshuis. Around 1630. 103

Figure 3.3. Rembrandt van Rijn, *Susanna and the Elders*, signed and dated 'Rembr[ant f]/f. 163[6]', oil on panel, 47.4 × 38.6 cm, The Hague, Mauritshuis. 105

Figure 3.4. Samuel van Hoogstraten, *Peepshow with Views of the Interior of a Dutch House*, oil and egg on wood, 58 × 88 × 60.5 cm, London, National Gallery. Around 1655–1660. 107

Figure 3.5. Pieter de Hooch, *Interior with a Young Couple and People Making Music*, oil on canvas, 72 × 67 cm, Copenhagen, Statens Museum for Kunst. Around 1644–1683. 109

Figure 3.6. Johannes Vermeer, *Lady Writing a Letter with her Maid*, detail, Dublin, National Gallery of Ireland. Around 1670–1671. 112

Figure 3.7. Johannes Vermeer, *Lady Writing a Letter with her Maid*, oil on canvas, 72.2 × 59.7 cm (with perspective drawing superimposed), Dublin, National Gallery of Ireland. Around 1670–1671. 112

Figure 3.8. Johannes Vermeer, four paintings spanning early to late works, placed in relative size on a horizon line. 115

Figure 3.9. Johannes Vermeer, *Girl with a Red Hat*, oil on panel, 23.2 × 18.1 cm. Washington, DC, National Gallery of Art. Around 1665. 115

Figure 3.10. Johannes Vermeer, *Girl with a Pearl Earring*, oil on canvas, 46.5 × 40 cm. The Hague, Mauritshuis. Around 1665. 116

Figure 4.1. Portrait of Charles de Croÿ by Antonius Wierix, 1599. 124

Figure 4.2. Golden portrait coin, private collection. Obverse: Charles de Croÿ. Reverse: phoenix with the motto 'SEUL'. 128

Figure 4.3. Plan of the first floor of the sixteenth-century castle of Heverlee, with a schematic indication of the rooms of the apartment. 129

Figure 4.4. Volumetric reconstruction of the ducal apartment at the Croÿ palace in Brussels. 131

LIST OF ILLUSTRATIONS

Figure 4.5. Schematic reconstruction of the floor plan of the castle at Beaumont and the connection to the Tour Salamandre. 132

Figure 4.6. Reconstruction of the floor plan of the *maison de plaisance* at Sint-Joost-ten-Node. 137

Figure 5.1. W. Delff after M. Jzn Van Mierevelt, *Constantijn Huygens*, engraving, 1625. From Huygens, *Otiorum libri sex*. The Hague, Royal Library of the Netherlands, KW 759 C 17. 146

Figure 5.2. 'Detail of map of the centre of The Hague', showing Huygens's working area, with his house on Lange Houtstraat and the quarters of Prince Frederik Hendrik. 149

Figure 5.3. 'Official registration of the wedding of Constantijn Huygens and Susanna van Baerle', 24 February 1627. Amsterdam, CAA, inv. 432, p. 67, act no. D. T. B. 432. 150

Figure 5.4. 'Title page of the printer's copy of *Dagh-werck*', designed by Huygens. The Hague, Royal Library of the Netherlands, KW KA 40ᵃ, 1638, fol. 6. 153

Figure 5.5. 'Frontispiece of Constantijn Huygens's, *Koren-bloemen*'. The Hague, Royal Library of the Netherlands, KW 302 E 52. 155

Figure 5.6. Jacob van Campen, 'Double Portrait of Constantijn Huygens (1596–1687) and Suzanna van Baerle (1599–1637)', c. 1635. The Hague, Mauritshuis, inv. 1089. 160

Figure 7.1. Ludolf Bakhuysen, *Nederlandse schepen op de rede van Texel; in het midden de 'Gouden Leeuw', het vlaggeschip van Cornelis Tromp* (Dutch ships at the Rede van Texel; in the middle the 'Golden Lion', the flagship of Cornelis Tromp), 1671. Rijksmuseum Amsterdam. 198

Figure 7.2. A box with ship's papers, procedural documents, ship's journal, ledgers, and a wallet with a French prayer book, captured in the seventeenth century during the Second and Third Anglo-Dutch Wars. Kew, National Archives, HCA 32 / 1845.1. 198

Figure 7.3. The relationship between senders and addressees. 200

Figure 7.4. Harmen ter Borch, *Tekenend of schrijvend kind* (Drawing or writing child), 1649. Rijksmuseum Amsterdam. 207

LIST OF ILLUSTRATIONS 11

Figure 7.5. Nicolaes Maes, *Meisje aan het venster, bekend als
'De peinzende'* (Girl at a window, known as 'the daydreamer'),
1650–1660. Rijksmuseum Amsterdam. 213

Figure 7.6. Pierre-Alexandre Wille, *L'Écrivain public*
(Paris, La Bibliothèque des Arts Décoratifs. 1780). 215

Figure 7.7. Letter of Lijsabet Ellerts to Claas Jansen Curf in
Batavia — Enkhuizen, 5 November 1672 (HCA 30-1061-2). 216

Figure 8.1. Frederick de Wit, *Theatrum Ichnographicum
Omnium Urbium et Præcipuorum oppidorum Belgicarum, XVII
Provinciarum peraccurate delineatarum*, map 20. Rotterdam, 1698. 229

Figure 8.2. *Bibliotheca Furliana*, title page. Fritsch, Bohm, and
Nicolaus Bos, Rotterdam, 1714. 233

Figure 8.3. Bookplate of Benjamin Furly, in William I. Hull,
Benjamin Furly and Quakerism in Rotterdam. Pennsylvania, 1941. 236

Figure 9.1. 'Original drawing for plate thirteen of the *Grachten-
boek* or *Verzaameling van alle de huizen en prachtige gebouwen
langs de Keizers en Heere-grachten der stadt Amsteldam* (1768–1771)'. 248

Figure 9.2. 'Façade of Herengracht 284, also known as Huis
van Brienen', Amsterdam. *Rijksdienst voor het Cultureel Erfgoed,
Amersfoort/303.562.* Photo by A. J. van der Wal, 1994. 250

Figure 9.3. 'Section and plan of Keizersgracht 284', in *Collectie
Bureau Monumentenzorg: negatiefvellen*. Amsterdam, CAA. 251

Figure 9.4. 'Interior of Herengracht 284'. Corridor on main floor
or *beletage*, leading to interconnecting section with staircase
and inner courtyard, and staircase leading to rear house, with
flight down to garden and flight up to great salon". 252

Figure 9.5. 'Great salon overlooking the garden, Herengracht 284'. 253

Figure 9.6. '*Porte-brisée* design for room en suite at Herengracht
284', *c.* 1730. 255

Figure 9.7. 'Façade of Keizersgracht 224, also known as
Saxenburg'. Amsterdam, CAA. 256

LIST OF ILLUSTRATIONS

Figure 9.8. 'Staircase design for canal house', c. 1750. Amsterdam, CAA. — 258

Figure 9.9. 'Corridor design for canal house', c. 1750. Drawing shows both sides of the corridor with niches, sculpture, suggested ornamental decoration, and proposed ceiling decoration, to be executed in plasterwork. Amsterdam, CAA. — 259

Figure 9.10. 'Drawing, plan, and section of room decoration', c. 1750, in *Collectie Stadsarchief Amsterdam: tekeningen en prenten*. Amsterdam, CAA. — 260

Figure 10.1. a: Johan Philipp Behr, *Maria Louisa of Hesse-Kassel*, c. 1720–1756; b: Jacques-André-Joseph Aved, *Willem IV, Prince of Orange-Nassau*, 1751; c: Johann Valentin Tischbein, *Anne of Hanover*, 1753. — 274

Figure 10.2. Routes of letters from Willem IV to his mother, Maria Louise of Hesse-Kassel, written from various European cities. — 278

Figure 10.3. Carel Frederik Bendorp after Jan Bulthuis, *Stadhouderlijk Hof in Leeuwarden*, 1786–1792. Rijksmuseum Amsterdam. — 281

Figure 10.4. Letter from Willem IV to his mother, Maria Louise of Hesse-Kassel. Royal Collections, The Hague, A28-11. — 283

Figure 10.5. Letters from Willem IV to Maria Louise of Hesse-Kassel and Anne of Hanover, Aachen, 4 September 1751. The Hague, Royal Collections, The Hague, A28–11, A30-VIa-1. — 288

Figure 10.6. Screenshot showing instances of *coucher*. — 291

Figure 10.7. Pieter Tanjé after Gerard Sanders, *Willem V and his sister Carolina of Orange-Nassau*, 1751. Rijksmuseum Amsterdam. — 293

Figure 10.8. Anonymous, *Death of Willem IV*, 1751. Rijksmuseum Amsterdam. — 297

Abbreviations

CAA: City Archives Amsterdam

MICHAEL GREEN AND INEKE HUYSMAN

IN COLLABORATION WITH JELENA BAKIĆ
AND NATACHA KLEIN KÄFER

The Low Countries, Private Life, and Privacy

Introduction

Doch alles met die meeninge, dat het moghte een camerspel onder de vrienden, ende in hare cameren blijven, ende geensins om het op thooneelen viese en wijse, reckelicke ende onbescheidene menschen allerhanden slagh van vonissen te doen uytwerpen, sulcks een yeders recht is, maer daer aen sich niet elck een en heeft te onderwerpen.

> (But all with the intention of its remaining a chamber play for friends only, and also to be held behind closed doors and by no means to be performed onstage, so that negative, pedantic, narrow-minded, and immodest people pass all kinds of judgements on it, something that everyone has the right to do, but to which not everyone feels called to submit.)[1]

Persuaded by his friends to publish his spicy burlesque *Trijntje Cornelis*, the Dutch poet and diplomat Constantijn Huygens (1596–1687) stated in his introduction that the play was only intended to be performed behind closed doors. This quote from Huygens, who is discussed at length later in this volume, clearly demonstrates that in the early modern Dutch Republic, one was very much aware of the invisible dividing line between private and public. What happens 'in hare cameren' (behind closed doors) and the boundaries of what this realm entails are the guiding theme of the contributions to this volume. These contributions originate from three inspiring interdisciplinary seminars organized by the Danish National Research Foundation Centre for Privacy Studies (DNRF 138) concerning the notion of privacy in the

* This text has been written with the generous grant of the IDUB Fellowship at the University of Lodz, Poland, for Michaël Green, who also expresses his gratitude to the Danish National Research Foundation (DNRF 138) for its support in the preparation of this text and for funding the Open Access edition of this introductory chapter, as well as to CLUE+ fellowship programme at the Vrije Universiteit of Amsterdam for providing the funding for archival research; and with support of the Huygens Institute /NL-Lab for Ineke Huysman. Research by Natacha Klein Käfer has been funded by the Danish National Research Foundation (DNRF 138).

1 Huygens, *Trijntje Cornelis*, ed. by Hermkens and Verhuyck, p. 28. Translation by Ineke Huysman.

Private Life and Privacy in the Early Modern Low Countries, ed. by Michael Green and Ineke Huysman, EER 19 (Turnhout: Brepols, 2023), pp. 13–26
BREPOLS ❧ PUBLISHERS 10.1484/M.EER-EB.5.132528

early modern Low Countries. The seminars were held on 21–22 March and 18 November 2019 at the University of Copenhagen, and on 31 January 2020 at the Huygens Institute for History and Culture of the Netherlands.[2] It was clear that researchers working on Dutch history, both within and outside the Netherlands, are interested in this topic and recognize the potential to contribute to this field. In this volume, we present various takes on early modern privacy by both well-known and newly established scholars, and we hope to pave the way for further research into this subject.

Developments in Research on Private Life and Privacy

In a recently published article, Mette Birkedal Bruun sums up the course of historiographical developments in research on early modern privacy:

> Research into the history of the term 'privacy' is linked to research into the private and related notions. There is no dearth of sociological and philosophical analyses that touch upon privacy and the private as well as the implications and historical evolution of these concepts. Such approaches share a tendency to deploy the notion of '(the) private' and its counterparts, most often 'public', as a vehicle for the identification of, for example, societal dynamics or practices in a given historical period, a *longue durée* development, or epochal shifts that herald the early stages of modernity.[3]

The question of what privacy may have meant to early modern societies reached scholarly prominence with the French-language series edited by Philippe Ariès and Georges Duby, *Histoire de la vie privée* (1983–1987), and its English translation *A History of Private Life* (1988–1991). The series is divided into four historical periods, with the third (in a volume edited by Roger Chartier) dedicated to the early modern period. In the introduction to this volume, Ariès outlines what, in his opinion, was the major change between the medieval and early modern periods, namely, the appearance of a separation between the public and private spheres in various domains such as architecture, behaviour, and religious devotion. According to Ariès, this separation was manifested in various ways, including in the division of rooms, the repurposing of space, the invention of new furniture, and the appearance

2 'Zones of Privacy in the Early Modern Netherlands', organized by Michaël Green and Natália da Silva Perez, Copenhagen, 21–22 March 2019; 'Privacy in Early Modern Dutch Art and Architecture', organized by Michaël Greeltn and Peter Thule Kristensen, Copenhagen, 18 November 2019; 'Perspectives on Privacy in the Seventeenth-Century Netherlands', organized by Ineke Huysman and Michaël Green, Amsterdam, 31 January 2020.

3 Bruun, 'Towards an Approach', p. 15. This article also provides an excellent overview of developments in the field of privacy studies to date.

of egodocuments (documents written by one self about oneself).[4] All of this, he claims, originated in England, which was the 'pioneer of privacy'.[5] Building upon the work of Norbert Elias and his own previous ideas, he considers privacy to consist in the opposition between a man of state and a private individual, and between the state and the private domain, as well as in the emergence of a more individual form of sociability.

Observations presented by the rich discussions in *A History of Private Life* point us in a possible research direction that is also explored to some extent in the present volume. For instance, Orest Ranum, writing in *A History of Private Life* about written sources, points out that privacy can also be traced through works of art, particularly self-portraits. This connection between art and privacy is developed by Jørgen Wadum in his contribution to our volume, in which he shifts the focus to the composition of artworks as a strategy for locating privacy.[6] However, although *A History of Private Life* is an important milestone in privacy research, many of its assumptions have been challenged in the almost forty years since its publication, such as its supposition that egodocuments are of an exclusively private nature (see Michaël Green's chapter) or that England was the place where privacy first emerged. Indeed, as recent research has demonstrated, the situation in the Low Countries in the early modern period was rather similar to that found in England.[7] Importantly, moreover, private life is not the same thing as privacy. If we start from Ariès's take, private life is everything that is away from professional life: we might think of the life of a family, things done at home during leisure hours, or simply a person who holds no official office. But privacy is much harder to define, and no single definition of it can be applied to all circumstances. Privacy can be seen as the regulation of access to a given person, place, or community, in line with a definition by Stephen Margulis.[8] Therefore, while we cannot give an exhaustive definition of either privacy or private life, in this volume we aim to add nuance to both concepts in order to facilitate further research in the field.

Other recent scholarship has also identified the early modern period as a key historical moment to understand how privacy began to take on more defined social contours. One of the more influential books on the topic is *Locating Privacy in Tudor London* by Lena Cowen Orlin, who reconstructs the local sixteenth-century milieu. She helps by defining the ways in which privacy can be traced: 'Personal privacy takes many forms: interiority, atomization, spatial control, intimacy, urban anonymity, secrecy, withholding, solitude'.[9]

4 The term 'egodocument' was coined by Jacob Presser in the 1950s. For an overview, see Baggerman, Dekker, 'Emotions, Imaginations, Perceptions'; Dekker, 'Introduction'.
5 Ariès, 'Introduction'.
6 Ranum, 'The Refuges of Intimacy'.
7 For example, in the emergence of spatial separation: Green, 'Spaces of Privacy'.
8 Margulis, 'Privacy as a Social Issue', p. 246.
9 Cowen Orlin, *Locating Privacy*, p. 1.

These related terms are helpful for identifying instances of privacy in the sources, and they appear repeatedly throughout the chapters in this volume. Our contributors expand Orlin's focus on privacy as something sought after by individuals, showing that the quest for privacy can also be found among groups of people and communities in the early modern period. Indeed, while we acknowledge that individual privacy was an important factor in historical developments, we also demonstrate that a more communal sense of privacy was just as fundamental to early modern societies.

With regard to the Dutch historical context, only a few previous volumes have explicitly explored the public domain in the early modern period. These works tend to distinguish insufficiently between modern understandings of privacy and the way that this idea appears in the historical sources. In our volume, we are aware of this important limitation, and we strive to let the sources speak for themselves rather than applying our contemporary perspective. One of the earliest books to deal with privacy and private life in the context of the Low Countries is *The Public and Private in Dutch Culture of the Golden Age*, edited by Wheelock and Seeff. This work is dedicated to the dichotomy of public and private in the seventeenth century, and it represents an important stepping stone into the world of Dutch privacy, with a range of topics covered, such as ethics and civic culture — although it focuses on urban elites and mostly within the province of Holland.[10] Another example is Schuurman and Spierenburg's edited volume *Private Domain, Public Inquiry*, which tackles the subject from the Dutch Revolt up to the present day, with only a fraction of the chapters dedicated to the early modern period.[11] In his seminal book *Divided by Faith*, Benjamin Kaplan explores the question of public and private in relation to the religious divide in the United Provinces, reflecting among other subjects on the 'hidden churches' (*schuilkerken*) that worshippers could attend in private.[12] This religious element is also present in the other works mentioned above, and most recently in a special issue of *Tijdschrift voor sociale en economische geschiedenis* edited by Natália da Silva Perez. This special issue focuses on several aspects of privacy in the United Provinces, including space, religious worship, diplomacy, and the life of

10 Wheelock and Seeff, eds, *The Public and Private in Dutch Culture*. This 'Hollandocentrism' is also true of the famous book *The Embarrassment of Riches* by Simon Schama, considered by many to be the standard survey of Dutch mentality in the Dutch Republic during the Golden Age. There are some comments to be made on Schama's book. The emphasis is heavily on Calvinism as a starting point, although other religions were also practised in the republic. Schama's often literal interpretation of visual sources can also cause misunderstandings. Nevertheless, if we take this into account, the book can be considered a suitable first introduction to the 'Dutch' mentality in the seventeenth century.

11 Schuurman and Spierenburg, eds, *Private Domain, Public Inquiry*.

12 Kaplan, *Divided by Faith*, especially pp. 172–97.

Dutch sailors at sea.[13] Some of these topics, particularly the spatial aspects of privacy and notions of private writing, are further explored in our volume.

In another instance, and referring to an Amsterdam city decree that limited the production of luxury items in order to prevent pious (i.e. Protestant) people from being offended by them, R. E.

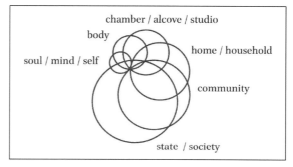

Figure 0.1. 'Zones of Privacy', Mette Birkedal Bruun, 2019.

Kistemaker writes: 'In the seventeenth century the two notions of "public", that is, of the government, and "private", that is, of the individual, were interwoven [… and overlapped in …] the public space'.[14] Kistemaker's claims align with the methodology recently developed by Mette Birkedal Bruun at the Centre for Privacy Studies, which maps out the early modern world through heuristic zones. Starting with the broadest zone of the state, we move through the community, household/family, chamber, and body, until we reach the innermost zone of the self/mind (Figure 0.1).[15] Ideas and practices around privacy can be traced not only within these zones but also, and perhaps even more so, at the thresholds, that is, the intersections and overlaps between the zones. At the same time, privacy is a negation and cannot exist without a point of reference to something that it is not: something that is not professional, something that is not public, something that is not open to access.

Here, we would like to suggest that the concept proposed by Bruun can be developed in a different direction that would better encompass our particular set of sources from the early modern Low Countries. The initial focus of the heuristic zones is on various spaces (apart from the innermost two of the mind and the body). A relationship between privacy and the social elements of the individual, the group, and the family had already been proposed by Ariès.[16] For the purpose of analysis, it may be no less useful to take another set of heuristic zones into consideration, focusing not on physical but on mental spaces. The starting point would be the same: the mind/self/soul, which is the most private and the most hidden from the outside world, of which only the owner can have a somewhat full overview, and which is never entirely exposed either in writing, through the power of words, or through one's behaviour. This zone includes a person's thoughts, ideas, and emotions

13 Silva Perez, ed., *Privacy and the Private*.
14 Kistemaker, 'Public and the Private', p. 17.
15 Bruun, 'Towards an Approach', figure 2.1; Bruun, 'Privacy in Early Modern Christianity'.
16 Ariès, 'Introduction', p. 7.

such as fear, love, emotional attachment, embarrassment, and happiness. These have a direct connection with the second zone, which is also the same: the body. The body feels pain, pleasure, fatigue, and energy. These feelings are not immediately available to another person's gaze, and they can be kept hidden. The third zone is that of the (married) couple. The best example here is a husband and wife who share not only each other's bodies but also their worries and pains, the care of their children, and financial burdens. The fourth is the zone of the nuclear family, which includes parents and their offspring. Families can keep their own secrets and perform their own rituals away from the gaze of others (with the exception of servants for wealthier families). The broader zone, the fifth, is the household (once again connecting to Birkedal Bruun's heuristic zones), where the servants are included. The sixth zone is the extended family, which includes grandparents, adult siblings, and their families, cousins, etc. It is very useful to consider this zone, for example, when business relations are discussed within one large family. The seventh zone is the professional sphere. This does not mean a profession in the modern sense of the word, but rather an understanding of people who engage in the same type of activity, such as nobles, shoemakers, lawyers, doctors, etc. Each of these groups keeps its professional activities or secrets 'private' at times. Finally, the eighth and last zone is friendship. This is not the least private of the zones, but rather occupies the same position as the zones of the couple and the nuclear family. It refers not to instrumental friendship — which was very common at the time and would fall within the professional zone — but to intimate friendships based on mutual liking and the performance of various activities together, such as visiting each other, writing to each other, etc. Just as with the sets of zones proposed by Bruun, here too there are overlaps: friendships can exist within the professional, extended family, and nuclear family zones, while the nuclear family zone partly overlaps with the zones of the couple and the extended family.[17] Taken together, these two models to a large extent represent the areas or zones of privacy found in the early modern Low Countries, as the chapters in this volume demonstrate.

One important question remains: how can we deduce from a given text that it is referring to privacy if the word itself is not mentioned?[18] This is where an approach developed at the Centre for Privacy Studies may come in useful: the terminological approach. Although at its core it is an examination of the root *priv* (from the Latin *privatus*), this approach also considers neighbouring words such as *confidential*, *personal*, *secret*, *clandestine*, and *intimate*. Such words point to the private sphere and need to be analysed within their proper context. This investigation helps to map out the context in which notions of privacy can be traced.

17 This model has been developed by Michaël Green with the assistance of Ineke Huysman, as an elaboration of the model presented by Mette Birkedal Bruun (Figure 0.1).

18 On the appearance of the word *privacy* in a Dutch context, see Green, 'Spaces of Privacy'.

The goal of this volume is to expand existing research by offering studies that have been conducted with one methodology in mind (albeit not exclusively) and engage with egodocuments, the private lives of the Jewish minority, Dutch art, personal collections, architecture, and sociability, while also giving a platform to contemporary research methods used in the digital humanities to help with the analysis. Our aim is to give a broad overview of various possibilities for future research that would lead to a better understanding of how notions of privacy emerged and were manifested in the early modern period, how one can tackle sources that do not always present their authors' ideas directly, and how one might distinguish between privacy and neighbouring concepts such as intimacy, secrecy, emotions, and many others. While we acknowledge that theoretical distinctions between *privacy* and its cognates are crucial for understanding the nuances of early modern notions of privacy, we aim here to treat them as deeply entangled concepts that are separated or brought together depending on particular events and contexts. Thus, each contribution explores a different constellation of privacy-related terms as they appear and inform each other in particular case studies.

As part of this process of understanding the interwoven dimensions of privacy in early modern daily experience, it is crucial to grasp the emotional aspects of people's lives. Tools developed by historians of emotions are valuable for understanding the meanings that privacy can assume in the multiple contexts explored in this volume.[19] According to historians working in this field, two main factors should be taken into consideration: the importance of emotions in human actions, and their instability — that is, emotions change as the historical context changes. Historians of emotions have recently argued that culture shapes people's emotions: feelings inevitably vary through history, and emotions are cultural and social practices that change over time.[20] These scholars are principally interested in understanding how historical actors expressed and understood their emotions, but they also ask how emotions were connected to emotional norms that were shaped and enforced in specific historical contexts.[21] In this volume, we pay attention to this intersection between privacy studies and the history of emotions: we are interested in how the private is shaped by emotions and in turn resignifies them. We look at the ways in which 'private emotions' are manifested in writing, design, architecture, art, or other forms of expression.[22] Indeed, throughout our

19 Stearns and Stearns, 'Emotionology'; Plamper, 'The History of Emotions'; Plamper, *The History of Emotions*; Matt and Stearns, *Doing Emotions History*; Rosenwein, *Generations of Feeling*; Scheer, 'Are Emotions a Kind of Practice'.

20 Mesquita and Boiger, 'Emotions in Context'.

21 This section on the history of emotions was written by Jelena Bakić, to whom the editors are thankful for the enlightening discussion.

22 The historian Lucien Febvre, a founder of this school of research, argued that there was a mutual relationship between textual and emotional cultures in the past: Febvre, 'History and Psychology'. For other major works on the history of emotions, consult the following: Matt,

volume, the contributors refer to emotions in private settings: for example, Ad Leerintveld focuses on a love poem written by a Dutch nobleman for his wife, Michaël Green discusses egodocuments, and Judith Brouwer examines the letters of sailors' wives.

The Chapters

As this volume demonstrates, notions of privacy in the early modern period take various shapes and can be assessed from various perspectives — from textual to legislative analysis, from the examination of private collections to the analysis of works of art. Interdisciplinary in nature, this volume is proud of its highly diverse contributions, which address many facets of privacy. The range of themes includes religion, architecture, art, interior design, and painting, and it covers the lower class, the bourgeoisie, the court, and the elite. This multiplicity of converging subjects, each of which informs the other, cuts across the chapters of the book and expands our understanding of privacy as an early modern phenomenon. The volume opens with three general discussions by Michaël Green, Heidi de Mare, and Jørgen Wadum, followed by seven case studies in more or less chronological order, starting in the mid-sixteenth century and ending in the mid-eighteenth century.

In the first chapter, Michaël Green analyses early modern notions of privacy on the basis of examples found in egodocuments written by merchants from Amsterdam in the seventeenth and eighteenth centuries. Guided by methodologies developed by Rudolf Dekker and Mette Birkedal Bruun, Green deduces how contemporaries perceived their private sphere and what they considered to be private.

Green's chapter is followed by Heidi de Mare's contribution, which asserts that privacy in the early modern Low Countries has often been identified with domesticity on the basis of interpretations of architecture from a modern point of view. Source criticism, however, entails the semantic and heuristic analysis of sources on their own merits in light of their embedment in the early modern conceptual universe. Expanding on her earlier article written in Dutch,[23] De Mare demonstrates this strategy by analysing Simon Stevin's (1548–1620) architectural treatise, in which he classifies the house in natural-philosophical terms: building materials, household substances, and inhabitants are understood in terms of Nature, their innate qualities, and the hindrances these may cause. Stevin's aim is to arrange the house so

'Current Emotion Research in History'; Stearns and Stearns, *Emotion and Social Change*; Huizinga, *The Autumn of the Middle Ages*; Reddy, *The Navigation of Feeling*; Reddy, *The Making of Romantic Love*; Broomhall, ed., *Early Modern Emotions*.

23 De Mare, 'Het huis, de natuur'.

that natural qualities are respected without causing discomfort, generating a liberated house that is free from nuisance and respects the inner dignity of all.

Jørgen Wadum demonstrates how Dutch seventeenth-century artists depicted various forms of privacy in both mythological and genre painting. Although this chapter significantly differs from the traditional historical perspective because of its focus on art history, it sheds light on how the artists, who each came from their own particular reality in the early modern Low Countries, transmitted that reality into their masterpieces. There is always a danger that modern viewers will interpret images on terms that make sense today but would have been regarded as far-fetched when the images were made. The elements of privacy may therefore have multiple faces, and Wadum examines this by studying mythological figures, interiors, and a *tronie* of a girl with a pearl earring.

Sanne Maekelberg provides the first of seven case studies in this volume. Here she examines the large network of residences of Charles de Croÿ (1560–1612), the highest-ranking nobleman in the southern Low Countries. His sixteenth-century court residences not only housed the family, but also embodied the power and prestige of the dynasty and assumed the role as the political centre of operations. Maekelberg examines how these physical environments were designed to regulate access and ensure that there was somewhere to be alone even in the public space of the early modern courtly residence.

Through a discussion of the love poem *Dagh-werck* (*The Day's Work*), composed by the Dutch poet and diplomat Constantijn Huygens for his wife Susanna van Baerle, Ad Leerintveld explores Huygens's private life. In his poem, Huygens describes how the couple is bound together by marriage and forms a unified entity. They find their most private intimacy within the walls of their own home. The concerns of the street, city, and state remain literally outside the door. Huygens also describes his own function as the link between the domestic space, the world of the *huysvrouw* (housewife) Susanna, and the outside world of court, state, and knowledge, in which he played an important role.

In her contribution, Tirtsah Levie Bernfeld analyses the background of the phenomenon of privacy among Portuguese Jews in early modern Amsterdam. She explains the extraordinarily closed character of this community in comparison with other religious denominations and the city administration. The Iberian background of the Dutch Sephardim, including their fear of Inquisitorial examinations, is considered as a cause of their extremely protective attitude to privacy, while the closed nature of the community can also be explained by ethno-religious and cultural components.

Judith Brouwer addresses the question of how best to examine the private lives of the lower social classes, as portrayed in captured letters from the year 1672. These unique letters, mostly written and sent by women to their loved ones during the Third Anglo-Dutch War (1672–74), never reached their destinations but were intercepted by the English fleet. Although these letters

obviously had a private purpose, the writers often used letter books or third parties to compose them, creating a complex tension between private and public that is the object of this chapter.

In her contribution, Hanna de Lange examines the personal life of the merchant Benjamin Furly (1636–1714), based on his membership of the Quaker community, his private correspondence, and his book ownership. Although Furly did not share much private information with the outside world, this chapter demonstrates that it is still possible to reconstruct his private life based on surviving sources. By analysing information obtained from various sources, such as details of his impressive book collection and the correspondence he maintained with his friend, the English philosopher John Locke, De Lange outlines Furly's life.

Freek Schmidt takes a closer look at the increasing size and interior distribution of the houses of the eighteenth-century elite on Amsterdam's canal ring, situating them within the context of contemporary sociocultural strategies of friendship, distinction, and entertainment. Substantial transformations were made in order to make the house function properly as an instrument of self-fashioning that could be shared with and displayed to selected audiences in order to affirm one's status and safeguard one's position in a network of relations. One of the determining factors in the use of the extended home was privacy, understood here as intimacy between relations rather than individual privateness.

Finally, by analysing and comparing the correspondence of Willem IV of Orange-Nassau with his mother, Maria Louise of Hesse-Kassel, and his wife, Anne of Hanover, Fayrouz Gomaa and Ineke Huysman address how members of the Dutch stadtholder's court exchanged information about their private lives. Focusing on the 1300 digitally available letters that Willem IV sent to his mother and his wife, Gomaa and Huysman use the digital tool Transkribus to study the terminology used in relation to private notions of health and emotion.

Conclusion

The contributors to this volume explore the multifaceted nature of early modern privacy without being bound by a single, predefined conception of what privacy should mean. The terms *public* and *private* during the early modern period did not have the same connotations as they do today, and they were often very different from — and more intertwined than — we experience them nowadays. Moreover, the meaning and relevance of these concepts has changed over time. For instance, the sixteenth-century concept of privacy was very different from the eighteenth-century concept. The same applies to the usage of the word *privacy* and related terms. Even the word *private* itself had different meanings in different countries: the Danish word *privat* referred at this time mostly to the realm of legislation

(i.e. private property and private education), whereas the French *privé* was more related to private counsel.[24] If we are open to understanding privacy as something that each individual perceives differently — and even individual perceptions change according to particular moments — we are able to explore privacy not as a term with a fixed definition, but as a set of shifting thresholds that can be felt once they are crossed. This is as true of the past as it is today. Therefore, this volume offers a range of approaches to the study of early modern notions of privacy, including the terminological and heuristic-zone approaches proposed by the Centre for Privacy Studies. It is our goal to let the early modern sources speak for themselves, and we therefore present various meanings of privacy and the private as understood by our contributors. This volume thus seeks to encourage and advance the analysis of privacy in its historical context.

A word of thanks is due to those who made this collection possible. We thank our (former) institutional homes at the Faculty of Philosophy and History at the University of Lodz, Interfaculty Research Institute for Culture, Cognition, History, and Heritage at Vrije Universiteit Amsterdam (Michael Green) and the Huygens Institute/NL-Lab (Ineke Huysman) for giving us the opportunity to edit this volume. The editors would like to express their gratitude to the Danish National Research Foundation Centre for Privacy Studies (DNFR 138) and its director, Mette Birkedal Bruun, for financial support during the organization of the three seminars that led to this publication as well as during the preparation of this volume. Our gratitude also extends to Maj Riis Poulsen, the Centre's head of administration, for the coordination of practical matters. We would also like to thank Natália da Silva Perez, Tom-Eric Krijger, and the anonymous reviewer for their helpful remarks and suggestions. Finally, we are grateful to Guy Carney, our publishing manager at Brepols, for his patience and help in making this volume see the light of the day.

24 This information has been demonstrated in the unpublished report prepared by Helle Vogt and Pernille Ulla Knudsen, prepared for the Centre for Privacy Studies in 2019; Merlin-Kajman, "'Privé" and "Particulier"'.

Works Cited

Primary Sources

Huygens, Constantijn, *Trijntje Cornelis*, ed. by H. M. Hermkens and Paul Verhuyck (Amsterdam: Prometheus/Bert Bakker, 1997)

Secondary Studies

Ariès, Philippe, 'Introduction', in *A History of Private Life*, III: *Passions of the Renaissance*, ed. by Roger Chartier, trans. by Arthur Goldhammer (Cambridge, MA: Belknap Press, 1989), pp. 1–11

Ariès, Philippe, and Georges Duby, eds, *Histoire de la vie privée* (Paris: Seuil, 1985–1987)

——, ed., *A History of Private Life*, trans. by Arthur Goldhammer, 5 vols (Cambridge, MA: Belknap Press, 1987–1991)

Baggerman, Ariane, and Rudolf Dekker, 'Jacques Presser, Egodocuments, and Jewish History', in *Emotions, Imaginations, Perceptions, Egos, Characteristics: Egodocuments in Dutch Jewish History*, ed. by Dan Michman (Amsterdam: Amphora Books, 2021), pp. 9–40

Broomhall, Susan, ed., *Early Modern Emotions: An Introduction* (London: Routledge, 2017)

Bruun, Mette Birkedal, 'Privacy in Early Modern Christianity and Beyond: Traces and Approaches', *Annali Istituto storico italo-germanico/Jahrbuch des italienisch-deutschen historischen Instituts in Trient*, 44.2 (2018), 33–54

——, 'Towards an Approach to Early Modern Privacy: The Retirement of the Great Condé', in *Early Modern Privacy: Sources and Approaches*, ed. by Michaël Green, Lars Cyril Nørgaard, and Mette Birkedal Bruun (Leiden: Brill, 2022), pp. 12–60

Cowen Orlin, Lena, *Locating Privacy in Tudor London* (Oxford: Oxford University Press, 2007)

Dekker, Rudolf, 'Introduction', in *Egodocuments and History: Autobiographical Writing in its Social Context since the Middle Ages*, ed. by Rudolf Dekker (Hilversum: Verloren, 2002), pp. 7–20

Febvre, Lucien, 'History and Psychology', in *A New Kind of History: From the Writings of Febvre*, ed. by Peter Burke, trans. by Keith Folca (New York: Harper and Row, 1973), pp. 1–12

Green, Michaël, 'Spaces of Privacy in Early Modern Dutch Egodocuments', *The Low Countries Journal of Social and Economic History/Tijdschrift voor sociale en economische geschiedenis*, 18.3 (2021), 17–40

Green, Michaël, Lars Cyril Nørgaard, and Mette Birkedal Bruun, eds, *Early Modern Privacy: Sources and Approaches*, ed. by Michaël Green, (Leiden: Brill, 2022)

Huizinga, Johan, *The Autumn of the Middle Ages*, trans. by Rodney J. Payton and Ulrich Mammitzsch (Chicago: University of Chicago Press, 1996)

Kaplan, Benjamin, *Divided by Faith: Religious Conflict and the Practice of Toleration in Early Modern Europe* (Cambridge, MA: Belknap Press, 2007)

Kistemaker, R. E., 'The Public and the Private: Public Space in Sixteenth- and Seventeenth-Century Amsterdam', in *The Public and Private in Dutch Culture of the Golden Age*, ed. by Arthur K. Wheelock Jnr and Adele F. Seeff (Newark: University of Delaware Press, 2000), pp. 17–23

Mare, Heidi de, 'Het huis, de natuur en het vroegmoderne architectonisch kennissysteem van Simon Stevin', in *The Art of Home in the Netherlands 1500–1800: Netherlands Yearbook for History of Art, Vol. 51*, ed. by Jan de Jong, Bart Ramakers, Herman Roodenburg, Frits Scholten, and Mariët Westermann (Zwolle: Waanders, 2000), pp. 35–59

Margulis, Stephen T., 'Privacy as a Social Issue and Behavioral Concept', *Journal of Social Issues*, 59.2 (2003), 243–61

Matt, Susan J., 'Current Emotion Research in History: Or, Doing History from the Inside Out', *Emotion Review*, 3.1 (2011), 117–20

Matt, Susan J., and Peter N. Stearns, *Doing Emotions History* (Urbana: University of Illinois Press, 2014)

Merlin-Kajman, Hélène, '"Privé" and "Particulier" (and Other Words) in Seventeenth-Century France', in *Early Modern Privacy: Sources and Approaches*, ed. by Michaël Green, Lars Cyril Nørgaard, and Mette Birkedal Bruun (Leiden: Brill, 2022), pp. 79–104

Mesquita, Batja, and Michael Boiger, 'Emotions in Context: A Sociodynamic Model of Emotions', *Emotion Review*, 6.4 (2014), 298–302

Plamper, Jan, 'The History of Emotions: An Interview with William Reddy, Barbara Rosenwein, and Peter Stearns', *History and Theory*, 49.2 (2010), 237–65

——, *The History of Emotions: An Introduction*, trans. by Keith Tribe (Oxford: Oxford University Press, 2015)

Ranum, Orest, 'The Refuges of Intimacy', in *A History of Private Life*, III: *Passions of the Renaissance*, ed. by Roger Chartier, trans. by Arthur Goldhammer (Cambridge, MA: Belknap Press, 1989), pp. 207–63

Reddy, William M., *The Navigation of Feeling: A Framework for the History of Emotions* (Cambridge: Cambridge University Press, 2001)

——, *The Making of Romantic Love: Longing and Sexuality in Europe, South Asia, and Japan, 900–1200 CE* (Chicago: University of Chicago Press, 2012)

Rosenwein, Barbara H., *Generations of Feeling: A History of Emotions, 600–1700* (Cambridge: Cambridge University Press, 2015)

Schama, Simon, *The Embarrassment of Riches: An Interpretation of Dutch Culture in the Golden Age* (New York: Knopf, 1987)

Scheer, Monique, 'Are Emotions a Kind of Practice (and Is That What Makes Them Have a History?) A Bourdieuian Approach to Understanding Emotion', *History and Theory*, 51 (2012), 193–220

Schuurman, Anton, and Pieter Spierenburg, ed., *Private Domain, Public Inquiry: Families and Life-styles in the Netherlands, 1500 to the Present* (Hilversum: Verloren, 1996)

Silva Perez, Natália da, ed., *Privacy and the Private in Early Modern Dutch Contexts* (= *The Low Countries Journal of Social and Economic History/Tijdschrift voor sociale en economische geschiedenis*, 18.3 (2021)

Stearns, Carol Z., and Peter N. Stearns, *Emotion and Social Change: Toward a New Psychohistory* (New York: Holmes & Meier, 1988)

Stearns, Peter N., and Carol Z. Stearns, 'Emotionology: Clarifying the History of Emotions and Emotional Standards', *American Historical Review*, 90.4 (1985), 813–36

Wheelock, Arthur K. Jnr, and Adele F. Seeff, eds, *The Public and Private in Dutch Culture of the Golden Age* (Newark: University of Delaware Press, 2000)

MICHAEL GREEN

'For my Personal Use'

Notions of Privacy in Egodocuments
from Early Modern Amsterdam

Introduction

In his almanac for the year 1745, Arent van der Meersch (1683–1768), a merchant from Amsterdam, wrote the following note: 'Tot mijn persoonlijk gebruijk. Parruijke' (for my personal use. Wig). It was followed by a list of wigs and clothes he had bought for himself for the years 1742–1754.[1] This curious note is just one example of the personal dimension of egodocuments from the early modern period, and it opens the door to the private sphere of the time. Egodocument, a word coined by Jacob Presser in the 1950s, refers to documents written by oneself about oneself, and most often contains the personal pronoun 'I'.[2] On this subject I will discuss four sources in this chapter, all of them written in Amsterdam between the years 1680 and 1755.

* This article was written with support from the Danish National Research Foundation, grant number DNRF 138 and of the IDUB fellowship at the University of Lodz. I am grateful to the Centre for Privacy Studies at the University of Copenhagen, CLUE+ at the Vrije Universiteit Amsterdam, and the University of Lodz for supporting the preparation of this chapter. I would like to express my gratitude to my colleagues at the Centre for Privacy Studies, and to the participants in the Low Countries History seminar organized by the Institute for Historical Research and the University of London, for discussing my chapter in its early stages. Particularly valuable were the discussions with Tom-Eric Krijger, Natacha Klein Käfer, Ineke Huysman, Fred van Lieburg, Johannes Ljungberg, and Sanne Maelkeberg, who commented on previous versions of my text.

1 Arent van der Meersch, 'Almanach Anno 1744', n.d., Amsterdam, CAA 15036, inv. 442. The almanac is not paginated. This handwritten text is located on a page with printed text entitled 'Verklaaring van het Tafereel Der Koopmans Beurs-Almanach'. The title page is missing.

2 The term 'egodocument' was coined by Jacob Presser in the 1950s. For an overview, see Baggerman, Dekker, 'Emotions, Imaginations, Perceptions'; Dekker, 'Introduction'.

Michaël Green is University Professor at the University of Lodz. He specializes in various aspects of early modern cultural, social and religious history, with an emphasis on notions of privacy.

Private Life and Privacy in the Early Modern Low Countries, ed. by Michael Green and Ineke Huysman, EER 19 (Turnhout: Brepols, 2023), pp. 27–61
BREPOLS ✠ PUBLISHERS 10.1484/M.EER-EB.5.132529

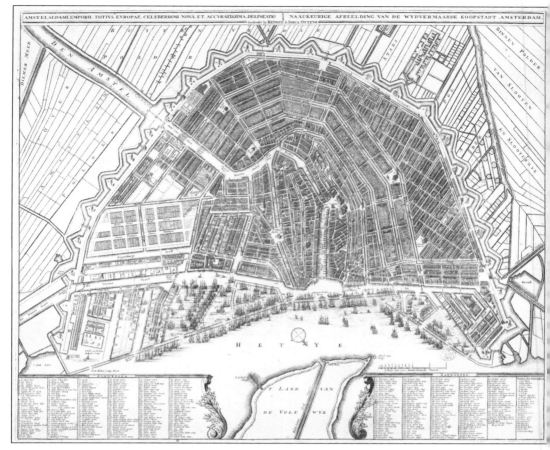

Figure 1.1. Anonymous, *Plattegrond van Amsterdam (Ground Plan of Amsterdam)*, 1726–1750. Print. Rijksmuseum Amsterdam, inv. no. RP-P-AO-20-55-2. © Rijksmuseum Amsterdam.

My decision to focus on Amsterdam stems from its being the largest and most diverse city in the United Provinces of the Netherlands (Figure 1.1).[3]

The United Provinces, or the Dutch Republic as it is often called, was a unique political entity in the early modern age due to its structure, which combined the institution of the States-General with the quasi-monarchical position of the House of Orange-Nassau. The multitude of different religious confessions that coexisted in the country contributed to its particular way of life.

At the end of the sixteenth century, during the Dutch Revolt and with the subsequent gaining of independence in 1648, the country was on the rise.[4] Amsterdam was a city that particularly benefited from this economic growth,

3 On the history of Amsterdam, see Frijhoff, Prak, and Carasso-Kok, eds, *Geschiedenis van Amsterdam, deel II-1*; Frijhoff, Prak, and Carasso-Kok, eds, *Geschiedenis van Amsterdam II-2*.
4 Israel, *The Dutch Republic*.

and its population grew from *c.* 13,500 inhabitants in 1500 to *c.* 200,000 in around 1700.[5] In this environment a prominent bourgeoisie arose that consisted mostly of merchants, but also of writers and artisans. The city thus developed a sense of beauty and culture, represented in the Dutch art of the period.[6] It was in the United Provinces that the architectural feature of the corridor was added to residential floor plans, breaking the tradition of walk-through rooms and thereby creating closed-off, private spaces, as represented for example in the work of Simon Stevin.[7] Following the nation's independence, the upper middle class — often rich merchants and traders — started to write about themselves. We also have examples from both the lower social strata and the higher echelons of society. The central focus of this article is on the combination of the sense of privacy and its representation in so-called egodocuments, particularly those written in Amsterdam, the economic centre of the country.

The recent edition of *Egodocumenten van Nederlanders* lists 659 egodoc-uments written by Dutch men and women who were born before 1801. Of course, the list is not exhaustive.[8] To date, only sixty-six documents written in Amsterdam or by Amsterdammers have been identified. The term 'ego-document' itself was coined by the Dutch-Jewish scholar Jacob Presser and further developed by Rudolf Dekker.[9] The topic of egodocuments became so important in Dutch historical research that Verloren, a prominent publisher from Hilversum, even established a series for the publication of these sources.[10] As documents written about oneself, egodocuments are sources that need to be consulted with care. While they offer a unique opportunity to explore the writers' inner worlds — their thoughts and reflections, feelings and sensations, worries and joys — it is nevertheless only through proper contextualization that a researcher can fully evaluate their accuracy. One of the most significant limitations of egodocuments is the fact that the author could write about anything that came to mind. This is why it is important to engage not just with the text itself, but also with its author, its context, its aim, and its addressee. My choice to focus on egodocuments in this chapter on early modern privacy is a deliberate one: because of their focus on the self, these texts are considered to reflect not only the writers' personal affairs (within the limitations mentioned above) but also societal norms. Back in 2000, Mieke B. Smits-Veldt wrote a short article in which she discussed how

5 By comparison, Paris and London at that time had over 500,000 inhabitants each. For figures on Amsterdam, see Kuijpers, 'Poor, Illiterate and Superstitious?', p. 58. On London and Paris, see Smith, *Clean*, p. 187.
6 Franits, ed., *The Ashgate Research Companion*; Fleischer and Munshower, eds, *The Age of Rembrandt*.
7 Van den Heuvel, 'De Huysbou'; De Mare, *Huiselijke taferelen*. See Heidi de Mare's and Freek Smidt's contributions to this volume.
8 Lindeman and Scherf, ed., *Egodocumenten van Nederlanders*.
9 Presser, 'Memoires als geschiedbron'; Dekker, 'Ego-Documents'.
10 The series comprises thirty-three volumes and is no longer active.

private life was depicted in three Dutch egodocuments.[11] She concluded that '[t]hese manuscripts, originally not intended for publication, are quite relevant to any research into early-seventeenth-century views on personal life'.[12] While one might argue about the intentions of the authors, the importance of the sources is evident. Rudolf Dekker reflected on family relations and teenagers' passage from the family home into the wider world.[13] His analysis made it clear how egodocuments such as diaries are important witnesses to the escape from the safety of what I would call 'the privacy of childhood' into the 'publicity of adulthood' — pointing to the more private status of the child in comparison with the publicity of an adult who has professional interactions at work or in service, and who exists within various social and political circles. But how do these sources relate to privacy?

Their private dimension was acknowledged by Ariès, who considered egodocuments to be a sign of private thinking which 'revealed the determination of some people to set themselves apart. They wrote in order to know themselves [...]. [They] did not necessarily write only *about* themselves, but *for* themselves and no one else'.[14] We must nonetheless always take into account that egodocuments were often meant to be read by others. Most of the time, they were written with a specific audience in mind. For instance, we can see that Moses Salomon Asser (1754–1826), an Ashkenazi Jew who lived in Amsterdam during the second half of the eighteenth and first half of the nineteenth centuries, wrote his memoirs for his grandchildren, in order to teach them about morals and how to succeed in life.[15] Jan Sijwertz (Siewertsz) Kolm (1589–1637), a playwright, poet, and painter from Amsterdam, related the history of his family and portrayed them in his 'Ghedenckboeck' (memory book).[16] The scope of the readership in many cases was not intended to be broad, but rather was limited to the family circle. There are of course exceptions, such as Jacob Bicker Raye (1703–1777), a descendant of Walloon Calvinists, who kept a diary. In it, he wrote about his own thoughts and experiences, events he had witnessed, and news he had heard, providing a kind of chronicle of his time. Then there is Abraham Chaim Bratbaard (1699–1786), his contemporary, who wrote a similar chronicle from a Jewish perspective. Both of these examples were probably intended for a broader readership.[17]

11 Smits-Veldt, 'Images of Private Life'.
12 Smits-Veldt, 'Images of Private Life', p. 164.
13 Dekker, 'Children on their Own'.
14 Ariès, 'Introduction', p. 5.
15 Van Eeghen, 'De autobiografie van Moses Salomon Asser'.
16 'Ghedenckboeck waerin state geteeckent, gerijmt en geschreven en gecoleurt alles wat hier in op 't paier vertoont wert is gedaen deur mij Jan Sywertsz Kolm ghebooren tot Amsterdam', Amsterdam, CAA 15030, inv. 56904, 52046, 77884.
17 Bicker Raye, *Het dagboek*; University of Amsterdam Library, Bibliotheca Rosenthaliana, hs. ROS. 486; 'Eyn nye kroniek', and the short version translated into Dutch in Fuks, ed., *De zeven provinciën in beroering*, especially pp. 7–14.

To turn to the religious affiliations of the authors, representatives of various religious groups — Jews, Calvinists, Catholics, and others — wrote egodocuments of various kinds. We should also take into account the various confessions written by Huguenot refugees, which were intended to be read in their congregations, or the memoirs of exile that they left for their children and communities.[18] There are also conversion stories of the Reformed and the Pietists, such as that of Steven Engelen (1689–1768), who wrote his conversion story to be read in his home circle in 1740.[19] The examples I have chosen here are taken from Amsterdam's merchant milieu, with some of my protagonists being economically better-off than others. This is because they belonged to the middle class, which was the driving force of early modern Dutch society and the social stratum in which most Dutch egodocuments were written. The above-mentioned examples position these literary works initially within the private domain, such as within the family or a close community circle.

While the introduction to this volume provides the reader with historiography and basic research possibilities on privacy in general and specifically in the United Provinces, it seems important to stress here that privacy has no strict definition, but it is often characterized as the limitation of access to a person.[20] A more nuanced approach to privacy considers not the limitation but the regulation of access, which can be made through a conscious decision.[21] This decision is made by the one who has the power to make it, which in the early modern period was often not the person concerned, due to the hierarchical structure of society: families who shared small spaces, servants who were wholly dependent on their masters, and the state's control of beliefs are just a few examples. The decision to regulate access can be made with regard to directly physical access, i.e. who is allowed to see and interact with the individual, but it can also refer to indirect access, such as information about that individual. At the same time, privacy concerns not only individuals but also groups. For example, in the case of the everyday functionality of a religious community, some rituals can be kept from the eyes of those who do not belong to the community.[22] Surprisingly for a concept that is so popular nowadays, there is limited historical research on this topic. Jürgen Habermas wrote that the bourgeois 'public sphere' emerged in the eighteenth century and comprised both the public and the private realms.[23] As Keith Michael Baker explains: 'The subjectivity of the private individuals comprising the new public originated in the "intimate sphere" of the bourgeois family'.[24]

18 Chappell Lougee, 'Huguenot Memoirs'.
19 See Lieburg, *Living for God*.
20 For a discussion of various modern definitions of privacy, see Allen, *Uneasy Access*.
21 Margulis, 'Privacy as a Social Issue', p. 246.
22 One thinks, for example, of the Jewish community, who did not initially allow strangers to attend their services. See Green, 'Public and Private'.
23 Habermas, *The Structural Transformation of the Public Sphere*.
24 Baker, 'Defining the Public Sphere', p. 184.

This article uses the model developed at the Centre for Privacy Studies, namely the heuristic zones of privacy that map out the early modern world, and the terminological approach, which makes use of associative terms related to the concept of privacy, even when the word 'privacy' itself does not exist in the text.[25] Having these this approaches in mind, we can now focus on the main question for this chapter: how can we trace the notions of 'private life' and 'privacy', and how do these two notions relate to each other in the egodocuments I discuss here? To answer this question, I will analyse some aspects of four egodocuments written by Amsterdammers in the seventeenth and eighteenth centuries, in order to understand how they defined their own private sphere. These egodocuments were chosen because they characterize one social stratum, namely the bourgeoisie, the authors being merchants and a magistrate. The texts represent three distinctive epistolary forms: two almanacs, i.e. commercially published diaries, which give only limited space for personal writing (Dirck van der Koghen and Arent van der Meersch), one autobiographical poem (Hermanus Verbeeck), and one diary (Jan Hendrik Hermans). The respective epistolary forms dictated the extent of the discussions held within them. Finally, these four documents cover a period of roughly a hundred years, from the late seventeenth to the late eighteenth century, and give the reader a glimpse of their authors' ideas within a given time period. In this account I do not focus on letters, as I have done so elsewhere.[26] In order to make a coherent analysis, I examine the following questions: in what contexts do notions of privacy come to the fore in the documents examined? What is the relationship between privacy/the private and space? What is the language used to mark privacy?

This chapter does not aim to give an exhaustive definition of what was considered 'private' or what constituted 'privacy', or to give a complete overview of all the egodocuments in Amsterdam relating to these two terms. Nor does it aim to deal with the possible interpretation of privacy as an emotion. Moreover, one needs to keep in mind that Amsterdam held a unique position in the United Provinces, being the largest and most important city, with prospering commerce and a flourishing bourgeois culture. Therefore, the situation in other Dutch cities and in the countryside may have been quite different, and additional research is required to determine this. The reader may also rightly consider that some of the findings are obvious. Nevertheless, there has hitherto been little effort to bring together all the known (and still unknown) aspects related to privacy in order to create an idea of what privacy may have meant for an early modern person — in our case, one living in Amsterdam.

In the following examples, I wish to demonstrate what notions of privacy and the private we can discover by using the concept of heuristic zones in close readings of egodocuments written in early modern Amsterdam.

25 These approaches presented by Bruun are outlined in the introductory chapter of this volume.
26 See Green, 'Autour du Grand Tour'.

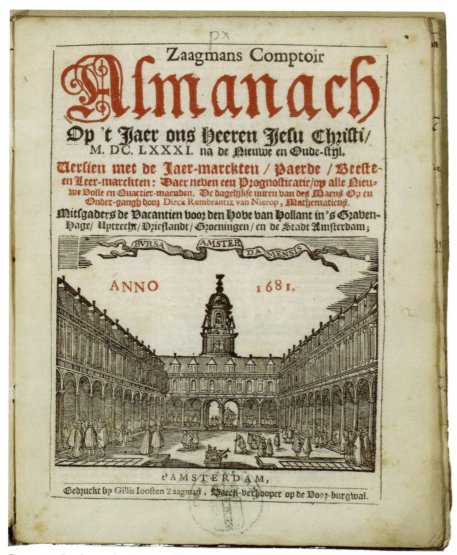

Figure 1.2. Dirck van der Koghen, 'Almanach 1681', title page with an engraving of Amsterdam's exchange. Amsterdam, CAA 15030, inv. 94939. © CAA.

What aspects of privacy can we determine when assessing egodocuments? Perhaps one of the most personal aspects is the way in which individuals express their feelings.[27] What spaces are mentioned in relation to private

27 On the notion of early modern emotion and its meaning, see Boddice, *The History of Emotions*; Scheer, 'Are Emotions a Kind of Practice?'.

Figure 1.3. Dirck van der Koghen, 'Almanach 1681', month of January. Amsterdam, CAA 15030, inv. 94939. © CAA.

Ad 96 Onder godts ghenadighe voorlootinghe. Jn Amsterdam Ao 1681 Januari

Maendt Junio
nu Maendagh quam ick van Haerlem daer jck 8 daghs de ghevaren j bedroeven gise
tot Amsterdam, ghebleven daere besocht nest kinde vande E. Cooghs de Wed al
luyghe tijt ekrancke ghewest t' ad n t' water. Jck quam t' woort van
daer de schipe de deurgnerk gise, de voor de wint oost op de middag was op ...
... al sijn de incommandte mij al vaert door sonder onghemack quam ickblike
des Godt wel te dancke voor al sulcke groote genade hijmij mij oude de
ghe coontse vay de bilantedoon. wed oversedch den 4 diser

.... int O. N. O. de vircheyfeon. des avonts te zal leerde sagicke de Commiss deerd
wedelicke goed boeck de huyse aen d' onse sijde also ick voor onsa kb voninge
o mij log vrudnt op de steurele Burgeras onde s' Anedt swaet ghaen id also
mij do ... wird zuyt wes day mij al vry goed boeck de huysh wan de ... met in
de lange rode oes raet om goet ... na ons toe na het doren ... raet
geht de waestig. sigge de vader of vader hed svaestig als t' walt daer met aen den
.... wes het woort parseden door konde sijn. doe wij wes voorder gaen
smadde, als doinck dit vais op den 26

ditto vais int bloch des avonts ontrent half wes ... de Commiss deerd ...
gogle als dit 8 diser aende ind vout de huysh met t' tight in uls boeck gelt daer
huys t. by ons t' voning en so ede wel bleind de raet oes brod
ditto ... jck de Commiss deerd maer wes so t' klein wabende

ditto jck na Haerlem wes ij t' del losint ganes gelt perijckle te sijn.
nest ... vande Cooghs th ... de Hovrele comt dits wat t hedt sijint
maer also ght water wes af 621, ... hedemed deur so is wijning goed
tot ghenedinge. de hovd bel vies glon ghenadighste sijn, t' te leerde

ditto com jck van Haerlem met de wags ses weder tot Amsterdam

life and privacy? Are there clear differences among the various kinds of egodocuments regarding the ways in which privacy is discussed? I will start with an example of an egodocument which is preserved in the Amsterdam City Archives.

Almanac of Dirck van der Koghen (1604–after 1681)

This egodocument is located in the Amsterdam City Archives, but we know very little about its author.[28] One of the problems with this kind of source is that there are often no biographical details available. The editors of *Egodocumenten van Nederlanders* identify Van der Koghen's birthdate as 4 November 1604, which means he would have been seventy-six years old at the time of writing his almanac during 1680–1681.[29] He was probably from a Mennonite family. Many of the entries relate to his travels.[30] Additional biographical information, albeit very brief, can be found in the archives: for example, a certain Dirck van de Cooghen (the letter K could be easily substituted for a letter C in the early modern period, due to the lack of clear grammatical rules) married Sara van Halmael on 4 May 1646.[31] No record of Van der Koghen's death can be found in the archives. If this is the same person who wrote the diary, it seems that his health was quite good, as he was still able to travel at an advanced age (Figure 1.2).

The fact that Dirck van der Koghen wrote in a printed almanac — the *Zaagmans Comptoir Almanach*, with an illustration of Amsterdam's exchange on the title page — makes it likely that he was a merchant.[32] Printed almanacs were divided into months, and each month began on its own page, with an engraving demonstrating the most important activities due to take place that month. The adjacent page would be empty, clearly indicating that it could be used for writing. Such an almanac usually contained practical details, such as the number of days in a month, or astrological information on the phases of the moon and positions of the planets (Figure 1.3).

In his almanacs for 1680 and 1681, Van der Koghen made notes about his daily life, focusing on his travels to Haarlem, where he had relatives.[33] If we take as an example the page for January 1681, we see that it states 'Januarius' (January) in red, and then 'Louw-Maendt' (tan month).[34] The engraving

28 Dirck van der Koghen, 'Almanach 1681', Amsterdam, CAA 15030, inv. 94939. Many thanks to Ineke Huysman for her help in transcribing some of the quotations from this almanac.
29 See Lindeman and Scherf, eds, *Egodocumenten van Nederlanders*, p. 109, entry 148.
30 Blaak, *Literacy in Everyday Life*, p. 123.
31 'Ondertrouwregister', Amsterdam, CAA 5001, inv. 678, p. 199.
32 Bib. Person, Amsterdam, CAA 15030, inv. 94938, 94939.
33 See Lindeman and Scherf, eds, *Egodocumenten van Nederlanders*, p. 109, entry 148. Amsterdam, CAA 15030, inv. 94938, 94939.
34 *Louwen* in modern Dutch becomes *leerlooien*, which means 'to tan'. Dutch months had additional names of German origin, which were commonly used until the seventeenth

depicts horses pulling sleighs and children playing on sledges. Beneath the engraving and on the reverse side of the page, there is a lot of empty space (Figure 1.4). In fact, Van der Koghen starts writing on the page before this, next to the title. His very first entry of the year is dedicated to travel. He writes:

> 6 Januar[ij 1681, M.G.] Heden sijnde maandach quam ick van Haerlem daar ick 8 daghen ben geweest ende wederom hier tot Amsterdam, hebbende daar besocht neef Leend[ert] van den Cooghen, dewelcke al enighen tijdt is kranck geweest aen 't water. Ick quam te voet van daer ten elf uren en ten drij uren hier. Den oostenwint corts op den middach wat opwaeijende incommodeerde mij al wat, doch sonder ongemack quam ick hier, dus hebbe Godt wel te dancken voor al succke grote genade en mijnen ouderdom.

> (On 6 January [1681], which was Monday, I came back from Haarlem, where I had been staying for eight days, and returned here to Amsterdam, after having visited my cousin Leendert van den Cooghen, who had been suffering for some time from dropsy. I left there on foot at eleven o'clock and arrived here at three o'clock. The eastern wind was blowing rather strongly around midday, and made me somewhat uncomfortable, but I still came here without much incommodiousness, so I have to thank God for such great grace and my old age.)[35]

This passage confirms that Van der Koghen was indeed old when he wrote these words, but can we speak of any private aspect here? How do the feelings of a person relate to privacy? The heuristic zones mentioned above may help to solve this question. One of the inner zones of privacy is the body. In the text, the author expresses his feelings, writing that the cold wind made him somewhat uncomfortable on his journey; in other words, his body felt cold, and it was an unpleasant sensation. The fact that he puts this sensation on paper means that it was significant enough for him to remember it. The act of making a note of this sensation allows the reader to enter within the private realm of the author, to understand how the author feels and thinks. It is most probable that the author wrote these notes for his own eyes only, or perhaps for the circle of his immediate family, as the subsequent details demonstrate. The almanac has too many entries to discuss them all, and therefore I have only chosen a few examples that are of interest in relation to privacy.

What other details can we learn about the private life of Dirck van der Koghen from his almanac? In an entry dated 8 January 1681, he describes the conditions where he lives. His *logement* (living quarters) are located on the Fluwelen Burgwal (now Ouderzijds Voorburgwal, adjacent to the oldest canal in Amsterdam), while his *woninghe* (living room) overlooks Sint Annenstraat (Saint Anne Street). He reports that he has been watching the stars.

century, and were related to agriculture and professional activities. *Website Het Genootschap Onze Taal* <https://onzetaal.nl/taaladvies/> [accessed 1 March 2021].

35 Van der Koghen, 'Almanach 1681'.

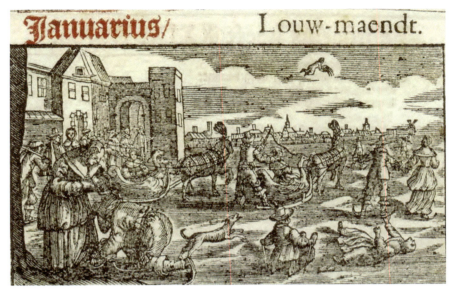

Figure 1.4. Dirck van der Koghen, 'Almanach 1681', January engraving. Amsterdam, CAA 15030, inv. 94939. © CAA.

Two subsequent entries, on 15 and 17 January, are also dedicated to astronomy, as he was observing comets on these days. On 18 January, Van der Koghen undertook another journey to Haarlem to visit his cousin Leendert, whose health had deteriorated, and on 21 January he notes his return to Amsterdam. These notes, listed in chronological order, could be used later to trace his activities on a specific date, should the need arise. At the same time, this information can be classified as private, as it engages directly with his person (Figure 1.5).

Figure 1.5. Dirck van der Koghen, 'Almanach 1681', month of January, detail of two comets. Amsterdam, CAA 15030, inv. 94939. © CAA.

Besides his personal observations, Van der Koghen also lists general details, such as the names of burgomasters, which he notes on the pages for the month of February. Most of all, throughout the entire text he allows the reader to access his mind (the innermost heuristic zone of privacy) and reveals his hobbies and preferences. The references he makes to his old age and ailing body also pertain to the private sphere. This example shows us how an early modern Amsterdammer of very advanced age reflected on his being, his daily life, and his interests. The almanac contains eleven other months' worth of similar information, but for the sake of our discussion here the aforementioned examples from January present a good overview the rest of the text. Van der Koghen's case is not unique, and in the next document we will discover even more revelations of a similar nature. Finally, in relation to the audience for this almanac, it seems that he mostly wrote for his own use, as a sort of reminder of what he had been doing on each day, particularly with his astronomical observations. Such a book might also have been read by his family after his death, without revealing any extremely intimate details about himself or others.

Memoir of Hermanus Verbeeck (1621–1681)

My next example is Hermanus Verbeeck, a Catholic Amsterdammer and contemporary of Dirck van der Koghen. His egodocument, entitled *Memoir ofte mijn levensraijsinghe* (memoir of my life course), was edited by Jeroen Blaak in 1999.[36] In his extensive introduction, Blaak points out that this memoir reveals how the author, a sick man, made a living and survived through economically and politically difficult times. One should keep in mind that due to the Alteratie (alteration) of 1578, when Protestants took power in the city, the Catholic population of Amsterdam had lost its ruling status and been marginalized, and subsequently became a subculture.[37] As Carolina Lenarduzzi explains, this marginalization created major problems in the daily lives of Catholics, which lasted well into the seventeenth and even eighteenth centuries.[38] One of the major problems was that of religious worship, which for Catholics, as Benjamin Kaplan points out, took the form of a 'private' practice, i.e. it was conducted in the *schuilkerken* (hidden churches), whose existence nonetheless was well known to all, even though Catholics never had the right to worship openly in public.[39] However, this did not prevent Verbeeck from occupying several positions, among them that of a broker. This occupation required

36 Verbeeck, *Memoriaal ofte mijn levensraijsinghe*. The original manuscript is located in The Hague, Royal Library of the Netherlands, hs. 187 A 4.
37 Verbeeck, *Memoriaal ofte mijn levensraijsinghe*, pp. 7–41. On the Alteration, see Van Nierop, 'Van wonderjaar tot alteratie'.
38 Lenarduzzi, *Katholiek in de Republiek*.
39 Kaplan, *Divided by Faith*, pp. 172–97.

support from a burgomaster (at that time there were four burgomasters in Amsterdam), one of whom Verbeeck managed to reach through his network, which shows that despite his misfortunes he was rather well connected.[40] The question is once again one of audience: for whom did Verbeeck write his memoir? We do not know, but as Blaak suggests, the memoir may have been his attempt to come to terms with his own suffering and thus have been religiously motivated, or it may otherwise have been meant for his children.[41] The memoir is written as a poem — which was not entirely unusual, as seen in the example of Kolm[42] — and this kind of writing requires much more effort on the part of the author than ordinary prose. Considering that Verbeeck was an amateur poet, it is not so surprising that he chose this genre to relate his life.[43] Could it be a sign that he intended it for a broader public? The answer remains unknown, but the possibility surely exists; unlike an almanac, poetry would have attracted a readership.

This egodocument presents various references to the private domain. I wish to focus here on a few references to his early years, as it is important to see how Verbeeck perceived his own formative years many years later, when he was nearing his end. This reflection by an old man on his childhood reveals personal dimensions that would otherwise not be known, as children do not reflect much on their inner worlds.[44] What might his reflections teach us about his understanding of the private sphere? While speaking of his childhood, Verbeeck writes that in his third year of life he 'soetaen groeij' (steadily grew up), i.e. ...was growing up well, which brought his parents much happiness; he also reflects that a child has no worries, and that all of his existence is taken care of by his parents.[45] Yet his happiness was cut short. On one occasion he was climbing up a ladder with a barrel full of beer, and he fell. He writes that '[d]aar lagh ick in mijn bloet' (I lay there in my blood), with his hat torn and his body so hurt from the inside that his mouth ran with blood.[46] He reflects on the bodily pain that he suffered from the fall, and the commotion in the house that followed. As mentioned above, the body is one example of what we consider a heuristic zone of privacy, but the innermost zone is that of the mind. Verbeeck's next entry is about precisely this. Having recovered from the fall, '[d]oen quam de eerste last van mijne kinsze jaaren: ik moest ter schoole gaan' (then came the first incommodiousness of my childhood years: I had

40 Verbeeck, *Memoriaal ofte mijn levensraijsinghe*, p. 14.
41 Verbeeck, *Memoriaal ofte mijn levensraijsinghe*, p. 32.
42 Kolm, 'Ghedenckboeck', Amsterdam, CAA.
43 Verbeeck, *Memoriaal ofte mijn levensraijsinghe*, p. 33.
44 There are not many contemporary egodocuments written by children. We can take as examples the letters of the young princes of Orange and counts of Nassau, in which there are few if any references to their thoughts and feelings. For references and a discussion of these sources, see Green, 'The Orange-Nassau Family'; Green, 'Educating Johan Willem Friso'.
45 Verbeeck, *Memoriaal ofte mijn levensraijsinghe*, p. 47.
46 Verbeeck, *Memoriaal ofte mijn levensraijsinghe*, p. 47.

Figure 1.6. Adriaen Jansz. van Ostade (1610–1685), *Interior of a Schoolroom*, Haarlem, 1666. Oil on canvas, 22.4 × 18.9 cm. Wikimedia Commons/public domain.

to go to school). While this is on his mind, he complains about the pain that this learning of the *geheijm* (secret) of knowledge brought to him.[47] As Blaak explains in the introduction, Verbeeck was first educated by a private tutor to make up for the lack of Catholic education, and then he was probably sent to a Latin school; such an education in the United Provinces would have included the humanistic curriculum, in particular Latin.[48] Yet how are we to classify this experience? If we keep in mind the heuristic zones, we see that Verbeeck speaks directly of his physical bodily pain on one hand, and of his mental pain on the other. This is what makes the text important for understanding how he perceived his private sphere. Further, his use of the word 'secret' suggests connotations of privacy to the reader, as it belongs to what I would call 'words hinting at privacy', which also include words such as 'intimate', 'personal', 'hidden', etc.[49] In this case, by using this word, the author shows us that he was entering a different world, the world of knowledge, which was open only to those who had access to it. The regulation of access, which regulates the privacy of a person, can also regulate access to a community — in this case, the community of those who possess knowledge.

The conditions under which children received their education in the early modern period are well known, and they often left much to be desired. The painting *Interior of a Schoolroom* by Adriaen Jansz. van Ostade (1610–1685) exemplifies this dark and messy environment, with a schoolmaster who shows little interest and children who are crammed into a dirty and lightless room (Figure 1.6).

At the same time, Verbeeck's experience of his education is not the only aspect of privacy that is significant here. There is another aspect involved: leaving home. Home presented a safe space, a place where the family lived and the person was taken care of. Some thirty years earlier, the schoolmaster David Beck (1594–1634), who lived in The Hague and then in Arnhem, depicted his home as a place where he socialised, hosting friends, making music, and conversing.[50] A hundred years later, in the eighteenth century, Maria de Neufville (1699–1769) was often unwell if she left her home, and she had also not been happy about going to school.[51] Therefore, 'leaving home' meant departing from a secure location, which might have negative consequences for the person. In the conclusion to his recent article on the Dutch Eelkens family, Willem Frijhoff stipulates that a Dutch house was not a private place, because it was the location where various meetings occurred and where commerce took place.[52] Nevertheless, in my view, this does not preclude the

47 Verbeeck, *Memoriaal ofte mijn levensraijsinghe*, p. 48.
48 Verbeeck, *Memoriaal ofte mijn levensraijsinghe*, p. 7.
49 Bruun, 'Towards an Approach'.
50 Beck, *Spiegel van mijn leven*; Beck, *Mijn voornaamste daden en ontmoetingen*.
51 De Neufville, *Verhaal van myn droevig leeven*, pp. 35–42. For an analysis of her text, see Green, 'Spaces of Privacy', pp. 29–38. Contrary to Verbeeck, she did enjoy school eventually.
52 Frijhoff, 'How to Approach Privacy'.

idea of the home as a private and secure location: being at home did not mean the same thing as being secluded. Rather, at least for the merchant milieu, it meant feeling comfortable and secure thanks to the possibility of regulating access to the premises. The childhood examples demonstrate the spatial aspect of privacy, which plays a role in our understanding of early modern privacy. In one instance, Verbeeck had a fall within his home — the fourth heuristic zone, as mentioned above, and the place where he was supposed to feel the most secure. In his case, this security was probably provided not only by the walls of the house, but also by the presence of his parents. In another instance, we learn that he went to study; the act of leaving home for school symbolizes a shift from the privacy of the home, stepping out into the fifth heuristic zone, that of the community. This is where he was to be prepared for his 'public' life and his future duties.

The two instances of pain mentioned above by Verbeeck — the fall from the ladder and leaving home for school — are both deeply personal, but the author emphasizes the second instance more profoundly: he felt mental pain while at school, whereas the fall, besides causing him physical pain, only made him aware that he may have burdened others with the commotion he triggered and the unpleasant sight of him lying in his own blood.

Due to lack of space, I do not intend to discuss the rest of the text, with the exception of one more instance of mental pain suffered by Verbeeck. The worst tragedy for him was when his 'sister' Bartha died, followed only two weeks later by his other 'sister' Maria, 'bloem des levens' (flower of life), on 3 and 17 November 1668 respectively.[53] While we should keep in mind the rhetorical side of poetry, the reference to the 'flower of life' with regard to a particular 'sister' shows the close bond between the two. Therefore, this description of the pain of the loss of a dear one, put down on paper, leads us into the inner world of the author.

Almanac of Arent van der Meersch (1683–1768)

Arent van der Meersch was a trader from a Mennonite family, like Dirck van der Koghen. In 1719 he married Petronella Heuvelingh (1701–1784).[54] His egodocument consists of an almanac for the year 1745, although the printed text says 1744.[55] This almanac, which resembles that of Dirck van der Koghen,

53 Verbeeck, *Memoriaal ofte mijn levensraijsinghe*, p. 207. He is most likely speaking of cousins rather than literal sisters. His siblings, born to Willem Pietersen Verbeeck (1582/1583–1644) and Adelbertha Klein (d. 1639), were Geertruijt (1615/1616–1662), Pieter (1616/1617–1681), and Maria (1631/1662–1671).

54 Lindeman and Scherf, eds, *Egodocumenten van Nederlanders*, entry 250.

55 Abraham van der Meersch, 'Almanach Anno 1744', Amsterdam, CAA 15030, inv. 442. His appointment by the States of Utrecht in 1709 as a soap maker (and probable trader) in Amersfoort is found in Amsterdam, CAA 198, inv. 34.

Iconologia . Fol. 212.

Dat Huys heeft een Gewenschte Stand,
Daar trouwlijk waakt eens Moeders hand:
In die met teugels vast bewaart,
't Geen vleijtig word bij een Vergaart:
Die vreedzaam alles overziet,
Die 't Huijsgezin met tucht Gebiet,
In die met Oordeel, en met maat,
Op alle Dingen Gaede slaat :
Wat Huijs een Zulke Moeder derft,
Dat Gaat Verlooren en Versterft.

Zie hoe Erasmus Paraphraseert
Over Matth.' XV. V. 4.5.&6. *Iconologia* F. 213.

De Oeijvaer draagt tot Zijne Vrucht,
Veel hulp en troost en Goede Zucht:
Het Jong Wanneer't is opgevoedt,
Zijn Ouders weer veel deugden doedt:
Ja alsze Zijn berooijt en mat,
Van kragten bloot, van 't leven Zat,
Zoo kweecken zij haar' Ouders op,
En draagens' over berg en top.
Begeeft mij Rijkdom, staat en Jeugd:
Gods Liefde maakt mijn hart Verheug

Figure 1.7. Arent van der Meersch, 'Almanach Anno 1744'.
Amsterdam, CAA 15030, inv. 442. © CAA.

A.º 1744. 13 January. Prijs Courant

6 S.ᵗ Domingo indigo 40 a 52. stff. ¼ ℔.
 Guatimalo 40 a 94 „
5 Boomolie Poulse ¼ Vat 717 mengt. £
 Sivielse £ 57 a 58.

7 Thee Boey ordinare 20 a 18 stff.
 kisten 29 a 28 „ groene 40 a 42 stff.
 koffy Boonen, Javaunse 8 stff. a 8½ „
 Surinaamze 7½ stffs a 7½ „
 kakau, Caraques 5stff. 10 stff.
 marignonse „ 8 stff.

12. Potasse, Moscovise d'200 ℔ ƒ³
 Danziger 34 a 40 ƒ³ Fijne dito ƒ³ Croon 26 a 36
 Braak . 23 a 25 — ƒ³ Rigase dubbele sleutel ƒ³
 Coninxberger . 22 a 32 ƒ³ Inkelde sleutel £ 26 a 22.
 Rig: Braak 23 a 26 ƒ³ Elbingse Potasse 25 a 30 ƒ³
 Witte Rijnse 41 a 43 ƒ³ Hamb: 40 a 42 ƒ³ Bremer 38 a 42 ƒ³
 Weedasch Deense 10 a 17 ƒ³
 Moscovische harde Blauwe Merkosse £ 12 a 140 ƒ³
 dito prinsen — £ Moscovische Blanke £
 Rijgsche Moscovische Spiegels £ 60 a 100 —
 Rijgsche Spiegels £ 30 a 50
 koningsberger Moscovische Beerenklau £ 60 a 80 —
 koningsberger Beeren Claw £ — — —
 Walachische Danziker Kroon
 Cassubische dubbelt geloogde ¼ ℔ Duijten 8½ a 9½ ℔
 Inkelde d: — — Elbingsche Harde Blauwe 6 a 8 ℔
 Stett. en Colb. Harde Blauwe d: 4 a 9½ ℔
 Elbing. Colb: en Stett. Blanke ƒ — — Pruijs d:
 Souda d'100 ℔ gt. 6:10:—

was not only used to record daily events, but also recorded his meals and even poems (in Dutch and Latin with Dutch translations), along with lists of goods and prices (Figure 1.7). It also includes explanations of astronomical matters, a list of cities Van der Meersch travelled to, and even a method for reducing swollen tonsils. After being used as a journal for the year 1744, the almanac was kept by the author to make note of various important events that happened both before and after the date of the almanac. Many of these are dated 1745. In relation to the private domain, the author's daily and family life are of direct importance, as most of the text is about these subjects. So how does the author portray his family life in his almanac?

On one of the almanac's first unnumbered empty pages, there is an entry dated 'A[nn]o 1745' with the title: 'Aan mijn zeer waarde en lieve huijsvrouw Petronella van der Meersch' (to my highly valued and beloved wife Petronella van der Meersch).[56] The subsequent text is a poem dedicated to Petronella, in which Van der Meersch thanks God for such a wonderful wife — 'een wijze vrouw komt van den Hemel af' (a wise wife comes from Heaven) — to whom he wishes all health and success, and whom he sees as his support and the builder of his house. This shows the ideal relationship Van der Meersch wanted to present.

What other dimensions of private life can we see in this almanac? One of the most curious and unusual aspects is nutrition. Van der Meersch meticulously notes his menus for each month. As an example, let us examine the first five days of April 1745. From this we learn that his menu was as follows:

> Donderdag 1 April 1745. Savoijkool en kout lams vlees. S'avonds vlaa.
> 2 Taraxacon, & vlees met uijen gestooft
> 3 Eijerstruijf met appelen
> Sond[ag, M.G.]
> 4 Aard appele & schalvis, item gestoofde schalvis
> 5 Taraxacon sala & gewent brood
>
> > (Thursday 1 April 1745. Savoy cabbage and cold lamb.
> > In the evening, custard.
> > 2 Taraxacum [a flower used for salads, M. G.],
> > stewed meat with onions
> > 3 Omelette with apples
> > Sunday
> > 4 Potatoes and haddock, the same [potatoes, M. G.]
> > with stewed haddock
> > 5 Taraxacum salad and French toast)[57]

56 Van der Meersch, 'Almanach Anno 1744'.
57 Van der Meersch, 'Almanach Anno 1744'.

Figure 1.8. Arent van der Meersch, 'Almanach Anno 1744', fragment. Amsterdam, CAA 15030, inv. 442. © CAA.

Why was noting his diet on a daily basis so important to the author? Food was a sign of social status, and when written down it could point to that status, but the almanac probably was not intended to be read by a wider audience. Therefore, although there may have been an attempt to impress a future reader, the most likely purposes were to help to vary his diet and to keep track of expenses relating to food.[58] As Ken Albala mentions: 'The cuisine of the Netherlands remained simple and straightforward, despite their enormous wealth [… and included] *bruwets* (broths) and *blanc-mangers*, jellies, pastries and various spiced and colored dishes'.[59]

For the five days of April 1745 listed above, we see recurring items of food — taraxacum and cold meat — and we can note that the consumption of meat occurs almost every day. The private here is of course the act of noting the diet — an activity that happens at home, and information that can reveal the economic state of the person and can therefore be considered private. This of course is also the case with the recipes noted in the almanac, such as cinnamon waffles, biscuits, and *oblie*, a sort of a pancake made with milk, butter, cinnamon, and ginger. One of these recipes, for the preparation of chestnuts, came from his mother, Elisabeth Boutens (1643–1706).

It is not only with regard to food that the almanac allows us to discover the personality and interests of Van der Meersch. One of the pages includes a contemplation of the Devil: 'VICarIUs DeI generaLIs is 666' (God's Deputy Vicar is 666).[60] This demonstrates not only religious zeal, but also a sense of wit, which is confirmed by another entry for the month of July. Right under a recipe for orange tablets (a sort of pastry), there is an inscription: 'Ik ben noit geboren; ook kan Ik noit sterven. Zeg mij dan, bid ik u wat ik ben?' (I was never born, I also can never die. Tell me then, I pray you, what am I?). This is a riddle, and the answer is written backwards: 'LEGEIPS NEE' (EEN SPIEGEL) (RORRIM A [A MIRROR]) (Figure 1.8). This sense of humour

58 For more information on early modern food and habits, see Albala, *Food in Early Modern Europe*.
59 Albala, *Food in Early Modern Europe*, p. 186. On food in history, see Claflin, 'Food among the Historians'. Scholars of food history could certainly benefit from analysing the extensive lists of meals and recipes in Van der Meersch's almanac.
60 The number 666 is the symbol of the Devil.

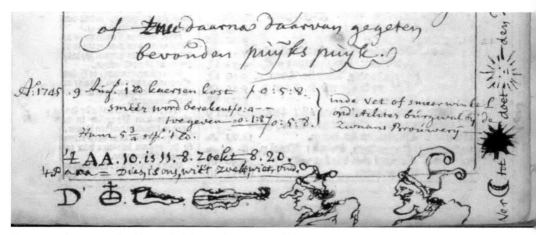

Figure 1.9. Arent van der Meersch, 'Almanach Anno 1744', fragment. Amsterdam, CAA 15030, inv. 442. © CAA.

is also demonstrated in various scribbles throughout the almanac (such as Figure 1.9).

Finally, there is a direct reference to the private sphere: on the first page, alongside the printed clarification about the use of the almanac, Van der Meersch notes the following in the margin: 'Tot mijn persoonlijk gebruik. Parruijke' (for my personal use. Wig.). This is followed by items for his personal use, including clothes.[61] Firstly, as I mentioned above, the word 'personal' immediately relates to privacy. Secondly, by stressing 'personal use', he distinguishes between his 'private' objects and those that can be shared with others. In this way, he draws lines of accessibility between the clothes he uses, his family, and the other inhabitants of the house. This refers back to the heuristic zones, pointing to the body as one of the zones of privacy, of which clothes are a part.

Quite surprisingly, there are almost no references to death in this almanac, with one exception on the very last page. It seems that he was fascinated by death and recorded the death rates from plagues over the years. How does death relate to the private and privacy? There is a striking difference in how death is described when it involves other people compared with when it occurs within one's family. Another Amsterdammer, Jacob Bicker Raye (1703–1777), meticulously noted the deaths that occurred in his city, but he expressed no feelings about them — one reads neither horror nor sadness, even when he knew the deceased.[62] At the same time, and in contrast, Maria de Neufville's short autobiographical piece *Mijn droevig leven* (My Sad Life) focused on

61 See the opening paragraph of this chapter.
62 Bicker Raye, *Het dagboek*.

various deaths in her family and the pain they caused her personally.[63] If we compare the descriptions of deaths within the community zone and deaths within the home or family, we see that the former have less personal impact than the latter, as we would expect.[64]

Having considered some references to the private life of Arent van der Meersch, we see that he was a person who had many different interests, with a particular liking for food. He was also rather spiritual, as entries containing meditations on God and the human condition occur quite often in his almanac. From this text we learn details about his life, his religiosity, and his love for his wife. All these details together construct a private picture, providing the reader with knowledge about his feelings and habits, his values, meals, and financial affairs. The spatial (or environmental) dimension is almost entirely absent, with only occasional references, such as in the poem dedicated to his wife, who he mentions keeps his house in order.

Secret Book of Jan Hendrick Hermans (1681–1759)

The last egodocument to be examined here is that of Jan Hendrik Hermans, which is called 'Geheim Boeckje begonnen in 't Jaer 1716 en der eenige gevallen van te vooren geschiet voor mijn Jan Hendrik Hermans' (secret book commenced in the year 1716, and a few cases which happened before, for me, Jan Hendrick Hermans).[65] Just like our first author, Hermans was a merchant. He was of German origin. After spending several years in Leiden and Nurnberg, he settled in Amsterdam in 1711, and he married Barta Kannegieter (1679–1752) in 1716.[66] They lived on the prestigious Keizergracht (Emperor's Canal), right in the centre of the city, and had several children (Figure 1.10).

What is a *geheimboek* (secret book)? This is one instance where the title may be misleading. The term is known nowadays from the world of book-keeping. Ernest Stevelinck writes that a secret book presented various bills that an owner wanted to keep secret from his bookkeeper.[67] Yet in the case of Hermans, although the 'secret book' contains some references to finance, most of it is occupied with personal writing. Why it is called 'secret' is not immediately clear. There is no particular organization of the text or topics. It seems that it was written in sections, some parts dealing with family history,

63 De Neufville, *Verhaal van myn droevig leeven*.
64 See Green, 'Spaces of Privacy'.
65 Hermans, 'Geheim Boeckje', The Hague, Royal Library of the Netherlands, shelf mark 78 H 68.
66 Lindeman and Scherf, eds, *Egodocumenten van Nederlanders*, entry 149. Their marriage was registered on 24 April 1716. See 'Marriage Register', Amsterdam, CAA 5001, inv. 552, p. 273. The bridegroom was thirty-two and the bride thirty-five years old. The bride was given away by her mother Tenntje van der Linden (Toendje Janszen van der Linden, as it is written in Hermans's book).
67 De Roover and Stevelinck, *De comptabiliteit door de eeuwen heen*, p. 226.

some dedicated to travel, while others deal with visits paid and received. Most of these entries are in chronological order within their own sections, with quite large gaps between the times recorded. It seems that the term 'secret' once again refers to the private sphere, as containing information that should not be widely known.

The book starts with an account of family history, quickly reaching the year 1716, when Hermans married. He writes that on Friday 22 April, at 10 o'clock in the morning, he went with his 'liefste' (beloved) Barta to City Hall for the proclamation of their marriage. On 17 May, he proudly states that 'ben ick Jan Hendrick Hermans getrouwt 's namiddags in de Oude Kerk' (I, Jan Hendrick Hermans, was married in the afternoon in the Oude Kerk) (Figure 1.11).[68]

The text becomes very personal on 31 August 1716, when he writes that while his wife was staying with her mother in Zwolle, she had a miscarriage (he later reports another miscarriage in November of the same year).[69] There is no sentiment in the text, but miscarriage involves three heuristic zones that help us to understand the impact of these events: the body, the mind, and the home. Such an event would easily be forgotten over the years by everybody besides those involved in it directly. Therefore, its inclusion in the text, which was probably written long after the event (the last entry on the page in question is dated 1752, but in the shaky handwriting of an older person), shows the impact it must have had on the writer.

It seems that positive occurrences have more prominence in the text. For example, the happy event of the birth of his first daughter is described in

Figure 1.10. Jan Hendrick Hermans, 'Geheim Boeckje begonnen in 't Jaer 1716 en der eenige gevallen van te vooren geschiet voor mijn Jan Hendrick Hermans', 1716, title page. The Hague, Royal Library of the Netherlands, shelf mark 78 H 68. © Royal Library of the Netherlands.

68 Hermans, 'Geheim Boeckje', p. 5.
69 Hermans, 'Geheim Boeckje', p. 6.

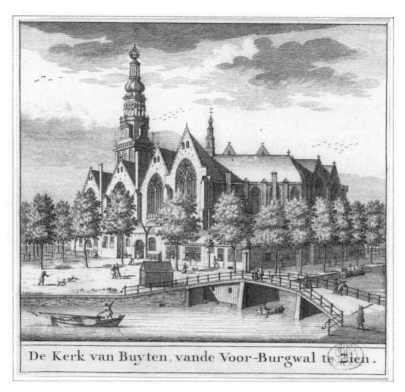

Figure 1.11. Daniël Stopendaal (possibly), *Gezicht op de Oude Kerk te Amsterdam* (View onto the Old Church in Amsterdam), 1685–1726. Print, 171 × 174 cm. Inv. no. RP-P-AO-23-6-1. © Rijksmuseum Amsterdam.

more detail than the miscarriage: we are told that his wife was in labour from 3 o'clock at night until 3 o'clock in the afternoon. The daughter was named Alida after her father's mother, and on 2 December she was baptized by pastor Johannes van Staveren (1662–1724).[70]

Page 16 of the book contains more general information on who married whom in the family, and the last mention on the page is of Herman's niece Regina Maria

70 Hermans, 'Geheim Boeckje', p. 15; Evenhuis, 'Staveren, Johannes Van'. Staveren was minister in Amsterdam from 1703, having previously served at Nootdorp and Alkmaar. Hermans's daughters were: Alida, born on 30 November 1717; Antonia, born on 22 September 1719; Johanna, born on 22 June 1721 and baptized on 25 June 1721 at the Nieuwezijds Chapel in Amsterdam, who probably died shortly thereafter; another daughter, also named Johanna, born on 19 May 1724 and baptized on 21 May 1724. 'Baptismal Register', Amsterdam, CAA 5001, inv. 69, p. 270 (fol. 135ᵛ), no. 2, witnesses Fenna Kannegieter and Engbertus van Kampen; 'Baptismal Register', Amsterdam, CAA 5001, inv. 49, p. 454 (fol. 217ᵛ), no. 13, witnesses Arend Merkendorp and Engberta van Kannegieter.

Figure 1.12. Jan Hendrick Hermans, 'Geheim Boeckje begonnen in 't Jaer 1716 en der eenige gevallen van te vooren geschiet voor mijn Jan Hendrick Hermans', 1716, pp. 58–71. The Hague, Royal Library of the Netherlands, shelf mark 78 H 68. © Royal Library of the Netherlands.

Happe from Mulheim, near Duisburg, who came to Amsterdam on 12 April 1718 on the boat of a certain Mme de Haan. The subsequent pages 17 to 44 are missing from the book, having been cut out. We will come back to this below.

Twenty-eight pages are missing from the 'secret book', which resumes on page 45 with an entry for 29 May 1724, when a certain Arend Arendtsen

boarded a boat at 10.30 in the morning to deliver wood to Deventer. There is absolutely no indication of what kind of 'secret' information the missing pages contained, if any. In order to discover what their contents may have been, let us examine what is actually left of the rest of the book. Pages 59 to 70 have also been ripped out, with only small fragments remaining at the bottom (Figure 1.12). However, from the content of page 71 it becomes clear that Hermans was not only writing about his own family history and affairs, but was also meticulously describing the misfortunes of others. On page 71 he writes that on 16 September 1735 Philip Hack, who was drinking a 'copjen tee' (cup of tea) with Madam (possibly his wife, but possibly another woman), had an 'overval' (possibly a stroke or heart attack), followed by another at 11 o'clock in the evening, when he lost consciousness. After page 72 there is another sheet missing, but the first words on page 75 tell us that it was about a certain 'domine Klein', who had brought with him a Black servant couple with two children, all of whom died of smallpox in 1736. Another sheet is then ripped out (pages 77–78) and the story resumes on page 79. The content of the missing pages of course remains unknown, but from the surviving page we can deduce that Hermans was providing details about the lives of others that were either uncomfortable for the reader or contained private information that was not meant for the eyes of others.

Who tore the pages out is a question that remains unanswered. It may have been Hermans himself, deciding at a later date that some of the information should be destroyed, or it may have been his kin who inherited the book and thought the details were perhaps too embarrassing. What is interesting is that there are references to people mentioned elsewhere in the book that were added later in his own visibly older hand.[71]

The surviving pages tell at first sight about the weather, which is noted down in detail:

> 1740 den 4 Januarij op Maandag naadat het eenige dagen gereegend had, gemist en zagt weer geweest, begon het te vriesen, dat van dag tot dag erger wierd, Sondags den 10 dito was de kouw op 't hoogste, men zegt dat se 3 graden hoger was als in 1709, op Woensdags den 13 nam de koude wat af, toen de kouw op 't felste was zijn veele menschen de neus vroren en vingers bevrooren, mijn neusdoeck bevroor in de zack [...] veele menschen vrooren doot, de koude continueerde die heele maand, met sneeuw en dooijweer.

> (1740: On 4 January on Monday, after a few days of rain, mist and mild weather, it started to freeze, which became worse from day to day; on Sunday the tenth of the same month the cold was at its

71 These references are often added at various points in the book, but in reality there is no such information about these people on the pages referred to (see for example page 14). Perhaps the pages refer to another document, which has not been preserved.

highest[.] People say that it was three degrees higher than in 1709[.] On Wednesday the thirteenth the cold somewhat subsided: when it was at its fiercest, many people had their noses frozen and fingers frostbitten, my handkerchief froze in my pocket [...] many people froze to death, [and] the cold continued the whole month, with snow and thaw weather.)[72]

Once again, there are references here to the body and mind: Hermans's body experiences the cold and suffers from it; his mind is agonizing because of the bad weather and the disaster it causes to him and others. It is perhaps the first time in his book that he is concerned with the community, rather than only with his own sentiments.

Although the next two sheets are torn out, we can read the word 'huijsvrouw' (wife) on page 90, which once again leads to the assumption that the author is writing about private affairs, either his own or others'. It seems that the other type of information contained on the torn pages was financial, as some numbers can be seen on the scraps of pages 107 to 116. In fact, in the correspondence of Paul Rapin-Thoyras and Viscount Woodstock with Hans Willem Bentinck, financial matters were considered to be private, both because of the real wealth that could be revealed through them, and also because of the image that a person could acquire due to his or her expenses.[73] Although in Hermans's case the book was intended to be kept away from the eyes of the strangers, the worry about self-image could well have been projected onto his own kin and descendants. This may bring us back to the initial idea — mentioned in the introduction to this chapter — of the 'secret book' as a book containing financial information. Therefore, it is possible that Hermans wrote his financial accounts together with his other stories in one place, for the sake of convenience.

Seemingly the most personal and affectionate entry is on page 132, describing the death of his wife Barta:

1752 den 10 Junij Saterdags morgens ten half twee ueren is zeer zagt in den Heere ontslapen mijn lieve Huijsvrouw Barta Kannegieter begraven den 17 Junij op Woensdag namiddag voor half drie Ueren in de Nieuwe Kerck, hare ziekte is begonnen in ca 24 Meij, met verkoudheit en zwaar hoesten, dog gaande en staande tot 6 Junij, wanneer doctor de Visser ontbooden, die een aderlating geordoneert, dat geschied is dien dag, door Mr Richard, dog met weijnig baat, hare borst wierd van dag tot dag erger, en hare vluijmen waren met etter beset, vrijdags namiddags meende zij beter te zijn, wijl zoo starck niet hoeste, dog dat was quaad, zij is overleden met

72 Hermans, 'Geheim Boeckje', pp. 87–88. This is an example of the so-called Little Ice Age, which happened in the early modern period, when the average temperatures got two degrees lower than it was the case before.

73 See Green, 'Autour du Grand Tour'.

volkome verstand en kennis tot de laaste oogenblick toe en uijtgegaan als een lamp die geen olij meer heeft. Zij is geboren 1679 den 25 9mber.[74]

(10 June 1752, Saturday morning at half past two, very quietly passed away to the Lord my beloved wife Barta Kannegieter, buried on 17 June on Wednesday, in the afternoon before half past two, in the Nieuwe Kerk. Her illness began around 24 May, with a cold and heavy cough, though she kept going until 6 June, when doctor De Visser was summoned [and] ordered a bloodletting, which was done on that day by Mr Richard, though with little benefit: her chest worsened her phlegm was full of pus, on Friday afternoon she seemed to be better, while she did not cough so hard, but that was wrong, she died in full awareness and understanding until the very last moment[.] She expired like a lamp that has no more oil. She was born on 25 November 1679.)

This account of the death of Hermans's wife is full of emotion and is far more detailed than the other accounts in the book. The reader can almost feel the pain of the writer and the sorrow he felt. Of course, we should keep in mind that this account was probably written for the couple's three daughters, who are named at the end of his account. Unlike the deaths of the Black servants, which occurred within the community zone and which Hermans mentions earlier in his book, the sentiment of mental anguish here is very strong.

Hermans's 'secret book' provides an understanding of several notions of privacy. The physical and mental pain experienced by Hermans and his wife point to the heuristic zones of home, body, and mind: these we can only assess through the first-hand information provided by the author. We also observe how the pain of losing his first unborn child is played out in the house of his mother-in-law, i.e. in the zone of the community, outside his own home. This threshold between the community and the home plays an important role in the notion of privacy among early modern people, as I have mentioned above. When speaking of the community in his account of the deaths of the Black servants, the author in fact seems to peek outside his own house, his comfort zone, observing them as a distant bystander. The physical book itself, with pages ripped out, adds to this private dimension. The fact that the 'secret book' of Jan Hendrik Hermans was subjected to such harsh censorship justifies its consideration as belonging to the private sphere — something that had to be hidden from the eyes of others. The person who tore the pages out of this book was most likely one of his descendants — whether his daughter Alida, one of her sisters, or their children — who wanted to prevent access to the privacy of the family and possibly of others, protecting such information from unfriendly eyes. Besides this book, there are no other documents belonging to the family in the archive, nor is there any record of how this document ended up in the archive.

74 Hermans, 'Geheim Boeckje', p. 132.

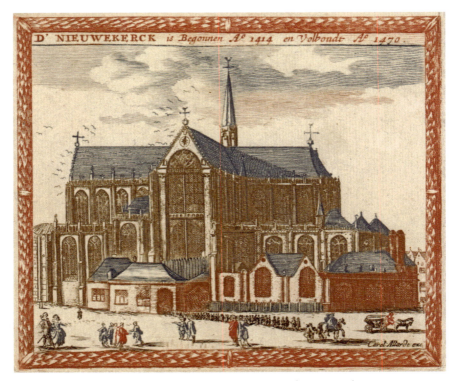

Figure 1.13. Anonymous, after Jan Veenhuysen, *Nieuwe Kerk te Amsterdam* (New Church in Amsterdam), Amsterdam, 1695–1699. Print, 124 × 147 cm. Inv. RP-P-1903-A-24101. © Rijksmuseum Amsterdam.

Conclusion

The four egodocuments examined here are just the tip of an iceberg, and only a few examples from each have been analysed in order to demonstrate how notions of privacy can be traced in this type of source through the guidance of heuristic zones and close textual reading. We have seen how one's privacy is affected by interactions with various factors — being outside, health issues, accidents, and gossip — and how privacy could be manifested by one's putting one's ideas, thoughts, and interests on paper. The texts also show that the 'private life' of an individual was intertwined with the 'privacy' of the family and the household, and that there existed the will to protect it. While there is often no concrete statement of an intended audience in this sort of document, many of them were written for the family, who would either have protected these texts from later strangers' eyes — such as by tearing the problematic pages out, in the case of Jan Hendrik Hermans — or otherwise ensured the texts' preservation, as with the three other examples.

What is particularly striking in all of the documents are the references to health, as well as to feelings such as gratitude, pain, happiness, and sadness. These references guide the reader to engage with the author, allowing something that I would call a 'comfortable conversation between close friends'. Most of the notions of privacy that can be seen in these texts revolve around the mind, the body, and the home. While privacy is seemingly a known aspect of research, the importance here is the particular attention given to the ensemble of various factors relating to privacy, and their examination as such. The picture drawn by the four sources gives an insight into the idea of privacy for early modern Amsterdammers: it is the home, where one occupies oneself with favourite pastimes, or which gives protection from the turbulent activities happening outside; it is also the sentimental aspect of love for one's partner and children; not least, it is the stories told about others in secret; finally, it is financial matters. This is only a first step towards a better understanding of what was considered private, and how early modern Amsterdammers referred to their private domain. More research is needed into similar notions among Dutch men and women in other locations throughout the country. A comparative study would elucidate similarities and differences between different locations within the United Provinces and also from other European cultures. Heuristic zones can be a tool for reading into these early modern interactions, possibly supplemented by the incorporation of other aspects such as notions of friendship and kinship.

Works Cited

Manuscripts and Archival Sources

Amsterdam, City Archives, 15030, inv. 442, Abraham van der Meersch, 'Almanach Anno 1744', written in Jan Albertsz van Dam for Willem Trouw, *D'Erven Stichters Comptoir Almanach, op 't schrikkel-jaar onses Heeren Jesu Christi, 1744, voorsien met alle de jaar, paarden, beesten, en leer-markten alsmede de vacantien, het varen der trek-schuyten en beurt-schepen, het reysen der posten en boodens, nevens de maens op en ondergangh* (Amsterdam: W. Blaeu, 1744)

——, 15030, inv. 56904, 52046, 77884, Jan Sywertsz Kolm, 'Ghedenckboeck waerin state geteeckent, gerijmt en geschreven en gecoleurt alles wat hier in op 't paier vertoont wert is gedaen deur mij Jan Sywertsz Kolm ghebooren tot Amsterdam'

——, 198, inv. 34

——, 5001, inv. 49, 'Baptismal Register'

——, 5001, inv. 678, 'Ondertrouwregister'

——, 5001, inv. 69, 'Baptismal Register'

——, Bib. Person, 15030, inv. 94938, Dirck van der Koghen, 'Almanach op 't jaer ons Heeren Jesu Christi MDCLXXXI na de nieuwe en oude stijl' (Amsterdam: Pieter Arentsz, 1680)

——, Bib. Person, 15030, inv. 94939, Dirck van der Koghen, 'Almanach op 't jaer ons Heeren Jesu Christi MDCLXXXI na de nieuwe en oude stijl' (Amsterdam: Pieter Arentsz, 1681)

Amsterdam, University of Amsterdam Library, Bibliotheca Rosenthaliana, hs. ROS. 486, 'Eyn nye kroniek'

The Hague, Royal Library of the Netherlands, hs. 187 A 4, Hermanus Veerbeck, 'Memoriaal ofte mijn levensraijsinghe'

——, shelf mark 78 H 68, Jan Hendrick Hermans, 'Geheim Boeckje begonnen in 't Jaer 1716 en der eenige gevallen van te vooren geschiet voor mijn Jan Hendrick Hermans'

Primary Sources

Beck, David, *Spiegel van mijn leven: Haags dagboek 1624*, ed. by S. E. Veldhuijzen (Hilversum: Verloren, 1993)

——, *Mijn voornaamste daden en ontmoetingen: Dagboek van David Beck, Arnhem 1627–1628*, ed. by Jeroen Blaak (Hilversum: Verloren, 2014)

Bicker Raye, Jacob, *Het dagboek van Jacob Bicker Raye 1732–1772*, ed. by F. Beijerinck and M. G. de Boer (Amsterdam: H. J. Paris, 1935)

Neufville, Maria de, *Verhaal van mijn druivig leven*, ed. by Tony Lindijer (Hilversum: Verloren, 1997)

Verbeeck, Hermanus, *Memoriaal ofte mijn levensraijsinghe: Hermanus Verbeeck (1621–1681)*, ed. by Jeroen Blaak (Hilversum: Verloren, 1999)

Secondary Studies

Albala, Ken, *Food in Early Modern Europe* (Westport, CA: Greenwood Press, 2003)

Allen, Anita L., *Uneasy Access: Privacy for Women in a Free Society* (Totowa, NJ: Rowman & Littlefield, 1987)

Ariès, Philippe, 'Introduction', in *A History of Private Life*, ed. by Philippe Ariès, Roger Chartier, and Georges Duby, trans. by Arthur Goldhammer, III (Cambridge, MA: Belknap Press, 1989), pp. 1–11

Ariès, Philippe, Roger Chartier, Georges Duby, Arthur Goldhammer, Michelle Perrot, Antonine Prost, and Gérard Vincent, *A History of Private Life*, 5 vols (Cambridge, MA: Belknap Press, 1987–1991)

Baker, Keith M., 'Defining the Public Sphere in Eighteenth-Century France: Variations on a Theme by Habermas', in *Habermas and the Public Sphere*, ed. by Craig Calhoun (Cambridge, MA: MIT Press, 1992), pp. 181–211

Blaak, Jeroen, *Literacy in Everyday Life: Reading and Writing in Early Modern Dutch Diaries*, trans. by Beverley Jackson (Leiden: Brill, 2009)

Boddice, Rob, *The History of Emotions* (Manchester: Manchester University Press, 2018)

Bruun, Mette Birkedal, 'Privacy in Early Modern Christianity and Beyond: Traces and Approaches', *Annali Istituto storico italo-germanico/Jahrbuch des italienisch-deutschen historischen Instituts in Trient*, 44.2 (2018), 33–54

——, 'Zones of Privacy', 2019 <https://teol.ku.dk/privacy/research/work-method/privacy_work_method.pdf/PRIVACY_Work_Method_Acces.pdf> [accessed 1 September 2020]

——, 'Towards an Approach to Early Modern Privacy: The Retirement of the Great Condé', in *Early Modern Privacy: Sources and Approaches*, ed. by Michaël Green, Lars Cyril Nørgaard, and Mette Birkedal Bruun (Leiden: Brill, 2022), pp. 12–60

Chappell Lougee, Carolyn, 'Huguenot Memoirs', in *A Companion to the Huguenots*, ed. by Raymond A. Mentzer and Bertrand van Ruymbeke (Leiden: Brill, 2016), pp. 323–47

Claflin, Kuri W., 'Food among the Historians: Early Modern Europe', in *Writing Food History: A Global Perspective*, ed. by Kuri W. Claflin and Peter Scholliers (London: Bloomsbury, 2012), pp. 38–58

Cowen Orlin, Lena, *Locating Privacy in Tudor London* (Oxford: Oxford University Press, 2008)

Dekker, Rudolf, 'Ego-Documents in the Netherlands 1500–1814', *Dutch Crossing: A Journal of Low Countries Studies*, 39 (1989), 61–71

——, 'Children on their Own: Changing Relations in the Family — the Experiences of Dutch Autobiographers, Seventeenth to Nineteenth Centuries', in *The Public and Private in Dutch Culture of the Golden Age*, ed. by Arthur K. Wheelock Jnr and Adele F. Seeff (Newark: University of Delaware Press, 2000), pp. 61–71

De Roover, Raymond, and Ernest Stevelinck, *De comptabiliteit door de eeuwen heen: Tentoonstelling in de Koninklijke Bibliotheek Albert I* (Brussels: Koninklijke Bibliotheek Albert I, 1970)

Eeghen, Isabella Henritte van, 'De autobiografie van Moses Salomon Asser', *Jaarboek Amstelodamum* (1963), 130–65

Elias, Norbert, *The Civilizing Process* (Oxford: Blackwell, 1994)

——, *The Court Society* (Dublin: University College Dublin Press, 2006)

Evenhuis, R. B., 'Staveren, Johannes Van', in *Biografisch lexicon voor de geschiedenis van het Nederlands protestantisme*, ed. by D. Nauta and others (Kampen: J. H. Kok, 1978), p. 357

Fleischer, Roland E., and Susan Scott Munshower, eds, *The Age of Rembrandt: Studies in Seventeenth-Century Dutch Painting* (University Park: Penn State Press, 1988)

Franits Wayne, ed., *The Ashgate Research Companion to Dutch Art of the Seventeenth Century* (New York: Routledge, 2016)

Frijhoff, Willem, 'How to Approach Privacy without Private Sources? Insights from the Franco-Dutch Network of the Eelkens Merchant Family around 1600', in *Early Modern Privacy: Sources and Approaches*, ed. by Michaël Green, Lars Cyril Nørgaard, and Mette Birkedal Bruun (Leiden: Brill, 2022), pp. 105–34

Frijhoff, Willem, Maarten Prak, and Marijke Carasso-Kok, eds, *Geschiedenis van Amsterdam, deel II-1: Centrum van de wereld 1578–1650* (Amsterdam: SUN, 2004)

——, *Geschiedenis van Amsterdam, deel II-2: Zelfbewuste stadstaat, 1650–1813* (Amsterdam: SUN, 2005)

Fuks, Leo, ed., *De zeven provinciën in beroering: Hoofdstukken uit een Jiddische kroniek over de Jaren 1740–1752 van Abraham Chaim Braatbard* (Amsterdam: Meulenhof, 1960)

Green, Michaël, 'Educating Johan Willem Friso of Nassau-Dietz (1687–1711): Huguenot Tutorship at the Court of the Frisian Stadtholders', *Virtus: Yearbook of the History of the Nobility*, 19 (2012), 103–24

——, 'The Orange-Nassau Family at the Educational Crossroads of the Stadtholder's Position (1628–1711)', *Dutch Crossing: Journal of Low Countries Studies*, 43.2 (2019), 99–126

——, 'Autour du Grand Tour', in *Le Grand Tour 1701-1703. Lettres de Henry Bentinck et de son précepteur Paul Rapin-Thoyras, à Hans Willem Bentinck* (Paris: Honoré Champion, 2021), pp. 11–51

——, *Le Grand Tour 1701-1703. Lettres de Henry Bentinck et de son précepteur Paul Rapin-Thoyras, à Hans Willem Bentinck* (Paris: Honoré Champion, 2021)

——, 'Spaces of Privacy in Early Modern Dutch Egodocuments', *Tijdschrijft voor Sociale en Economische Geschiedenis/Low Countries Journal of Social and Economic History*, 18.3 (2021), 17–40

——, 'Public and Private in Early Modern Jewish Egodocuments of Amsterdam (ca. 1680–1830)', in *Early Modern Privacy: Sources and Approaches*, ed. by Michaël Green, Lars Cyril Nørgaard, and Mette Birkedal Bruun (Leiden: Brill, 2022), pp. 213–42

Habermas, Jürgen, *The Structural Transformation of the Public Sphere: An Inquiry into a Category of Bourgeois Society*, trans. by Thomas Burger, assisted by Frederick Lawrence (Cambridge, MA: MIT Press, 1991)

Heuvel, Charles van den, *'De Huysbou': A Reconstruction of an Unfinished Treatise on Architecture, Town Planning and Civil Engineering by Simon Stevin* (Amsterdam: Koninklijke Nederlandse Akademie van Wetenschappen, 2005)

Israel, Jonathan Irvine, *The Dutch Republic: Its Rise, Greatness, and Fall, 1477–1806*, 2nd edn (Oxford: Clarendon Press, 1998)

Kaplan, Benjamin, *Divided by Faith: Religious Conflict and the Practice of Toleration in Early Modern Europe* (Cambridge, MA: Belknap Press, 2007)

Kistemaker, Renée E., 'The Public and the Private: Public Space in Sixteenth- and Seventeenth-Century Amsterdam', in *The Public and Private in Dutch Culture of the Golden Age*, ed. by Arthur K. Wheelock Jnr and Adele F. Seeff (Newark: University of Delaware Press, 2000), pp. 17–23

Kuijpers, Erica, 'Poor, Illiterate and Superstitious? Social and Cultural Characteristics of the "Noordse Natie" in the Amsterdam Lutheran Church in the Seventeenth Century', in *Dutch Light in the 'Norwegian Night': Maritime Relations and Migration across the Northern Sea in Early Modern Times*, ed. by Louis Sicking, Harry de Bles, and Erlend des Bouvrie (Hilversum: Verloren, 2004), pp. 57–80

Lenarduzzi, Carolina, *Katholiek in de Republiek: De belevingswereld van een religieuze minderheid 1570–1750* (Nijmegen: Vantilt, 2020)

Lieburg, Fred van, *Living for God: Eighteenth Century Dutch Pietist Autobiography* (Lanham, MD: Scarecrow Press, 2006)

Lindeman, Ruud, and Yvone Scherf, eds, *Egodocumenten van Nederlanders uit de zestiende tot begin negentiende eeuw: Repertorium* (Amsterdam: Panchaud, 2016)

Mare, Heidi de, *Huiselijke taferelen: De veranderende rol van het beeld in de Gouden Eeuw* (Nijmegen: Vantilt, 2012)

Margulis, Stephen T., 'Privacy as a Social Issue and Behavioral Concept', *Journal of Social Issues*, 59.2 (2003), 243–61

Nierop, Henk F. K. van, 'Van wonderjaar tot alteratie, 1566–1578', in *Geschiedenis van Amsterdam: Een stad uit het niets – tot 1578*, ed. by Marijke Carasso-Kok (Amsterdam: SUN, 2004), pp. 451–81

Presser, Jacob, 'Memoires als geschiedbron', in *Algemene Winkler Prins Encyclopedie*, ed. by Herman Richard Hoetink, E. De Bruyne, J. F. Koksma, R. F. Lissens, and J. Presser, VIII (Amsterdam: Elsevier, 1958), pp. 208–10

Scheer, Monique, 'Are Emotions a Kind of Practice (and Is That What Makes Them Have a History)? A Bourdieuian Approach to Understanding Emotion', *History & Theory*, 51.2 (2012), 193–220

Schuurman, Anton, and Pieter Spierenburg, eds, *Private Domain, Public Inquiry: Families and Life-Styles in the Netherlands, 1500 to the Present* (Hilversum: Verloren, 1996)

Smith, Virginia, *Clean: A History of Personal Hygiene and Purity* (Oxford: Oxford University Press, 2007)

Smits-Veldt, Mieke B., 'Images of Private Life in Some Early-Seventeenth-Century Dutch Egodocuments', in *The Public and Private in Dutch Culture of the Golden Age*, ed. by Arthur K. Wheelock Jnr and Adele F. Seeff (Newark: University of Delaware Press, 2000), pp. 164–77

Wheelock, Arthur K. Jnr, and Adele F. Seeff, eds, *The Public and Private in Dutch Culture of the Golden Age* (Newark: University of Delaware Press, 2000)

HEIDI DE MARE

Inward Dignity

The Liberated House in Simon Stevin's Architectural Knowledge System as an Indication of his Early Modern Conception of 'Privacy'

Privacy in the early modern Netherlands is often identified with domesticity.[1] Conceived as a typically Dutch phenomenon, domesticity is described in terms of warm intimacy, cosiness, comfort, and personal emotional involvement, and as focused on celebrating a peaceful and sober life in the house, dedicated to the modern nuclear family, and secluded from public life outside the home.[2] The phenomenon fits with the growing desire for privacy, individuality, and personal autonomy among the European elite. Stimulated by the Reformation, this desire generated an increasing inner civilization that manifested itself in codified manners, as well as in the need for a bourgeois identity. It coincided with 'affective individualism', which has often been linked to the separation between private and public spheres, the spatial differentiation of functions in the middle-class home, and gender segregation.[3]

As an idea, privacy appeals to the imagination. After all, seventeenth-century sources seem to vividly reveal Dutch domesticity. Consider, for example, the Dutch genre paintings of Pieter de Hooch (1629–1684) and Johannes Vermeer (1632–1675), devoted to private life at home; the poetry of Grand Pensionary Jacob Cats (1577–1660), with its many moralizing and oft-quoted maxims in praise of the nuclear family; or the differentiated floor plans created by Simon

1 This chapter is an adaptation of De Mare, 'Het huis, de natuur', based on De Mare, *Het Huis*.
2 The literature is extensive, but to give a few examples: Betsky, *Building Sex*; Chapman, 'Home and the Display'; Franits, *Paragons of Virtue*; Hollander, 'Public and Private Life'; Honig, 'The Space of Gender'; Schuurman and Spierenburg, *Private Domain*; Sneller, 'Reading Jacob Cats'; Westermann, *Art and Home*; Wigley, 'The Housing of Gender'.
3 Keulen and Kroeze summarize this view of the rise of privacy, which has been dominant since the 1970s. Keulen and Kroeze, 'Privacy', pp. 24–27, p. 39.

Heidi de Mare is educated in art, architecture and film history, and was awarded *cum laude* for her dissertation which focused on the early modern Dutch house (2003). She is a board-member of the IVMV, Dutch Foundation of Public Imagination, www.ivmv.nl.

Private Life and Privacy in the Early Modern Low Countries, ed. by Michael Green and Ineke Huysman, EER 19 (Turnhout: Brepols, 2023), pp. 63–97
BREPOLS ⊛ PUBLISHERS 10.1484/M.EER-EB.5.132530

Stevin (1548–1620) and Philips Vingboons (1607–1678), striking illustrations of the period's increasing individualization 'fed by the idea to shape "a room of one's own"'.[4] Numerous scholars of art and architectural, cultural, and literary history, as well of historical anthropology and sociology, have embraced this idea in recent decades, often loosely combining sources such as De Hooch, Cats, and Vingboons.[5] As a result, this supposedly typical early modern Dutch idea of privacy has been widely accepted as historical fact. In addition, from the 1980s onwards, some criticisms from women's history began to appear: according to these critics, the painted representations, poetic exhortations, and differentiated floor plans were in reality signs of patriarchal power, providing a form of oppressive petit-bourgeois privacy aimed at the happy family and based on a diligent and caring housewife who was confined indoors, with the man as breadwinner outside the house. Indeed, it has been argued, this notion still has an impact in the Netherlands today insofar as it is considered a decisive factor in women's low participation in the Dutch labour market.[6] All these ingredients have become established, and although they may be interpreted differently from an academic point of view, they inform our current view of private and public in the early modern Netherlands.[7]

Because neither 'domesticity' nor 'privacy' appear as concepts in the early modern vocabulary of the above-mentioned sources,[8] in this chapter I will examine the epistemological problems that underlie this widely held view by exploring early modern discursive and visual Dutch sources. I will focus on the architectural treatise by engineer Simon Stevin (1548–1620), who hailed from Bruges but worked in the Dutch Republic from 1581 onwards in close collaboration with Prince Maurits (1567–1625).[9] I will do this on the one hand by exploring the 'meanings and values connoted by terms and notions' that Stevin uses when alluding to the private,[10] and on the other hand by analysing his architectural house drawings in terms of 'particular practices', 'thresholds', and 'classifications' of activities and individuals.[11] Both lines of analysis will be helpful in enabling me to deconstruct the modern concept of privacy in order to learn more about 'privacy' in the early modern Dutch conceptual universe. I will first explain my historical formalist approach by briefly outlining three common obstacles to the analysis of text and image sources from the past.

4 Rang, 'Space and Position', p. 124.
5 Damsma and Kloek, ''T Huys Best', pp. 101–04.
6 Damsma and Kloek, ''T Huys Best', p. 109.
7 I will not elaborate further on this debate here, since I have already done so extensively elsewhere: De Mare, 'The Domestic Boundary', 'A Rule Worth Following', 'Domesticity in Dispute', and Het Huis, pp. 1–20.
8 Although huiselijkheid (domesticity) was lacking as a concept, Westermann still considers genre paintings to be an 'incontrovertible' source for it. Westermann, 'Wooncultuur', p. 23.
9 Posthumously published by his son Hendrick in 1649.
10 Conform the 'semantic mapping', mentioned by Bruun, 'The Centre for Privacy Studies', p. 5.
11 Conform the 'heuristic zones', mentioned by Bruun, 'The Centre for Privacy Studies', p. 3.

In order to gain insight into Stevin's conception of 'privacy', we need to take into account the Aristotelian natural-philosophical discourse in which it is embedded.[12] This will explain Stevin's proposals for natural classifications and suitable arrangements in architecture, which he based on respect for the innate qualities of heterogeneous building materials, household substances, and members of the household.

Historical Formalism:
Analysing the Early Modern Conceptual Universe

About halfway through his treatise 'Onderscheyt vande oirdeningh der Steden' ('On the layout of Towns', with a 'Byvough' (Appendix) on the house), Stevin describes the vicissitudes the master of a house may have to deal with.[13] He may be troubled by other members of the household walking through his chambers and watching his activities. He may be disturbed by noise made by others overhead. He also runs the risk of being secretly spied on by a member of the household through a hole in the ceiling. Because the master of the house deals with important matters — managing money, jewels, and all kinds of important papers — Stevin proposes that he be given his own chambers: his own *slaepcamer* (sleeping chamber) as well as the *kelder* (basement) below, the *solder* (attic) above, and the *steyghers* (staircases) that connect them. The *huysgesin* (nuclear family) is gathered elsewhere, in the *voorsael* (front hall).[14] In this way, the master of the house is able to draw up his own plan, free from the rumours, observations, and interruptions of the other members of the household (Figure 2.1).

At first glance, Stevin's sketch contains many of the ingredients of the current view of private and public in the early modern Netherlands with which I began this chapter: a description of the residential culture of the well-to-do bourgeois merchant and his family as it developed in the early-seventeenth-century Netherlands. Indeed, Brita Rang and Charles van den Heuvel argue that Stevin contributed to the development of modern housing culture in the Republic with his logical planning of social use and privacy.[15] But this interpretation of Stevin's architectural thinking about the early modern house ignores the architectural terminology Stevin himself applies, and instead projecting modern engineering ideas onto Stevin's treatise.

12 Van den Heuvel confirms that 'Stevin was first of all an Aristotelian'. Van den Heuvel, 'De Huysbou', p. 27.
13 Stevin, 'Byvough', p. 67.
14 Stevin, 'Byvough', p. 65.
15 Rang looks for 'the social connotations of a large, spacious burgher house with manifold functions', while Van den Heuvel states: 'Privacy was also an important aspect of the internal arrangement of adjoining rooms'. Rang, 'Space and Position', p. 123; Van den Heuvel 'De Huysbou', p. 46.

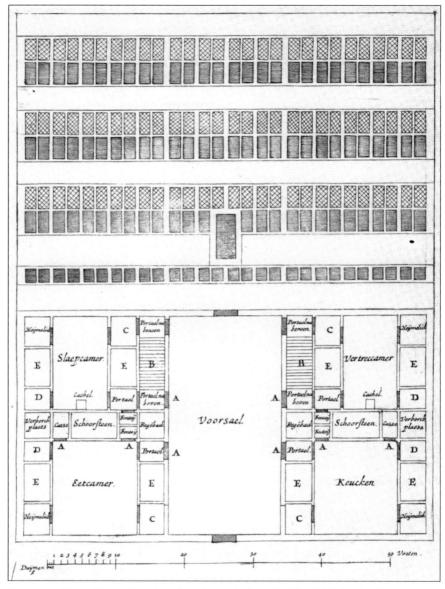

Figure 2.1. Simon Stevin, *Drawing of the house*. Included in Hendrick Stevin, *Materiae Politicae. Burgherlicke Stoffen*, Leiden 1649. Photo Koninklijke Bibliotheek, The Hague. Reproduced with permission.

A = doors, B = staircase, C = place for *schrijfpercken* (small place to write), *cabinetkens*, (small cabinets), *botelrie* (pantry) or *morshoeck* (spill corner); D = *rommelhoeck* (clutter corner), wood or peat box; E = place for box beds or cupboards. Furthermore: *Voorsael* (front hall), *Slaepcamer* (sleeping chamber), *Eetcamer* (dinner chamber), *Keucken* (kitchen), *Vertreccamer* (separate chamber to retreat to), *Verberchplaets* (storage place), *Portael* (portal), *Heymelick* (privy), *Cachel* (stove), *Schoorsteen* (chimney), and *Fonteij* (washbasin with running water).

The first misconception is related to oft-used terminology. Terms such as 'function', 'space', 'use', 'design', 'social', and 'private', invoked by Rang and Van den Heuvel, are nowhere to be found in early modern architectural texts. This is not surprising, because these terms are part of an architectural discourse articulated in the course of the twentieth century.[16] This modernist discourse expresses the relationship between architecture and society in a revealing way. As Adrian Forty has demonstrated, modernist architectural theory has a preference for a static rather than dynamic model of society. The dichotomy of 'public and private domains' is paradigmatic for this mindset. The advantage of such social terms for architects is that they can be translated into spatial equivalents.[17] On the one hand, a 'programme of social requirements' can be converted into a design; on the other, a building can be 'read' as a medium of social processes, even in the past.[18] Modernist discourse is therefore unsuitable to analyse early modern thinking about the house. Instead of clarifying the situation, these modernist concepts suggest connections that were unthinkable in the early modern architectural knowledge system, while at the same time neglecting all the 'technical' aspects of the architectural process that have become industrialized since the nineteenth century. Although Rang and Van den Heuvel agree that the anachronistic use of modernist terms is incorrect, they nonetheless continue to use them and consider a critical deconstruction of these terms to be superfluous.[19]

The second misconception is related to this in a more fundamental way. Modernist discourse implies a modern rationality that also shapes the many disciplines that have appropriated historical architecture through terms that are taken from sociology, women's studies, psychology, or philosophy and then used to 'contextualize' historical architecture. According to Rang, Stevin 'was primarily related to the development of modern western science and its methods of that period', using 'functionalist and technical applications'; his architectural thought 'is marked by the new enlightened conceptualization of men, nature and culture'.[20] Of course, context is necessary, but in the case of this source, the context should consist of other early modern architectural treatises and contemporary Dutch writings on the house.[21] Together, these discursive sources offer us insight into the epistemological tenets that were

16 On the differences between modern and pre-modern architectural thinking, see Tzonis, *Towards a Non-Oppressive Environment*; Johnson, *The Theory of Architecture*; Forty, *Words and Buildings*.

17 Forty, *Words and Buildings*, p. 105.

18 'There is no a-spatial society and no a-social space': Markus, *Buildings and Power*, p. 13. See also Betsky, *Building Sex*; Hillier and Hanson, *The Social Logic of Space*.

19 Rang, 'Space and Position', p. 125; Van den Heuvel, 'De Huysbou', pp. 60–61. Keulen and Kroeze also agree, but they too are unable to take the historical discourse seriously. Keulen and Kroeze, 'Privacy', pp. 21, 39.

20 Rang, 'Space and Position', pp. 123–25.

21 Rang instead borrows ideas from Mittelstraβ, for example. Rang, 'Space and Position', p. 124; Mittelstraβ, *Neuzeit und Aufklärung*.

shared in this conceptual universe. This early modern rationality challenges us to search for its logical reasoning, thought patterns, and internal coherence. Concluding, as Van den Heuvel does, that Stevin's architectural thinking and models were 'purely provisional' and 'incomplete', and that in fact 'no coherent system exists', fails to detect the nature of this early modern rationality.[22]

The third misunderstanding is the loose interpretation of early modern visual sources — architectural drawings as well as paintings. This misunderstanding is also found in Rang:

> A considerable number of seventeenth-century paintings emphasize open doors and open windows, offer a free view from the space to the other and on to the street and other houses. Genre-painting[s] [...] demonstrate [...] also pleasurable social encounters between generations and sexes.[23]

Unfortunately, such interpretations of historical visual sources are still widespread among (art) historians, literary scholars, social scientists, and philosophers. Apparently, it is very difficult to reflect on one's own, often unconsciously photographic modern perceptions, and then to search for 'meanings' beyond the supposedly realistic three-dimensional representation.[24] Instead, it would be more fruitful to open ourselves to a historical analysis of visual material in terms of the early modern rules of the art of painting, focusing on the mastery of eye, mind, and hand, as articulated by Leon Battista Alberti (1404–1472), Samuel van Hoogstraten (1627–1678), and many others.[25] In this context, Pieter de Hooch's *kamergezichten* (chamberscapes) can be understood as surfaces covered with pigments, generated by the meticulous observation and dissection of the visible world in all its external shapes and colours, as part of what historian of science Alexandre Koyré once characterized as the 'universe of precision' that culminated in the Scientific Revolution.[26] Tiled floors, windows, curtains, and open doors turn out to play a primary role in arranging this flat surface in a credible way.[27]

These misconceptions and anachronistic projections can be overcome by source criticism or *Begriffsgeschichte*, analytical tools introduced by historians who wish to take seriously the conceptual universe in which sources are

22 Van den Heuvel, *'De Huysbou'*, pp. 66–68.

23 Rang, 'Space and Position', p. 122.

24 As has recently been encouraged, for example, by Rabb's 'How Should Historians Use Images?', which refers to Burke's *Eyewitnessing*. For a critique, see De Mare, 'Not Every Broom Sweeps Clean!'.

25 Alberti, *On Painting*; Van Hoogstraten, *Inleyding*. See De Mare, 'Johannes Vermeer' and *Het Huis*.

26 Cohen, *The Scientific Revolution*, pp. 506–25. In 'Picturing Dutch Culture', Alpers points out that the early modern art of painting was a way of exploring and acquiring knowledge about the surrounding world, akin to the visual knowledge about Nature generated by engineers, mapmakers, and others during this period.

27 On the art of painting as visual rhetoric, see De Mare, 'The Art of Living Well' and 'Visual Rhetoric'.

embedded.[28] For Michel Foucault, this entails analysing the archaeological level that constitutes the articulated ideas.[29] I use this method — which I have previously dubbed 'historical formalism'[30] — to analyse the internal connections between the words, terms, and concepts Stevin uses and the knowledge this generates about the early modern house. This method reveals the relationship between his knowledge system and the classical authors to whom he refers, such as Vitruvius (*c.* 85–20 BCE), Alberti, and Andrea Palladio (1508–1580), as well as the relationship with contemporary Dutch writings on the architecture of the house, such as those by Philips Vingboons and Willem Goeree (1635–1711). Moreover, it is also helpful to investigate the relationship with Jacob Cats's treatise on marriage as well as De Hooch's *kamergezichten*. In short, my primary question is: what rationality underlies Stevin's architectural thinking, and to what extent does it provide us with insight into matters of 'privacy'? For all these reasons, my research differs significantly from Van den Heuvel's informative but hypothetical reconstruction of Stevin's alleged original *Huysbou*, which is based on an assemblage of various (unpublished) fragments by Stevin.[31]

Stevin and the Qualities of Natural Substances

Because Stevin devotes most of his treatise to issues concerning the natural substances that result in architectural inventions, his reasoning may help us to understand his treatment of human beings. He writes page after page about the wind and the turbulence to which it is subject. He extensively discusses various methods of collecting and purifying rainwater. He pays attention to the pros and cons of materials used for roofing. Stevin wants to use this knowledge about Nature to make a good house. But while he devotes specific paragraphs to his inventions relating to sunlight, water, and smoke — classic issues in architectural thought since Vitruvius — his remarks about household goods, food, animals, and human beings are scattered throughout his writings and small in number, so their impact on his conception of 'privacy' is not immediately clear.

To make a good house, the architect must first of all prevent it from collapsing, sagging, or rotting away. Nature manifests itself in large, impressive, and often disastrous phenomena such as erosion and shrinkage. But Nature also endows stone, brick, wood, glass, and mortar with certain favourable qualities. For Stevin and other pre-modern authors, who think in an Aristotelian

28 Hampsher-Monk, Tilmans, and Van Vree, 'A Comparative Perspective'.
29 Foucault, *The Archaeology of Knowledge*.
30 Understood as the systematic study of the different layers of cultural artefacts, and primarily examining the formal quality and patterns of words and images. De Mare, 'A Disciplined Eye' and *Het Huis*, pp. 69–116.
31 Van den Heuvel, '*De Huysbou*', pp. 2, 143.

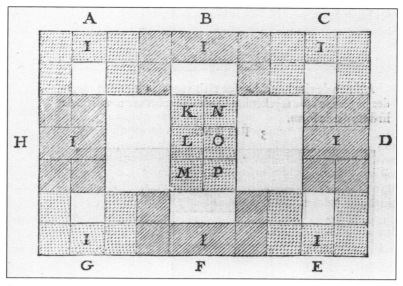

Figure 2.2. Simon Stevin, *Fourth form of a block of burgher houses*. Included in Hendrick Stevin, *Materiae Politicae. Burgherlicke Stoffen*, Leiden 1649, p. 28. Photo Koninklijke Bibliotheek, The Hague. Reproduced with permission.

> A, B, C, D, E, F, G, H: eight houses, each house is composed of similar shaded squares.
>
> I = front hall of each house; unshaded parts are courtyards. The distribution of the chambers can be done in two ways: 1) K, L, M: three chambers belonging to house H; N, O, P = three chambers belonging to house D; 2) K, N = two chambers belonging to house B; M, P: two chambers belonging to house F; L = chamber belonging to house H; O = chamber belonging to house D.
> In both distributions each chamber belonging to a house has free incoming sunlight (either from the street or from the courtyard). Each house has its own courtyard and the wall where the house touches the courtyard of the neighbouring house is always windowless.

framework, substances such as building materials have their own qualities and purposes, and they follow their own intrinsically given courses of action in order to take their place in the natural order. Instead of problems and solutions, Stevin writes laboriously (by modern standards, at least) about the qualities of substances in order to prevent problems.[32] Stevin points out, for example, that lime eats wood, iron hinges naturally rust (and disrupt stone frames), sunlight causes wood to split, and new mortar rots the ends of wooden beams due to its sharp, acrid, and ingressive humidity.[33] Therefore,

32 However, Van den Heuvel understands Stevin's technical interventions as solutions, and as a result sees Stevin as a forerunner of modern engineers. Van den Heuvel, 'De Huysbou', p. 94.
33 Many unpublished notes on architectural substances made by Stevin, were published by

according to Stevin, the architect must appropriate this knowledge of Nature, avoiding the mixing of certain building materials so as to be able to use them in a fruitful way for his own purpose.

Even numbers, lines, and drawings have 'mysterious qualities' that are implanted by Nature.[34] Numbers have the natural ability to procreate and add offspring to their family in the form of new numbers.[35] That is why drawings are able to expand and shrink harmoniously, following the geometric rules of Nature. Stevin understands the *vervoughing* (conjugation) of chambers and cabins that make up the overall house as the regulated change of form of drawings of the house and block. This understanding results in several drawings conceived as a visual demonstration of these rules from Nature (Figure 2.2).[36] The qualities of the arithmetic and geometrical quantities are therefore just as much part of Nature as Man's quality of reason or the qualities of the building materials, Stevin emphasizes. In other words, when one is making a house, all these forces of Nature must be taken into account.

The second aspect the architect should take into account in making a good house is the nature and (positive and negative) qualities of human beings. In the early modern period, the question of why people — like animals — show certain inclinations lay beyond the scope of reason. Nature, Stevin explains, has provided the bee and the pig with different qualities. It is by their nature that bees enjoy sweet, fragrant flowers while the pig prefers filthy, stinky muck.[37] In order to guarantee *gerief* (convenience) and *gemak* (comfort) in the house, Stevin classifies the qualities and inclinations of human beings in the same way as he does building materials, climate phenomena, and animals. The same goes for Jacob Cats, who discusses the innate and sometimes contradictory qualities of spouses and encourages them to find a good balance in the honourable domestic enterprise of their marriage.[38]

Because in general people appear to suffer from moisture, cold, darkness, wind, smoke, dirty water, and rotting food, respect for innate human qualities will in turn prevent the house from sickening its inhabitants. To be able to live well and maintain good health, people need light, air, clean water, good food, and warmth. However, the latter inevitably means inconvenience because of the smoke and stench. While the architect cannot prevent or change these qualities of the human body, his task is to prevent annoying hindrances as much as possible — for example, by making chimneys that work well and odourless water closets.

others, such as Isaac Beeckman (1588–1637). See De Waard, *Journal*, pp. 394–403.

34 Qualities which can be revealed through algebra. Stevin, 'Arithmetique', p. 681.

35 Alberti too writes that by doubling or halving, by adding or multiplying related numbers can be generated within the same family. Alberti, *The Ten Books of Architecture*, IX. 6.

36 Stevin, 'Byvough', pp. 60–65. Van den Heuvel translates *vervoughing* as 'inclusion'. Van den Heuvel, 'De Huysbou', p. 321.

37 Stevin, 'Onderscheyt', pp. 12–13.

38 De Mare, *Het Huis*, pp. 251–395, 'The Finding Place of Domestic Life', and 'The Art of Living Well'.

At the same time, *ongerief* (inconvenience) stems not only from the erroneous placement of utensils, but also from the inappropriate combination of human beings. Human nature allows members of the household to jump and dance, sing and play, stroll and walk around.[39] Apart from these general human qualities, certain types of people can be distinguished on the basis of their specific traits, Stevin observes (again, entirely in line with other early modern writers). For example, pregnant women are vulnerable to monstrous depictions, so Stevin advises against the creation of glass paintings where human and animal limbs are mixed or gruesomely grimacing figures appear.[40] Another example of his Aristotelian view of innate qualities is his remark about Dutch women's ineradicable urge to clean. This urge explains why women polish the insides of wooden window frames until they shine. Men, on the other hand, are endowed with the desire for stone window frames. If they want to live in peace with their wives, men must find a middle ground between their two natures. If these men had knowledge of stones that shone even more beautifully than polished wood, Stevin argues, the problem would not exist. The peculiar qualities of women (who prefer shiny material) and men (who prefer hard stone) can both be honoured, without threatening the peace in the house.[41]

The House as a Suitable Arrangement of Heterogeneous Matter

In Stevin's architectural thinking, which is embedded in the classical natural-philosophical universe, respect for the inherent nature of inanimate substances and living beings also has consequences for the internal organization of the house. Stevin classifies utensils according to the qualities they possess and then locates them in certain places in the house. He separates objects that need to be stored dry from objects that can tolerate moisture. Things for dirty work are isolated from things that need to stay clean. Daily household utensils are stored in the *botelrie* (pantry), separated from seldom-used items, which are placed in cupboards outside the kitchen.[42] Because of their shared characteristic of resistance to moisture, money, jewellery, peat, wood, certain forms of merchandise, and empty barrels are located in the basement, whereas books and valuable papers are kept in the dry attic.[43] Household goods that

39 In 'Byvough', Stevin writes about making noise (pp. 57, 67), peeking in (pp. 58, 67, 70–71), and playing (pp. 43, 56).

40 Stevin, 'Byvough', p. 112. Alberti, Cats, Huygens, and others in the early modern period share this conception. See Roodenburg, 'The Maternal Imagination'.

41 Stevin, 'Byvough', p. 120.

42 Stevin, 'Byvough', pp. 66–67. Alberti too classifies household goods according to such categories. Alberti, *The Ten Books of Architecture*, v. 14–15, 17–18.

43 Stevin, 'Byvough', pp. 67, 96.

get dirty and need to be washed or sanded are located in the *morshoek* (spill corner). Washed and dried clothing or linen is stored in the linen closet and clothes chest.[44] Things that are hard to classify are allocated a place in the *rommelhoeck* (clutter corner) or the basement.[45] On the basis of their specific shared natural qualities (dried food, food that smells, food that is sensitive to frost or heat), foodstuffs are located in the house according to the qualities of certain places (such as the basement, which is warm in winter and cold in summer).[46] In other words, Stevin uses classification based on natural qualities as a strategy to prevent substances from weakening or damaging each other.

Like building materials and household substances, human beings possess innate qualities that may cause inconvenience or hindrance. Here too, starting from people's innate tendencies, Stevin classifies them according to their pros and cons in order to avoid offensive combinations in the house. According to Alexander Tzonis, this pre-modern approach is 'an autonomous alternative system of organization of human thought and action', a rational approach by the architect to arrange 'the elements of the natural environment in a manner which reveals relations between them and responds to his impulse to classify the natural environment'.[47]

It is on the basis of this 'taxonomical' rationality, as Tzonis calls it — avoiding inconvenience by taking conflicting qualities seriously — that Stevin observes the everyday habits of the members of the household.[48] Especially when various objects, substances, and human beings have to reside together under the same roof, it is important to avoid bad and disturbing arrangements. Because of the diverse collection of human beings, the house of the burgher is a particularly complex task. For Stevin (as for other early modern writers), the classification of heterogeneous kinds of human beings on the basis of their innate qualities is a method to regulate their cohabitation in the best possible way. Living well in the house implies recognizing and avoiding mutual hindrances caused by the mixing of conflicting human qualities. Burghers strive for the most pleasant and best life, writes Stevin, referring to Aristotle.[49] This is echoed approvingly by Willem Goeree in 1681:

> Those who knew about the wise building of the house said that dwelling implies living well, and that a comfortable house makes the world convenient. There is nothing fairer or more profitable for Mankind than to live in a good house, said Socrates.[50]

44 Stevin, 'Byvough', pp. 66, 73.

45 Stevin, 'Byvough', p. 62.

46 Stevin, 'Byvough', pp. 96–97.

47 Tzonis, *Towards a Non-Oppressive Environment*, pp. 29, 31.

48 Van den Heuvel, on the other hand, is of the opinion that since 'Stevin wrote relatively little on the subject of women', his remarks are 'irrelevant' because they reveal 'nothing about the layout of a house'. Van den Heuvel, 'De Huysbou', p. 59.

49 Stevin, 'Onderscheyt', p. 8.

50 Goeree, *d'Algemeene bouwkunde*, p. 133.

Natural Classification of Human Beings in the House

This 'natural' taxonomy of human beings is a familiar theme in architectural thinking after Vitruvius. Vitruvius's description of the Greek house, with its internal order, migrates through time and appears not only in Stevin's architectural treatise, but also in that of Palladio (Figures 2.3a–b, 2.4, and 2.5).[51]

Vitruvius's distinctive criteria form the basis of later classifications: the distinctions between men and women (biological sex), family members and strangers, guests, or servants (kinship), and human beings and animals. The classical idea is that 'natural apartheid' serves the well-being of humans, an idea that was transmitted into early modern architectural thinking:

> We observe not only individual activities contained, schematized but also the manner with which an individual contacts another individual. Thus, besides the elimination of conflict and hindering of aggression, pre-rational products function positively, they lead individuals to recognize a common element behind each own separate experience; they reduce the separateness of experiences, transforming them into a collective conscience.[52]

Vitruvius's Greek house was divided into separate areas, in his words because 'attention to suitability [...] requires a perfect distribution of places without hindrance to users'.[53] In the women's domain, women are occupied with wool (and men are excluded). In the men's domain, men enjoy the communal meal (and women are denied access). The common lodgings of the house belong to the family members (where guests have no access), while guests have their own domain (where family members are not allowed).[54] Alberti too classifies members of the household in terms of age, biological sex, health, and kinship. For Alberti, childbirth is an argument for separate bedrooms for women and men. His second argument for this is that it is good 'to be able to sleep undisturbed in the summer at will'.[55] Because of their incompatible qualities, the maidens and young men, the sick old father and the wet nurse, the guests and the adult sons should each have their own chamber.[56]

51 Stevin refers to Vitruvius VI. 10, but the correct reference is VI. 7. Stevin, 'Byvough', pp. 48–50; Alberti, *The Ten Books of Architecture*, v. 17; Palladio, *Die vier Bücher*, II. 11.

52 Tzonis, *Towards a Non-Oppressive Environment*, p. 36. Although this pre-modern classification of human beings according to innate inclinations is particularly suspect nowadays, because of the various political forms of 'modern apartheid' in which natural differences have been abused and have led to oppression and exclusion of groups, we need to acknowledge it in historical research on pre-modernist periods.

53 Vitruvius, *Handboek bouwkunde*, I. 3.

54 Stevin explains this 'apartheid' using Vitruvius's argument for the building of separate guesthouses, because this provides guests with 'a secluded freedom'. Stevin, 'Byvough', pp. 48–50; De Mare, 'A Rule Worth Following'.

55 Alberti, *The Ten Books of Architecture*, v. 17; see also v. 14–15, v. 18.

56 Alberti's classification goes even further, listing sentries, servants, slaves, and riding and draught horses as separate categories.

INWARD DIGNITY 75

Figure 2.3a. Vitruvius, *Greek house, gynaikonitis* (wing with housing for women).
Illustration by Thecla Hersbach. Included in Vitruvius, *Handboek bouwkunde*, p. 184.
Photo Vrije Universiteit Amsterdam. Reproduced with permission.

Figure 2.3b. Vitruvius, *Greek house, andronitis* (wing with housing for men).
Illustration by Thecla Hersbach. Included in Vitruvius, *Handboek bouwkunde*, p. 185.
Photo Vrije Universiteit Amsterdam. Reproduced with permission.

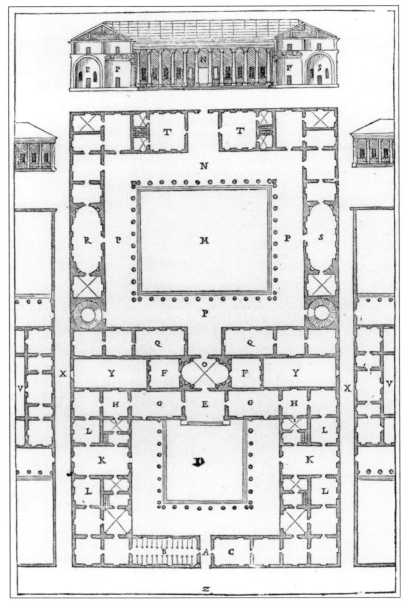

Figure 2.4. Andrea Palladio, *Greek house*. Included in Palladio, *Die vier Bücher der Architektur*, p. 160. Photo Vrije Universiteit Amsterdam. Reproduced with permission.

A = entrance; B = stables; C = guardian's chamber; D = first courtyard; E = access to the chambers; F = chambers where the women work; G = first large front hall; H = medium-sized chamber; I = small chamber; K = eating chambers; L = chambers; M = second, large courtyard; N = portico; O = passageway; P = three colonnades with small columns; Q = triclinea, kyzikeni, offices and chambers where one can paint; R = hall; S = library; T = square eating chamber; V = housing for guests; X = small streets separating the housing from guests and master of the house; Z = main street.

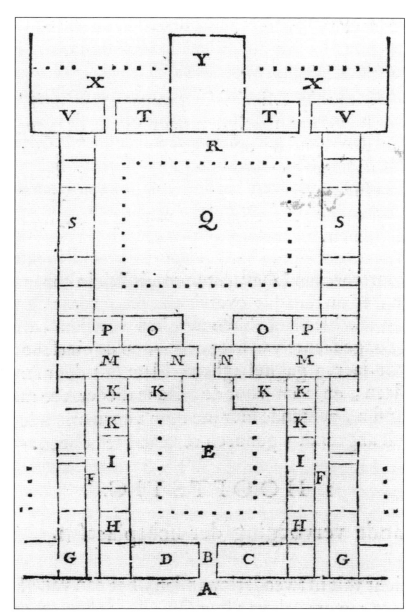

Figure 2.5. Simon Stevin, *Greek house*. Included in Hendrick Stevin, *Materiae Politicae. Burgherlicke Stoffen*, Leiden 1649, p. 49. Photo Koninklijke Bibliotheek, The Hague. Reproduced with permission.

A = gate; B = entrance; C = horse stables; D = guard chamber; E = first courtyard or colonnade; F = two central corridors; G = two guest chambers; H = two bedrooms for guests; I = two eating chambers for guests (triclinia); K = sleeping chambers around the courtyard; M = two wrestling courts; N = two large chambers where the mothers of the house are sitting with their wool; O = two women's chambers; P = two women's bedrooms; Q = large courtyard; R = upper gallery; S = libraries and chambers; T = two treasuries; V = two Cyzycian eating chambers; X = two galleries near the Cyzycian eating chambers; Y = square chambers.

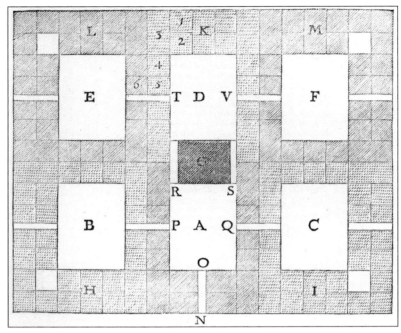

Figure 2.6. Simon Stevin, *Ground drawing of the Princely house*. Included in Hendrick Stevin, *Materiae Politicae. Burgherlicke Stoffen*, Leiden 1649, p. 68. Photo Koninklijke Bibliotheek, The Hague. Reproduced with permission.

A = courtyard with housing for the military; B = courtyard with stables and housing for servants; C = courtyard with kitchens, bakery, brewery, wine- and beer cellar, apothecary; D = courtyard with housing for the prince; E = courtyard with housing for the princess and her female servants; F = courtyard with housing for the council, treasurer, and foreign guests; G = church; H, I, K, L, M = large hall; N = gate and entrance to the princely house; O, P, Q, R, S, T, V = corridors connecting courtyards.

The extent to which Alberti's natural taxonomy of household members is an early modern commonplace is evident from the great resemblance between his arrangement and the enumeration given by Willem Goeree at the end of the seventeenth century.[57] Philips Vingboons too occasionally presents a natural arrangement in a house.[58]

Although Stevin is less outspoken, he also lists different kinds of household members. In addition to a *dienstbode* (single servant) or cook, there are children of different ages, with their various peculiarities. The baby wants to be rocked; the young tend to play ball games. Daughters like to look out of

57 Goeree, *d'Algemeene bouwkunde*, pp. 135–36.
58 Vingboons, 'Tweede deel van de Afbeeldsels', pp. 230, 232.

INWARD DIGNITY 79

the window across the street. *Vreyers* (suitors) have the urge to enter their lover's house at night.[59] But housewife and housefather also differ. First of all, they differ because of their nature, given the innate differences between the two sexes.[60] Secondly, and as a result, they differ in their activities and ways of dealing with things. According to Stevin, the *huysvrou* (housewife) is attracted to the care of linen and clothing, while the *huysvaer* (housefather) tends to take care of money, jewels, and paperwork.

Stevin too arranges human beings in the house according to the registers of kinship, age, and biological sex. A good and comfortable life in the house requires that household members hinder each other as little as possible, given their specific natures. One person's sound is another's noise. The same applies to smells and glances that can cause a nuisance, such as foul stenches and sneaky peeks. Stevin uses a number of remedies to prevent unease among members of the household. Apart from a large number of chambers (as advocated by others up to the modern era), his attention is focused on the accessible passageway in the house, inward dignity, the use of a large number of keys, and finally the exclusion of strangers. I will briefly address these four points.

In the tradition of architectural thinking, it is not uncommon to isolate the annoying qualities of household members by means of a large number of chambers. Behaviour which is offensive or harmful to others can be located elsewhere. Stevin elaborates this in his princely house, which is based on a similar categorization according to qualities of the occupants and the avoidance of mutual hindrance (Figure 2.6).[61] Stevin's house has many chambers: fifteen, divided over two floors and a basement, not counting the attic. For each chamber, a number of smaller chambers can be added, such as a *schrijfperk* (a small place to write) or *kabinetjes* (small cabinets) for separate activities that have to be dealt with in seclusion.[62]

Another way to organize a convenient house is to regulate the accessibility of the chambers. Stevin devotes a separate paragraph to this.[63] Vitruvius had already pointed out that not all chambers in the house are generally accessible. The Italian atrium house, situated around a courtyard, comprises two types of places (Figure 2.7). There are locations such as the *vestibulum* (front court), hall, and *peristyle* (colonnade), where people have the right to

59 Stevin, 'Byvough', p. 56.
60 Stevin, 'Byvough', p. 109. Stevin points out that it is wise for men and women to be recognizable by clothes attributed to their biological sex. Because each culture has its own rules that men and women must obey, according to Stevin it is not Nature that determines which specific clothes are to be worn. Given the innate difference, however, it is useful to make this distinction visible; only then can confusing accidents be prevented. The extent to which human beings could change their 'sex' was debated by Hugo de Groot (with regard to the legal consequences) and Jacob Cats (with regard to the disruption of marital procreation).
61 Stevin, 'Byvough', pp. 68–71; Van den Heuvel, '*De Huysbou*', p. 59.
62 Stevin, 'Byvough', p. 62.
63 Stevin, 'Byvough', pp. 65–67.

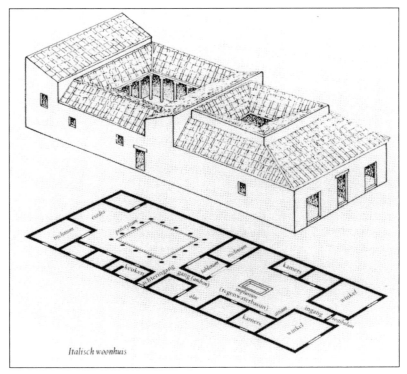

Figure 2.7. Vitruvius, *Italian house*. Illustration by Thecla Hersbach. Included in Vitruvius, *Handboek bouwkunde*, p. 176. Photo Vrije Universiteit Amsterdam. Reproduced with permission.

enter without invitation; and there are locations where one may enter only with the permission of the master of the house (such as the bed chamber, dining chamber, and bath).[64] For Vitruvius, accessibility depends on what is suitable. For him, *decorum* (dignity) is a matter between the master of the house and urban publicness. The impeccable appearance of a house must be in accordance with the external status of the owner. 'That is why', Vitruvius writes, 'people in a mediocre position do not need beautiful courtyards, workplaces, or atriums, because they are visiting others and do not need to receive visits themselves.'[65]

Stevin too states that the house is only accessible to strangers to a limited extent. Guests do not go beyond the *voorsael* (front hall), which is only accessible from the outside through the front door. When a stranger wishes to speak to the master of the house alone, he is at most allowed into

64 Vitruvius, *Handboek bouwkunde*, VI. 3–5.
65 Vitruvius, *Handboek bouwkunde*, VI. 5.

INWARD DIGNITY 81

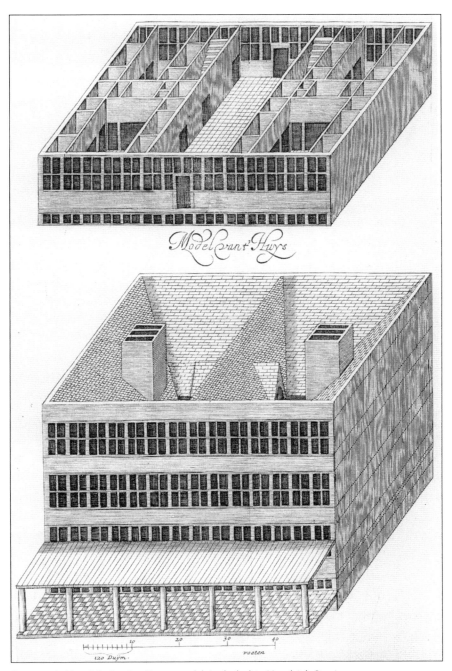

Figure 2.8. Hendrik Stevin, *House model*. Included in Hendrick Stevin, *Materiae Politicae. Burgherlicke Stoffen*, Leiden 1649. Photo Koninklijke Bibliotheek, The Hague. Reproduced with permission.

the *vertreccamer* (a separate chamber into which to withdraw). Stevin shares Vitruvius's attention to suitability and dignity. But in Stevin's architectural thinking, the accent has shifted somewhat. What is appropriate in the house is determined not only by the public status of the master of the house, but also by the guarantee of the dignity of each household member. According to his examples, he is seriously concerned to prevent anyone's dignity from being violated by the annoying behaviour of other household members. To this end, he strives to make chambers free from the arbitrary mingling of household members.[66]

This explains his statement that it is inappropriate to go through the *eetcamer* (chamber for eating, where one may still sit at the table) or through the *slaepcamer* (chamber for sleeping, where one may still lie on the bed) to the *voorsael* (front hall, where all members of the household and strangers may sit together). Such passageways make the chambers unfree and disturb the human beings who might be in them. In the same way, it is inappropriate to have to go through the *botelrie* (pantry) or *morshoeck* (spill corner) to get into the *keucken* (kitchen).[67] Because of such irregular passages, household members will be disturbed in their doings.[68] But instead of speaking of a lack of privacy of household members in the modern sense, Stevin writes that the chambers are deprived of their freedom. According to him, it is more appropriate to move unhampered from the front hall to another chamber: via the dining chamber to the bed chamber, or via the kitchen to the pantry.[69] In order to meet his requirement of accessible passageways, Stevin provides the house with two staircases, of which his son Hendrick Stevin (1614–1668) created an impression (Figure 2.8). Each staircase consists of three straight flights of stairs, one on top of the other. One of the staircases he assigns to the master of the house, while the other is at the service of the other members of the household. This prevents family members from entering each other's chambers irregularly.[70]

66 Van den Heuvel regards this as just 'practical considerations'. Van den Heuvel, '*De Huysbou*', p. 46.

67 Stevin, 'Byvough', p. 66.

68 Stevin speaks of the *ontvryen* of chambers (making chambers unfree), and of people who are *bevreyt* (freed) from noise and stench. In *Het Burgherlick leven*, he explains that a *burgher* is the inhabitant of a *Burcht* (fortified place), 'freed from attacks by neighbouring or foreign folks'. Stevin, *Het Burgherlick leven*, p. 34.

69 Goeree writes that chambers in the house 'are suitable' and that 'the bed chambers and kitchens are liberated from the general passage'. Goeree, *d'Algemeene bouwkunde*, p. 133.

70 Stevin, 'Byvough', pp. 57, 63. Goeree speaks rather disparagingly of Stevin's ideas on accessibility. However, Vingboons (Figures 2.9 and 2.10) already gives the staircase a more prominent place, and the corridor (which Stevin only mentions) has been integrated into the floor plan. Goeree, *d'Algemeene bouwkunde*, p. 152.

Organizing Inward Dignity

The theme of respect and the internal dignity of the chambers also explains why Stevin repeatedly points out that one should keep chamber doors closed.[71] He argues that this is because doors have the purpose of preventing chamber's inhabitants from being looked at, as it is uncomfortable and unsuitable to sit in an open chamber against one's will.[72] For this reason, the water closet too should have a door. Only out of the sight of others can one relieve oneself at ease. Stevin thus follows Alberti and Palladio, who consider the privy to be a *heymelick* ('secret' place).[73] That which is a natural state of affairs for each person, but which for others stinks (Alberti) or is unpleasant to see (Palladio), should be placed at a distance or out of sight. Both Alberti and Palladio (and Stevin joins them) believe that a natural phenomenon such as relieving oneself should be given a dignified, free place. They therefore advocate a separate *bestecamer* ('best' place) that is not openly accessible.[74] To support the respectful treatment of this natural activity, it is not unimportant that Alberti and Palladio both refer to examples from Nature. No matter how natural the actions are for living beings, they do bring nuisance to others. This is why swallows remove the unclean, stinking droppings directly from their nest: 'Since Nature has given us this excellent instruction, I think we ought by no means to neglect it', Alberti writes.[75] This is also why Nature has not placed the ignoble parts of the human being in plain sight, Palladio argues. In a similar way, it is inappropriate to prominently display in the house activities that are vital but offensive to the eye and nose, and which would thus damage the appearance of the house with their ugliness and stench. So, Alberti prefers the privy to be outside the house, while Palladio gives it a place in the basement.[76] Stevin, on the other hand, explicitly calls for a water closet in the house. In his drawing he even includes a small, enclosed cabin in each

71 In 'Houwelick', Jacob Cats also writes about dignity in the house, concerning gestures, clothing, facial expressions, and attitudes. See De Mare, *Het Huis*, pp. 250–395, and 'The Art of Living Well'.

72 Stevin, 'Byvough', p. 81.

73 Stevin, 'Byvough', pp. 91–95. However, nowhere does this dignity appear to be an expression of a mental change in the way Elias argues in *The Civilizing Process*. The reason for the early modern privy is not 'embarrassment' (in front of others) but one's own convenience given natural features that request a liberated place.

74 Goeree agrees with them: 'The *gemakken* (conveniences) or secret places do require a concealed place of their own, but the need for everyone to make use of them forces the architect to arrange them in such a way that they are easy to find, and the house nevertheless remains free of stench or other inconvenience'. Goeree, *d'Algemeene bouwkunde*, p. 136.

75 Alberti, *The Ten Books of Architecture*, v. 17.

76 Alberti notes that, in contrast to the placing of dung piles out of sight, as happens in the countryside, in town houses one can see the peculiar habit of placing smelly excrement beside a pillow or next to the main chambers. Alberti, *The Ten Books of Architecture*, v. 17; Palladio, *Die vier Bücher*, II. 2.

chamber. Each *heymelick* (privy) is fitted with an easily lockable door, two windows that can be opened outwards, a seat with a cover, a deep drain, and permanent flushing with rainwater.[77]

Stevin wants to guarantee the freedom of the chambers and thus the dignity of the members of the household not only by installing many doors (thirty-two per floor), but also by making the chambers lockable. Traditionally, valuables were kept under lock and key in chambers, cupboards, or chests, due to the inclination of some human beings to steal them.[78] But Stevin introduces a system in which both the master and the mistress of the house have their own general key. Both have access to six locks for their own use (the master to his office and chests with money, jewels, and papers, the mistress to her linen closet, wardrobe, and jewellery box) and also to thirty other locks (each of which has its own key). So, the mistress of the house can open thirty-six locks in the house with her key, excluding her husband's six. Neither her husband's key nor the other thirty keys can give access to her possessions. With this system, Stevin guarantees the internal freedom of the chambers and the integrity of the inhabitants' possessions.[79]

In addition, he uses locks and keys as a means against dishonest folk, referring to suitors and thieves. Suitors have a natural inclination to visit the daughter of the house at night. Thieves tend to search for other people's property during the night. Both are trying to gain access to the house in an unusual way, to the detriment of family members. Thieves do this by drilling holes in the window frame, smashing glass, and unlocking windows with their hands. Suitors prefer to try to enter by opening a window.[80] However, the resulting inconvenience can be prevented by not situating the courtyard on the street, making the shutters out of iron or copper, and placing bars in the upper and lower windows.[81]

Finally, another form of unwanted entrance consists in people peeking in, such as when passers-by on the street look at the housewife or her daughters sitting at the window, or when neighbours look out of their own houses and cast uncomfortable glances on the activities of the household members. Because of their unstoppable tendency to peer inside, both passers-by and neighbours infringe the freedom of the house and harm the dignity of the members of the household. Therefore, the consequences of this innate quality of looking in must be prevented. In the first case, this is done by raising the ground floor (by two to two and a half feet) so that one can no longer see

77 Stevin, 'Byvough', p. 92.

78 See Alberti, *The Family in Renaissance Florence*, pp. 221–24.

79 Stevin, 'Byvough', pp. 73–74. Van den Heuvel interprets Stevin's treatment of doors and locks in a modernist way as an investigation into 'the separation of the private and the more public rooms'. Van den Heuvel, 'De Huysbou', pp. 46–47.

80 Stevin, 'Onderscheyt', pp. 24, 26; Stevin, 'Byvough', pp. 56, 120, 122–23.

81 Stevin, 'Byvough', pp. 122–24. By locking the windows from the inside, Stevin prevents problems in case of fire.

what is happening inside from the street (although an unobstructed street view from the chamber is still possible).[82] In the second case, it is done by arranging the block of houses so that the courtyards always have blind walls where neighbouring houses adjoin (Figure 2.2).

The shift from external *decorum* (dignity) in Vitruvius to internal appropriateness can be seen in European architectural treatises from the middle of the fifteenth century onwards. In Stevin's architectural thinking, both aspects of dignity can be found. On the one hand, he points to the public 'princely' prestige a burgher can derive from the grandeur of the closed urban façade of which his house is a part.[83] On the other hand, his work reveals a process that Meischke once described as 'chamber formation': a chamber evolution in the Dutch house whereby the medieval house with only one stone chamber expands into an ensemble of chambers and corridors.[84] Instead of interpreting this transformation as an expression of functional differentiation or increasing individualization, Meischke considers it a process that seeks to ban all kinds of malignant matter from the house. Two of these matters explicitly occur in Stevin's work: firstly, there is the control of 'the indoor climate' by the elimination of odour, moisture, wind, and smoke; secondly, there is the protection of valuables by storing them in lockable chambers or cabins.[85]

However, the term 'chamber formation' deserves an expanded scope. It can also articulate the rationality of the early modern connection between the natural order and the classical taxonomy. Stevin's natural classification of human beings in the burgher house has a twofold purpose: on the one hand, to protect their innate idiosyncrasies, and on the other, to avoid mutual hindrance, disturbance, and harm in the house (caused by differences in biological sex, age, and kinship). Classical suitability is to the benefit of everyone's dignity. As a result, Stevin's house has been cleansed of the annoying, uncomfortable, insignificant, and insulting behaviours that human beings exhibit given their nature. This explains the logic behind Goeree's story about an Amsterdam merchant who held the architect responsible for a servant's impregnation of his maidservant: in placing their bed chambers too close together, the architect had ignored the natural cravings of maidens and youths.[86]

In this sense, Stevin's chamber formation is in line with the house drawings that Philips Vingboons published half a century later. His houses also have many different chambers and cabins, including secluded water closets, kitchens

82 Stevin, 'Byvough', p. 96.
83 Stevin, 'Onderscheyt', p. 24.
84 Meischke, 'In den kwade reuk'.
85 Meischke, 'In den kwade reuk', p. 20. Interestingly, it is only when the smell of the house (subsoil, building materials, excrement) is under control that people begin to smell themselves and baths appear.
86 Goeree, *d'Algemeene bouwkunde*, pp. 136–37. Van den Heuvel discusses the incident in social terms ('too intimate contacts'), reducing it to an anecdote that is incomprehensible to modern readers. Van den Heuvel, 'Willem Goeree', pp. 137–53.

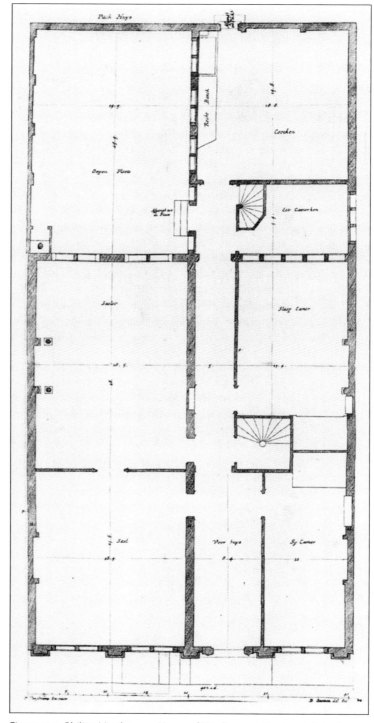

Figure 2.9. Philips Vingboons, *House of Nicolaes van Bambeeck* (1650), Colveniers burgh-wal (Kloveniersburgwal), Amsterdam. Included in Vingboons, 'Tweede deel van de Afbeeldsels', p. 236. Photo Universiteitsbibliotheek van Amsterdam. Reproduced with permission.

INWARD DIGNITY 87

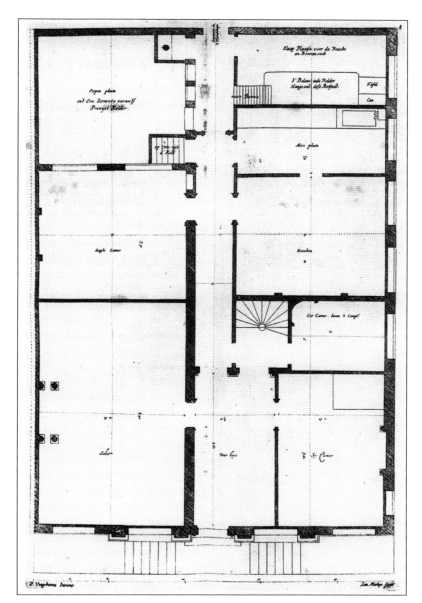

Figure 2.10. Philips Vingboons, *House of Pieter de Mayer* (1655), Fluwele Burgwal (Oudezijds Voorburgwal), Amsterdam. Included in Vingboons, 'Tweede deel van de Afbeeldsels', p. 237. Photo Universiteitsbibliotheek van Amsterdam. Reproduced with permission.

with various pumps, and numerous windows providing chambers with daylight (Figures 2.9 and 2.10). Here too, the decisive factor is the connection between the natural, innate qualities of human beings, the abundance of separate chambers, and the accessible passageways in the house.

The Early Modern Art of Building

In early modern Europe there are numerous authors who explore the house and its place in Nature in writings and images. From 1600 onwards, this classical architectural knowledge system is retrieved by Stevin, Vingboons, Goeree, and others, using similar terminology. It is only in light of this embedment in natural philosophy that we can understand why the vast majority of early modern architectural thinking consists of the discussion of matters considered 'trivial' since the twentieth century. But as A. J. Close once noted: 'Building houses [...] does not assist nature in the sense of encouraging the development of some natural organism; rather, it serves nature by satisfying a human need with the finished product'.[87] So, the good architect must be aware of all the qualities of the substances with which he is working: he must fathom Nature in all its innate peculiarities. He should make good use of the talents he has inherited from Nature and use his knowledge wisely.[88] If he uses bad instead of sustainable building materials and makes poor constructions, the rain will do its natural job, the houses will rot, and ultimately whole towns will fall into disrepair. Knowing that openwork ornaments attract dirt (knowledge of climatic matters), knowing that they consist of precious materials (knowledge of materials and costs), and knowing that the client will be all too easily seduced by a perspectival drawing with ornaments instead of investing money in maintenance (knowledge of human tendencies), the wise architect must spend the available money on a building that is sustainable in every respect.[89]

The scientific nature of the early modern 'art of building' does not lie in its mathematical basis.[90] There is none of the modernist fixation on 'beauty', 'symmetry', or 'mathematics' that in 1949 Rudolf Wittkower attributed to the ingenious architects of the Renaissance.[91] Building is an 'art' (*technē, ars, const*) that presupposes knowledge of Nature in all its activities.[92] Referring to Aristotle, Euclid, and other Greek authors, Stevin distinguishes between *Spiegheling* ('theoria', reflection, systematic knowledge without substance) and *Daet* ('praxis', deed, determining the value and weight of disordered matter

87 Close, 'Commonplace Theories', pp. 472–73.
88 In this sense, the master builder is comparable to the classical orator who serves the public interest.
89 Stevin, 'Byvough', p. 98.
90 De Mare, 'Towards a Historiography of Science'.
91 Wittkower, *Architectural Principles*; Payne, 'Rudolf Wittkower', pp. 322–24.
92 De Mare, *Het Huis*, pp. 231–48.

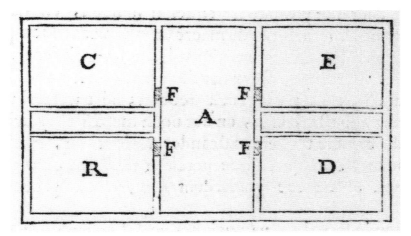

Figure 2.11. Simon Stevin, *First ground drawing*. Included in Hendrick Stevin, *Materiae Politicae. Burgherlicke Stoffen*, Leiden 1649, p. 61. Photo Koninklijke Bibliotheek, The Hague. Reproduced with permission.

A = *Voorsael* (front hall); B = *Eetcamer* (eating chamber); C = *Slaepcamer* (sleeping chamber); D = *Keucken* (kitchen); E = *Vertreckcamer* (separate chamber); F = 4 doors.

in practice, based on systematic knowledge). *Spiegheling* is possible without *Daet*, but never *Daet* without *Spiegheling*, which underlines the great early modern and antique appreciation of *Daet*.[93] For instance, *wis-const* (mathematics, understood by Stevin as 'certain' knowledge) is for him part of Nature, albeit without knowledge of natural substances in practice.

Stevin's art of building is a knowledge system based on the rules of Nature. In his drawings of houses, blocks, and a town, his acquired knowledge of natural reasons is demonstrated on two levels, conforming to architectural thought since Vitruvius. Firstly, there is the classification of the elements (the taxonomy of things, substances, and inhabitants according to their respective natural qualities) that have to be placed within the house (*ordinatio*). Secondly, there is the appropriate visual arrangement of all these elements (*dispositio*), a drawn demonstration based on the (geometric) rules of Nature (Figure 2.11).[94]

To explain his drawing procedure, Stevin introduces the term *lycksydicheyt* to replace the Greek concept of 'symmetry', which according to him has been misinterpreted since Vitruvius.[95] Stevin explains his concept in detail in terms

93 Stevin, 'Wysentyt', pp. 618–23; De Mare, *Het Huis*, pp. 231–48.
94 Vitruvius, *Handboek bouwkunde*, I. 1–2. Van den Heuvel, on the other hand, interprets Stevin's drawings as 'experimental laboratories' understood as 'simulation models for various practical situations [...] without immediately presenting a coherent and conclusive system to be directly translated into practice'. Van den Heuvel, '*De Huysbou*', pp. 63–64.
95 That is, it follows the proportions of the human body. Stevin 'Onderscheyt', pp. 11–16. See De

of the way Nature organizes the human face: the face consists of some parts of which there are two, each of which is equal in shape, position, matter and size (eyes, ears, cheeks, nostrils), and of singular parts (nose, mouth, chin), which are placed in the middle between those pairs.[96] A house arrangement that follows *lycksydicheyt*, according to him, also evokes innate delight. The geometrical term 'congruity', which focuses on the corresponding and balanced formal and material qualities of all the parts in Stevin's drawings, acknowledges his Nature-based clarification of *lycksydicheyt*.[97]

Later, with the foundation of the French Royal Academy of Architecture in 1671, the early modern architectural knowledge system in Europe changes. Theoretical debates begin to revolve around abstractions such as Architecture, Beauty, Harmony, and Taste. The house as the goal of architectural thinking disappears into the margins; it is only at the beginning of the nineteenth century that it comes to the fore again. But then the house is conceived as a technical means by which to plan society and the population through a rationally implemented design process, where privacy is one of the parameters.[98]

To Conclude: Stevin's Articulation of 'Privacy'

For Stevin, the recognition of heterogeneous natural qualities — of building materials, household substances, and human beings — is an Aristotelian framework within which to make suitable combinations in the house, in order to prevent the problems that arise if these qualities are ignored (architecture attuned to Nature). In modern times, when Nature no longer plays a vital role in architecture, building materials are industrially produced, and human beings are primarily conceived as social beings that efficiently fulfil the functions planned by architecture (form follows function), consequently generating all kinds of ambivalences and dilemmas that then need to be resolved. Feminist architecture, for example, sometimes regards domestic privacy as a patriarchal means of oppression (isolating the woman in the house), and sometimes celebrates it as a means to achieve progressive female autonomy (in terms of Virginia Woolf's *A Room of one's Own*).[99]

Mare, *Het Huis*, pp. 177–248.

96 See also Alberti, *The Ten Books of Architecture*, IX. 5.

97 Van den Heuvel considers this early modern embedment in Nature to be irrelevant, and reduces Stevin's *lycksydicheyt* to the purely modern technical engineering term 'mirror symmetry', which focuses on the final result. Van den Heuvel, '*De Huysbou*', p. 39. In the 1755 Leoni Edition of Alberti's *The Ten Books of Architecture*, IX. 5, the term 'congruity' is also used.

98 Tzonis, *Towards a Non-Oppressive Environment*, pp. 93–100.

99 For a historical and critical overview, see Edhoffer, De Mare, and Vos, 'Women and the City', pp. 33–52, De Mare, 'From Housewife to Women's House', pp. 110–16.

Based on my deconstruction of Stevin's architectural knowledge system, the modern search for the origin of privacy, conceived as an expression of a psychosocial change that occurred in the Renaissance, has now been replaced by the observation that an inward dignity evolved during the early modern period through the transformation of the classical decorum that takes Nature seriously in all its aspects. Stevin and other early modern architects demonstrate that the conception of the liberated house in terms of respect for all kinds of natural qualities, including innate human qualities, generates an inward dignity that does justice to the house and its inhabitants as a coherent ensemble. This early modern liberated house is the fundamental and indispensable condition that paves the way for the advent of the modern politics of privacy, which has narrowed down to the protection of personal autonomy, individual legal freedom, and an independent way of life.[100]

100 Keulen and Kroeze, 'Privacy', pp. 52–53.

Works Cited

Manuscripts and Archival Sources

Stevin, Simon, 'Vande Oirdeningh der Steden', in *Eenighe Stucken der Crychconst Beschreven deur Simon Stevin*, ed. by Hendrick Stevin, The Hague, Koninklijke Bibliotheek, MS 128-A-9-II, pp. 1–17

Primary Sources

Alberti, Leon Battista, *On Painting*, trans. by John R. Spencer (New Haven: Yale University Press, 1956)

——, *The Family in Renaissance Florence*, trans. by Renée Neu Watkins (Columbia: University of South Carolina Press, 1969)

——, *The Ten Books of Architecture. The 1755 Leoni Edition*, trans. by Giacomo Leoni (New York: Dover, 1986)

Cats, Jacob, 'Houwelick, dat is, Het gansche Beleyt des Echten-Staets', in Jacob Cats, *Alle de Wercken*, I (Amsterdam, 1712), pp. 235–424

Goeree, Willem, *d'Algemeene bouwkunde. Volgens d'Antyke en Hedendsdaagse Manier* (Amsterdam: op 't Rokin, 1682)

Hoogstraten, Samuel van, *Inleyding tot de Hooge Schoole der Schilderkonst: Anders de Zichtbaere Werelt* (Rotterdam: Francois van Hoogstraten, 1678)

Palladio, Andrea, *Die vier Bücher zur Architektur*, trans. by Andreas Beyer and Ulrich Schütte (Darmstadt: Wissenschaftliche Buchgesellschaft, 1986)

Stevin, Simon, 'Onderscheyt vande oirdeningh der Steden', in *Materiae Politicae: Burgherlicke Stoffen*, ed. by Hendrick Stevin (Leiden, 1649), pp. 3–39

——, 'Byvough der stedenoirdeningh, vande oirdening der deelen eens huys, met 'tgheene daer ancleeft', in *Materiae Politicae: Burgherlicke Stoffen*, ed. by Hendrick Stevin (Leiden, 1649), pp. 40–128

——, 'Arithmetique', in *The Principal Works of Simon Stevin*, ed. by D. J. Struik, IIB (Amsterdam: C. V. Swets and Zeitlinger, 1958), pp. 457–745

——, 'Wysentyt', in *The Principal Works of Simon Stevin*, ed. by Ernst Crone, III (Amsterdam: C. V. Swets and Zeitlinger, 1961), pp. 591–623

——, *Het Burgherlick leven: Vita Politica*, ed. by Pim den Boer (Utrecht: Erven J. Bijleveld, 2001)

Vingboons, Philips, 'Afbeelsels der voornaemste gebovwen uyt alle die Philips Vingboons geordineert heeft', in *Philips Vingboons (1607–1678), architect*, ed. by Koen Ottenheym (Zutphen: De Walburg Pers, 1989), pp. 185–226

——, 'Tweede deel van de Afbeeldsels', in *Philips Vingboons (1607–1678), architect*, ed. by Koen Ottenheym (Zutphen: De Walburg Pers, 1989), pp. 227–70

Vitruvius, *Handboek bouwkunde*, trans. by Ton Peters (Amsterdam: Athenaeum/ Polak and Van Gennep, 1997)

Secondary Studies

Alpers, Svetlana, 'Picturing Dutch Culture', in *Looking at Seventeenth-Century Dutch Art: Realism Reconsidered*, ed. by Wayne Franits (Cambridge: Cambridge University Press, 1997), pp. 57–67

Betsky, Aaron, *Building Sex: Men, Women, Architecture and the Construction of Sexuality* (New York: William Morrow, 1995)

Bruun, Mette Birkedal, 'The Centre for Privacy Studies Work Method' (Copenhagen, 2019) <https://teol.ku.dk/privacy/research/work-method/> [accessed 24 January 2022]

Burke, Peter, *Eyewitnessing: The Uses of Images as Historical Evidence* (Ithaca: Cornell University Press, 2001)

Chapman, H. Perry, 'Home and the Display of Privacy', in *Art and Home: Dutch Interiors in the Age of Rembrandt*, ed. by Mariët Westermann (Zwolle: Waanders, 2001), pp. 128–52

Close, Anthony J., 'Commonplace Theories of Art and Nature in Classical Antiquity and in the Renaissance', *Journal of the History of Ideas*, 30.4 (1969), 467–86

Cohen, H. Floris, *The Scientific Revolution: A Historical Inquiry* (Chicago: University of Chicago Press, 1994)

Damsma, Dirk, and Els Kloek, '"T Huys Best": Huiselijkheid in Holland sedert de Gouden Eeuw', *Historisch Tijdschrift Holland*, 44.3 (2012), 100–09

Edhoffer, Lisl, Heidi de Mare, and Anna Vos, 'Women in the City', in *Vrouwen en de stad. Deel 1*, ed. by Lisl Edhoffer, Heidi de Mare, and Anna Vos (Delft: Faculty of Architecture and the Built Environment, TH Delft, 1986, English translation 2022), pp. 3–59 <https://www.academia.edu/88710657/2022_Women_and_the_city_Womens_Studies_in_Architecture_in_the_Post_Feminist_Era> [accessed 30 June 2023]

Elias, Norbert, *The Civilizing Process: Sociogenetic and Psychogenetic Investigations* (Oxford: Blackwell, 2000)

Forty, Adrian, *Words and Buildings: A Vocabulary of Modern Architecture* (London: Thames and Hudson, 2000)

Foucault, Michael, *The Archaeology of Knowledge* (New York: Taylor and Francis, 1982)

Franits, Wayne E., *Paragons of Virtue: Women and Domesticity in Seventeenth Century Dutch Art* (Cambridge: Cambridge University Press, 1993)

Hampsher-Monk, Iain, Karin Tilmans, and Frank van Vree, 'A Comparative Perspective on Conceptual History — An Introduction', in *History of Concepts: Comparative Perspectives*, ed. by Iain Hampsher-Monk, Karin Tilmans, and Frank van Vree (Amsterdam: Amsterdam University Press, 1998), pp. 1–9

Heuvel, Charles van den, 'Willem Goeree (1635–1711) en de ontwikkeling van een algemene architectuurtheorie in de Nederlanden', *Bulletin KNOB*, 5 (1997), 154–76

——, 'De Huysbou': A Reconstruction of the Unfinished Treatise on Architecture, Town Planning and Civil Engineering by Simon Stevin* (Amsterdam: KNAW, 2005)

Hillier, Bill, and Julienne Hanson, *The Social Logic of Space* (Cambridge: Cambridge University Press, 1984)

Hollander, Martha, 'Public and Private Life in the Art of Pieter de Hooch', in *The Art of Home in the Netherlands 1500–1800: Netherlands Yearbook for History of Art, 51*, ed. by Jan de Jong, Bart Ramakers, Herman Roodenburg, Frits Scholten, and Mariët Westermann (Zwolle: Waanders, 2000), pp. 273–93

Honig, Elisabeth A., 'The Space of Gender in Seventeenth-Century Dutch Painting', in *Looking at Seventeenth-Century Dutch Art: Realism Reconsidered*, ed. by Wayne Franits (Cambridge: Cambridge University Press, 1997), pp. 186–201

Johnson, Paul-Alan, *The Theory of Architecture: Concepts, Themes, and Practices* (New York: Van Nostrand Reinhold, 1994)

Keulen, Sjoerd, and Ronald Kroeze, 'Privacy from a Historical Perspective', in *The Handbook of Privacy Studies: An Interdisciplinary Introduction*, ed. by Bart van der Sloot and Aviva de Groot (Amsterdam: Amsterdam University Press, 2018), pp. 21–56

Mare, Heidi de, 'From Housewife to Women's House, from Men's House to Houseman', in *Vrouwen en de stad. Deel 1*, ed. by Lisl Edhoffer, Heidi de Mare, and Anna Vos (Delft: Faculty of Architecture and the Built Environment, 1986; English translation 2022), pp. 61–119 <https://www.academia.edu/86757340/2022_From_housewife_to_womens_house_from_mens_house_to_houseman> [accessed 30 June 2023]

——, 'The Domestic Boundary as Ritual Area in Seventeenth-Century Holland', in *Urban Rituals in Italy and the Netherlands: Historical Contrasts in the Use of Public Space, Architecture and the Urban Environment*, ed. by Heidi de Mare and Anna Vos (Assen: Van Gorcum, 1993), pp. 108–31 <https://www.academia.edu/6003852/1993_The_Domestic_Boundary_as_Ritual_Area_in_Seventeenth_Century_Holland> [accessed 30 June 2023]

——, 'A Rule Worth Following in Architecture? The Significance of Gender in Simon Stevin's Architectural Knowledge System (1548–1620)', in *Women of the Golden Age: An International Debate on Women in Seventeenth-Century Holland, England and Italy*, ed. by Els Kloek, Nicole Teeuwen, and Marijke Huisman (Hilversum: Verloren, 1994), pp. 103–20 <https://www.academia.edu/5582385/1994_A_rule_worth_following_in_architecture_The_significance_of_gender_classification_in_Simon_Stevins_architectural_treatise_1548_1620_> [accessed 30 June 2023]

——, 'A Disciplined Eye: From Art History to Historical Formalism', *Kunstlicht*, 20.3–4 (1999), 14–20 <https://www.academia.edu/39324587/2019_A_Disciplined_Eye_From_Art_History_to_Historical_Formalism> [accessed 30 June 2023]

——, 'Domesticity in Dispute: A Reconsideration of Sources', in *At Home: An Anthropology of Domestic Space*, ed. by Irene Cieraad (New York: Syracuse University Press, 1999), pp. 13–30 <https://www.academia.edu/5100964/1999_Domesticity_in_Dispute_A_Reconsideration_of_Sources> [accessed 30 June 2023]

——, 'Het huis, de natuur en het vroegmoderne architectonisch kennissysteem van Simon Stevin', in *The Art of Home in the Netherlands 1500–1800: Netherlands Yearbook for History of Art*, 51, ed. by Jan de Jong, Bart Ramakers, Herman Roodenburg, Frits Scholten, and Mariët Westermann (Zwolle: Waanders, 2000), pp. 35–59

——, *Het Huis en de Regels van het Denken: Een cultuurhistorisch onderzoek naar het werk van Simon Stevin, Jacob Cats en Pieter de Hooch* (doctoral thesis, Vrije Universiteit Amsterdam, 2003) <https://research.vu.nl/en/publications/het-huis-en-de-regels-van-het-denken-een-cultuurhistorisch-onderz> [accessed 30 June 2023]

——, 'Johannes Vermeer: Migration of an Icon', originally in *Heiligen of helden: Opstellen voor Willem Frijhoff*, ed. by Joris van Eijnatten, Fred van Lieburg, and Hans de Waardt (Amsterdam: Uitgeverij Bert Bakker, 2007), pp. 198–214 <https://www.academia.edu/4103788/2007_Johannes_Vermeer_migration_of_an_icon> [accessed 30 June 2023]

——, 'The Finding Place of Domestic Life: The Chamberscape in the Dutch Golden Age', *Historisch Tijdschrift Holland*, 44.3 (2012), 110–18 <https://www.academia.edu/37026510/2018_The_Finding_Place_of_Domestic_Life_The_Chamber_Scape_in_the_Dutch_Golden_Age> [accessed 30 June 2023]

——, *Huiselijke taferelen: De veranderende rol van het beeld in de Gouden Eeuw* (Nijmegen: Uitgeverij Vantilt, 2012)

——, 'The Image as Historical Source: Contemplation in Response to Recent Research by Frans Grijzenhout on *The Little Street* by Vermeer', *Tijdschrift voor historische geografie*, 2.4 (2017), 248–59 <https://www.academia.edu/39575140/2019_The_image_as_historical_source_Contemplation_in_response_to_recent_research_on_The_Little_Street_by_Vermeer> [accessed 30 June 2023]

——, '"The Art of Living Well": Jacob Cats and the Early Modern Imagination of Living in a Tenable Way', in *Waartoe is Nederland op aarde? Nadenken over verleden, heden en toekomst van ons land*, ed. by Gabriël van den Brink (Amsterdam: Boom Uitgevers, 2018), pp. 117–42 <https://www.academia.edu/39150365/2019_The_Art_of_Living_Well_Jacob_Cats_and_the_early_modern_imagination_of_living_in_a_tenable_way_> [accessed 30 June 2023]

——, *The House and the Rules of Thought: A Historical Comparative Research into the Work of Simon Stevin, Jacob Cats, Samuel van Hoogstraten and Pieter de Hooch*, trans. (2021) of *Het Huis* (2003) <https://www.academia.edu/44106917/2020_THE_HOUSE_AND_THE_RULES_OF_THOUGHT> [accessed 30 June 2023]

——, 'Not Every New Broom Sweeps Clean: Two Bold Studies on Women and Brooms in Seventeenth Century Dutch Painting. Double Review: Martha Moffitt Peacock, *Heroines, Harpies, and Housewives* (2020) and Piotr Oczko, *Bezem & Kruis* (2021)' (Leiden: IVMV, Dutch Foundation of Public Imagination, 2021) <https://www.academia.edu/51600167/2021_DOUBLE_REVIEW_Not_Every_New_Broom_Sweeps_Clean_Two_bold_studies_

on_women_and_brooms_in_seventeenth_century_Dutch_painting_
Peacock_2020_and_Oczko_2021> [accessed 30 June 2023]

——, 'Visual Rhetoric and the Potencies of the Image', in *Bewegen en bewogen worden: Retorisch handelen in taal, beeld en muziek*, ed. by A. Kok (Nijmegen: Valkhof Pers, 2021), pp. 118–64 <https://www.academia.edu/47784497/2021_Visual_rhetoric_and_the_potencies_of_the_image> [accessed 30 June 2023]

——, 'Towards a History of Science as "const"! Reflection on "Rethinking Stevin" (2021)', review of *Rethinking Stevin, Stevin Rethinking: Constructions of a Dutch Polymath*, ed. by Karel Davids, Fokko Jan Dijksterhuis, Rienk Vermij, and Ida Stamhuis (Leiden: IVMV, Dutch Foundation of Public Imagination, 2023) < https://www.academia.edu/97063963/2023_Towards_a_History_of_Science_as_const_Reflection_on_Rethinking_Stevin_2021_ > [accessed 30 June 2023]

Mare, Heidi de, and Anna Vos, 'Rethinking Designing the Social. A Journey from Women's Studies in Architecture towards a Contemporary "Vitruvius"' (Leiden: IVMV, Dutch Foundation of Public Imagination, 2022) <https://www.academia.edu/92381534/2022_Rethinking_Designing_the_Social_A_Journey_from_Womens_Studies_in_Architecture_towards_a_Contemporary_Vitruvius>[accessed 30 June 2023]

Markus, Thomas A., *Buildings and Power: Freedom and Control in the Origin of Modern Building Types* (London: Taylor and Francis, 1993)

Meischke, Ruud, '"In den kwade reuk". De geschiedenis van de huislucht', *Heemschut*, 66.5/6 (1989), pp. 19–22

Mittelstraß, Jürgen, *Neuzeit und Aufklärung: Studien zur Entstehung der neuzeitlichen Wissenschaften* (Berlin: De Gruyter, 1970)

Payne, Alina A., 'Rudolf Wittkower and Architectural Principles in the Age of Modernism', *Journal of the Society of Architectural Historians*, 53.3 (1994), 322–42

Rabb, Theodore K., 'How Should Historians Use Images?' in Theodore K. Rabb, *Why Does Michelangelo Matter? A Historian's Questions about the Visual Arts* (Palo Alto: Society for the Promotion of Science and Scholarship, 2018), pp. 37–40

Rang, Brita, 'Space and Position in Space (and Time): Simon Stevin's Concept of Housing', in *Women of the Golden Age: An International Debate on Women in Seventeenth-Century Holland, England and Italy*, ed. by Els Kloek, Nicole Teeuwen, and Marijke Huisman (Hilversum: Verloren, 1994), pp. 121–25

Roodenburg, Herman, 'The Maternal Imagination: The Fears of Pregnant Women in Seventeenth-Century Holland', *Journal of Social History*, 21 (1988), 701–16

Schuurman, Anton, and Pieter Spierenburg, eds, *Private Domain, Public Inquiry: Families and Life-styles in the Netherlands and Europe, 1550 to the Present* (Hilversum: Verloren, 1996)

Sneller, A. Agnes, 'Reading Jacob Cats', in *Women of the Golden Age: An International Debate on Women in Seventeenth-Century Holland, England and Italy*, ed. by Els Kloek, Nicole Teeuwen, and Marijke Huisman (Hilversum: Verloren, 1994), pp. 21–34

Sterkenburg, P.G.J. van, *Een glossarium van zeventiende-eeuws Nederlands* (Groningen: Wolters-Noordhoff, 1981)

Tzonis, Alexander, *Towards a Non-Oppressive Environment* (Boston: I Press, 1972)

Waard, C. de, *Journal tenu par Isaac Beeckman de 1604 à 1634* (The Hague: Martinus Nijhoff, 1939–1953), pp. iii–xxi, 291–300, 394–405

Westermann, Mariët, '*Wooncultuur* in the Netherlands: A Historiography in Progress', in *The Art of Home in the Netherlands 1500–1800: Netherlands Yearbook for History of Art*, 51, ed. by Jan de Jong, Bart Ramakers, Herman Roodenburg, Frits Scholten, and Mariët Westermann (Zwolle: Waanders, 2000), pp. 7–33

——, *Art and Home: Dutch Interiors in the Age of Rembrandt* (Zwolle: Waanders, 2001)

Wigley, Mark, 'Untitled: The Housing of Gender', in *Sexuality and Space*, ed. by Beatrice Colomina (Princeton: Princeton Architectural Press, 1992), pp. 326–89

Wittkower, Rudolf, *Architectural Principles in the Age of Humanism* (New York: Norton, 1971)

Woolf, Virginia, *A Room of One's Own* (London: Penguin, 2009)

JØRGEN WADUM

Privacy in Seventeenth-Century Dutch Cabinet Painting

Introduction

In this article, I shall introduce certain aspects that may have evoked a sensation of privacy in the seventeenth-century viewer — particularly nudity or eroticism, as well as the privacy of a household or the mesmerizing gaze of a young woman.[1] Millions of painted images were produced in the seventeenth century, and thanks to museums and digitization, many are now readily available for enjoyment, inspiration, and comparison.[2] Originally, each of these paintings hung on the walls of (mainly) private houses, some accompanied by only one or a few other paintings, others as part of larger collections. In any event, the images were generally reserved for the enjoyment of a select few.[3] Owners of paintings and their learned friends would discuss the artists' impressions, and hidden messages would be sought.

This obviously continues today, and while studying paintings from the past, we tend to read our present-day concerns into the images, continuously rewriting art history and well-known stories from the past to make them an active part of our own time. In this way, we create imaginaries of the past with a contemporary sense of topical relevance and significance. As my analysis will show, this always presents the risk of our reading things into the images that make sense to us today but might have been regarded as far-fetched during the period when the pictures were conceived and set in oils on a panel or canvas. Literature studies will naturally assist us in understanding the past; however,

1 This text is based on more than thirty years of engagement with theories and images of seventeenth-century Dutch art. I am indebted to numerous individuals for their scholarly insights, notably Eric Jan Sluijter and John Michael Montias. Thanks also to Angela Jager for inspiration and critical comments, René Lauritsen for language editing, and my wife Christine E. Swane for her early review of the text and her continued encouragement.

2 Jager, *The Mass Market for History Paintings*, pp. 21–36; Van Ginhoven, *Connecting Art Markets*, pp. 35–72, pp. 124–44.

3 Loughman and Montias, *Public and Private Spaces*, pp. 19–50.

Jørgen Wadum is an art historian and painting conservator. Currently he is the director of Wadum Art Technological Studies and a special consultant at the Nivaagaard Collection, Nivå.

Private Life and Privacy in the Early Modern Low Countries, ed. by Michael Green and Ineke Huysman, EER 19 (Turnhout: Brepols, 2023), pp. 99–120

BREPOLS ❧ PUBLISHERS 10.1484/M.EER-EB.5.132531

as we only have fragments left from the large amount of writing produced in the seventeenth century, and access to only a very limited fraction of what was said and discussed between connoisseurs and laypeople, we can only make qualified guesses and presumptions. Our current conversations when we are describing the image of a seventeenth-century painting are arguably the exact opposite of what would once have been an intimate or private viewing of the painting itself — cherished in solitude for its quality, often through just a few timely or indeed private readings.

Background

Only when very deliberately viewing paintings as paintings, and not just as images, does one realize the scope of multilayered information available to the beholder. Sensations may be caused by colour and composition, by the story depicted, by subtle hints of deeper levels beneath the surface, or by the combined drama and significance of all these aspects. The interpretation of what is in front of us depends not only on our eyes and the emotions evoked in our body by an image, but also on the cultural background in which each of us is embedded, and therefore on the degree to which we are prepared to engage with the particular understanding intended or hinted at by the artist. The moral code of the beholder, combined with the faculty of imagination, will therefore be vital for how, for example, we perceive images that are attractive, invite our attention, and require us to reconsider our ideas about privacy.

The question of how seventeenth-century viewers distinguished between the *public* and the *private*, and what meaning those terms held for individuals in the early modern period, is open to discussion.[4] The Dutch poet Jacob Cats (1577–1660), also a solicitor and a humourist, published extensively and often appealed directly to the decency of his contemporaries. His moralistic emblem books were widely popular, most notably *Sinne en Minnebeelden* (1626), for which the multitalented painter, poet, and book illustrator Adrian van der Venne (1589–1662) designed the plates. Cats's book *Huwelijk* (marriage) found many readers as well. Here he warned against all inappropriate pictures of nude women that might induce uncontrolled lust in young men, and it is clear that little distinction was made between the effect of beholding naked women in paintings and the effect of seeing them in real life.[5] This, together with the more intangible meanings of the image — whether moralizing or created to evoke lust in the mind of the viewer — may be difficult for present-day observers to fully comprehend. In the following I shall nevertheless seek to illustrate these considerations by turning to paintings by especially Rembrandt van Rijn (1606–1669) and Johannes Vermeer (1632–1675).

4 Longfellow, 'Public, Private, and the Household', pp. 313–14.
5 Sluijter, *Rembrandt and the Female Nude*, pp. 145–48.

Turning our gaze towards the many paintings of domestic activities set in Dutch interiors, we understand that they were all constructed based on the intentions and wishes of the artists. We often see simple interiors featuring card-playing or bragging peasants in a dimly lit tavern, or we are presented with lavishly decorated homes where elegant people sport the latest couture. We should be aware that these images are to be understood not so much as reflections or mere illustrations of daily life, but more as exhortations and warnings translated into paint. In *Seductress of Sight*, the Dutch art historian Eric Jan Sluijter has extensively analysed seventeenth-century art dealing with beauty and seduction, love and desire, chastity and unchastity.[6] What we need to recognize is the fact that in the seventeenth century, the correct reading of images depended on several factors: the viewing of the image itself, and the viewer's comprehension of the meanings behind various elements and allusions to the good — and bad — aspects of lust or chastity. This again would be combined with a knowledge of, for instance, emblematic literature (the images and accompanying verses), which would act as a key to the story told by the painter.[7] Apart from these requirements for proper interpretation, we may go on to ask whether these views into Dutch interiors were communal or private. An interesting opinion about this may be gleaned from the English Puritan clergyman William Gouge's (1575–1653) conduct book *Of Domestical Duties* (1622), where he pointed out that women had no public function but found their calling and duties at home, although he does not refer to them as *private* duties.[8] On the other hand, we know that paintings of a more seductive nature were not on display in the *voorhuis*, the most public room in Dutch houses. Here we would find landscapes and portraits, whereas images of nudes or erotic scenes would generally be found in the more private rooms of the household.[9]

The Private and the Exposed

Metamorphoses by the Roman poet Ovid (43 BCE–17/18 CE) was very popular among sixteenth- and seventeenth-century intellectuals, offering plenty of drama, battles, and eroticism.[10] One character is Andromeda, the daughter of the Ethiopian king Cepheus and his wife Cassiopeia. When Cassiopeia's hubris leads her to boast that Andromeda is more beautiful than the Nereids, Poseidon sends the sea monster Cetus to ravage Andromeda as a divine punishment. Andromeda is chained to a rock as a sacrifice to the savage sea monster but is saved from death by Perseus, who arrives at the last minute on his winged

6 Sluijter, *Seductress of Sight*.
7 De Jongh, *Zinne- en minnebeelden*, pp. 7–24.
8 Longfellow, 'Public, Private, and the Household', p. 319.
9 Sluijter, *Rembrandt and the Female Nude*, pp. 158–63.
10 The topic discussed in what follows is considered in great detail in Sluijter, *Rembrandt and the Female Nude*, esp. pp. 78–97 and pp. 113–41.

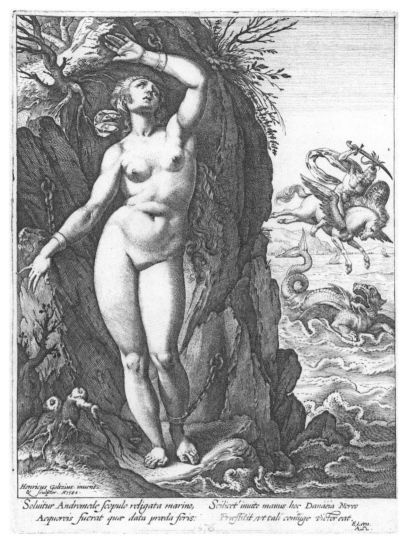

Figure 3.1. Hendrick Goltzius, *Perseus and Andromeda*, inscribed 'Henricus Goltzius. inuent & Sculptor. A° 1583', engraving, 19.8 × 14.4 cm. Rijksmuseum Amsterdam.

horse Pegasus. The nude of Andromeda, presented full-length towards the very front of the picture plane of an engraving by the German-born Netherlandish printmaker, draughtsperson, and painter Hendrick Goltzius (1558–1617), primarily illustrates the artist's virtuosic skill in depicting the anatomy and proportions of the nude body; it is devoid of any privacy (Figure 3.1). Seated on his horse in the background, Perseus approaches, flying above the fearful sea monster he is about to slay. The image of Andromeda became particularly

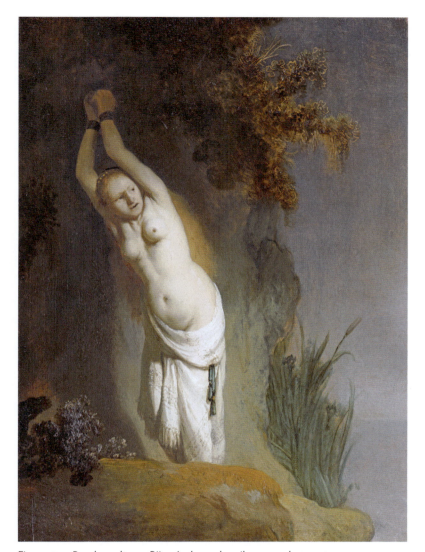

Figure 3.2. Rembrandt van Rijn, *Andromeda*, oil on panel, 34 × 24.5 cm, The Hague, Mauritshuis. Around 1630.

popular as a print, not only because of the reference to chastity — one of the seven Christian virtues, related to temperance and defined as abstinence from any sexual conduct or romantic relationships — but also, and perhaps rather more so, due to the inherent erotic appeal of the depiction.[11] In the seventeenth

11 Sluijter, *Seductress of Sight*, pp. 23–69.

century, the story of Andromeda was not often depicted in oils. This may have been to do with the difficulty of finding buyers who would display a fully nude and exposed female on the walls of their homes. Nor was this image fit for a public building as a political allegory, although Andromeda was sometimes represented as the nation (meaning the Netherlands) under threat, with Perseus cast as William I of Orange (1533–1584), who established the United Provinces of the Netherlands in 1581 after their liberation from Spanish rule.[12]

The Amsterdam-based painter Rembrandt van Rijn painted a rather different version of Andromeda: a scene with no saviour on his way to rescue the harassed woman (Figure 3.2). Instead, we witness the frightened young woman, chained as she is to the rock, looking over her shoulder towards the empty space from where her saviour is expected.[13] Examining the small panel with the young Andromeda, we realize that the erotic aspect of the stripped woman is moderate compared with the almost voluptuous woman seen in Goltzius's print. Rembrandt obviously chose to depict not an ideal nude, but on the contrary a very ordinary woman. Her face is not particularly attractive, her body not idealized in the slightest. Kenneth Clark (1903–1983), the twentieth-century British art historian, museum director, and broadcaster, commented upon Rembrandt's nudes by calling them 'to our eyes, some of the most unpleasing, not to say disgusting, pictures ever produced by a great artist'.[14] Clark's taste and eye were offended, yet this view had already been expressed by the Amsterdam writer Andries Pels (1631–1681) in 1681, only twelve years after Rembrandt's death. Pels wrote:

> Als hij een' naakte vrouw, gelyck 'somtijds gebuerde, zou schild'ren tot model geen Griekse Venus keurde; Maer eer een' waschter, of turftreedster uit een' schuur […]. Slappe borsten, Verwrongen' handen, ja de neepen van de worsten Des ryglyfs in de buik, des kousebands om 't been.

> (When he [Rembrandt] had to paint a naked woman, he would take no Greek Venus as his model, but rather a washerwoman or peat treader from some barn […]. Pendulous breasts, distorted hands, even the marks of the corset laces over the belly, or the garter around the leg.)[15]

Is Rembrandt eschewing the canon of painted beauty out of sheer stubbornness? Or is his approach to be explained by his being a Reformed Christian who regarded nature as God's creation *as it comes to us* — and who therefore painted nature as it was? We do not know anything about Rembrandt's beliefs; however, his father was a member of the Reformed Church, while his mother was a Roman Catholic.[16] I propose that we consider Rembrandt rather modern in

12 Sluijter, *Seductress of Sight*, p. 54.
13 Sluijter, *Rembrandt and the Female Nude*, pp. 89–97.
14 Schama, 'Rembrandt and Women', p. 24.
15 Pels, *Gebruik én misbruik des tooneels*, p. 77.
16 Wetering, *Rembrandt*, p. 35.

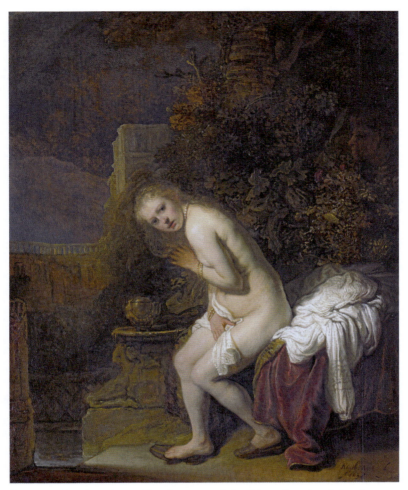

Figure 3.3. Rembrandt van Rijn, *Susanna and the Elders*, signed and dated 'Rembr[ant f]/f. 163[6]', oil on panel, 47.4 × 38.6 cm, The Hague, Mauritshuis.

his depiction of the details of sheer uncensored reality, including the garter mark below Andromeda's knee and the marks of the corset. These details emphasize her vulnerability, presenting something very private.

Rembrandt's depiction of the naked Bathsheba, wife of Uriah the Hittite, bathing in her garden shows her body with perfectly ordinary yet very private marks left on her flesh by tight clothing.[17] This gives the viewer an almost tangible impression of the damp skin and flesh of the woman's body.

17 Sluijter, *Rembrandt and the Female Nude*, pp. 333–60. The biblical story of Bathsheba appears in 2 Samuel.

Displaying the woman's body in all its imperfection may evoke an intense feeling of privacy that would be recognizable to the beholder — it certainly would have been readily so to women of the day. Here, the human body is devoid of any religious subjectivity and perfection; it has become earthly, erotic, simply the subject of an anatomical study.[18] This mood is entirely different from that evoked by an erotic pin-up on a wall, such as Goltzius's *Andromeda*. By adding extra figures to another depiction of the nude female body — not a Perseus on his Pegasus, but two elderly gentlemen peeping at a naked woman through bushes and leaves — Rembrandt transforms this story into that of *Susanna and the Elders* (1636) (Figure 3.3).[19]

The young married Hebrew woman is bathing alone in her garden. Two lustful elders secretly observe her, and when she makes her way back to her house, they stop her and demand that she have sex with them. When she refuses, they have her arrested on the false accusation that she met and had sex with a young man in the garden.[20] The woman's gaze in the painting reveals her very uncomfortable situation with this unwelcome intrusion on her private moment. Susanna's privacy has clearly been violated, and she desperately tries to cover her nakedness while directing an accusing, distressed glance directly at the spectator: you and me. In this way, the beholder is fully involved in the unacceptable intrusion on the bathing Susanna, rendering us complicit in her abuse. In Susanna's body we see the 'naked truth', not the stereotypical, idealized nudity of the supernatural or retouched world. Rembrandt deliberately changed idolized notions of Andromeda, Bathsheba, and Susanna into perfectly ordinary, familiar seventeenth-century women of flesh and blood. Commenting on this, Simon Schama writes: 'He is making us aware that the mythological or biblical heroine is fleshly and close, even to the point of self-recognition, by bringing us uncomfortably, embarrassing close to their peculiar corporal spell'.[21] We as viewers relate the image to *our own* most private parts.

Peep Shows

If we shift our gaze from mythological or biblical images to peep into the interiors found in the Dutch Republic, another kind of privacy may be observed. Whether the interior is a mundane household or one belonging to a wealthy burgher, the artist's angle or view into the interior can be decisive for our understanding of what often appear to be sheer force of perspective, lavish clothing in satin and fur, or trivial domestic activities.

Around 1655–1660, the ingenious painter Samuel van Hoogstraten (1627–1678) constructed a box with a Dutch interior painted inside (Figure 3.4).

18 Miles, *A Complex Delight*.
19 Sluijter, *Rembrandt and the Female Nude*, pp. 122–31.
20 Daniel 13.
21 Schama, 'Rembrandt and Women'.

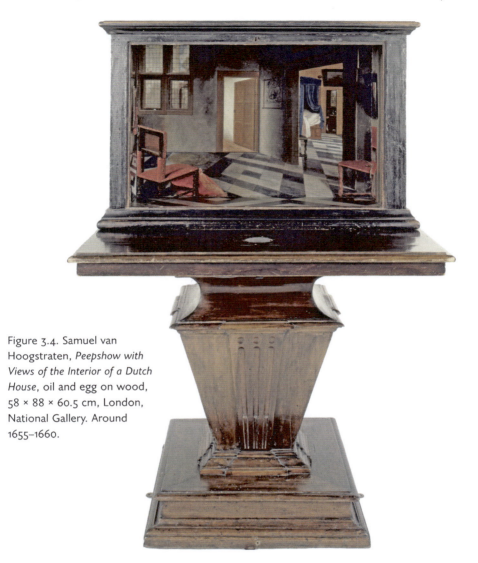

Figure 3.4. Samuel van Hoogstraten, *Peepshow with Views of the Interior of a Dutch House*, oil and egg on wood, 58 × 88 × 60.5 cm, London, National Gallery. Around 1655–1660.

One could peep into the box through small, subtle apertures in the sides.[22] Would the *Peepshow with Views of the Interior of a Dutch House* prompt a seventeenth-century onlooker to wonder whether they were trespassing into a private sphere? Or was the ingenious construction of this convincing interior, with its painted foreshortenings, the main focus of interest?[23]

22 Brown and others, 'Samuel van Hoogstraten'.
23 Bomford, 'Perspective, Anamorphosis, and Illusion'.

The viewer's level of education would probably be essential for the success of the image, as illustrated by the visit of book collector Zacharias Conrad von Uffenbach (1683–1734) to Gerrit Tydeman (1636–1713), a book dealer and collector in Zwolle. Von Uffenbach describes seeing all the mathematical and theoretical publications on the creation of perspectives, as well as looking into two perspective boxes. When looking through the peephole, he finds that the otherwise incomprehensible image becomes whole and complete.[24] Von Uffenbach does not heap any superlatives upon this observation. Research in the social sciences has demonstrated that our minds search our inner impressions, thoughts, and feelings for references within our cognitive maps in order to comprehend and experience the expected message; for present-day observers of seventeenth-century artworks, this also involves bridging the gap of time.[25]

A contemporary painter in Delft was Pieter de Hooch (1629–1684), whose *Tavern Interior with a Seated Soldier with a Serving Woman, Figures Playing Cards in the Background* (1652) presents an everyday tavern scene of the mid-seventeenth century. However, apart from displaying his skill in painting light reflected on the polished armour, for contemporary viewers the scene would steer the beholder's cognitive map in the direction of the imaginary world of a brothel. Would a twenty-first century audience sense this aspect of eroticism, or the moral embedded in the wider message? Would the private acts alluded to in the depiction be understood today without some edifying explanation? Over time, words may change their meaning, and the visual stimuli offered by a painting rely equally on an interpretative vocabulary to unravel the connotations from the cultural context in which the image was formed. In order to comprehend the full potential of past visual messages, we need to interrogate the original intent and couple this with new narratives to bridge the time gap.

Homescapes

In De Hooch's later *Interior with a Young Couple and People Making Music* (1644–1683), he takes the illusionistic and iconographic aspects one step further (Figure 3.5). Behind a *trompe l'oeil* in the form of a green curtain drawn aside, the artist invites us to peer into a lavish scene of merrymakers in a saloon. On the back wall is a partly visible painting of what looks like the adoration of the shepherds. De Hooch is teasing our senses, confronting us with a surprising combination of elements from reality coupled with an imaginative world. We view an elegant, apparently amorous couple dancing a minuet, within a setting that — thanks to the foreshortening and perspective

24 Von Uffenbach, *Merkwürdige Reisen*, pp. 366–67.
25 Downing, 'Image Banks', p. 442.

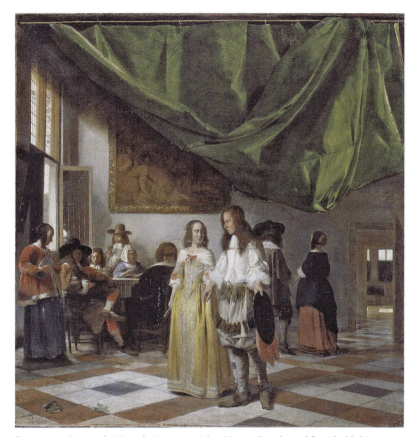

Figure 3.5. Pieter de Hooch, *Interior with a Young Couple and People Making Music*, oil on canvas, 72 × 67 cm, Copenhagen, Statens Museum for Kunst. Around 1644–1683.

of the marble floor — offers the illusion of a deep space, further accentuated by the door opening onto adjacent, probably private chambers, with the sun shining through the window onto the floor of the room at the rear. Another couple appear to have paused in their dancing, turning their backs towards us and heading towards the private rooms of the brothel. Yet the illusory green curtain, which is lifted to enable us to view the merrymakers in the brothel, casts a shadow over the interior. This shadow makes us realize that we are indeed only peeping at the flat surface of the painted illusion of an elegant interior with rather private goings-on.

De Hooch's colleague Johannes Vermeer (1632–1675) demonstrated similar artistic mastery in creating illusionistic scenes. The viewer's cognitive maps aid the construction of the image through the application of our knowledge of space and dimensions, allowing the mind's eye to visualize the image.

But how does this relate to the codes or mapping employed by the people of the mid-seventeenth century for whom these images were painted?[26] By means of a few examples, I aim to illustrate this and the various mental maps that need to be activated if we are to more fully comprehend the meanings and possible hidden information within genre paintings in the Dutch Republic, exemplified by Vermeer's works. In the painting *The Geographer* (*c.* 1668), Vermeer depicts a scholar at work. Light plays an important part in our understanding of the spatial illusion. The beam of light falling on the objects on the floor behind the man accentuates our sense of space. As in present-day photography, Vermeer employs a reflector — the map on the table — to make the light falling in from outside reflect upwards onto the shadowed part of the man's face, offering a better, less contrasted view of him. Compass in hand, the geographer has stopped his activity and looks out of the window; in a private moment, he seems to be pondering how to understand his latest measurements on the chart in front of him.

Creating illusions on the two-dimensional surface of a canvas requires a certain skill, and from the end of the sixteenth century onwards, many northern artists employed the technique of central perspective to its full potential. In 1604, Hans Vredeman de Vries (1527–*c.* 1607), an architect, engineer, and painter, published his book *Perspective*, which offered artists a visual guide on how to master this skill.[27] Furthermore, visits to artists' private studios became very fashionable among connoisseurs in the seventeenth century. In 1663, Vermeer had a visit from Balthasar de Monconys (1611–1665), a French traveller, diplomat, physicist, and magistrate. Although his private diary — made public by his son shortly after de Monconys's death — only comments briefly on his impressions,[28] fortunately we have another eyewitness account of Vermeer's paintings, written by Pieter Teding van Berckhout (1643–1713). The young heir of a family of gentry, Van Berckhout visited Vermeer in May 1669. He must have been deeply impressed by the work he saw on this first visit, as he returned for a second visit less than a month later, and on 21 June he noted: 'Ie sortis ensuite et fus voijr un celebre peijntre nommé Vermer, qui me monstra quelques eschantillons de son art dont la partie la plus extraordinaijre et la plus curieuse consiste dans la perspective' (I then went out and visited a famous painter named Verme[e]r, who showed me some examples of his art, the most extraordinary and most curious of which consist in perspective).[29]

26 Kitchin, 'Cognitive Maps'.
27 Vredeman de Vries, *Perspective*; Wadum, 'Vermeer and the Spatial Illusion'.
28 De Monconys, *Journal des voyages*, p. 149.
29 Montias, 'A Postscript on Vermeer', p. 48.

Perspectives

I have discussed Vermeer's perspectives at length elsewhere, so here I shall pick only a few examples for the purpose of my argument.[30] One of his late paintings, *Lady Writing a Letter with her Maid*, was stolen in 1986 but fortunately recovered in 1993.[31] After an examination of the painting, small indentations in the paint on the left eye of the woman writing proved not to be the result of an accident during the recent robbery (Figure 3.6); the dents had another explanation. In 1949, a similar observation was made of a small indentation on Vermeer's *Allegory of Painting* (*c.* 1666–1668); however, the observation was never further examined.[32] Since then, I have found evidence or traces of comparable indentations in another fifteen paintings by Vermeer, and I can safely conclude that the minute holes in the paint layers reveal the vanishing points in the perspectives within the paintings. Vermeer must have employed a century-old technique: inserting a pin tied with string at the vanishing point of the composition. In the case of *Lady Writing a Letter with her Maid*, the vanishing point is situated in the woman's left eye (Figure 3.7). The horizon line is thus positioned horizontally through this tiny hole in her face, and not at the viewpoint of the standing woman behind her. Does this indicate that we — as onlookers in this private room, where we are seemingly present without anyone observing us — are seated in the same way as the writing woman?

Created approximately ten years earlier, Vermeer's *Milkmaid* (*c.* 1660) also offers the spectator a view from below. By doing this, Vermeer turns an everyday domestic action — the act of pouring milk — into a majestic scene, despite the painting's limited format.[33] The vanishing point is found above the hand holding the jar, with the white stream of milk pouring downwards along a vertical line from the vanishing point. Through this pictorial decision, the woman's focused concentration is transmitted to the beholder, engaging us in the banal act of pouring milk with the same concentrated absorption as the milkmaid herself. Is Vermeer deliberately using composition and choice of perspective to draw the spectator into his scenes of everyday life in Dutch households? If so, to what extent is this a recurring method of his, influencing our sense of participation in the private acts he painted? Back in 1649, the Dutch painter Pieter Fransz de Grebber (*c.* 1600–1652/1653) — one of twelve painters to decorate De Oranjezaal (1648–1652), the private mausoleum of Amalia van Solms (1602–1675) in Palais Huis ten Bosch in

30 Wadum, 'Johannes Vermeer (1632–75)'; Wadum, 'Vermeer in Perspective'.
31 Hart, *The Irish Game*.
32 Hultén, 'Zu Vermeer Atelierbild'.
33 Seventeenth-century Dutch 'homescape' paintings feature in the historiography of the modern home as evidence that the century was the cradle of female domesticity. However, letters sent home by seamen in the large Dutch mercantile fleet, as well as women's letters to their seafaring husbands, tell a different story of hardship. Cieraad explains how the myth of Holland as the cradle of female domesticity came about: Cieraad, 'Rocking the Cradle'.

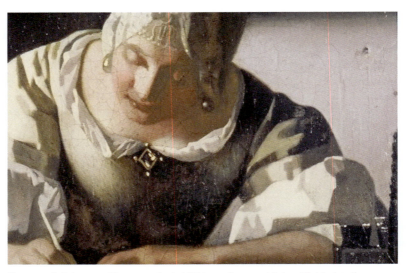

Figure 3.6. Johannes Vermeer, *Lady Writing a Letter with her Maid*, detail, Dublin, National Gallery of Ireland. Around 1670–1671.

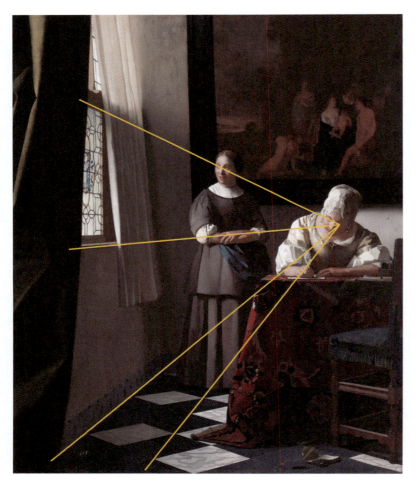

Figure 3.7. Johannes Vermeer, *Lady Writing a Letter with her Maid*, oil on canvas, 72.2 × 59.7 cm (with perspective drawing superimposed), Dublin, National Gallery of Ireland. Around 1670–1671.

The Hague — had published his treatise *Regulen welcke by een goet Schilder en Teyckenaar geobserveert en achtervolght moeten warden; te samen ghestelt tot lust van de leergierighe discipelen* (rules to be observed and followed by a good painter and draughtsman; compiled for the interest of studious apprentices), in which he emphasized not only the importance of the viewing position for a painting, but also that the painter should consider distance, perspective, and the fall of light within the painting in order not only to enhance readability but also to evoke a convincing experience.[34] To what extent did Vermeer, in nearby Delft, share these observations on the optimal viewing position to stimulate the beholder's inner experience of a good painting?

Guide to Viewing

Certainly, perspective and the notion of vision continued to enchant art theorists and painters. This was recognized by Gérard de Lairesse (1641–1711), whose very influential *Het groot schilderboek* (1707) argued that the desired visual effect could only be obtained if a painting was hung so that the horizon matched the height of the beholder's viewpoint.[35] Therefore, for the sake of demonstration, I shall place four of Vermeer's paintings, spanning his entire oeuvre, on the common horizon line depicted by the artist in the interiors. This line would be the ideal eye level of the beholder as defined by seventeenth-century perspective manuals, from Vredeman de Vries's 1604 publication to the 1628 manual by the mathematician and military engineer Samuel Marolois (1572–1627) and the French mathematician and engineer Gerard Desargues's 1664 book on perspective, published by his compatriot, the engraver Abraham Bosse.[36] What becomes apparent is the rather consistent positioning of the vanishing point on a horizon line that lies below the heads of the persons in the paintings (Figure 3.8). Each of the painted individuals therefore always towers above the beholder's viewpoint. This pictorial technique may spark two different yet related impacts on the spectator. First, all the activities, mundane though they may be — whether pouring milk into a jar, playing music, or hesitantly pondering a mapping problem — are elevated into significant, almost valiant activities. Second, the beholder, who is positioned at a lower viewpoint than the painted figures, almost becomes an intruder or voyeur, peeping at the private actions in the scenes.

In the catalogue for the exhibition *The Public and the Private in the Age of Vermeer*, the authors describe the above-mentioned and comparable scenes as views that would have been easily recognizable, representing experiences

34 Van Eikema Hommes, 'Pieter de Grebber'.
35 De Lairesse, *Het groot schilderboek*, p. 346.
36 Marolois, *Perspective contenant la théorie*; Desargues, *Algemene manier*; Wadum, 'Vermeer and the Spatial Illusion'.

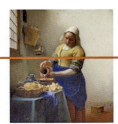
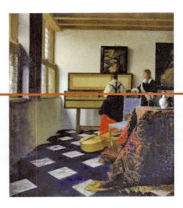
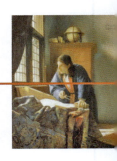

Horizon line

shared by every citizen of Delft at the time.³⁷ A more nuanced view of this claim is warranted, as there was a strict class division between the well-to-do and the many families whose income depended on a man's position as one among thousands of seafarers.³⁸ Even though the individual activities and values represented in the paintings provided the artist with a focus, it is underscored that these images were private.

Mise en scène

The world that seventeenth-century Dutch artists portrayed seems real and immediate. One can almost imagine wandering within their flat landscapes with towns and church towers silhouetted against the Dutch sky, as Alpers writes, or participating in the tender human encounters these artists so movingly captured in their renderings of daily life.³⁹ Alpers describes Dutch artists as having a 'mapping instinct', referring to their truthful way of depicting surrounding landscapes as well as elaborate marble-floored interiors.⁴⁰ However, most Dutch paintings, while seemingly true to life, were after all the creations of artists, with licence to deploy reality to fit their compositional — and financial — needs. Nonetheless, wealthy buyers would read and understand the resulting images as true (if highly idealized) records of life, despite such artistic manipulations.⁴¹ Some of these images simultaneously contain ideas and beliefs that may remain elusive for a twenty-first century viewer.

Vermeer's *Girl with a Red Hat* (c. 1665), which is not even as large as a sheet of writing paper, is believed to have been rendered through the lens of an early camera obscura (Figure 3.9).⁴² In particular, the apparently out-of-focus

37 Wheelock and others, *The Public and the Private*.
38 Cieraad, 'Rocking the Cradle'.
39 Alpers, *The Art of Describing*.
40 Fock, 'Semblance or Reality?'.
41 Cieraad, 'Rocking the Cradle', pp. 81–84.
42 Wheelock, 'Vermeer of Delft'.

PRIVACY IN SEVENTEENTH-CENTURY DUTCH CABINET PAINTING 115

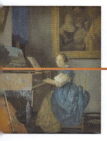

Figure 3.8. Johannes Vermeer, four paintings spanning early to late works, placed in relative size on a horizon line. Left to right: *Milkmaid*, oil on canvas, 45.5 × 41 cm. Rijksmuseum Amsterdam (*c.* 1657–1661). *The Music Lesson* (*c.* 1662–1665). *The Geographer*, oil on canvas, 53 × 46.6 cm, Frankfurt am Main, Städelsches Kunstinstitut (*c.* 1668–1669). *A Lady Seated at a Virginal* (*c.* 1670–1675).

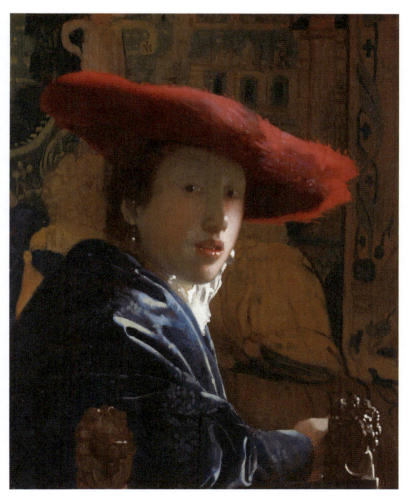

Figure 3.9. Johannes Vermeer, *Girl with a Red Hat*, oil on panel, 23.2 × 18.1 cm, Washington, DC, National Gallery of Art. Around 1665.

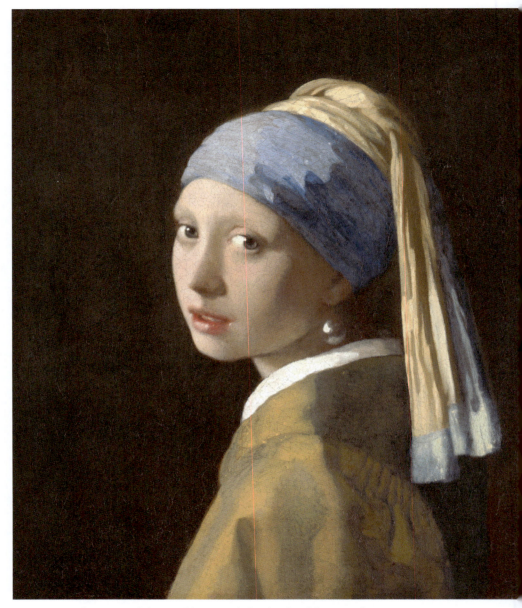

Figure 3.10. Johannes Vermeer, *Girl with a Pearl Earring*, oil on canvas, 46.5 × 40 cm. The Hague, Mauritshuis. Around 1665.

depiction of the lion finials on the chair in the foreground has been interpreted as demonstrating that Vermeer painted these to mimic the image as seen through an early camera obscura that was difficult to set in focus. However, would Vermeer have carefully mapped an image produced by a camera obscura, or would his painterly licence rather allow him to manipulate us, the spectators? For various reasons, I question the suggestion that Vermeer used the camera obscura in his painting process, a topic that has triggered much debate.[43] Without embarking on an argument about this, I invite you to view the following exquisite painting with me: Vermeer's *Girl with a Pearl Earring* (*c.* 1665) (Figure 3.10).

As with the previous *tronie*, here the woman's eyes, nose, and lips are clearly rendered in focus for our gaze — as is the elegantly painted pearl. In contrast, her headgear, the scarf hanging down her back, and her shoulder are all slightly out of focus. Today, the background appears uniformly dark and without nuance, but it once showed the soft folds of a heavy green curtain.[44] Is this, as with the *Girl with the Red Hat*, because Vermeer intended to mimic a camera lens that was unable to focus on more than a narrow plane of observation? It is my belief and interpretation that Vermeer's intention was to create a mesmerizing depiction of something that triggered a sense of privacy. By painting less important elements (such as the background curtain, the headgear, and the protruding shoulder clad in some undefined textile) as slightly blurred, he forces the viewer's eyes to unconsciously search for something in focus, a well-defined line or form with a clear pictorial and identifiable message for our cognitive mapping capacities. In doing so, Vermeer guides us — almost obliges us — to engage with the woman and her gaze towards us. We each establish our own private relationship with the woman, whose emotions lie hidden behind her slightly parted lips and questioning gaze. She is not looking at the person beside you, behind you, or in front of you: she is looking directly and exclusively at you. Vermeer thus creates a sense of intimacy, a feeling that we are having a private experience with the woman that can be deciphered independently of time, independently of any knowledge about seventeenth-century habits, norms, or limitations of interpretation. I call this an exceptional experience of interlocked privacy between the depicted woman and us.

43 Schwartz, 'Vermeer and the Camera Obscura'; Wheelock, *Perspective, Optics, and Delft Artists*; Steadman, *Vermeer's Camera*. See also Delsaute's frequently overlooked work 'Camera Obscura'.

44 Vandivere, Wadum, and Leonhardt, 'The Girl in the Spotlight'.

Conclusion

A work of art may initially appear to have several layers of embedded significance, enjoyment, beauty, and pleasure, and to make references to mythological stories involving stimuli for shared or private thoughts and sensations. The question remains regarding the degree to which seventeenth-century images, and our interpretation of the private in mythological images of the nude and in genre painting, are synchronized with current cognitive maps. Today, we define cognitive maps as internal representations of our physical-cultural-social environment, particularly those associated with spatial or metaphorical relationships. We assert that our memory uses these internal representations of our environment as a guide to explain that environment. In this context, we should recall that the seventeenth-century emblematic way of thinking furthered a keenness of observation that sought to unveil all the meanings of a painted image. It therefore becomes necessary to ask whether our twenty-first-century cognitive maps are adequate to equip the individual museum visitor or art book reader to conduct the necessary decoding. Do we satisfactorily store, recall, and decode information about the relative locations and attributes of phenomena such as privacy in the metaphorical and spatial environments created by seventeenth-century artists? It is my hope that these questions and observations will encourage reflections and foster further research into elements of privacy as they pertain to a twenty-first-century spectator who can look at the vast abundance of past images, which are now accessible to so many, but which were originally painted for and viewed by only the few.

Works Cited

Primary Sources

Desargues, Gerard, *Algemene manier van de H'. Desargues, Tot de praktijk der Perspectiven, gelyck tot die Meet-Kunde, met de kleyne Voet-maat, Mitsgaders Der plaatsen, en proportien van de sterke en flaauwe Rakingen, of Kleuren* (Amsterdam: Abraham Bosse, 1664)

Grebber, Pieter Fransz de, *Welcke by een goet Schilder en Teyckenaer geobserveert en achtervolght moeten werden; Tesamen ghestelt tot lust van de leergierighe Discipelen* (Haarlem: Pieter Casteleyn, 1649)

Lairesse, Gérard de, *Het groot schilderboek* (Amsterdam: Willem de Coup, 1707)

Marolois, Samuel, *Perspective contenant la théorie, pratique et instruction fondamentale d'icelle* (Amsterdam: Jansson Caesius, 1628)

Monconys, Balthasar de, *Journal des voyages de Monsieur de Monconys, Conseiller du Roy en ses Conseils d'Estat & Privé, & Lieutenant Criminel au Siège Presidial de Lyon*, II (Lyon: Liergues son fils, 1666) <http://gutenberg.beic.it/webclient/DeliveryManager?pid=856326> [accessed 4 January 2021]

Pels, Andries, *Gebruik én misbruik des tooneels* (Amsterdam, 1681)

Von Uffenbach, Zacharias Conrad, *Merkwürdige Reisen durch Niedersachsen, Holland und Engelland* (Frankfurt and Leipzig: Christian Ulrich Wagner, 1753) <https://onb.digital/result/10329B2B> [accessed 4 January 2021]

Vredeman de Vries, Hans, *Perspective, Dat is, de hooch-gheroemde conste eens schijnende in oft door-siende ooghen-ghesichtespunt … (&c.)* (The Hague: Hondius, 1604)

Secondary Works

Alpers, Svetlana L., *The Art of Describing: Dutch Art in the Seventeenth Century* (Chicago: University of Chicago Press, 1983)

Bomford, David, 'Perspective, Anamorphosis, and Illusion: Seventeenth-Century Dutch Peep Shows', *Vermeer Studies: Studies in the History of Art*, 33.55 (1998), 124–35

Brown, Christopher, David Bomford, Joyce Plesters, and John Mills, 'Samuel van Hoogstraten: Perspective and Painting', *National Gallery Technical Bulletin*, 11 (1987), 60–85 <https://www.nationalgallery.org.uk/technical-bulletin/brown_bomford_plesters_mills1987> [accessed 4 January 2021]

Cieraad, Irene, 'Rocking the Cradle of Dutch Domesticity: A Radical Reinterpretation of Seventeenth-Century "Homescapes"', *Home Cultures: The Journal of Architecture, Design and Domestic Space*, 15.1 (2018), 73–102

Delsaute, Jean-Luc, 'The Camera Obscura and the Painting in the Sixteenth and Seventeenth Centuries', *Vermeer Studies: Studies in the History of Art*, 33.55 (1998), 111–23

Downing, Francis, 'Image Banks: Dialogues between the Past and the Future', *Environment and Behaviour*, 24.4 (1992), 441–70

Eikema Hommes, Margriet van, 'Pieter de Grebber and the Oranjezaal in Huis ten Bosch, Part I: The Regulen (1649)', *ArtMatters: Netherlands Technical Studies in Art*, 3 (2005), 20–36

Fock, C. Willemijn, 'Semblance or Reality? The Domestic Interior in Seventeenth-Century Dutch Genre Painting', in *Art & Home: Dutch Interiors in the Age of Rembrandt*, ed. by Marlene Chambers and Mariët Westermann (Zwolle: Waanders, 2001), pp. 83–101

Hart, Matthew, *The Irish Game: A True Story of Crime and Art* (New York: Walker & Co., 2004)

Hultén, Karl G., 'Zu Vermeer Atelierbild', *Konsthistorisk Tidskrift*, 18 (1949), 90–98

Jager, Angela, *The Mass Market for History Paintings in Seventeenth-Century Amsterdam: Production, Distribution, and Consumption* (Amsterdam: Amsterdam University Press, 2020)

Jongh, Eddy de, *Zinne- en minnebeelden in de schilderkunst van de zeventiende eeuw.* (Amsterdam: Nederlandse Stichting Openbaar Kunstbezit/Openbaar Kunstbezit in Vlaanderen, 1967)

Kitchin, Robert M., 'Cognitive Maps: What Are They and Why Study Them?', *Journal of Environmental Psychology*, 14.1 (1994), 1–19

Longfellow, Erica, 'Public, Private, and the Household in Early Seventeenth-Century England', *Journal of British Studies*, 45.2 (2006), 313–34

Loughman, John, and John Michael Montias, *Public and Private Spaces: Works of Art in Seventeenth-Century Dutch Houses* (Zwolle: Waanders, 2000)

Miles, Margaret R., *A Complex Delight: The Secularisation of the Breast 1350–1750* (Berkeley: University of California Press, 2008)

Montias, John Michael, 'A Postscript on Vermeer and his Milieu', *Hoogsteder Mercury*, 12 (1991), 42–52

Schama, Simon, 'Rembrandt and Women', *Bulletin of the American Academy of Arts and Sciences*, 38.7 (April 1985), 21–47

Schwartz, Heinrich, 'Vermeer and the Camera Obscura', *Pantheon*, 24 (May–June 1966), 170–80

Sluijter, Eric Jan, *Seductress of Sight: Studies in Dutch Art of the Golden Age* (Zwolle: Waanders, 2000)

——, *Rembrandt and the Female Nude* (Amsterdam: Amsterdam University Press, 2006)

Steadman, Philip, *Vermeer's Camera: Uncovering the Truth behind the Masterpieces* (Oxford: Oxford University Press, 2001)

Van Ginhoven, Sandra, *Connecting Art Markets: Guilliam Forchondt's Dealership in Antwerp (c. 1632–78) and the Overseas Paintings Trade* (Leiden: Brill, 2017)

Vandivere, Abbie, Jørgen Wadum, and Emilien Leonhardt, 'The Girl in the Spotlight: Vermeer at Work, his Materials and Techniques in Girl with a Pearl Earring', *Heritage Science*, 8 (2020), 20

Wadum, Jørgen, 'Johannes Vermeer (1632–1675) and his Use of Perspective', in *Historical Painting Techniques, Materials, and Studio Practice*, ed. by Arie Wallert, Erma Hermens, and Marje Peek (Los Angeles: Getty Publications, 1995), pp. 148–54

——, 'Vermeer in Perspective', in *Johannes Vermeer*, ed. by Frances P. Smyth (Zwolle: Waanders, 1995), pp. 67–79

——, 'Vermeer and the Spatial Illusion', in *The World of Learning in the Time of Vermeer*, ed. by Ton Brandenbarg and Rudi Ekkart (Zwolle: Waanders, 1996), pp. 31–49

Wetering, Ernst van de, *Rembrandt: Zoektocht van een genie* (Zwolle: Waanders, 2006)

Wheelock, Arthur K., Jnr, *Perspective, Optics, and Delft Artists around 1650* (New York: Garland, 1977)

——, 'Vermeer of Delft: His Life and his Artistry', in *Johannes Vermeer*, ed. by Frances P. Smyth (Zwolle: Waanders, 1995), pp. 15–29

Wheelock, Arthur K., Jnr, and others, *The Public and the Private in the Age of Vermeer* (Tokyo: Philip Wilson, 2000)

SANNE MAEKELBERG

'Au couvert, sans estre vues'

*Aspects of Privacy in the Residences
of Charles de Croÿ (1560–1612)*

Introduction

By the end of the sixteenth century, the northern Low Countries had virtually split off from the Spanish southern Low Countries, although it would not become an independent Dutch Republic until the peace of Westphalia.[1] In 1598, the sovereign governors of the southern Low Countries, Archduke Albert of Austria (1559–1621) and the Infanta Isabella (1566–1633), permanently settled in the territory, installing their court at the Coudenberg palace in Brussels. They brought with them Spanish rituals, which they merged with the customs of the Low Countries, resulting in a politics of access, where access to the ruler was directly related to political influence.[2] Life at a sixteenth-century court was dominated by ceremonies and expressions of power, and the architecture can often be seen as a measure of how ceremonies, rooms, and sequences changed and adapted — as far as this was possible — to new customs upon the arrival of different regents.[3] The princely court served not only as the prince's household, but also as a government body, a point of contact between the lord and his subjects, and a tool of representation, a manifestation of the monarch's patronage and architectural pageantry.[4]

1 This research article has been developed within the framework of the Danish National Research Foundation Centre for Privacy Studies (DNRF 138), based at the University of Copenhagen and directed by Mette Birkedal Bruun, and the research project 'Strategies of Self-Representation: Noble Residences in the Low Countries during the Sixteenth Century (1477–1635)', directed by Krista De Jonge and financed by Bijzonder Onderzoeksfonds KU Leuven (BOF 2015–19, C14-15-046).
2 Murphy, 'The Court on the Move'. Other princely courts across Europe and Asia also developed mechanisms of access: Raeymaekers and Derks, 'Introduction'.
3 De Jonge, 'Het paleis op Coudenberg'.
4 Olden-Jørgensen, 'State Ceremonial', p. 65.

Sanne Maekelberg is a postdoctoral researcher in architectural history at the Centre for Privacy Studies at the University of Copenhagen in association with the Royal Danish Academy.

Private Life and Privacy in the Early Modern Low Countries, ed. by Michael Green and Ineke Huysman, EER 19 (Turnhout: Brepols, 2023), pp. 121–143
BREPOLS ❧ PUBLISHERS 10.1484/M.EER-EB.5.132532

In December 1595, after the death of his father Philip III de Croÿ (1526–1595), Charles de Croÿ (1560–1612) became head of the Croÿ dynasty.[5] As fourth Duke of Aarschot, Prince of the Holy Roman Empire, and Grande de España, Charles was the highest-ranking nobleman in the Low Countries after the regents.[6] His inheritance included a vast collection of residences spread over the southern Low Countries and France, ranging from leisure pavilions to fully fledged castles with substantial hunting forests and grounds. Immediately after coming into his inheritance, Charles developed an extensive renovation programme for the entirety of this built heritage, which had been constructed and expanded by his forebears over the course of two centuries. The comprehensive nature of this undertaking is remarkable and gives some insights into the residential needs of the high nobility.

Given the great diversity of residences within the network, the living conditions at Charles's itinerant court were highly contingent on location. Depending on where the court resided, there would be greater numbers of larger rooms, elaborate kitchen quarters, and even extensive gardens and hunting forests where one might seek seclusion from the busy life at court. This helps to explain why, towards the end of his life, Charles developed a clear preference for the castles at Beaumont and Heverlee, two of his largest and most centrally located residences, both with several gardens and hunting facilities.[7]

In this chapter I argue that physical privacy at the early modern noble court could be considered a privilege that was reflected in the spatial sequence and organization of courtly residences. The chapter focuses on the need to be alone, a temporary solitude that was much sought after in the sixteenth-century courtly environment.[8] The combination of private functions — the noble residence as a home for the family — and public purposes — as a place of power — led to a tension between these two realms. On the one hand, openness, which often translated into hospitality to guests, visitors, and strangers, was used as a matter of self-representation, demonstrating magnificence and opulence.[9] It could also be seen as part of the Christian beneficence known as charity, whereby one should offer help to all those less favoured.[10] Given that in the sixteenth century the high nobility also relied on a very extensive staff for their

5 For general references on the Croÿ dynasty, see Born, *Les Croÿ*; De Jonge and Maekelberg, *Noble Living*; Duvosquel and others, *Een stad*; Soen, 'La causa Croÿ'; Soen and Junot, *Noblesses transrégionales*. On Charles de Croÿ specifically, see De Villermont, *Le Duc Charles de Croy*; Duvosquel, 'Charles III de Croy'; Maekelberg, 'Residential System'; Maekelberg and De Jonge, 'Castles and Gardens'; Maekelberg, 'Mapping through Space'; Maekelberg, 'The Materialisation of Power'; De Reiffenberg, *Une existence*.

6 Grandeza de España was the highest rank at the Spanish court, and Charles de Croÿ was the only person to be granted the title outside the Iberian Peninsula at this time. Esteban Estringana, 'El collar del Toison'.

7 Maekelberg, 'Mapping through Space'.

8 Göttler, '"Sacred Woods"', p. 170.

9 Heal, *Hospitality*, p. 24.

10 Fuller, *The Holy State*, p. 153.

most mundane personal needs, the noble residence was filled with servants, staff, visitors, and guests.[11] How could privacy be conceived in such a busy environment? According to Altman's article on privacy regulation, selective control of access to the self was essential to the notion of privacy. In order to achieve this control, several mechanisms could be used, depending on cultural, social, and environmental conditions.[12] In this chapter I examine whether the physical environment could be used to regulate access, or rather, whether architecture could be considered one of the mechanisms to ensure privacy in the sixteenth-century noble residence. Where in this public sphere of the court was there a place to be alone? Which rooms allowed one to be left to oneself, without the interference of staff, guests, or wandering visitors? How did the architecture of the early modern noble residence provide barriers or thresholds between what was considered public and what was considered more private? Was there flexibility in the use of rooms?

In order to examine the different notions of privacy in the spatial organization and architecture of the Croÿ residences, I will first take a look at the available sources. The textual sources do not contain any *priv** words, and they do not give explicit information about privacy.[13] However, information about the different notions of privacy can be deduced from ordinances written by Charles, and can be inferred from the spatial layout of the apartments and the awkward accessibility of some spaces. Most of the Croÿ residences did not stand the test of time.[14] I have therefore used a wide range of source material to reconstruct the spatial organization of the ducal apartments. Charles de Croÿ took it upon himself to check every document in his administration personally, leaving notes and additions in the margins. A question thus arises regarding the extent to which the source material gives insights into the real inner workings of Charles's mind, or whether they were meant as representations of his architectural patronage.

After considering the sources, I will then take a closer look at the composition of the noble household. Early modern nobles were highly dependent upon servants and staff for most of their personal needs, which meant that their residences were crowded with house personnel and secretaries.[15] Subsequent sections of this chapter will look at places where the Duke might have had the possibility to withdraw from the hustle and bustle of daily court life, which was characterized by the concept of open hospitality. The layout of the apartment, the location and use of the private oratory, the library or room for study, and the long gallery all point towards the need for seclusion, or at least the careful selection of those who could approach the fourth Duke of Aarschot.

11 Stone and Fawtier Stone, *An Open Elite?*, p. 213.
12 Altman, 'Privacy Regulation'.
13 See Bruun, 'Towards an Approach'. On terminology, see also Bruun, 'Privacy', pp. 33–54.
14 A notable exception is the castle at Heverlee, which survives to this day.
15 Stone and Fawtier Stone, *An Open Elite?*, p. 213.

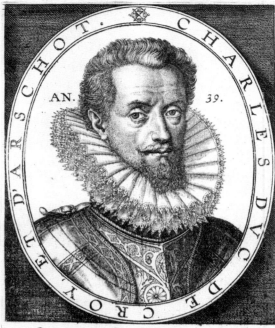

Figure 4.1. Portrait of Charles de Croÿ by Antonius Wierix, in: Jean Bosquet, Reduction de la ville de bone, Antwerp: Martinus Nutius, 1599. Private collection.

The Sources

In 1845, the Belgian historian Baron Frédéric Auguste Ferdinand Thomas de Reiffenberg (1795–1850) published Charles de Croÿ's *mémoires autographes*, a brief description of Charles's life in relation to the troublesome history of the Low Countries at the end of the sixteenth century (Figure 4.1).[16] The published manuscript includes other documents transcribed by Baron de Reiffenberg and his staff, including a will dated 1610, and instructions for the staff and *chambre des comptes*. The whereabouts of the original manuscript, supposedly written in 1606, are unknown, but according to Reiffenberg it was probably written out by Alexandre d'Arenberg (1590–1629), Charles's nephew, as the Duke's hands were so affected by gout that in 1612 he could barely write his own signature.[17] A statement at the end of the volume declares that Duke Charles de Croÿ himself signed the manuscript to testify to his approval of the text. Rather than a diary, the memoirs are a:

16 De Reiffenberg, *Une existence*.
17 De Reiffenberg, *Une existence*, p. xxxv.

brief extraict, succinte et véritable narration de tout ce qui s'est passé touschant la personne de messire Charles, sire et premier ducq de Croy et quatriesme d'Arschot, depuis le [...] jour de sa nativité, jusques au premier jour de mois de Janvier de l'année mille six cent six ensuivant. Ensemble aussy un brief recueil de tout ce qui s'est passé de mémorable au Païs-Bas durant ce temps, le tout descript par iceluy.

> (Brief extract and true narration of everything that happened concerning the person of Charles de Croÿ from the [...] day he was born up until 1 January 1606, including a brief collection of everything memorable that happened in the Low Countries during his lifetime, all described by Charles himself.)[18]

While the memoirs are a valuable source of knowledge about Charles's life, especially his military endeavours and political responsibilities, they reveal little about his private thoughts. Moreover, the document probably served as propaganda, justifying his behaviour as a young man when he moved to Antwerp to join the Calvinist cause together with his wife Marie de Brimeu (*c.* 1550–1605).[19] According to the Duke's own writings, he was highly influenced by his wife, an heiress ten years his senior, whom he had been forced to marry by his father (and who would in fact remain a loyal Calvinist, living separately from Charles for most of her life). The lengthy passage covering their journey and stay in Antwerp is an almost exact copy of a 'true history' that appeared in 1588, explaining Charles's governance of the city of Bruges, which he led back to Alexander Farnese and the Catholic king.[20] What might be considered the most likely source for research into the Duke's private thoughts thus turns out to be primarily a plea *pro domo*.

The Duke's last will, also included in Reiffenberg's publication, is more useful here, giving us information about Charles's desires and plans for the future.[21] Among other things, he left very clear instructions for his second wife, Dorothée de Croÿ (1575–1662), to continue his building projects, testifying to the value he attached to these undertakings. Moreover, Charles devoted a great deal of time to monitoring and revising the administration of his domains, including the renovation of many of his residences. This new administration produced a systematic collection of documents, a large part of which is still available to us today and consists of architectural plans and writings concerning his residences (inventories and descriptions). As part of the revision process, the Duke left his distinctive signature 'V[er]a R[e]p[lic] a Faict et Painct à Huylle Sur Toille' (true replication made and painted in

18 De Reiffenberg, *Une existence*, pp. 1–108.
19 Dekker, *Egodocuments and History*.
20 Duke, *Dissident Identities*, p. 259; *Histoire veritable*, pp. 7–27. In response to this portrayal of Charles de Croÿ as a faithful servant to the Spanish Crown, the rebels of the Reformed faith published *Ampliation du discours*, in which they labelled him a traitor.
21 De Reiffenberg, *Une existence*, pp. 229–94.

oil on canvas) on most of the documents.[22] While it seems unlikely that the vast number of documents bearing this phrase were all executed as painted canvases, it does point towards the more public character of the drawings. Rather than being part of the Duke's personal administration, they may have been part of a more public display of his territories. Some of these documents do find their counterparts in the famous *Albums de Croÿ*, a collection of over 2500 views of the Low Countries commissioned by Charles.[23] These views, executed by Adrien de Montigny (*c.* 1570–1615) and his workshop, were painted in watercolour on parchment, however, not oil on canvas.[24] The goal of this obsessive recording was rather public: it aimed to capture the scale and splendour of Charles's inheritance for posterity, as per his instructions for the composition of the written documents.[25] Most often the drawings included in the albums record the actual state of the buildings, villages, and surrounding landscape. In some exceptional cases — for example, the castle of Heverlee — an idealized version of the residence is included, reflecting the Duke's wishes and ambitions. These views give an insight into his private aspirations for his domains and help us to reconstruct lost or never-executed building phases.

Life at the Sixteenth-Century Noble Court of Charles de Croÿ

According to the instructions Charles de Croÿ left for his successors, a modest household was something to strive for. The size and especially the expense of the domestic staff was to be restricted, since noblemen with large numbers of staff could ruin the most prominent noble dynasties. Obsessed with his posterity, Charles wanted to avoid this at all costs. Nevertheless, his downgraded list of essential staff included five high officials with eight assistants for his personal council and main chamber of accounts, sixty-six domestic servants, and fifty-four horses.[26] The accounts of payments to the members of his council and *chambre de comptes* feature the same recurring names for long periods of time, some of them combining multiple high offices at the Duke's court. To judge from their names, Charles relied on a limited number of confidants, often from the Hainaut region.[27] Depending on the residence, some of the highest officials — such as the general treasurer and Charles's personal physician — had their own rooms, as was the case in the castles at Sint-Joost-ten-Node, Beaumont, and Comines. The vast majority of the staff,

22 Maekelberg, 'The Residential System', p. 80.
23 Duvosquel, *Les Albums de Croÿ*, i–xxvi.
24 Machelart, 'Adrien de Montigny'.
25 Maekelberg, 'Building Practice'.
26 De Reiffenberg, *Une existence*, pp. 109–15.
27 Maekelberg, 'Building Practice'.

however, slept on folding beds, blankets, and cushions in the halls and rooms that were available. In the case of Heverlee, which was a construction site for most of Charles's reign, the staff shifted around, depending on where the building works were taking place.[28] Thus the sources, especially the descriptions of the castle, are only snapshots of living conditions at certain moments in time. Furthermore, living conditions at court could change completely on the occasion of visits or festivities. The noble court thus remained a flexible environment, subject to change according to the needs of its users and their guests. To this end, for example, the Croÿ residence in Beaumont had a *salle de roi*, added in the middle of the fifteenth century.[29] If the Duke of Burgundy were to grace them with a visit, a suitable apartment would always be ready. This indeed proved convenient when Charles V (1500–1558) and his son Philip II of Spain (1527–1598) visited the residence during their tour of the Low Countries in 1549.[30] In addition to the day-to-day staff, the head of the Croÿ dynasty could also choose to house, nourish, and entertain other noblemen or their sons, a long-standing tradition in the Croÿ household, since Guillaume de Croÿ (1458–1521) — Charles's great uncle — had been a tutor to Charles V.[31]

Life at the noble court was highly regulated, as illustrated by the directives to staff and the various instructions left by Charles himself. The Duke's rising ritual required the presence of the *maître d'hotel*, the *gentilhommes*, his *secretaires*, his valets, and his personal physician. Every morning at four o'clock (or seven o'clock in the winter), the porter came to the Duke's room to collect the keys from the *maître d'hotel*, who slept in the Duke's room and was responsible for the keys of the castle. Breakfast was served at half past eight, lunch at half past eleven in the morning, and dinner at half past six in the evening. All members of staff were assigned a fixed place at the table, according to a hierarchy. Mass was held in the residence's chapel before every meal: at seven in the morning, eleven in the morning, and six in the evening. Charles was accompanied all day long by *gentilhommes* and visiting young noblemen, for whom he served as an exemplar, displaying the virtues of noble life. He never failed to mention these virtues in the various genealogies he commissioned.[32] The family trees included in these documents are bursting with well-known characters whose virtues are thus indirectly linked to the Croÿ dynasty: Attila, as well as Nimrod and other biblical figures, were meant to illustrate the Duke's fighting spirit, hunting skills, and virtue. Because he had constant companionship, without a single unescorted moment, Charles conveyed a self-conscious projection

28 Leuven, UA KUL, ADA, 432, fol. 83ᵛ.
29 Brussels, ARAB, CC, 27065: building accounts for the castle at Beaumont, 1456–63.
30 Calvete de Estrella, *Le tres-heureux voyage*, p. 79.
31 De Reiffenberg, *Une existence*, p. 110; Varillas, *La pratique*.
32 The first known genealogy commissioned by Charles dates from 1606: Dülmen, HCVD, HS 7. In 1612 a printed version was published: de Bie, *Livre contenant la genealogie*.

 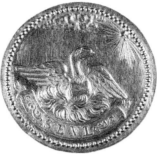

Figure 4.2. Golden portrait coin, private collection. Obverse: Charles de Croÿ. Reverse: phoenix with the motto 'SEUL'.

of the exemplar he wanted to be.[33] According to Charles himself, he was indeed 'seul ducq et premier seigneur des Pays-Bas' (the only duke and first lord of the Low Countries), and this was illustrated on the golden coin that bore his portrait and a phoenix ascending from the motto 'SEUL' (ALONE) (Figure 4.2).[34] This motto was further emphasized by the fact that for most of his life Charles lived alone, estranged from his first wife Marie de Brimeu. The Duke's entire daily life could therefore be considered a ceremonial act, orchestrated by court instructions that he drew up himself.[35] Getting up, going to sleep, eating, and praying all adhered to a strict schedule; during the time in between, he was accompanied by noble youngsters.

It was not only his body that was the interface through which he transferred his noble image, externalizing his inner qualities; so was the architecture of his residence. Indeed, the built environment of the court was oriented towards the display of power and prestige — to bring honour to the dynasty and legitimate its high position in the Low Countries — more than it was concerned with providing a private environment for its inhabitants.[36] Nevertheless, in solitude there may have been an opportunity for Charles to step away from his noble duty and exemplary role. In the next sections I explore how the architecture and spatial sequence of the noble residence facilitated this privileged privacy of solitude at court.

The Apartment

On the occasion of his wedding to Marie de Brimeu in 1580, Charles received the principality and castle of Chimay; after the death of his mother Jeanne d'Halluin in 1581, he became baron of Comines and proprietor of the castles

33 Gaylard, *Hollow Men*, pp. 3–5.
34 De Reiffenberg, *Une existence*, p. 67.
35 The social pressure to lead an exemplary life led to unprecedented self-constraint on the part of the high nobility. Duindam, *Myths of Power*, pp. 159–60.
36 Gaylard, *Hollow Men*, p. 10; De Jonge and Maekelberg, 'Matters of Representation', p. 193; Orlin, *Locating Privacy*, p. 226.

'AU COUVERT, SANS ESTRE VUES' 129

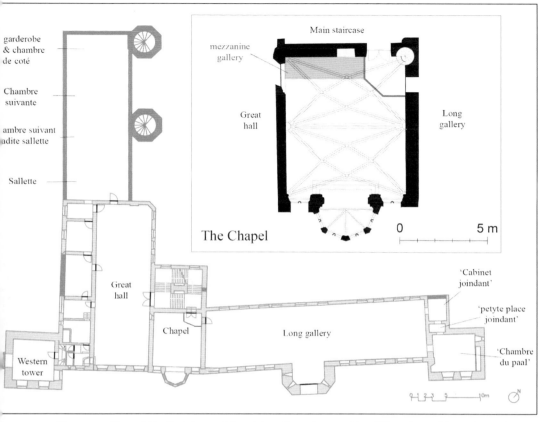

Figure 4.3. Plan of the first floor of the sixteenth-century castle of Heverlee, with a schematic indication of the rooms of the apartment, author's drawing based on reconstruction by Krista De Jonge. Reconstruction plan of the chapel, author's drawing based on ArchDOC exercise of Raymond Lemaire International Centre for Conservation, 2011.

at Comines and Halluin; in 1595, after the death of his father Philip III de Croÿ, he inherited the entire Croÿ fortune. Following the rhythm of this gradual inheritance, by the end of the sixteenth century Charles had made restoration plans for the entirety of his built inheritance. Depending on the state of the residences at the moment of their inheritance, Charles applied various strategies in this comprehensive renovation project.[37] The residences at Brussels and Aarschot, together with the tower at Rotselaar and the castle at Halluin, had been extensively damaged by the religious riots of the previous decades. The rebellion against Philip II of Spain, and the subsequent revolt against the mutinous Spanish army, had destroyed many noble residences.

37 Maekelberg, 'The Residential System', pp. 107–08.

In Brussels, the renovation was limited to refurbishment works, restoring the residence to its former glory by adding impressive marble porticos, repairing the damage, and adding pomp and decoration featuring Charles's personal coat of arms. In Rotselaar, the crumbling tower was restored and a new storey added, making it a visible presence in the rural landscape. In both Aarschot and Halluin, Charles planned almost entirely new residences; however, neither building project was completed, probably due to a lack of financial resources. The construction work on some of the other hereditary Croÿ residences focused on representational aspects. The general layout of the residence at Beaumont remained the same as it had been in the middle of the fifteenth century, when the Burgundian Duke Philip the Good (1396–1467) had commissioned the last substantial restoration works, but Charles did incorporate two more towers into the residence, each crowned with an onion-shaped spire. In Chimay and Heverlee, he planned to expand the existing two-wing residences with another two wings, creating regular square residences. Neither residence was ever finished in this way, but at Heverlee the foundations were probably in place by 1615, as they are shown in a sketchbook of Leuven and its surroundings.[38] Since Charles's building projects were more focused on representational features (towers, porticos, and decorative furnishings), the spatial layout and sequence of rooms in many of the actual apartments often remained unchanged from his predecessors.

Looking at the castle at Heverlee in closer detail, we see that there were different routes one could take to reach the Duke, depending on one's status (Figure 4.3). Everyone had to pass the first checkpoint at the residence's gate, which was closed during the night and guarded at every hour of the day.[39] Stopping strangers from entering the castle was part of the porter's job description. After passing through the gate, one entered the inner courtyard with the main entrance in the southern corner. After taking the stairs to the first floor, most visitors would continue to the great hall. The sixteenth-century ducal apartment built for Guillaume de Croÿ, Lord of Chièvres, was presumably situated in the west wing and accessible from the great hall. It consisted of three rooms — the *salette*, *chambre suivante ladite sallette* (chamber following the *sallette*), and *chambre suivante* (following chamber) — that preceded the actual room and closet of the Duke.[40] In the castle at Heverlee, there was an alternative route for visitors of high standing. After climbing the main staircase to the first floor, this route continued through the portal of the chapel rather than to the great hall. From this wooden portal the visitor would enter a thirty-five-metre gallery, at the end of which was a room referred to as the *chambre du paal* in the eastern tower.[41] Provided with a large stove and

38 Brussels, KBR, MS II 2123, fol. 103.
39 De Reiffenberg, *Une existence*, p. 131.
40 Leuven, UA KUL, ADA, 398, fols 176r–191r.
41 Leuven, UA KUL, ADA, 398, fol. 243r.

Figure 4.4. Volumetric reconstruction of the ducal apartment at the Croÿ palace in Brussels, author's drawing.

luxuriously decorated, this room was probably meant for private audiences. The servant responsible for maintaining the stove needed to take the same route, since there was no vertical communication between the rooms in the tower on this level. However, it was possible to feed the stove from behind, where a small separate room housed a supply of wood, so no servant needed to enter the *chambre du paal*.[42] In the other residences, no such private audience chamber was explicitly present; however, the Duke's apartment always had multiple chambers that served different purposes and were accessible to different members of court or visitors, depending on their rank. In the castle at Comines, for example, visitors had to enter over the wooden drawbridge, cross the inner courtyard, and take the winding staircase to the second floor.[43] Depending on the visitor's status, it was possible to proceed to an audience in the great hall on the right, or to the first of the three rooms of the Duke's apartment.

In Brussels, the Duke's apartment consisted of a vertical sequence of rooms organized around a large staircase tower (Figure 4.4).[44] On the ground floor there was a small garderobe accessible from the *sallette*. Crossing the staircase,

42 Leuven, UA KUL, ADA, 432, fol. 154r: 'Petyte place joindant entre ledit Paal et le cabinet joindant. Lad(ite) place est entierement faicte de brycques placquee et blanchie comme il convient, le plancher d'embas estant faict de planches de blancq bois, avecq() deux degrez de mesmes. Toutte lad(ite) place, où il n'y at paintures est painte de diversitez de feuillages, fleurages fruyctages et grottesques, en laquelle place y est la bouche du paal par où l'on faict du feu, avecq() la platine de fer pour le serrer'.
43 Brussels, KBR, MS 19.611, fol. 39v: floor plan of the castle of Comines *c.* 1610 by Pierre Lepoivre.
44 De Jonge, 'Vivre noblement'; Maekelberg, 'The Residential System', p. 201.

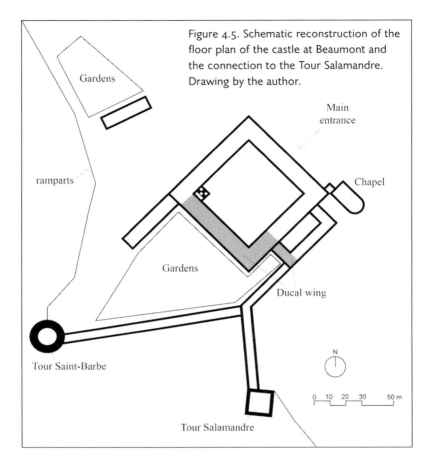

Figure 4.5. Schematic reconstruction of the floor plan of the castle at Beaumont and the connection to the Tour Salamandre. Drawing by the author.

one entered the *antechambre* or *chambre enbas* (downstairs room), a beautiful room with a chimney piece supported by pillars. The sequence continued with a *retrait* (withdrawal room) and a *secret* or lavatory. Between the *chambre enbas* and the inner courtyard was another closet facing the court, together with a small *alée* (gallery). On the first floor, adjacent to the chapel, was the *chambre où sont les chartres* (room where the charters are kept), which also gave access to the Duke's private oratory. Leaving the staircase from the other side, one was led to the *chambre devant la chambre de son ex[cellen]ce* (room in front of the Duke's room), a splendid room with white walls, a wood-beamed ceiling, and a large fireplace, and illuminated by stained glass windows featuring beautiful stories and heroic devices. The *chambre de son excellence* (room of the Duke) itself was adjacent to the lavatory. These rooms were also accessible from the vaulted gallery surrounding the inner courtyard. A beautiful door, flanked by two wooden pillars supporting decorative mouldings, painted and gilded with the Duke's arms, gave entrance to this first room. Following the staircase to the second floor, one came to a cabinet above the charter room, specified as

a library. This staircase tower continued with a small spiral staircase hidden behind a door, which led to two superimposed vaulted cabinets at the top of the tower, one specified as a *chambre des joyaux* (jewellery room) and the other offering views over the city of Brussels on four sides.[45] The rooms that housed the most precious items and the library were thus situated at the top of the staircase. In order to get there, one had to pass the Duke's apartment and cross the route towards the private oratory, indicating the exclusive character of these rooms.

Similarly, the library in the residence at Beaumont was located somewhat remotely in the Tour Salamandre, which was part of the old ramparts of the city. The sources do not enable a complete reconstruction of the ducal apartment located in the south-west wing of this residence, but the inventory of the Tour Salamandre indicates that it contained the Duke's library, which housed his most precious manuscripts and the *Albums de Croÿ*.[46] These manuscripts were not meant for an audience, but rather for the Duke's own pleasure, since they were placed in a room that was only accessible through galleries connected to the most private rooms in the ducal apartment (Figure 4.5). After his death, however, the library — considered to be one of the richest and most extensive in the Low Countries at the time — was moved to Brussels and publicly auctioned.[47] This was the end of the elevated status these objects had enjoyed during Charles de Croÿ's lifetime, and the public auction started the dispersal of this immense collection.

The location of these rooms for study and collections shows that during the Duke's lifetime, access not only to his person but also to some of his most prized personal possessions was restricted. In particular, his building projects and architectural plans were maintained with the highest care, and accessible to few people. The Duke's garderobe in the leisure pavilion at Sint-Joost-ten-Node, one of the most private rooms of this apartment, featured a large table surrounded by six shelves for his papers, jewellery, and other things he might need. In two small square boxes, one black and the other red, both covered with leather and gilded with his coat of arms, he kept several accounts and writings related to his building and renovation projects.[48] The Duke considered his building projects and designs to be of the utmost personal importance, which might explain why they were not only enclosed within the relative privacy of his apartment but also kept in separate closed boxes. The execution of these projects was entrusted to a select group of confidants who oversaw the works *in situ*, reporting to the Duke on a regular basis.[49]

45 Enghien, Arenberg Archives, box 60/12, no number.
46 Bernier, *Histoire de la ville*, pp. 239–40.
47 In 1614, an inventory was drawn up of the collection to be sold. A printed version is preserved in the Arenberg Archive in Enghien, and published in Delsaerdt, *Lectures princières*.
48 Enghien, Arenberg Archives, box 60/12, no number.
49 Maekelberg, 'Building Practice'.

Devotional Privacy

In the residence at Brussels, the library was almost adjacent to the Duke's private oratory, from which it was separated only by a flight of stairs. This proximity allowed the Duke to move between his study and his private oratory without observation by other members of court. Indeed, to enable him to escape the eyes of his staff and visitors, his residences' spatial organization provided hidden connections or rooms that were not easily accessible. In the residence at Sint-Joost-ten-Node, Charles had a secret passage that led from his apartment to the oratory overlooking the chapel. The description of the castle mentions that this was made in order to go from the apartment to the oratory 'au couvert, sans estre vues' (under cover, without being seen).[50] The oratory in Sint-Joost-ten-Node offered a view of the chapel, which was decorated with murals of Saint Francis, Saint Antony, Saint Mary Magdalene, and Saint Claire. It was oriented towards the altar underneath a canopy. It must indeed have been a luxury to escape the scrutiny of the *gentilhommes*, noble guests, and staff. These hidden passages allowed Charles to make exceptional disappearances from the public and ceremonial life dictated by the court schedule and instructions. In the castle at Heverlee, the chapel was the pivotal link between the two wings of the castle, with visual connections to the great hall, the long gallery, and even the adjacent staircase.[51] A winding staircase, starting in the chapel's entrance portal and hidden in the thickness of the wall, led to a mezzanine gallery, where the highest members of court could follow Mass.[52] This small wooden construction was positioned so that nobody could see the Duke in his oratory, despite the various viewing slits that allowed the ducal household to follow Mass from the great hall or even the staircase. Similarly, the urban palace in Brussels had a (probably wooden) oratory that looked out over the chapel and was accessible from the Duke's apartment.[53]

The presence of these hidden passageways seems to have been part of the Duke's Burgundian inheritance, as the castle in Sint-Joost-ten-Node was a former Burgundian residence, and had often been used by Philip the Good to dine, bathe, and entertain guests.[54] In the prince's court at Bruges, which had been thoroughly renovated by Philip the Good and his third wife, Isabella of Portugal (1397–1471), the Duke and Duchess each had their own oratory. The Duchess's apartment, located above the great hall, had a small winding

50 Enghien, Arenberg Archives, box 60/12, no number.
51 De Jonge, 'Schloss Heverlee bei Löwen', pp. 69–80.
52 Leuven, UA KUL, ADA, 398, fol. 226ʳ.
53 Brussels, CAB, AH, Liasse 885, 17 (1600): 'Estimations des ouvraiges de sa maison de Croÿ en Bruxelles […] meubles de la chapelle (1515), painctures estans à la chapelle (1438), la vasselle de la chappelle (1233), ouvrages de la chapelle (1760), libvres estans dans l'oratoire (120 s.7), ouvrages de l'oratoire (137), meubles estans aud(it) oratoire (17 s.10)'.
54 De Jonge, 'Images inédites'.

staircase that came down to the hall's entrance portal, from where a closed gallery led to her oratory, which overlooked the large and small chapels. The Duke, on the other hand, had to cross some of his apartment's more public rooms, including the *grant chambre*, to reach the small staircase that served as a pivotal link between his oratory, the *salette*, the private gallery overlooking the garden, and the *grant chambre*.[55] In the Palais Rihour at Lille, one of the rare newly built Burgundian residences, the connection between the Duke's apartment and his private oratory was established by wooden galleries attached to the façade of the Duke's residential wing.[56] The Duchess's apartment was located in a separate wing joined to the Duke's residential quarters. In Bruges, the Duke and Duchess each had their own apartment, this time beneath the pointed roofs of two separate but parallel buildings. A perpendicular gallery housing some of the most valuable possessions, including the Duke's world maps and clocks, ensured the connection between the two lodgings.

Retiring from Court

Given the busy court life, solitude and confidential conversations were often sought outdoors, as walls had ears in the crowded interior spaces of the court residence.[57] Conveniently enough, Charles's residences were mostly surrounded by vast domains consisting of gardens, parks, and forests that were exclusively accessible to the Duke. He invested considerable time and effort in the construction of these gardens; in some cases, this was the only part of the major restoration plans that was actually executed.[58] The gardens were furnished with pavilions, small wooden constructions providing shelter. In Heverlee, in addition to a very extensive hunting forest, the Duke had a large garden and park at his disposal. He even went so far as to construct a private road connecting his suburban castle to the city of Leuven.[59] Closed off by gates on both sides, the new road was for the Duke's exclusive use, thus privatizing parts of the public domain. A similar strategy was followed in Beaumont, where a description characterizes the entire town as belonging to Charles de Croÿ, including not only the street pavements and all the houses, but also the professions carried out within the city, and all the chapels and churches on the territory.[60]

Often the large court residences had smaller buildings in their vicinity. These could not function alone, as they did not have the necessary facilities to

55 Maekelberg and De Jonge, 'The Prince's Court at Bruges', p. 23; De Jonge, 'Bourgondische residenties', pp. 93–134.
56 Bosmans, 'Digitale reconstructie', p. 29.
57 Orlin, *Locating Privacy*, p. 231.
58 Maekelberg, 'The Residential System', pp. 183–86.
59 Leuven, UA KUL, ADA, 2419, quire I.
60 Mons, ARAM, ACB, 316.

house the Duke and his household. They did, however, provide an opportunity for him to retire from busy court life with a smaller group of trusted servants or guests. In the Duchy of Aarschot, two smaller tower structures were built: one in Rotselaar, and the other on the edge of Meerdaalforest in Bierbeek.[61] The latter, often referred to as the castle of Harcourt, was meant as a starting point for the hunt. It did not have a representational apartment, and it was never intended to be lived in by the Duke. In Sint-Joost-ten-Node, Charles built a leisure pavilion consisting of an independent gallery that looked out over the adjacent gardens.[62] This construction was one of the first stand-alone galleries in the Low Countries, and it must have particularly appealed to the English ambassadors who were received there during the festivities following the peace treaty of 1604.[63] After several public festivities — including a banquet for three hundred people, a visit to the Coudenberg chapel, and a *combat à pied* judged by Charles de Croÿ — a select group was invited to the *maison de plaisance* in Sint-Joost-ten-Node. The leisure pavilion's largest gallery — a rectangle that was just 3.4 metres wide and thirty-five metres long, with large windows on both sides — was the setting for a *disner et soupper* (lunch and supper) on Saturday 14 May 1605 (Figure 4.6).[64] This was the only part of the festivities that did not take place in the crowded Coudenberg palace in Brussels city centre, and it was probably intended to foster private conversation among a select group of guests, since the design of this particular leisure pavilion did not allow for large banquets with a sizeable company. The pavilion stood at the edge of a water feature in the middle of extensive gardens, where the delegation could walk and engage in conversation. The specific design of the gardens, with long lanes and low plants and bushes, made it possible to spot approaching people from afar.[65]

Apart from their representational role during this diplomatic visit, the gardens at Sint-Joost-ten-Node were also considered an extension of the urban palace in Brussels city centre.[66] Indeed, the gardens in Sint-Joost-ten-Node were within walking distance of the residence in Brussels. By crossing the gardens of the Coudenberg palace, the Duke could pass the city gate, and just five hundred metres outside the city ramparts he reached his *maison de plaisance*. His payment to the porter of the Coudenberg palace testifies to the regular use of this route.[67]

A very similar structure stood in the gardens of the Croÿ residence at Chimay, in the province of Hainaut. Although the original structure had probably been built by Charles's father, Philip III de Croÿ, it underwent significant changes at

61 De Jonge, and Maekelberg, 'Matters of Representation'.
62 Maekelberg, 'Suburban Expansion of Brussels'.
63 Orlin, *Locating Privacy*.
64 Pinchart, *Relation*, p. 10; Maekelberg, 'Suburban Expansion of Brussels'.
65 De Maegd, 'En ung sien jardin'.
66 Maekelberg, 'Suburban Expansion of Brussels'.
67 De Villermont, *Le Duc Charles de Croy*, p. 254.

Figure 4.6. Reconstruction of the floor plan of the *maison de plaisance* at Sint-Joost-ten-Node. Drawing by the author.

the beginning of the seventeenth century.[68] The one-storey brick building with a large gate was transformed into a thirty-nine-metre gallery with large windows overlooking the gardens and adjoining water feature, a set-up remarkably similar to the *maison de plaisance* in Sint-Joost-ten-Node. The odd location of the gardens in Chimay, rather far from the main residence, suggests that they were not part of the main residence's representative programme; rather, they were meant for the Duke to spend time alone or organize festivities for a very limited number of guests.

Other Croÿ residences had similar long and relatively narrow galleries. In Heverlee, the gallery on the first floor led to the *chambre du paal*, and this was repeated on the floor above. Both long spaces had large windows on both sides looking out over the gardens and the castle's interior courtyard. In Brussels, the entire second floor around the small inner courtyard was referred

68 Buchin, 'Parc et jardins'.

to as the gallery, with the exception of the spaces above the great hall, where there was a second hall superimposed on the first. The same disposition of two superimposed galleries returns in the designs for the castle of Aarschot, while the castle at Beaumont had a myriad of galleries surrounding and overlooking the various gardens.[69]

Conclusion

Within the strictly organized and hierarchical life at court, the leader of the household, Charles de Croÿ, held an exemplary role, constantly subject to the scrutiny of *gentilhommes*, noble visitors, staff, and servants. While smaller residences would provide less space in which guests and visitors might observe the Duke, Charles preferred the comfort of large residences with enough room for an extensive staff. Two of his favourite residences, the castles at Beaumont and Heverlee, were surrounded by large gardens and associated with private hunting facilities. The garden pavilions at Sint-Joost-ten-Node and Chimay cannot be considered complete residences; rather, they presented an opportunity to retreat from the busy court life. Similarly, the hunting pavilion at Harcourt was only a short horse ride from the castle at Heverlee. Solitude and private conversation could thus be sought outdoors, since walls had ears in the early modern noble residence. Although large parts of the Duke's extensive renovation programme were never executed, the gardens and designed landscapes surrounding the residences were often the first to be completed, as was the case in Heverlee, Sint-Joost-ten-Node, and Chimay.

Indoors, access to the Duke and especially the ducal apartment was provided by a specific route that guests had to follow. The architectural routing was provided with barriers to prevent too-easy passage to the innermost rooms of the ducal apartment. Stairs, doors, and guards were put in strategic locations to ensure the sorting of guests according to the Duke's wishes. Access to the Duke's person was thus highly regulated by the Duke himself, through his instructions. These instructions reflect the ideal situation at court. During visits or on special occasions, rooms could serve different functions, and there was always flexibility and temporariness in the use of rooms during Charles de Croÿ's lifetime, especially due to the many building activities.

The question remains as to whether this differentiation can be considered a materialization of different instances of privacy. By writing his own instructions, which served as court ordinances, dictating access to his person and his residences, Charles de Croÿ controlled the processes of boundary control that applied to his life and his person — an essential aspect of privacy, according to Altman.[70] However, it is difficult to discern the Duke's personal

69 Maekelberg, 'The Residential System', pp. 229–30.
70 Altman, 'Privacy Regulation'.

tastes in these directives, since most of them mirrored contemporary habits and followed on from other noble dynasties as well as his own forebears. Despite these rules about access to the ducal residence and certain rooms within it, there was a group of people — including the *maître d'hotel* and the Duke's personal physician — who accompanied him all day long. In a sense, the time he spent in the oratory or study was the most private, since these were often small rooms capable of hosting only one or two people. Despite the chapel's central location in most of the Croÿ residences, the routes to the oratory were often hidden and had inconvenient access, making it difficult for staff and guests to enter. Rather than the written social code, it was the architecture or spatial organization of the ducal residences that facilitated solitude at court for Charles de Croÿ.

Works Cited

Manuscripts and Archival Sources

Brussels, Algemeen Rijksarchief, Chambre des Comptes, 27065
Brussels, Koninklijke Bibliotheek België, MS II.2123
——, MS 19.611
Brussels, City Archives, Archives Historiques, Liasse 885, 17
Dülmen, Herzog von Croy'sche Archive, HS 7
Enghien, Arenberg Archives, box 60/12
Leuven, University Archives KU Leuven, Archive of the Duchy of Aarschot, 398
——, 432
——, 2419, quire I
Mons, Algemeen Rijksarchief, Archives du Château de Beaumont, 316

Primary Sources

Ampliation du discours intitulée: Histoire veritable des choses passées, soubz le gouvernement du tresillustre Prince Charles de Croÿ (s.n., 1589)
Calvete de Estrella, Juan Christoval, *Le tres-heureux voyage fait par très-haut et très-puissant prince Don Philippe fils du grand empereur Charles-Quint depuis l'Espagne jusqu'à ses domaines de la Basse-Allemagne avec la description de tous les Etats de Brabant & de Flandre écrit en quatre livres*, III, trans. by Jules Petit (Brussels: Fr.-J. Olivier, 1876)
De Bie, Jacques, *Livre contenant la genealogie et descente de ceux de la Maison de Croy tant de la ligne principale estant chef du nom et armes d'Icelle que des branches et ligne collaterale de ladicte maison* (Antwerp: J. de Bye, 1612)
De Reiffenberg, Frédéric Auguste Ferdinand Thomas, *Une existence de grand seigneur au seizième siècle: Mémoires autographes de Duc Charles de Croy* (Brussels and Leipzig: C. Muquardt, 1845)

Fuller, Thomas, *The Holy State* (Cambridge: Roger Daniel, 1642)

Histoire veritable des choses les plus signalées et memorables qui se sont passées en la ville de Bruges, & presques par toute la Flandres, soubs le Gouvernement de tresillustre Prince Charles de Croy, Prince de Chimay, &c. (Düsseldorf, 1588)

Pinchart, Alexandre, *Relation de ce que s'est passé à l'entrée des ambassadeurs anglois en Pays-Bas (1605)* (Brussels: Fr.-J Olivier, 1874)

Varillas, Antoine, *La pratique de l'éducation des princes: Contenant l'histoire de Guillaume de Croy, surnommé le Sage, seigneur de Chièvres, Gouverneur de Charles d'Autriche qui fut Empereur Cinquième du Nom* (Amsterdam: chez H. Wetstein & H. Desbordes, 1684)

Secondary Sources

Altman, Irwin, 'Privacy Regulation: Culturally Universal or Culturally Specific?', *Journal of Social Issues*, 33.3 (1977), 66–84

Bernier, Théodore, *Histoire de la ville de Beaumont* (Mons: Imprimerie Dequesne-Masquillier, 1880)

Born, Robert, *Les Croy: Une grande lignée hennuyère d'hommes de guerre, de diplomates, de conseillers secrets, dans les coulisses du pouvoir, sous les ducs de Bourgogne et la Maison d'Autriche (1390–1612)* (Brussels: Editeurs d'art associés, 1981)

Bosmans, Charlotte, 'Digitale reconstructie van het Palais Rihour te Rijsel' (unpublished master's dissertation, University of Leuven, 2016)

Bruun, Mette Birkedal, 'Privacy in Early Modern Christianity and Beyond: Traces and Approaches', *Annali Istituto storico italo-germanico/Jahrbuch des italienisch-deutschen historischen Instituts in Trient*, 44, no. 2 (2018), 33–54

——, 'Towards an Approach to Early Modern Privacy: The Retirement of the Great Condé', in *Early Modern Privacy: Sources and Approaches*, ed. by Michaël Green, Lars Cyril Nørgaard and Mette Birkedal Bruun (Leiden: Brill, 2022), pp. 12–60

Buchin, Jacques, 'Parc et jardins de Chimay', in *Propriétés des Croÿ*, I, ed. by Jean-Marie Duvosquel (Brussels: Crédit Communal de Belgique, 1985), pp. 88–89

Cai, Sally and others, 'Geometric Documentation of the Chapel' (unpublished ArchDOC exercise, Raymond Lemaire International Centre for Conservation KU Leuven, 2011)

De Jonge, Krista, 'Het paleis op de Coudenberg te Brussel in de vijftiende eeuw: De verdwenen hertogelijke residenties in de Zuidelijke Nederlanden in een nieuw licht geplaatst', *Belgisch Tijdschrift voor Oudheidkunde en Kunstgeschiedenis*, 61 (1991), 5–38

——, 'Bourgondische residenties in het graafschap Vlaanderen: Rijsel, Brugge en Gent ten tijde van Filips de Goede', *Handelingen der Maatschappij voor geschiedenis en oudheidkunde te Gent*, 54 (2000), 93–134

——, 'Images inédites de la villégiature dans la périphérie de Bruxelles, XVIe-XVIIIe siècles: Maisons des champs et maisons de plaisance', in *Maisons des champs dans l'Europe de la Renaissance*, ed. by Monique Chatenet (Paris: Picard, 2006), pp. 269–82

——, 'Schloss Heverlee bei Löwen (Leuven) und die Residenzbildung in den südlichen Niederlanden um 1500', in *Burgen und Schlösser in den Niederlanden und in Nordwestdeutschland*, ed. by G. U. Grossmann and G. v. Büren (Munich: Deutscher Kunstverlag, 2014), pp. 69–80

——, 'Vivre noblement: Les logis des hommes et des femmes dans les résidences de la haute noblesse habsbourgeoise des anciens Pays-Bas (1500–1550)', in *Le prince, la princesse et leur logis: Manières d'habiter dans l'élite aristocratique européeene (1400–1700)*, ed. by Krista De Jonge and Monique Chatenet (Paris: Picard, 2014), pp. 105–24

De Jonge, Krista, and Sanne Maekelberg, *Noble Living: The Castle at Heverlee, from Croÿ to Arenberg* (Leuven: KU Leuven Bibliotheken, 2018)

——, 'Matters of Representation: On the Revival of the Early Mediaeval Keep in Brabant during the Early Modern Period', in *Romanesque Renaissance: Carolingian, Byzantine and Romanesque Buildings (800–1200) as a Source for new All'Antica Architecture in Early Modern Europe (1400–1700)*, ed. by K. Ottenheym and M. Kwakkelstein (Leiden: Brill, 2021), pp. 191–216

De Maegd, Chris, 'En ung sien jardin de plaisance au faubourgs de ceste ville: Het hof van plaisantie van Karel van Croÿ in Sint-Joost-ten-Node rond 1600', *Tijdschrift van Dexia Bank*, 55.4 (2001), 45–68

De Villermont, Marie Hennequin, *Le Duc Charles de Croy et d'Arschot et ses femmes Marie de Brimeu et Dorothée de Croy* (Brussels: Dewit, 1923)

Dekker, Rudolf, *Egodocuments and History: Autobiographical Writing in its Social Context since the Middle Ages* (Hilversum: Uitgeverij Verloren, 2002)

Delsaerdt, Pierre, and Yann Sordet, eds, *Lectures princières commerce du livre: La bibliothèque de Charles III de Croÿ et sa mise en vente (1614)* (Paris: Éditions des Cendres, 2017)

Duindam, Jeroen, *Myths of Power: Norbert Elias and the Early Modern European Court* (Amsterdam: Amsterdam University Press, 1994)

Duke, Alastair, *Dissident Identities in the Early Modern Low Countries* (Aldershot: Ashgate, 2009)

Duvosquel, Jean-Marie, ed., *Les Albums de Croÿ*, 26 vols (Brussels: Crédit Communal de Belgique, 1985–1996)

——, 'Charles III de Croÿ (1560–1612), un Prince de la Renaissance, collectionneur et bibliophile', in *Lectures princières & commerce du livre: La bibliothèque de Charles III de Croÿ et sa mise en vente (1614)*, ed. by Pierre Delsaerdt and Yann Sordet (Paris: Éditions des Cendres, 2017), pp. 17–44

Duvosquel, Jean-Marie, Luc Janssens, Bart Minnen, and Patrick Valvekens, *Een stad en een geslacht, Leuven en Croÿ* (Brussels: Gemeentekrediet van België, 1987)

Esteban Estringana, Alicia, 'El collar del Toison y la grandeza de Espana: Su gestion en Flandes durante el gobierno de los Archiduques (1599–1621)', in *El Legado De Borgona: Fiesta y Ceremonia Cortesana en la Europa de los Austrias*, ed. by Krista De Jonge, Alicia Esteban Estringana, and Bernardo José García García (Madrid: Fundacion Carlos de Amberes, 2010), pp. 503–57

Gaylard, Susan, *Hollow Men: Writing, Objects, and Public Image in Renaissance Italy* (New York: Fordham University Press, 2013)

Göttler, Christine, '"Sacred Woods": Performing Solitude at the Court of Duke Wilhelm V of Bavaria', in *Solitudo: Spaces, Places and Times of Solitude in Late Medieval and Early Modern Cultures*, ed. by Karl A. E. Enenkel and Christine Göttler (Leiden: Brill, 2018), pp. 140–78

Heal, Felicity, *Hospitality in Early Modern England* (Oxford: Oxford University Press, 1990)

Machelart, F., 'Adrien de Montigny, peintre de Valenciennes', in *Les Albums de Croÿ*, ed. by Jean-Marie Duvosquel, XXVI (Brussels: Crédit Communal de Belgique, 1996), pp. 119–32

Maekelberg, Sanne, 'Suburban Expansion of Brussels: The Croÿ Manor House as Representational Architecture in Relation to the Urban Residence', *A Cidade de Évora*, 1 (2016), pp. 90–102

——, 'The Materialisation of Power and Authority: The Architectural Commissions of Charles of Croÿ (1596–1612)', in *Proceedings of the Fifth International Conference of the European Architectural History Network*, ed. by Andres Kurg and Karin Vicente (Tallinn: Estonian Academy of Arts, 2018), pp. 188–99

——, 'Mapping through Space and Time: The Itinerary of Charles of Croÿ (1560–1612)', in *Mapping Historical Landscapes in Transformation: Methods, Applications, Challenges*, ed. by Thomas Coomans, Bieke Cattoor, and Krista De Jonge (Leuven: Leuven University Press, 2019), pp. 259–75

——, 'The Residential System of the High Nobility in the Habsburg Low Countries: The Croÿ Case' (unpublished doctoral thesis, University of Leuven, 2019)

——, 'Building Practice of the High Nobility in the Low Countries: The Architectural Mastermind of Charles of Croÿ (1560–1612)', in *Building the Presence of the Prince: The Institutions Related with the Ruler's Works as Key Elements of the European Courts (XIVth–XVIIth Centuries)*, ed. by Merlijn Hurx and Eloy Hortal Muñoz (Turnhout: Brepols, forthcoming)

Maekelberg, Sanne, and Krista De Jonge, 'Castles and Gardens: The Croÿ Legacy', in *Arenberg: Portrait of a Family, Story of a Collection*, ed. by Mark Derez, Soetkin Vanhauwaert, and Anne Verbrugge (Turnhout: Brepols, 2018), pp. 184–91

——, 'The Prince's Court at Bruges: A Reconstruction of the Lost Residence of the Dukes of Burgundy', *Architectural Histories*, 6.1 (2018), 23–37

Murphy, Neil, 'The Court on the Move: Ceremonial Entries, Gift-Giving and Access to the Monarch in France, c. 1440–c. 1570', in *The Key to Power? The Culture of Access in Princely Courts, 1400–1750*, ed. by Dries Raeymaekes and Sebastiaan Derks (Leiden: Brill, 2016), pp. 40–64

Olden-Jørgensen, Sebastian, 'State Ceremonial, Court Culture and Political Power in Early Modern Denmark, 1536–1746', *Scandinavian Journal of History*, 27.2 (2002), 65–76

Orlin, Lena Cowen, *Locating Privacy in Tudor London* (Oxford: Oxford University Press, 2008)

Raeymaekers, Dries, *One Foot in the Palace: The Habsburger Court of Brussels and the Politics of Access in the Reign of Albrecht and Isabella, 1598–1621* (Leuven: Leuven University Press, 2013)

Raeymaekers, Dries, and Sebastiaan Derks, eds, *The Key to Power? The Culture of Access in Princely Courts, 1400–1750* (Leiden: Brill, 2016)

Raeymaekers, Dries, and Sebastiaan Derks, 'Introduction: Repertoires of Access in Princely Courts', in *The Key to Power? The Culture of Access in Princely Courts, 1400–1750*, ed. by Dries Raeymaekes and Sebastiaan Derks (Leiden: Brill, 2016), pp. 1–15

Soen, Violet, 'La causa Croÿ et les limites du mythes bourguignon: La frontière, le lignage et la mémoire (1465–1475)', *Publications du Centre Européen d'Etudes Bourguignonnes*, 52 (2012), 81–97

Soen, Violet, and Yves Junot, eds, *Noblesses transrégionales: Les Croÿ et les frontières pendant les guerres de religion en France, Lorraine et aux Pays-Bas* (Turnhout: Brepols, 2021)

Stone, Lawrence, and Jeanne C. Fawtier Stone, *An Open Elite? England 1540–1880*, abridged ed. (Oxford: Oxford University Press, 1986)

AD LEERINTVELD

Huygens at Home

Constantijn Huygens (1596–1687) on Privacy in his
Poem Dagh-werck (The Day's Work) (1627–1638)

In die stilte van twee menschen,	(In this silence of two spirits,
Vind ick 'tuijterst mijner wenschen,	All the sum of my desiring:
Mijner tochten leste witt,	Solitude companionable
U, en eenicheits besitt.	Rests united in possession.)[1]
Met u, meer en minder blij,	(With you, more and yet less happy,
Sal ick voor uw oogh verschijnen,	Will I emerge, for your eyes,
En mijn' sorghen doen verdwijnen	And make my cares disappear
Tusschen straet en stoep en poort.	Between street and stoop and gate.)[2]

Introduction

This chapter presents the poem *Dagh-werck* (the day's work), which Constantijn Huygens (1596–1687; Figure 5.1) wrote between 1627 and 1638.[3] This unfinished and striking poem is perhaps the most personal in his oeuvre. It bears witness to his good fortune having married Susanna van Baerle (1599–1637). *The Day's Work* is a love poem in which Huygens addresses Susanna in an uninterrupted monologue. At the same time, *The Day's Work* is a description of the life that he would like to live with her; it unfolds in the intimacy between two people and in the privacy of their home and marriage.

1 Huygens, *Dagh-werck*, ll. 1049–52. I refer to the Zwaan edition of *Dagh-werck*, prepared after the manuscript versions kept in The Hague, Koninklijke Bibliotheek, shelf mark KW KA 40³, 1638. All translations of Huygens's verse are taken from Davidson and Van der Weel, *A Selection of the Poems*, unless otherwise stated.
2 Huygens, *Dagh-werck*, ll. 528–31, trans. by Isabella Lores-Chavez.
3 This chapter was translated from the Dutch by Isabella Lores-Chavez.

> **Ad Leerintveld** served as the Keeper of Modern Manuscripts at the Royal Library of the Netherlands. He is a guest researcher on the Huygens Correspondence Online project at the Huygens Institute.

Private Life and Privacy in the Early Modern Low Countries, ed. by Michael Green and Ineke Huysman, EER 19 (Turnhout: Brepols, 2023), pp. 145–171
BREPOLS ❧ PUBLISHERS 10.1484/M.EER-EB.5.132533

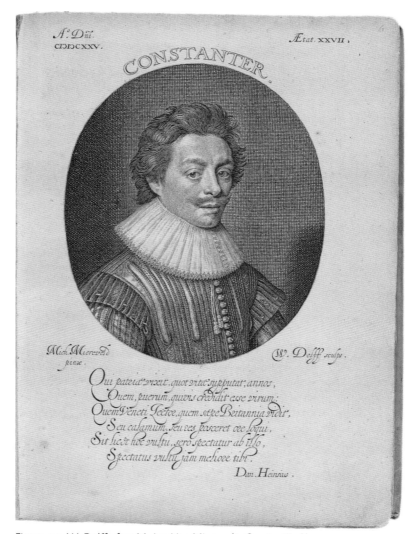

Figure 5.1. W. Delff after M. Jzn Van Mierevelt, *Constantijn Huygens*, engraving, 1625. From Huygens, *Otiorum libri sex*. The Hague, Royal Library of the Netherlands, KW 759 C 17.

Through passages from *The Day's Work*, I elucidate Huygens's vision of the intimacy between him and his wife, and of their privacy. Before I elaborate further, however, certain background information is required. Who were Constantijn Huygens and Susanna van Baerle? How can Huygens's poetic work be characterized? How does *The Day's Work* fit into that œuvre?

Constantijn Huygens

Huygens was born on 4 September 1596 in The Hague, to parents from Brabant.[4] His father, Christiaan Huygens (1551–1624), was born in Terheijden, a village in the district of Breda, while his mother, Susanna Hoefnagel (1561–1633), came from Antwerp. She was the youngest daughter of the immensely wealthy merchant Jacob Hoefnagel (b. 1525). Before the fall of Antwerp, Susanna fled with her mother to Holland, and from there to the German city of Stade, where a group of Reformers from the Southern Netherlands had settled. There she received a marriage proposal from Christiaan Huygens, who had met her in Antwerp. Christiaan had been one of the secretaries of Prince William I of Orange (1522–1584), and after the prince's death he became secretary to the Council of State and a confidant of William's successor, Prince Maurits (1567–1625).

Christiaan Huygens was forty years old when he married the thirty-year-old Susanna Hoefnagel in Amsterdam in 1592. They went to live on Nobelstraat in The Hague, near the Grote or Sint Jacobskerk. Together they had six children: two sons, Maurits (1595–1642) and Constantijn (1598–1687), and four daughters, Elisabeth (1598–1612), Geertruyd (1599–1632), Catharine (1601–1618), and Constance (1602–1667).

Along with his brother Maurits, Constantijn enjoyed a model upbringing at home, according to a schedule developed by their father.[5] The boys learned not only French, Latin, Greek, music, and drawing, but also horse riding, fencing, swimming, and even dancing. Christiaan educated his sons for official public roles. On 20 May 1616, both brothers departed for Leiden, where they would study law. Maurits was quickly recalled to The Hague to assist his sick father in the Council of State. He would go on to succeed him as secretary. Constantijn completed his studies with a disputation and returned home in the summer of 1617. As a *gentilhomme*, he was permitted to be a part of the Republic's official diplomatic missions to England and Venice. Throughout this period, he wrote poems and became a virtuosic lute player. His 'Batava Tempe' and ''t Kostelick Mall' of 1622 were well received.[6] A permanent position

4 This short biographical sketch is based on Leerintveld, *Constantijn Huygens: De collectie*, in which there are further references to secondary literature (pp. 126–27). Secondary literature in English includes Colie, *Some Thankfulnesse to Constantine*; Bachrach, *Sir Constantine Huygens*; Schenkeveld-van der Dussen, 'Bridging Two Cultures'; Jardine, *Going Dutch*; Gosseye, Blom, and Leerintveld, *Return to Sender*; Joby, *The Multilingualism of Constantijn Huygens*.

5 In his autobiography, Huygens gratefully recalls the education provided by his father Christiaan, who developed this curriculum from the practical insights of his friend Philips de Marnix de St Aldegonde (1540–1598). Huygens, *Mijn jeugd*; Strengholt, *Constanter*, p. 15; Groenveld, 'Een out ende getrouw dienaer', pp. 5–6. In 'Marnix over de opvoeding', Frijhoff comments on the *Ratio instituendae iuventutis*, written by Marnix de St Aldegonde around 1583 and published for the first time in Franeker in 1615.

6 Huygens, *Nederlandse gedichten*, I, pp. 103–29 ('Batava Tempe'), pp. 130–53 (''t Kostelick

in diplomacy or at court, however, would have to wait.[7] With the compilation of his poetry in Latin, French, Italian, and Dutch, published in 1625 with the title *Otiorum libri sex* (six books of leisure), he made it clear that he had not been idle, and that he was a talented man upon whom the homeland could call. He had, as it were, made his bid for an official role through his poetry compilation.[8] In June 1625 it finally came to pass: he was named secretary to the stadtholder Prince Frederik Hendrik (1584–1647), a position he held until the latter's death, that is, for twenty-two years.

Secretary to the Stadtholder

As secretary, Constantijn Huygens had daily access to Frederik Hendrik, the stadtholder of five provinces of the Netherlands and captain-general of the military. Alongside Jacobus Junius (d. 1645), who had already been secretary to Frederik Hendrik's predecessor Prince Maurits, and who was in charge of the secretariat, Huygens was responsible for the prince's correspondence, among other duties. He summarized and sometimes translated incoming mail, deciphered letters, and encoded messages; when appropriate, he would draft a response in consultation with the prince and have it written out by one of the clerks before it was signed by Frederik Hendrik. Outgoing documents, such as appointments, passports, and licences, also passed through Huygens's hands. He was tasked with making records of the stadtholder's discussions and archiving them properly. Additionally, Huygens played an important role in military administration as the secretary of the commander-in-chief. At the beginning of a campaign, military commands, marching routes, and official orders needed to be drawn up and sent. After a campaign, army units were quartered in cities. Records of this were maintained to ensure that Frederik Hendrik was always aware of the size and whereabouts of his troops. Huygens was thus extremely well informed about the organization of the prince's military apparatus, and he was therefore also frequently approached by individuals seeking better military positions for themselves, a son, or a friend.[9] Whenever he was not called away from The Hague — in the summertime he would accompany the prince's annual campaign — Huygens usually worked in the stadtholder's quarters in the Binnenhof in the morning, and often also in the late afternoon after taking lunch at home (Figure 5.2).[10]

Mall'); Huygens, *Nederlandse gedichten*, II, pp. 246–385 ('Commentary').

7 A position as ambassador to Venice or London was out of the question, since the States-General had decided in 1624 that only noblemen could obtain such a position. Groenveld, 'Een out ende getrouw dienaer', p. 8.

8 Blom, 'Solliciteren met poëzie'; Blom, 'Building in Stones and Words'.

9 In this manner, Huygens thus acted as a broker. Bisschop, 'Dat hi in d'crijch'; Groenveld, 'C'est le père qui parle'.

10 Hofman, *Constantijn Huygens*, p. 143; Groenveld, 'Een out ende getrouw dienaer'; Grootes, 'Het arbeidsethos van Constantijn Huygens'.

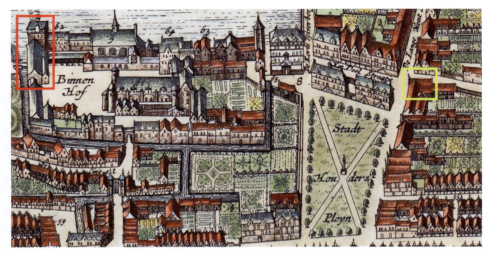

Figure 5.2. 'Detail of map of the centre of The Hague', showing Huygens's working area, with his house on Lange Houtstraat on the right (yellow square) and the quarters of Prince Frederik Hendrik on the left (red square). From Frederik de Witt, *Theatrum ichnographicum omnium urbium et præcipuorum oppidorum Belgicarum XVII Provinciarum peraccurate delineatarum* (Amsterdam, after 1698). The Hague, Royal Library of the Netherlands, KW 1046 B 16.

Marriage to Susanna van Baerle

In September 1626, Constantijn Huygens began to court Susanna van Baerle, a cousin who lived in Amsterdam.[11] Susanna was no stranger. A few years before, in 1622, the whole Huygens family had made vain efforts to unite Susanna with Constantijn's brother Maurits. As their father Christiaan Huygens wrote to 'lieff Susanneken' (darling little Susanna), no one would value her 'groot verstandt, wetenschap en perfectien meer [...] achten end in waerde houden, als hy [Maurits] ende wy al te samen in ons huys, daer vader en moeder, bruer ende zusters u allen eere, vruntschap, dienst zouden bewijsen' (great understanding, knowledge, and perfection more than he [Maurits], and all of us in our home, father and mother, brother and sisters, would like to bestow, only upon you, honour, friendship, and favour).[12] But Susanna did not want to marry Maurits, who sensed this and feared suffering the shipwreck of a prolonged courtship. Instead, he advised his brother, who was in London at the time, to try courting Susanna.[13]

11 Susanna was a daughter of Jan van Baerle, a German cousin of Constantijn Huygens's mother. The following passage is based on Blom and Leerintveld, 'Vrouwen-schoon met Mannelicke reden'.
12 Christiaan Huygens to Susanna van Baerle, The Hague, 14 January, 1623, Amsterdam, Allard Pierson, OTM hs. 27 A 4; Blom and Leerintveld, 'Vrouwen-schoon met Mannelicke reden', p. 99.
13 Maurits Huygens to Constantijn Huygens, The Hague, 24 August 1622: 'Si pour ma part

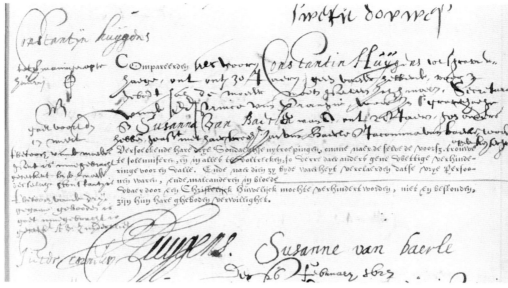

Figure 5.3. 'Official registration of the wedding of Constantijn Huygens and Susanna van Baerle', 24 February 1627. Amsterdam, CAA, inv. 432, p. 67, act no. D. T. B. 432.

Constantijn handled things differently. His father did not have to negotiate for him. He addressed himself directly to Susanna, whom he would come to call 'Sterre' (Stella, or 'star'). In the sonnet 'Aen sterre' (to Stella), he wrote: 'Segt jae, maer seght het mij, dat zijn de kortste wegen' (say yes, but say it to me, that is the shortest way). In the preceding lines, Huygens included *en passant* an overview of his own qualifications: he was amiable, young, responsible, sensible, rich, literary, and learned.[14] Moreover, he was a man *in bonis*, now that he was permanently in the service of Frederik Hendrik.

Susanna did not immediately say yes. She kept Constantijn in great suspense. On 23 January 1627, he sent her another poem, which in the first edition of his poetry was given the title 'Vrij-dicht' (courtship poem).[15] From the first lines of the poem, we become acquainted with his state of mind: 'Ick doolde bijster-sweghe in 'tswartste van 'tonseker | In twijffel-misticheit, in schrick' (I wandered aimlessly in the darkest uncertainty | In the fog of doubt, in fear). Further on in the text, he becomes more optimistic. He imagines that he will follow his 'Sterre' (star), his 'Stall-licht' (will-o'-the-wisp), to heaven, and that

naufragiam facio, bien que je n'aye point le courage assés ladre pour ne ressentir un peu ceste picquere, je vous conseilleroy en frère. Tentés la mesme fortune et ou je me trompe, ou vous y courrés moins d'hasard'. Huygens, *Correspondence*, no. 172.

14 Huygens, *De gedichten van Contantijn Huygens*, II, p. 165.
15 Huygens, *Koren-bloemen*, pp. 1038–44; Huygens, *De gedichten van Contantijn Huygens*, II, pp. 170–74; Huygens, 'Vrij-dicht'.

he will fall upon her with an abundance of kisses. Then the two together will travel through the orbits of the seven planets, and from there he will sweep her away to bed, into marriage:

Daer sal mij 't stall-licht leiden,
Daer sal ick twijffelen wie ben ick van ons beiden,
En missen gaerne 'tlicht van sonn of Sterre-schijn,
En tasten na mijn self, en dat sal Sterre zijn.

(There the will-o'-the-wisp shall lead me | There I shall question which of the two of us I am | And gladly miss the light of the sun or the stars | And feel for myself | And there shall Stella be.)[16]

This is how he imagines their romance. The text is wishful thinking. The poet puts the words in the mouth of his alter ego 'Stella-friend', whose voice 'queelde [...] ter antwoord van sijn' Luyt' (sang thusly in response to his lute).[17]

Three days later, on 26 January, Huygens felt more confident about his case. It was moving in the right direction. He would suffer no shipwreck. That day, he wrote the triumphant song "'T kan mijn Schip niet qualik gaen' (my ship cannot go astray), based on a melody from a French book of courtly airs. It included powerful lines, such as the following:

'Ksie mijn Sterr in 't oosten staen,
Mijn morgensterre;
Stiermann houw vrij Oostwaerd aen,
Het land en is niet verre.

(I see my star standing in the east, | My morning star, | Steersman, keep to the east, | For land is within reach.)[18]

Indeed, on 18 February 1627, Susanna sent Constantijn a diamond in the form of an S, the first letter of her first name.[19] They went to obtain their marriage licence in Amsterdam on 24 February.

On 13, 21, and 28 March, the banns were read. They married on 6 April 1627 — coincidentally or not, the *dolce giorno* when Petrarch and Laura had met three hundred years earlier (Figure 5.3).[20] It was a society wedding that was celebrated in songs by fellow poets Pieter Cornelisz. Hooft (1591–1647), Caspar Barlaeus (1584–1648), and Jacob van der Burgh (1600–1659).[21]

16 Huygens, 'Vrij-dicht', ll. 145–48.
17 Huygens, 'Vrij-dicht', l. 149.
18 Huygens, *De gedichten van Contantijn Huygens*, II, pp. 174–76, translation taken from Mook, *Proba me Deus*.
19 Leerintveld, 'De "S" van Sterre'.
20 Huygens, *Mijn leven*, I, p. 13.
21 Hooft, 'Bruiloftslied voor Constantijn Huigens [...] en Susanna van Baerle', in *De gedichten*, pp. 483–87; Barlaeus, 'In nuptias Constantini Hugenii Equitis', in *Poematum editio nova*,

The young couple settled down in The Hague, from where Constantijn could readily follow his master Frederik Hendrik, who was attempting to recapture the eastern city of Groenlo from the Spanish. They lived initially in Huygens's mother's house on Voorhout, but on 14 October 1627 they moved to Lange Houtstraat. Here, their children were born, four sons and one daughter: Constantijn (10 March 1628), Christiaan (14 April 1629), Lodewijk (13 March 1631), Philips (12 October 1633), and Susanna (13 March 1637). Father Constantijn recounted their births and earliest childhood years in an exceptional handwritten chronicle that is now part of the Huygens Collection in the Library of the University of Leiden, and which was first printed in 1987 in the catalogue for a Huygens exhibition at the Royal Library. A striking feature of this chronicle is the affection with which the young father notes the ups and downs that his young wife experienced during her pregnancies.[22] The same love is expressed in the robust poem *The Day's Work*, which Constantijn began during their honeymoon year of 1627. Alas, the marriage of Constantijn and Susanna would last a mere ten years. Susanna died on 10 May 1637, nearly two months after the birth of their only daughter, Susanna.

The Day's Work: An Overview of the Content

Dagh-werck was initially supposed to be called *Ernst van Voorraed* (calm advisement), a serious preconsideration (Figure 5.4). In manuscript, the poem first bore the title *Huys-Raed* (home counsel), which many understand as meaning advice regarding how best to run a household.[23]

Huygens began writing it early in their marriage, for and at the request of his new wife.[24] Their first son, Constantijn, had not yet been born. The poet worked on it intermittently, as evidenced by the mention of important historical events such as the conquest of Wesel and Den Bosch in 1629. Because of the death of his Stella, Huygens was unable to complete the poem. About a year after her passing, he was barely able to add an ending to it: he composed a closing passage about her death and about losing her, but otherwise he left the poem unfinished.

Huygens could not have done otherwise, because the poem concerns the activities that the two spouses could and would cultivate. He allows these activities to occur over the course of a single day, from waking up to going to bed. He thus creates a poem about the ideal marriage that he and his Stella

pp. 194–201; Van der Burgh, 'Echt-gedicht Ter eeren van den Heer C. Huygens [...] En Me-joffrouw Susanna van Baerle', in *Verscheyde Nederduytsche Gedichten*, pp. 16–20.

22 Heer and Eyffinger, 'De jongelingsjaren'.

23 The Hague, Koninklijke Bibliotheek, KW KA 40a, 1638; Huygens, *Dagh-werck*, p. 76, v. 33.

24 Huygens, *Dagh-werck*, pp. 7–8, letter of 10 April 1639 from Huygens to Anna Maria van Schurman; Van der Stighelen and De Landtsheer, 'Een *suur-soete Maeghd*', p. 183; Huygens, *Correspondence*, no. 2078.

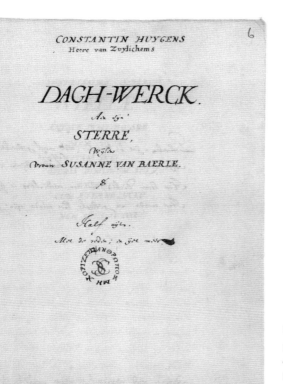

Figure 5.4. 'Title page of the printer's copy of *Dagh-werck*', designed by Huygens. The Hague, Royal Library of the Netherlands, KW KA 40ª, 1638, fol. 6.

experienced. The manuscripts contain a diagram of the subjects that Huygens wanted to comment upon through the use of this format. From these we can deduce that the description of the day in the poem had only reached the beginning of the afternoon when Susanna's death befell them.

The poem is a single monologue addressed to Stella until the abrupt ending brought about by her death. It begins with a declaration of love to her, with lines such as 'Sterre, mergh van all'mijn'vreugden, | Die mij eens met Ia verheugden' (Stella, of my joys the marrow, | Who with 'yes' did once delight me).[25] The poem proceeds from this apostrophe to a description of how they pray to God after waking up, and how they dress themselves simply, without modish frills. Next, Huygens goes to court, where he presents people's pleas for mediation to the stadtholder, who subsequently makes a decision.

25 Huygens, *Dagh-werck*, ll. 9–10.

Once back home, Huygens leaves his troubles at the door. He and Susanna then speak about housekeeping and share in each other's happiness. The midday meal is plain; they drink wine sparingly. After their meal, they enjoy a healthy stroll or take a short trip by coach. Sometimes Huygens goes out alone, for a walk or on horseback, and revels in everything he sees, from the flowers to the smallest animals visible under a magnifying glass. He writes poetry about it all. When the weather is bad, he wanders in his 'Boss van Boecken-blad' (forest of book leaves), his library.[26] There he learns — from his books on theology, law, medical knowledge, anatomy, pharmacology, and biology — what must be the truth. Susanna, with her great intellect and knowledge, which the elder Huygens had so lauded, helps him distinguish illusion from reality. Stella draws the distinction between 'boom en schellen' (tree and bark), that is between what is valuable (the tree) and what is worthless (the skin or bark).[27] Constantijn and Susanna thus discuss together, as equals, the subjects of the books in the library, and Constantijn agrees with Susanna's opinion of their truth value.

With 'spreeckt ghij, Sterre, neffens mij' (speak forth, Stella, beside me still), the original poem ends.[28] Up to this point, Huygens had used his characteristic poetic metre of four trochees. On 16 June 1638, he attached to this original verse an ending with ninety lines in alexandrines. This more contemplative section ends dramatically: 'Spreeckt vrienden, ick besw… | Daer leijt mijn plompe Penn' (speak, friends, I succ… | There lies my blunted pen).[29] The poet can go no further. He has succumbed, and his pen, worn to a stump, falls from his hand. Only on 12 July did he conjure an ending, in prose, in which he recounted how he had wanted to proceed with the poem.

In February 1639, Huygens sent his *Day's Work* to his friend the poet Hooft, who immediately responded 'Ik scheidd' er niet uit, eer 't uit was' (I could not stop reading until it was over) and 'aen zoo blinkend een Daghwerk den dagh te verbieden, waere jammer' (it would be a pity to forbid the daylight to such a shiny day's work). He believed that *The Day's Work* had to see the light of day quickly in printed form.[30] At Huygens's request, he allowed Barlaeus and others to read the poem. They promised to write endorsements to be included in the proposed publication. Two fellow poets, Joost van den Vondel (1587–1679) and Daniel Mostart (1592–1646), provided commentaries on Huygens's word choice, language use, and metre.[31] The poem itself, however,

26 Leerintveld, 'Constantijn Huygens's Library'. With the phrase 'Boss van Boecken-blad' (forest of book leaves, l. 1460), Huygens is playing on the word *beuk* (tree), an etymologically related variant of *boek* (book).

27 Huygens, *Dagh-werck*, l. 1967.

28 Huygens, *Dagh-werck*, l. 1969.

29 Huygens, *Dagh-werck*, ll. 2057–58.

30 Hooft to Huygens, 21 February 1639, in Hooft, *De briefwisseling*, III, no. 946; Huygens, *Correspondence*, no. 2047.

31 Huygens, *Dagh-werck*, pp. 42–62.

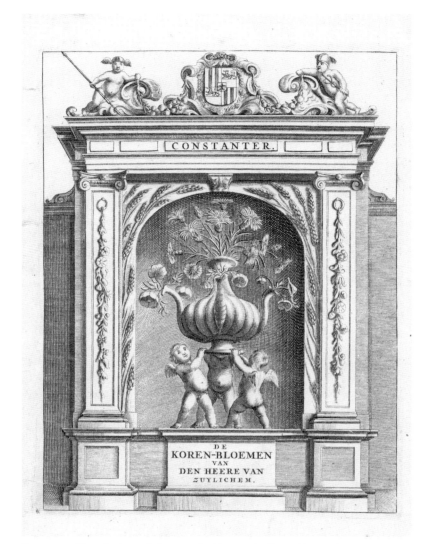

Figure 5.5. 'Frontispiece of Constantijn Huygens's, *Koren-bloemen*'.
The Hague, Royal Library of the Netherlands, KW 302 E 52.

did not appear as a free-standing publication in its own right during this period. Twenty years would pass before Huygens included *The Day's Work* — along with a title page, the collected laudatory poems, and a prose 'uytleggingh' (explanation) — in his composite volume of Dutch poetry, which appeared in 1658 with the title *Koren-bloemen* (*Cornflowers*).[32]

32 Huygens, *Koren-bloemen*, pp. 333–438.

Huygens's Poetry

'Ick heb voor Lant en Kerck Standvastelick gesweet' (and I for Church and Land have laboured *constantly*), says Huygens in his poem 'Op de Titel-print' (on the title) in the collection *Cornflowers* (Figure 5.5).[33] With reference to his motto 'Constanter', he lets his reader know that he has persistently gone to great lengths for Church and state. Clearly, he finds it necessary to justify his extensive poetry collection. Huygens hastens to call his dedication to the homeland the 'wheat' amidst which the cornflowers of poetry emerge. The latter appear beautiful, like children of the nobility in their Easter best, in blue and red satin, but they are useless amidst the corn; they are merely pretty weeds.

Huygens thus reprises the theme he had invoked in earlier compilations of his work. For him, his poetry and music were merely secondary. This is apparent from the title of his first poetry collection, *Otiorum libri sex* (six books of leisure, 1625), from the Latin poetry he published in 1644 and 1655 with the title *Momenta desultoria* (moments of leisure),[34] and from the fact that in 1647 he published an anonymous songbook in Paris with the title *Pathodia sacra et profana occupati* (secular and spiritual emotive songs from a busy man). His poetry may have originated as a side project, but Huygens nevertheless composed an extensive oeuvre.[35] As previously stated, he published much of his poetry in the compilations *Otiorum libri sex* (1625), *Momenta desultoria* (1644, 1655), and *Cornflowers* (1658, 1672), but he also allowed his work to appear in individual publications such as *Sacred Days* (1645), *Hofwijck* (1653), *Tryntje Cornelis* (1657), and *The New Zee-straet from 's-Gravenhage to Scheveningh* (1667).[36] Secondary or not, anyone who looks at Huygens's collected poems and surviving pieces of music cannot deny that he emphatically presented himself both as a poet and as a composer.[37]

Huygens's poetry is personal and often autobiographical. His work has a conversational nature: the poet speaks with himself and with others.[38]

33 Huygens, *Koren-bloemen*, 3ʳ, l. 25.

34 Huygens himself designed the frontispiece for this publication. It shows Mercury, the god of poetry, standing on a pedestal. On the front of the pedestal, two horses are visible: the winged horse of poetry and a workhorse. With this, Huygens is signalling that he 'leaps': he jumps from the workhorse onto the horse of poetry. Poetry, for him, is a way to spend his free time.

35 On the basis of the standard edition of Huygens's poetry (i.e. the Worp edition), Van Seggelen has calculated that in total he wrote 75,555 lines of verse, including 48,590 in Dutch, 19,962 in Latin, and 6579 in French. There are also 146 verses in Italian, thirty-one in Greek, twenty-four in German, and twenty-four in Spanish. Seggelen, 'Huygens' Franse Poëzie', p. 72; see also Joby, *The Multilingualism of Constantijn Huygens*.

36 There is no modern bibliography of Huygens's work. For a characterization of the titles mentioned, see Leerintveld, *Constantijn Huygens: De collectie*.

37 Blom, 'Solliciteren met poëzie'; Blom, 'Building in Stones and Words'.

38 Strengholt, *Dagh-werck*, pp. 7–8.

This parlando is strengthened by the metre in which Huygens preferred to compose. His lines of verse consist mostly of four trochees or six iambs that together form an alexandrine. In his longer poems, Huygens is often busy with associations. From one word, image, or thought, he moves on to the next.[39] This applies to *The Day's Work*. Huygens's poems testify to an enormously rich vocabulary. He likes to reveal hidden meanings in the words he uses, and he takes great pleasure in wordplay and figures of speech such as paradox or oxymoron. His ideal style is the *obscuritas*.[40] Because of this, he was (and still is) both praised and vilified. On the occasion of the first publication of his verses 'Batava Tempe' and ' 't Kostelick Mall', Jacob Cats (1577–1660) advised readers to consume Huygens's poems 'ghelijck de kieckens drincken' (as the chickens drink, i.e. sip by sip) or, in another analogy with the animal world, 'ghelijck het schaepjen eet' (as the sheep eats, i.e. bit by bit).[41] *The Day's Work* also bears witness to this ideal style. As a result, it has been called one of the most difficult texts in our seventeenth-century literature.[42] In the poem itself, Huygens also indicates the demands he makes on ideal poetry:

> Keur van woorden, pitt van sinn,
> Drijmael dobbel binnen in
> Wat of schael of schell beloven,
> Heldre tael en onbestoven,
> Spraeck van huijden, toon van straet,
> Mannen meening, vrouwen praet,
> Klare letter, duijster denkcen,
> Min dan herssenen kan krencken,
> Meer dan herssenen ontoom'
> 'Trijm voor wind,'tgerijmd'in stroom.[43]

Porteman and Smits-Veldt paraphrase these demands in their history of literature: perfect words, succinct thoughts, the content triple what its exterior promises; the clear, pure, natural language of common people; including well-considered thoughts common to man, conveyed routinely in the language of women (who in Huygens's opinion speak naturally and effectively); a clear expression of a difficult way of thinking, not so difficult that one must torture one's mind, but difficult enough that one must sustain concentration; the rhyme spontaneous, but the content always different than expected.[44]

39 Pieters identifies this tendency in *Hofwijck*. Pieters, *Op zoek naar Huygens*, pp. 147–48.
40 Schenkeveld-van der Dussen, 'Duistere luister'.
41 Huygens, *Nederlandse gedichten*, I, pp. 353–54, ll. 25 and 27.
42 Grootes, 'Hoe te leven', p. 13.
43 Huygens, *Dagh-werck*, ll. 1335–44.
44 Porteman and Smits-Veldt, *Een nieuw vaderland*, p. 366, trans. by Isabella Lores-Chavez.

The Day's Work *Once Again*

It is useful to consider *The Day's Work* anew with this context in mind. We have seen that Constantijn Huygens married Susanna van Baerle, a woman of 'great intellect, knowledge, and perfection' — his 'Stella'. He then made his brilliant debut as a poet in Dutch (and neo-Latin) literature with his collection *Otiorum libri sex*, and he secured a permanent position in the court of the stadtholder Frederik Hendrik. With his poems — and of course with all his other qualifications — he managed to make Susanna his. As 'Stella-friend', introduced in the courtship poem quoted above, he had led her to his bed, where he would wonder:

> Wie ben ick van ons beiden,
> En missen gaern het licht van sonn of Sterre-schijn,
> En tasten na mijn self, en dat zal STERRE zijn.
>
> > (Which of the two of us I am | And gladly miss the light of the sun or the stars | And feel for myself | And there shall Stella be.)[45]

He now no longer had to pose the question about their union. They were married and had become one. For her, and at her request, he began to write the poem *The Day's Work*. He expressed their unity, the binding of their souls, right at the beginning of the poem:

> Sterre, alleen en all mijn heil,
> Nu 't den Hemel soo gepast heeft
> Dat mijn' siel aen d'uwe vast leeft,
> Dat Ick Gij, en 'teener tijd,
> Ghij tot Ick geworden zijt,
> Nu wij maer van naem en schillen,
> Nu mijn' lusten zijn uw' willen,
> All uw willen all mijn lust,
> IJeders vrede elkanders rust.
>
> > (Stella, sole and whole salvation | Now that Heaven has ordained it | That our souls live as one. | I am you, while you conversely | Are turned me in that same moment, | Names are all that part us now. | My desires your will becoming. | And your will my sole desiring, | Peace for one's the other's joy.)[46]

45 Huygens, 'Vrij-dicht', ll. 145–47, trans. by Isabella Lores-Chavez.

46 Huygens, *Dagh-werck*, ll. 16–24. Zwaan sees a biblical parallel (with Genesis 44. 30) in the imagery of souls bound together. I would further point to the classically inspired line 66 in the poem 'Is t quelling sonder vreucht', which Huygens wrote in 1619 in response to his failed relationship with 'Doris' (Dorothea van Dorp, 1592–1657), where he mentions 'twee herten in een siel, twee sielen in een hert' (two hearts in one soul, two souls in one heart). Huygens,

Their unity extends so far that Constantijn asks her to help him to bring this poem (this child) into the world. Its mother must be called 'we':

Tkint sal *Ernst van Voorraed* heeten;
Helpt mij door den arbeid sweeten,
Daer Ghij Ick zijt, en Ick ghij,
Moe de Moeder heeten, Wij.

> (Make the child's name *Calm Advisement* | Help me through the pains of labour | You are me and I am you | 'We' must be the mother's name.)[47]

With her substantial intellect, Susanna understands her husband's difficult poetry. She is his first reader, and she determines the poem's content as well:

Hoe wij dese kleine wereld,
Die ghij, Sterr, alleen beperelt,
Die ick, verr van uws gelijck
Ick, en ick alleen beslijck,
Dese, om nauwer te beschrijuen,
Bedd-gemeente van twee Lijuen,
Van twee lieven, segg ick best,
Tortelen van eener nest,
Tamelixt bestieren sullen,
En met vreugd op vreugd vervullen,
Hebb ick, hebben ick en ghij
Dus beregelt, seggen wij.

> (How should we now rule our kingdom: | You its star and pearl together; | I, so far am I below you, | Being its serpent and its stain. | This our world (to speak precisely | Commonwealth and marriage bed | Better, commonwealth of lovers, | Turtledoves in common nest) | We shall fill with joys unending | I have ordered matters thus. | But it is not 'I' who orders | You are me and I am you, so | All things are ordained by 'We'.)[48]

The poem will be about their microcosm, their kingdom, their marriage bed, their marriage. *The Day's Work* is therefore not a personal diary or a script for 'scenes from a marriage'. It is a monologue about an ideal future married life, addressed to the wife in the words of the husband.[49] In this monologue,

Nederlandse gedichten, 1, p. 22, l. 66; Bloemendal and Leerintveld, 'De "literaire" vriendschap'. In his ideal love, Constantijn Huygens is also 'constant'.

47 Huygens, *Dagh-werck*, ll. 33–36.
48 Huygens, *Dagh-werck*, ll. 57–69.
49 Strengholt has counted the frequency of the use of the future tense. The auxiliary word *zullen* appears 108 times in 1969 lines of verse. Strengholt, 'Dagh-werck', p. 94.

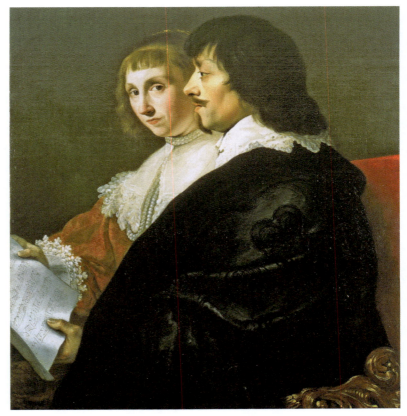

Figure 5.6. Jacob van Campen, 'Double Portrait of Constantijn Huygens (1596–1687) and Suzanna van Baerle (1599–1637)', c. 1635. The Hague, Mauritshuis, inv. 1089.

the poet makes a sketch of how he imagines his married life with his better half will ideally proceed. The perspective belongs to him. This is his vision.[50]

We do not know what Susanna expected from their married life. In the only known portrait of her, a double portrait with Constantijn painted c. 1635 by Jacob van Campen (1596–1657), she looks at the viewer, not at her husband (Figure 5.6).

Here, she seems to interrupt the scene — probably staged by Constantijn — of a harmonious couple immersed in a piece of music. Susanna was an autonomous, powerful woman, who also made a significant impression on Huygens's intellectual and literary friends, such as René Descartes (1596–1650) and P. C. Hooft.[51] Nevertheless she surely approved of the poem and the articulation of love that Constantijn offered her.

50 Grootes, 'Hoe te leven', pp. 20–22.
51 Blom and Leerintveld, 'Vrouwen-schoon met Mannelicke', pp. 103–05. Descartes to

Thus far I have given a brief overview of the content of *The Day's Work*. Now we may take a closer look at the concepts of 'intimacy' and 'privacy' in the poem.

Intimacy and Privacy in *The Day's Work*

In *The Day's Work*, Constantijn Huygens describes the unity and soul connection that he and Susanna van Baerle experienced — and wished to continue to experience — in their marriage. Movingly and lovingly, he describes their compatibility, their wordless peace, in these lines:

> In die stilte van twee menschen,
> Vind ick'tuijterst mijner wenschen,
> Mijner tochten leste witt,
> U, en eenicheits besitt.

> (In this silence of two spirits | All the sum of my desiring: | Solitude companionable | Rests united in possession.)[52]

These lines flow from Constantijn's pen in the description of a coach trip that he and Susanna take together in the environs of The Hague as part of their joint daytime activities. This 'silence of two spirits' is the supreme intimacy in their harmonious marriage, which mainly occurs indoors in their home on Lange Houtstraat in The Hague.

Huygens juxtaposes their life at home with life on the street, in the city, or in the state. He sets the private against the public. He says, for example, that when he comes home from work, from his activities at the court of Frederik Hendrik:

> Met u, meer en minder blij,
> Sal ick voor uw oogh verschijnen,
> En mijn' sorghen doen verdwijnen
> Tusschen straet en stoep en poort.

> (With you, more and yet less happy, | Will I emerge, for your eyes, | And make my cares disappear | Between street and stoop and gate.)[53]

A little further on (lines 537–39), he calls his house his harbour where, weary from lurching and toiling (aboard the state ship, with Frederik Hendrik at

Huygens, Leiden, 3 March 1637: 'Que si Mme de Zuylichem y voulait aussi joindre les siennes [remarks on his *Discours de la méthode*], je le tiendrais à une faveur inestimable, et je croirais bien plus à son jugement, qui est très excellent par nature, qu'à celui de beaucoup de philosophes qui souvent est rendu par art fort mauvais'. Huygens, *Correspondence*, no. 210.

52 Huygens, *Dagh-werck*, ll. 1049–52.

53 Huygens, *Dagh-werck*, ll. 528–31, trans. by Isabella Lores-Chavez.

the helm), he seeks 'stilte' (silence). He will inform Stella 'binnens muers' (within walls) of what is happening outside:

> Loop ick ouer van geruchten,
> Die ick melden met genuchten,
> Die gij sonder afsien meught
> Menghen onder ander vreughd,
> 'Ksall u 'swerelds meeste maren,
> Binnens muers doen wedervaren,
> Soomen door 't gelasen gat
> 'tLeuen van de dingen vatt
> Die sich op het heetste daghen
> Buijtelende binnen dragen.

> > (When my mind is filled with rumours | I shall whisper news to please you | Things which you may hear with pleasure | I shall add unto your joys; | These are things reflected to you, | Secrets told within our fortress, | Mirrors of the world without: | As the *camera obscura* | Topsy-turvy through its lenses | Draws the sunlit world inside.)[54]

Huygens here uses the camera obscura (*gelasen gat*) as a metaphor. During his second stay in England, from 1621 to 1622, Huygens had met the inventor Cornelis Drebbel (1572–1633), and he brought back with him to The Hague instruments that Drebbel had invented or improved, such as the camera obscura and the microscope.[55] In his prose annotation to these verses, he describes the workings of the camera obscura: 'Hebb ick aengenae niewe tijdingen, ick salse u binnens huijs voorbrenghen, gelijckmen in een duijstere Camer door een geslepen Glas bij sonneschijn verthoont 'tghene buijtens huijs om gaet, maer aeverechts' (if I have pleasant new reports, I shall bring them home to you, as one in a dusty room displays all that happens outside, but upside down, by means of sunshine through a smooth glass).[56] To this 'upside down' and 'topsy-turvy', he then attaches a warning in his address to Stella:

> Buijtelende, Sterre; Merckt:
> Dat's gelijck de Loghen werckt
> Op de nieuw-geboren Waerheit,
> Niewgeboren inde klaerheit
> Van des middaghs hooghen dagh.
> Diese soo ten teersten sagh,
> Sou'se van geen vuijl verdencken:
> Maer, wie kan soo schielick wencken

54 Huygens, *Dagh-werck*, ll. 549–58.
55 Colie, *Some Thankfulnesse to Constantine*, pp. 105–08; Huygens, *Mijn jeugd*, pp. 131–32.
56 Huygens, *Dagh-werck*, p. 198, trans. by Isabella Lores-Chavez.

Als het neen voor ja verschijnt
Als het ja tot neen verdwijnt?

> (Topsy-turvy, Stella, mark this: | Not the real thing, but reflexion, | Just as lies may work upon | Truth that's tender and new-born, | Transparent as the noonday sun. | Who have seen her at her gentlest | And believed that sin could touch her? | But whose eye can blink so swiftly, | Winking 'no' and 'yes' confounded, | Making 'yes' make way for 'no'?)[57]

What appears at first glance to be real is not necessarily so, Huygens is saying. It is striking that he sees himself here as an intermediary who transmits rumours from the exterior to his Stella for her pleasure, just as, through a camera obscura, sunlight brings the world indoors via the lens.

In this function, as the one linking inside and outside, Huygens will take into consideration Stella's state of mind:

Binnens deurs sal uw gelaet
'Tvoorslagh zijn van ons gepraet.
Staet het als uw'-minder stralen,
Sterre, die den nacht in halen,
Staet het als een sterr in 't holl
Van een' wolck, die, vuijl en voll
Van gereede somer-plassen
Om den hoij-boer te verrassen,
't Lieue licht sijn tintel staeckt;
[...]
'Ksalder mijn gesegh nae setten,
En beslaen mij in de wetten
Die de reden en 'tbescheidt
Heeft gestelt op uw beleidt.

> (Within the house, your countenance | Will be discourse's governor; | If it should set, like meaner stars, | Which are the harbingers of night, | Or sit in the occluding cave | Of troubled clouds of summer storm | Clouds that surprise the harvester | And rob the farmer of his hay, | That hide your loved and glimmering light | [...] | I'll fit my utterance to you | Speak in subjection to your laws | Which reason and judiciousness | Have imposed upon your acts.)[58]

57 Huygens, *Dagh-werck*, ll. 559–68.
58 Huygens, *Dagh-werck*, ll. 643–51, ll. 657–60.

When his Stella is sad, the anguish that plagues her shall also be his: 'Toverkomen leed sal mijn zijn' (all your sorrows shall be mine).[59] But:

Staen uw' sterren, Sterr, als sterren
Die haer oogh in punten sperren
En betintelen schoon weer
Huijden eerst en merghen weer,
D'eerste locht van ongenucht en
Salmen in mijn oogh niet luchten:
Sondeloose vreughd om vreughd
Kind en moeder van de deughd
Sal ick wisselen en ruijlen.

> (Stella, when your eyes shall open | Wide as points of starling shining, | Glimmering to portend fair weather | For tomorrow, for today. | Then my eyes shall find but pleasure | Joy and innocence combining | Virtue's mother, virtue's child, | All your joys I shall requite you.)[60]

When Stella is radiant, happy, and cheerful, then he shall take part in her joy.

Uyt de wegh ontijdigh pruijlen,
'Tleuen is soo korten spann,
'Tslapen steelt'er soo veel van,
Kleeding, reeding alle morgen,
Straetsche, Staedsche, steedsche sorgen,
Elck ontsnijdt het sulcken sné
Dat sij 't van de vier op twee
Vande twee op een verenghen:
Maer 't genoeghen kan 't verlengen,
Tweemael is, die welgesint
Allerzijds genoeghen vindt.

> (Worries, begone: | Life is short enough already, | Sleep steals much of it away, | Rising, dressing every morning, | Cares of street and state and city | Take their share of time allotted | Cutting time away, reducing | Four to two and two to one. | But life's lengthened lived in pleasure: | He who seeks joy every moment | Doubles his allotted span.)[61]

59 Huygens, *Dagh-werck*, l. 665.
60 Huygens, *Dagh-werck*, ll. 717–25.
61 Huygens, *Dagh-werck*, ll. 726–36.

He, she, they shall find this joy, Huygens maintains:

> 'Tsal voor eens gevonden blijven,
> En gemackelick beklijven
> Als het entjen aenden tack,
> Als aen een gesmolten lack.

> (Joy then will be found forever | Found forever and remain, | As
> the buds which end the branches, | As the wax fused by the seal.)[62]

Whether Stella is feeling sad or happy, their conversation will unfold as follows:

> Sulcke sal de tweespraeck wesen,
> Stilleswijgend', van ons wesen,
> Sprekende, van beider mond,
> Still of niet, van ijeders grond;
> Still en sprekend' onder 'tmalen
> Onser dagelickscher maelen,

> (Such will be our discourse; silent | Countenance and mute
> expression, | Speaking tongues' articulation. | Silent, speaking,
> minds together; | Eloquent or mute together | As we take our daily
> meals.)[63]

This 'stilte van twee menschen' (silence of two spirits) that both understand tacitly, fully, without words during their mealtime is yet another telling description of their intimacy.

After a simple meal, there will be time — as I described above — for a walk, either together or alone. In the description of these afternoon activities, Huygens continues to address himself to Stella. The poem is still a monologue. Here, the perspective remains his as well. The affairs described are Constantijn's. He networks, makes connections, and writes further — for example, about the need for a walk after eating, insight into one's own mistakes, the landscape around The Hague, his discoveries with the microscope, and the wisdom that he finds in his library. Huygens must then stop at the description of books on state law in his library, although he had wanted to discuss each of its substantive sections. As previously indicated, he cannot complete the description of the rest of the day that he and Susanna should have passed together. There is only a diagram of the overall scheme and a sort of justification in prose for the incompleteness.

In the closing prose passage, dated 12 July 1638, Huygens says that his intention was to wander in the same manner through the 'boeck-kamer' (book room), and along the way to articulate his own opinions on all the

62 Huygens, *Dagh-werck*, ll. 745–48.
63 Huygens, *Dagh-werck*, ll. 749–54.

disciplines.[64] He had wanted to discuss even the smallest activities during the stolen hours at home, just as they were: the garden, music, painting, drawing, moulding, casting, turning, etc. He would have liked to contrast the useless pastimes of chess, dames, or tric-trac with truly useful and agreeable physical exercise, such as horse riding, ball games, and dancing. After the description of the afternoon hours, he would have gone back to court. Having returned home, a light evening meal and a communal prayer with his family would have formed another part of the poem. He would have devoted a few words to the upbringing of the children. Alas, he says, 'mijn' lieve leester, dien dit eenigh te gevalle gewrocht werde, dieder mij in steunde en stierde, die mij leerde wat sij hooren wilde, ontviel mij' (my beloved reader, for whom this was written, who supported and directed me in it, who taught me what she wanted to hear, has slipped away from me).[65] At the end of this prose discourse, overcome with sorrow, Huygens finds consolation in Petrarch's *Canzoniere*, from which he cites a few lines of verse, including 'Anzi tempo per me nel suo paese | E ritornata, et alla par sua STELLA' (she too early for me has returned to her own country and to her star which is worthy of her) and 'E compiè sua giornata inanzi sera' (And completed my day before evening).[66]

Conclusion

The Day's Work is a poem with which the poet Constantijn Huygens declares his love for his better half, Susanna van Baerle. They are bound to one another in marriage through heavenly decree, and together they form a unified entity. They understand each other without words, and they can literally and figuratively read and write with one another. They create *The Day's Work* together. Constantijn, the celebrated poet, began the composition. He let Susanna read or hear his text, and she offered comments on it that he in turn incorporated into subsequent versions. The poem is a monologue to Susanna in Constantijn's words. In the poem, he frequently speaks directly to her. He names her 'Stella' and plays in the poem with the significance of the star, which can twinkle or grow dim.

They find their ultimate happiness in their ability to understand each other, whether in a coach or in their own house during a meal. Their unity is their world, and within it they find their most extensive intimacy. This world is situated in *The Day's Work* within the walls of their home. The private and personal is juxtaposed against the public. The concerns of the street, city,

64 Huygens, *Dagh-werck*, p. 153.
65 Huygens, *Dagh-werck*, p. 156, ll. 48–49, l. 51.
66 Huygens, *Dagh-werck*, p. 156, translation taken from Durling, *Petrarch's Lyric Poems*, sonnet 289, ll. 3–4, and sonnet 302, l. 8.

and state remain literally outside the door.[67] They can avoid interrupting the harmonic peace of their house and marriage. Home is private.

But despite the unity and equality between the two partners extolled in *The Day's Work*, the marriage described here retains a traditional husband-wife relationship.[68] The wife is at home, while the husband works outside the home. The married woman is socially dependent on her spouse. This was true even for Susanna van Baerle, who was lauded by her husband as 'femininely beautiful with manly purpose' and as 'virtutis imago' (the paragon of manly virtue), and who demonstrated her independent opinions on the poetry of Hooft and Huygens, or the science and philosophy of Descartes.[69] This traditional distribution of roles produces beautiful passages in *The Day's Work*, in which Constantijn describes his function as the link between the domestic space, the world of the 'huysvrouw' (housewife) Susanna, and the outside world of court, state, and knowledge, where he plays an important role.

To this end, Huygens uses the image of the camera obscura, the instrument improved by Drebbel and capable of projecting images of the exterior through a lens indoors. This not only provides a compelling comparison between home and street — between private and public — but also encapsulates what Huygens does in *The Day's Work*. He presents himself in this poem as a loving spouse, a devout Christian, and a hardworking servant of Frederik Hendrik, but also an erudite scholar with a library that is well stocked and up to date on modern insights into the natural sciences. Optics particularly enthralled him.[70] Much-improved instruments such as the telescope and the microscope, and in conjunction the disciplines of astronomy and biology, held a powerful allure for him. In her 'pioneering work in the English language on Huygens' — here I agree with and cite Lisa Jardine[71] — Rosalie Colie maintains that 'Huygens, good innovator, brought back from his English journey the themes of the new science for Dutch poetry'. She called *The Day's Work* 'one of the earliest "physicotheologies" of the seventeenth century'. She sees the scientific content of *The Day's Work* as 'part of the reason for its "obscurity"'.[72]

Another reason for the difficulty in understanding *The Day's Work* lies in Huygens's ideal style of *obscuritas*. On the one hand, he did not want to dole out long, drawn-out rhymes; on the other, he did not like poetry that led the reader into a 'doolhof' (maze).[73] His poetry had to be powerful, pithy, surprising, and written in clear language. He defined this ideal in *The Day's*

67 This is a fine example of the overlap between home/household and state/society. See Bruun's 'heuristic zones' in *Work Method*.

68 Grootes, 'Hoe te leven', p. 20.

69 Huygens, *Hofwijck*, lines 1886–87; Blom and Leerintveld, 'Vrouwen-schoon met Mannelicke', p. 113.

70 Leerintveld, 'Huygens eert Huygens', pp. 29–30.

71 Jardine, 'The Reputation of Sir Constantijn Huygens', p. 45.

72 Colie, *Some Thankfulnesse to Constantine*, p. 112.

73 Huygens, *Dagh-werck*, l. 1368.

Work, and he also put it into practice. Not all of the fellow poets who read the poem in manuscript were impressed by the work. Vondel and Mostart gave critical comments. Hooft was genuinely enthusiastic and thought that Vondel sometimes made overly petty critiques. He believed that the lively rays of Huygens's excellence could dispel the darkest mists and turn 'midnight' into 'midday'.[74] Hooft enjoyed Huygens's ideal style but apparently still deemed some parts of the poem too obscure.[75] Huygens did not change a single letter of the poem, but with publication in mind, and probably influenced by Hooft's veiled criticism, he clarified passages from *The Day's Work* in prose. It was not until 1658 that *The Day's Work* saw the light of day as a publication.

In *The Day's Work*, as he himself wrote in a letter to his friend Erycius Puteanus (1574–1646) in Leuven, Huygens, 'exposed the complete Huygens' ('in hoc Poemate non diffiteor totum me Hugenium exeruisse').[76] Huygens was therefore aware that in this poem he had revealed private matters and simultaneously presented a self-image of his own choosing. This combination makes *The Day's Work* a unique, personal work of art from 'Holland's foremost and most widely remembered virtuoso', Constantijn Huygens.[77]

74 Hooft to Huygens, Amsterdam, 21 February 1639: 'Gemerkt het met de scherpe straelen zijner aerdighejt de dompighste dujsterhejt konde doen verdwijnen, en midnacht tot middagh maeken'. Hooft, *De briefwisseling*, III, no 946; Huygens, *Correspondence*, no. 2047.

75 In a letter to Huygens dated 21 February 1639, Hooft talks about the 'dompighste dujsterhejt' (most misty darkness) of the poem. Hooft, *De briefwisseling*, III, no. 946; Huygens, *Correspondence*, no. 2047.

76 Huygens to Puteanus, Bergen op Zoom, 25 June 1638. Huygens, *Correspondence*, no. 1860; Huygens, *Dagh-werck*, pp. 2–3.

77 Jardine, 'The Reputation of Sir Constantijn Huygens', p. 64.

Works Cited

Manuscripts and Archival Sources

Amsterdam, Allard Pierson, OTM hs. 27 A 4
The Hague, Koninklijke Bibliotheek, KW KA 40ª, 1638

Primary Sources

Barlaeus, Caspar, *Poematum editio nova* (Lugdunum Batavorum: Ex officina Elzeviriana, 1641)

Hooft, P. C., *De briefwisseling van Pieter Corneliszoon Hooft*, ed. by H. W. van Tricht, 3 vols (Culemborg: Tjeenk Willink/Noorduijn, 1976–1979)

——, *De gedichten*, ed. by Johan Koppenol and Ton van Strien (Amsterdam: Athenaeum, Polak & Van Gennep, 2012)

Huygens, Constantijn, *Correspondence* <http://resources.huygens.knaw.nl/briefwisselingconstantijnhuygens/> [accessed 4 November 2020]

——, *Dagh-werck van Constantijn Huygens*, ed. by F. L. Zwaan (Assen: Van Gorcum and Comp, 1973)

——, *De gedichten van Constantijn Huygens, naar zijn handschrift uitgegeven door dr. J. A. Worp: Tweede deel, 1623–1636* (Groningen: Wolters, 1893)

——, *Hofwijck*, ed. by Ton van Strien, 2 vols (Amsterdam: KNAW Press, 2008)

——, *Koren-bloemen, Nederlandsche Gedichten Van Constantin Huygens Ridder, Heere van Zuylichem, Zeelhem, ende Monickeland: Eerste Raad ende Rekenmeester van S. Hoocheit den Heere Prince van Orange, in XIX Boecken* ('s Graven-Hage: By Adriaen Vlack, 1658)

——, *Mijn jeugd*, trans. by C. L. Heesakkers (Amsterdam: Em. Querido, 1987)

——, *Mijn leven verteld aan mijn kinderen in twee boeken*, trans. and ed. by Frans R. E. Blom, 2 vols (Amsterdam: Prometheus/Bert Bakker, 2003)

——, *Nederlandse gedichten 1614–1625*, ed. by Ad Leerintveld, 2 vols (The Hague: Constantijn Huygens Instituut, 2001)

——, *Otiorum libri sex* (Den Haag: Aert Meuris, 1625)

——, 'Vrij-dicht', in *Tien gedichten van Constantijn Huygens*, ed. by F. L. Zwaan (Assen/Amsterdam: Van Gorcum, 1976), pp. 80–117

Verscheyde Nederduytsche gedichten van Grotius, Hooft, Barlaeus, Huygens, Vondel en anderen versamelt door J V. J S. T V D. B. G P. C L B. (Amsterdam: Voor Lodewijck Spillebout, 1641)

Secondary Studies

Bachrach, A. G. H., *Sir Constantine Huygens and Britain, 1596–1678: A Pattern of Cultural Exchange* (Leiden: Leiden University Press, 1962)

Bisschop, Geeske, '"Dat hi in d'crijch moet leeven en sterven": Militaire patronage in de correspondentie van Constantijn Huygens, 1625–1650' (unpublished master's dissertation, University of Leiden, 2020)

Bloemendal, Jan, and Ad Leerintveld, 'De "literaire" vriendschap tussen Constantijn Huygens en Dorothea van Dorp: Een verliefde jongen te rade bij een emblematicus?', *Spiegel der Letteren*, 47.3 (2005), 275–85

Blom, F. R. E., 'Solliciteren met poëzie: Zelfpresentatie in Constantijn Huygens' debuutbundel *Otia* (1625)', *De zeventiende eeuw*, 25.2 (2007), 230–44

——, 'Building in Stones and Words: Strategies of Self Presentation in Huygens' Volumes of Collected Poetry', in *Return to Sender: Constantijn Huygens as a Man of Letters*, ed. by Lise Gosseye, Frans Blom, and Ad Leerintveld (Ghent: Academia Press, 2013), pp. 3–22

Blom, Frans R. E., and Ad Leerintveld, '"Vrouwen-schoon met Mannelicke reden geluckigh verselt": De perfect match met Susanna van Baerle', in *Vrouwen rondom Huygens*, ed. by Els Kloek, Frans Blom, and Ad Leerintveld (Hilversum: Verloren, 2010), pp. 97–114

Bruun, Mette Birkedal, *Privacy Work Method* (2019) <https://teol.ku.dk/privacy/research/work-method/privacy_work_method.pdf> [accessed 4 November 2020]

Colie, Rosalie L., *'Some Thankfulnesse to Constantine': A Study of English Influence upon the Early Works of Constantijn Huygens* (The Hague: Martinus Nijhoff, 1956)

Davidson, Peter, and Adriaan van der Weel, *A Selection of the Poems of Sir Constantijn Huygens (1596–1687): A Parallel Text Translated, with an Introduction and Appendices* (Amsterdam: Amsterdam University Press, 1996)

Durling, Robert M., ed., *Petrarch's Lyric Poems: The Rime Sparse and Other Lyrics*, trans. by Robert M. Durling (Cambridge, MA: Harvard University Press, 1979)

Frijhoff, Willem, 'Marnix over de opvoeding', in *Een intellectuele activist: Studies over leven en werk van Philips van Marnix van Sint Aldgonde*, ed. by H. Duits and T. van Strien (Hilversum: Verloren, 2001), pp. 59–75

Gosseye, Lise, Frans Blom, and Ad Leerintveld, eds, *Return to Sender: Constantijn Huygens as a Man of Letters* (Ghent: Academia Press, 2013)

Groenveld, Simon, '"C'est le père, qui parle": Patronage bij Constantijn Huygens (1596–1687)', *Jaarboek Oranje-Nassau Museum* (1988), 52–107

——, '"Een out ende getrouw dienaer, beyde van den staet ende welstandt in t'huys van Orangnen": Constantijn Huygens (1596–1687), een hoog Haags ambtenaar', *Holland, regionaal-historisch tijdschrift*, 20 (1988), 3–32

Grootes, E. K., 'Het arbeidsethos van Constantijn Huygens', *Literatuur*, 96.6 (1996), 361–65

——, 'Hoe te leven, hoe te overleven? Huygens' *Dagh-werck* en Hoofts *Dankbaar genoegen*', Fifth Golden Age Lecture, Centrum voor de Studie van de Gouden Eeuw, Amsterdam, 30 October 2008

Heer, A. R. E. de, and A. Eyffinger, 'De jongelingsjaren van de kinderen van Christiaan en Constantijn Huygens', in *Huygens herdacht: Catalogus bij de tentoonstelling in de Koninklijke Bibliotheek ter gelegenheid van de 300ste sterfdag van Constantijn Huygens*, ed. by Arthur Eyffinger (The Hague: Royal Library of the Netherlands, 1987), pp. 89–165

Hofman, Hendrik Arie, *Constantijn Huygens (1596–1687): Een christelijk-humanistisch bourgeois-gentilhomme in dienst van het Oranjehuis* (Utrecht: HES, 1983)

Jardine, Lisa, *Going Dutch: How England Plundered Holland's Glory* (London: Harper Press, 2008)

——, 'The Reputation of Sir Constantijn Huygens: Networker or Virtuoso?', in *Temptation in the Archives: Essays in Golden Age Dutch Culture* (London: UCL Press, 2015), pp. 45–64

Joby, Christopher, *The Multilingualism of Constantijn Huygens (1596–1687)* (Amsterdam: Amsterdam University Press, 2014)

Leerintveld, Ad, 'De "S" van Sterre', in *In de zevende hemel: Opstellen voor P. E. L. Verkuyl over literatuur en kosmos*, ed. by H. van Dijk, M. A. Schenkeveld-Van der Dussen, and J. M. J. Sicking (Groningen: Passage, 1993), pp. 9–13

——, 'Constantijn Huygens's Library', in *Crossing Boundaries and Transforming Identities: New Perspectives in Netherlandic Studies*, ed. by Margriet Bruijn Lacy and Christine P. Sellin (Münster: Nodus Publikationen, 2002), pp. 11–18

——, 'Huygens eert Huygens', in *In opdracht van Huygens: De ontdekking van bijzondere stillevens met boeken ter ere van Constantijn en Christiaan Huygens*, ed. by Saam Nijstad and Ad Leerintveld (Voorburg: Huygensmuseum Hofwijck, 2008), pp. 24–35

——, *Constantijn Huygens: De collectie in de Koninklijke Bibliotheek* (Amersfoort: Bekking and Blitz, 2013)

Mook, Willem, *Proba me Deus* (Spaarne SP 0601, 2006) [CD]

Pieters, Jürgen, *Op zoek naar Huygens: Italiaanse leesnotities* (Ghent: Poëziecentrum and Koninklijke Academie voor Nederlandse Taal- en Letterkunde, 2014)

Porteman, Karel, and Mieke B. Smits-Veldt, *Een nieuw vaderland voor de muzen: Gescheidenis van de Nederlandse literatuur 1560–1700* (Amsterdam: Bert Bakker, 2008)

Schenkeveld-van der Dussen, M. A., 'Bridging Two Cultures: The Story of the Huygens Family', *The Low Countries*, 5 (1997–1998), 178–85

——, 'Duistere luister: Aspecten van obscuritas', in *In de boeken, met de geest: Vijftien studies van M. A. Schenkeveld-van der Dussen over vroegmoderne Nederlandse literatuur, uitgegeven bij haar afscheid als hoogleraar van de Universiteit Utrecht op 31 oktober 2002*, ed. by A. J. Gelderblom, E. M. P. van Gemert, M. E. Meijer Drees, and E. Stronks (Amsterdam: Amsterdam University Press, 2002), pp. 153–73

Seggelen, André van, 'Huygens' Franse Poëzie', *De zeventiende eeuw*, 3.2 (1987), 71–78

Strengholt, L., 'Dagh-werck: Gedicht over voornemens', in *Huygens-studies: Bijdragen tot het onderzoek van de poëzie van Constantijn Huygens*, ed. by L. Strengholt (Amsterdam: Buijten en Schipperheijn, 1976), pp. 93–99

——, *Constanter: Het leven van Constantijn Huygens* (Amsterdam: Em. Querido, 1987)

Van der Stighelen, Katlijne, and Jeanine De Landtsheer, 'Een *suer-soete Maeghd* voor Constantijn Huygens: Anna Maria van Schuurman (1607–1678)', in *Vrouwen rondom Huygens*, ed. by Els Kloek, Frans Blom, and Ad Leerintveld (Hilversum: Verloren, 2010), pp. 149–202

TIRTSAH LEVIE BERNFELD

Withdrawn and Secretive

*Privacy among Portuguese Jews
in Early Modern Amsterdam*

Privacy as a concept cannot be found explicitly formulated in the records of the Dutch Sephardim of the early modern period.[1] This was a community that arose out of nothing in Amsterdam, formed by former *conversos* or New Christians who became New Jews after fleeing the Iberian peninsula and the Spanish and Portuguese Inquisitions at the end of the sixteenth century.[2] It is not surprising that the concept is never mentioned: privacy — in the sense of the ability of an individual or group to seclude itself or information about itself, and thereby to express itself selectively — is not really in use as an idea within any Dutch context before the nineteenth century.

Privacy as we know it today can be revealed in different 'heuristic zones', as devised by the Centre for Privacy Studies at the University of Copenhagen. These zones provide us with a framework to analyse aspects of privacy in different spheres: society, community, home, household, chamber, body, and soul.[3] The boundaries and content of what is considered private differ among cultures and times.

This chapter focuses on privacy among the Portuguese Jews of early modern Amsterdam, at both communal and private levels. It discusses communal policy regarding the privacy of individual members. It is also concerned with the private zone as seen through the prism of records such as letters, wills, and domestic inventories.

Let us first look at the parameters that created the concept of privacy among the Portuguese Jews of early modern Amsterdam. To begin with, this leads us back to the Iberian peninsula.

1 With thanks to Dr Rudolf Dekker for his comments on an earlier version of this paper.
2 Kaplan, 'The Jews in the Republic Until about 1750'; Kaplan, 'Between Christianity and Judaism'; Kaplan, *Minotsrim*.
3 Bruun, 'The Centre for Privacy Studies', pp. 3–5.

Tirtsah Levie Bernfeld is an independent scholar. She specializes in European Jewish History, concentrating in particular on social and cultural aspects of the Sephardi community of early modern Amsterdam.

Private Life and Privacy in the Early Modern Low Countries, ed. by Michael Green and Ineke Huysman, EER 19 (Turnhout: Brepols, 2023), pp. 173–196
BREPOLS ❦ PUBLISHERS 10.1484/M.EER-EB.5.132534

Historical Background: Inquisitions and *Conversos*

Life for *conversos* on the Iberian peninsula was enveloped in secrecy. The Spanish and Portuguese Inquisitions fixed their gaze on anyone that did not truly adhere to Catholicism, and on crypto-Jews in particular. Any suspicion that one practised Judaism could not only mean loss of honour but also lead to imprisonment, banishment, sequestration of goods, and even death at the stake.

Therefore, the inner worlds and domestic family lives of these *conversos* were heavily protected spaces. They had to maintain a façade towards the outside world, behaving as devout Catholics even while many of them secretly held onto Jewish practices at home.[4] By maintaining such postures, they were able to prevent enquiries into their religious experience by the Inquisition or other authorities.

It looks as if these former *conversos* internalized these attitudes, forging them into a special way of life once they reached the more openly Jewish world of places such as Amsterdam. Even here, they were not totally free from the Inquisition's spies, who endangered their lives. Moreover, information gathered by these spies could reach their families back on the peninsula.[5] The aura of secrecy thus continued and became rooted in Amsterdam soil. The policy of the Amsterdam-based international dowry society Dotar serves as an example.[6] It guarded the privacy of members who had not yet arrived at a Jewish centre, keeping their names hidden as *auzentes* (absentees) in sealed secret notes (*escritos secretos*).[7] Only after their arrival in communities where Judaism could be openly professed would the administrators dare to note down these members' names in full.

4 On the life of *judeoconversos* on the peninsula in the early modern period, see for example the bibliography of Haim Beinart in Beinart Kaplan, 'A Bibliography'; Bodian, *Hebrews*, Chapter 1; Yerushalmi, *From Spanish Court*, Chapter 1; Caro Baroja, *Los Judíos*. On the daily life of *conversas*, see Levine Melammed, *Heretics*.

5 Roth, *Het vreemde geval*; Levie Bernfeld, *Poverty and Welfare*, pp. 25, 222, 282 n. 98.

6 On the activities of Dotar, which provided dowries to members of the Spanish Portuguese Jewish nation, see Levie Bernfeld, *Dowries and Dotar*.

7 For examples of these *auzentes*, including one of the founders of Dotar, see Amsterdam, City Archives 334, 1144, p. 21/13, 20, 16 Adar 5475; Amsterdam, City Archives 334, 1144, p. 17, 119, 5395; Amsterdam, City Archives 334, 1144, p. 24/32, 299, 300, 301, 5419; Amsterdam, City Archives 334, 1144, pp. 24–25, 318, 319, 320, 326, 5421; Amsterdam, City Archives 334, 1144, p. 26/61, 370, 5427; Amsterdam, City Archives 334, 1144, pp. 129, 11 Tishri 5428. Normally their names would be written in sealed notes (Amsterdam, City Archives 334, 1144, pp. 313, 14 Nisan 5430). See also Levie Bernfeld, *Dowries and Dotar*, pp. 30–31 (NB 'Juda' on p. 31 should read 'Jacob'). One of the notes explicitly states that it deals with a secret note: Amsterdam, City Archives 334, 1144, pp. 15, 81, 5383.

The Ethnic-Religious Element

The idea of being a nation apart, which had already existed on the peninsula (the Spanish-Portuguese Jewish nation, or *a nação/la nación*), stimulated the attitude towards the stricter protection of privacy among Portuguese Jews in early modern Amsterdam. The fact that these former New Christians were integrated yet simultaneously marginalized in Spanish and Portuguese societies created a special group identity, and determined a distanced attitude among Spanish and Portuguese Jews towards the Jews from different backgrounds whom they encountered in their new place of refuge. Anyone not belonging to the *nação* was often not accepted into the community and its various organizations, being considered secondary. This 'members-only' attitude stimulated a life of privacy, at a distance from others outside one's own circle.[8]

Pride and Honour

The feeling of being different — a nation apart — was also fed by the notion of superiority, pride, and honour, a widespread phenomenon in Spanish society. Successful integration into the noble class, or into other 'honourable' segments of society, filled many a Spaniard with feelings of pride, purity, and superiority, including a sense that one was aloof from those 'tainted' by Jewish or Moorish blood. The *conversos* internalized these traits and gave expression to them in their new place of refuge. They approached Jews from other backgrounds with a similar attitude of pride and superiority, refusing to admit them into their caste, just as they themselves had so often been excluded in their country of birth. They often treated non-Portuguese Jews with arrogance and disrespect. Thus, Portuguese Jews, influenced by these Spanish ideas, gave expression to them through their behaviour and appearance in their new environment. Moreover, as heirs to Spanish Jewry's glorious Golden Age of the tenth and eleventh centuries, they also considered themselves the aristocracy of the Jewish nation, and so they put on airs, aloof from and supposedly superior to Jews from other nations.[9] There was also cause for embarrassment from within, however: as 'wealthy cosmopolitans' and successful merchants, they feared a loss of reputation resulting from the growing poverty among their ranks. They tried to cover it up, hiding this aspect of communal life from the outside world as best they could.[10]

8 On the ethnic-religious aspect of the community, see Kaplan, 'Between Religion and Ethnicity'; Kaplan, 'Political Concepts'; Kaplan, 'Wayward New Christians'; Kaplan, 'Between Christianity and Judaism'. With regard to welfare policy, see Levie Bernfeld, *Poverty and Welfare*, pp. 83–86.
9 On the feeling of superiority and nobility of Sephardim over other Jews, see Kaplan, 'Political Concepts', pp. 50–51, 60; Kaplan, 'The Self-Definition', pp. 138–39; see also Graizbord, 'Religion and Ethnicity', pp. 47–48.
10 See Levie Bernfeld, *Poverty and Welfare*, pp. 96, 175, 177, 229; Defourneaux, *Daily Life*,

176 TIRTSAH LEVIE BERNFELD

All these ingredients together led the Portuguese Jewish community to protect its inner private circles. This is in sharp contrast to the lack of privacy in the circles of the privileged Reformed Church, for example, as can be deduced from the detailed manner in which the Church registered issues concerning honesty, shame, and poverty.[11]

Fear and Caution as Underlying Factors for Privacy

The tendency among Dutch Sephardim to protect their privacy was also nurtured by other motives. There was always the worry that their position as a tolerated religious minority might be harmed. Thus, the Portuguese community was eager to protect its status in its new haven of freedom.

In particular, the three restrictions placed on Jews by the municipality (Jews were not allowed to speak or write against Christianity; Jews were not to convert Christians to Judaism; Jewish men should not have sexual relations with Christian women) put Dutch Sephardim on their guard, making them become cautious and withdrawn in order to protect their communal and private lives. These restrictions were issued on the basis of actual incidents, which alerted the Portuguese leadership and put it on its guard, and the leadership issued warnings throughout the early modern period in an attempt to prevent such occurrences.[12]

For example, writings attacking Christianity in order to prove the superiority of Judaism remained mostly in unpublished form.[13] Discussions in the street regarding Christianity versus Judaism were kept to a minimum, or otherwise punished by the communal leadership.[14] Moreover, any member of the Portuguese community who attacked fellow Sephardim for having converted to Christianity was reprimanded, for fear of comments from the municipality or the Reformed Church. As was said in the *Livro de Escamot*

Chapter 2; Casey, *Early Modern Spain*, e.g. Chapter 7; Bennassar, *The Spanish Character*, e.g. Chapter 8.

11 See for example the cases described in Roodenburg, *Onder censuur*, pp. 244–54. Roodenburg specifically confronts the issue of lack of privacy among members of the Reformed Church: Roodenburg, *Onder censuur*, pp. 253–54.

12 On the legal position of the Sephardi Jews, see Huussen, 'The Legal Position', pp. 26–27; see also Swetschinski, 'Settlement, Toleration and Association', pp. 55–60.

13 See for example Saul Levi Morteira's *Providencia de Dios* and Isaac Orobio de Castro's *Prevenciones Divinas a Ysrael*.

14 For an example of members' continuous efforts to convince others to leave Christianity and convert to Judaism, see the case of David Abenasar, who tried to convince two Spanish boys to do so in 1649: Amsterdam, City Archives 5061, 307, p. 255ᵛ, 17 June 1649. See also the case of Eleasar Bassan from Venice, who was arrested for a similar delict in 1657: Amsterdam, City Archives 5061, 312, p. 8, 9 February 1657.

in 1695, 'it damages our position among our neighbours who treated us with so much love and kindness'.[15]

Consequently, the Sephardi community and its board of governors were keen to control the behaviour of its members and thus prevent scandals from reaching the outside world, as this could have grave consequences.[16] Members who might harm the reputation of the community were kept at a distance. Jews with a criminal record were ostracized, sent away, or left to the supervision and punishment of the city government.[17] Begging Ashkenazim too were often sent away, or were removed from visibility on the streets by being shut up in a workhouse established by the Portuguese community during 1642–1670.[18]

No wonder, then, that communal decrees were often couched in hidden and defensive terms, or left without details so as not to be understood beyond the circles of the community's ruling body. Some decisions were not even registered. In this way, the community tried not to reveal any disharmony that might harm its position in the city or in the Republic at large.

Privacy and Secret Books: The *Livros Segredos*

A closer look at a series of 'secret books' composed between 1763 and 1817 can help us to understand the extent to which privacy was guarded by the Portuguese community.[19] Secrets can be defined as intentionally concealed knowledge, according to Daniel Jütte.[20] The secret books formed part of the communal administration and were only intended to be viewed by the president of the community. They deal with issues of privacy that were not meant to come to the surface or be made public.[21] Prior to 1763, cases similar

15 Cited in Amsterdam, City Archives 334, 20, p. 195, 28 Menahem-Av 5455. The warning was issued in relation to the case of a woman scolded by members of the Portuguese community for converting to the Reformed Church in order to get a position as a *turfdraagster* (peat carrier): Levie Bernfeld, *Poverty and Welfare*, pp. 472–73 n. 371. The Amsterdam burgomasters went to complain to the board of governors of the Portuguese community; the board in turn called on members to reveal which aggressors had committed this crime, while promising to keep the names of informers secret: 'que quem tiber noticia do aggressor ou agressores o venha a declarer aos ssres do Mahamad que selhe guardara segredo' (the person who receives information on the aggressor or aggressors should come to declare such with the board of governors, who will keep this [information] secret). See also the case of Sara Lumbrosa in Levie Bernfeld, *Poverty and Welfare*, pp. 215–16.

16 Swetschinski, *Reluctant Cosmopolitans*, pp. 225–77.

17 See the decision cited in in the accords of the nation in 1639, paragraph 45: Amsterdam, City Archives 334, 19, p. 25/110, 22 Tamuz 5399. On sending away the unwanted, see Levie Bernfeld, *Poverty and Welfare*, pp. 39–60.

18 See Levie Bernfeld, *Poverty and Welfare*, pp. 117–21.

19 Amsterdam, City Archives 334, 61–62, 1763–1817: *Livro de segredos*.

20 Jütte, *The Age of Secrecy*, p. 10.

21 Secret books were found not only on the presidential level but also elsewhere in the communal administration, especially when dealing with charity — for example, the

to those noted down in these secret books were only discussed orally, with no written records. Oral communication appears to have created chaos, with agreements denied and left unverified by the next generation of leaders. Therefore, it was decided in 1763 that as of that moment — in contrast to one and a half centuries of oral settlements — presidents should note such cases in secret books that only the president of the board and his successors were allowed to consult.[22]

These books deal with various issues, such as the honour of women, adultery, illegal weddings, the reputations of merchants, financial disputes, and family fights. The leadership apparently did its utmost not to let these cases become known to the public, or even worse to reach the city authorities. The reputation of the community was at stake here, and the protection of privacy was thus of the utmost importance. However, although the books were considered secret and private, even here the community took care not to elaborate on issues in detail. This is in striking contrast to the similar 'secret books' of other denominations, or those of the city authorities, including the judicial arm, where secret books were a normal phenomenon.

In the secret books of non-Jewish society, issues were registered in full detail. The secret books of the municipal authorities, for example, contain political decisions, explicitly recorded.[23] Some notaries had secret registers, but the content of these did not differ much from ordinary minutes, as both contained detailed descriptions.[24] The leadership of the Dutch Republic also tried to keep state affairs secret, although not always successfully.[25]

Livro de segredos containing names of the shameful poor: Amsterdam, City Archives 334, 973: 1733–1817. Furthermore, in the distribution of some legacies, such as that of Jahacob Mazahod in 1721, a differentiation was applied by the community, as follows. One of the two books used for distribution was meant for the registration of the secret poor, i.e. those who had applied for a gift through secret petitions, with such gifts being handed out exclusively by the board: Amsterdam, City Archives 334, 736, Estate Jacob Mazahod, register of yearly distributions to people on welfare through the official community channels, 1721–1918 (5481–5678). The second book registered yearly distributions to people not provided with welfare through official community channels, 1721–1865: Amsterdam, City Archives 334, 737, Estate Jacob Mazahod, especially p. 1, 7 Elul 5481.

22 Amsterdam, City Archives 334, 61, p. 1, 6 Nisan 5523.

23 Amsterdam, City Archives 5025, 161–62: 1663–1725; 1684–85: 'Secrete resoluties van de vroedschap'.

24 An example is the notary Hendrik Outgers, who also had Jews among his clients. We can only guess as to the reason why notaries used such secret registers: perhaps the people mentioned in these books, including Jews, preferred to guard their privacy to the utmost and keep their personal issues as secret as possible, including their last wills, their inventories, their contracts, and their conflicts. See for example the last will of Salomon de Lima: Amsterdam, City Archives 5075, 3378, Not. H. Outgers, pp. 45ᵛ–47 (here p. 46), 8 May 1692. For an example of conflict, see the inheritance of the Portuguese-Jewish Aboab Lopes family: Amsterdam, City Archives 5075, 3378, 57, pp. 116ᵛ–121, 8 December 1692; Amsterdam, City Archives 5075, 3378, 116, pp. 220–43, 21 October 1693, inventory of Jacob Bueno de Mesquita.

25 Bruin, *Geheimhouding en verraad*. On secrecy in politics, see also Jütte, *The Age of Secrecy*, Chapter 1.

In the secret files of the city's judiciary, the *secrete Confessieboeken*, cases were registered if they were politically sensitive or related to boundary-crossing sexual behaviour (sodomy or paedophilia).[26] Despite (or perhaps because of) the fact that such crimes were considered grave at the time, they were still registered in full detail. One case in these secret *Confessie* books refers to a Jew, namely Jacob Gamis, a sixty-year-old Sephardi from Hamburg, whose sexual abuse of an eleven-year-old girl we can read about in detail.[27] One would never find such cases specified in the administration of the Portuguese community, secret or not.

Let me compare Gamis's case, as described by the judicial city authorities, with one discussed in the *Livros de segredos*, the secret books of the Portuguese community. The case deals with a couple trying to protect their own privacy. On a Thursday night in 1764, a married woman, described here as 'of our nation' (her name kept secret!), was seen entering a 'public and indecent house' in the company of a well-known man, a *parnas* (governor) of the Portuguese community. In contrast to the woman, his name is mentioned explicitly: Jacob Jessurun Barzilay.[28] After one and a half hours, the couple were observed leaving the tavern together. The 'indecent house', apparently some sort of brothel, was situated outside the Jewish neighbourhood. It must have been chosen because it was unexceptional, with the intention that this would protect the couple's privacy. But this was a secret enterprise that came out into the open; what had been conceived as private became public. Bystanders — members of the Portuguese community — had apparently followed the couple or been present in the same tavern, and had run back to report the event that same night to Haham Salem, an Amsterdam rabbi in 1761–1781. The following day, these people also communicated the case to the president of the community; a few days later, they were summoned as witnesses to appear before the entire board of the community. Barzilay, who was called upon to testify, apparently fled this embarrassing situation by leaving the city, and he was therefore condemned *in absentia*: a prohibition on holding any positions, a thousand guilders to be paid to the welfare fund, and a punishment deemed fit by Haham Salem. Only on his return two years

26 For the *secrete Confessieboeken*, see Amsterdam, City Archives 5061, 533–40: 1618–1810. For *Confessieboeken*, see Amsterdam, City Archives 334, 5061, nos 269–532: 1534–1811. The *Confessieboeken* recorded interrogations and punishments relating to crimes.

27 Amsterdam, City Archives 5061, 534, 23–24 April 1659, 20 May 1659.

28 Between 1758 and 1764, Jacob Jessurun Barzilay held various leading positions within the community, functioning as the communal treasurer among other things: see Amsterdam, City Archives 334, 250, pp. 26, 31, 33, 62, Nisan 5518–19; see particularly Amsterdam, City Archives 334, 22, p. 213, 25 Tebet 5519; Amsterdam, City Archives 334, 22, p. 237, 4 Tebet 5422; Amsterdam, City Archives 334, 22, p. 247, 2 Nisan 5524; Amsterdam, City Archives 334, 155, pp. 7 (5518, 5521, 5522), 34 (5511, 5521), 41 (5518), 51 (5518, 5521, 5523); on p. 51 of the latter, next to the function of *parnas* of the Mahamad, it says 'se despediu de Jahid', meaning that he left the community.

later did Barzilay settle the issue by paying the fine, after which the case was secretly closed.

Thus, even though we are dealing here with a sensitive issue couched in serious terms as being against 'Holy Law' and 'human society', the community refrained from registering details of the interrogation and testimonies, even in its secret books, in contrast to the judiciary of the city.[29] Moreover, this case was only mentioned in the communal secret register, with no trace to be found in the books recording official decisions. Or is there an allusion to this case in a cryptic decree issued at the same time, forbidding (young) people from visiting public houses and taverns late at night, playing violent games, indulging in other dishonourable pastimes, and causing serious conflicts?[30] Was it because of the presence of such youths in the same tavern that Barzilay and the woman were detected? At any rate, the privacy of the couple was protected in the end, especially for the woman involved. Why was her position guarded so heavily?

Women and Privacy

As the Portuguese community, for various reasons, maintained a strict supervision of privacy, it was particularly on its guard when dealing with women. The obsession with women's honour can be traced back to Spanish culture, which had been influenced in turn by the Arab presence on the Iberian peninsula. This obsession strongly affected the attitude of Portuguese Jews towards women of their 'nation' and influenced their stance on privacy, in the sense that the privacy of Sephardi women of the diaspora was much more strongly protected than that of women in other communities. For example, a striking difference can be observed between the restricted freedom of movement of Sephardi women in the Dutch Republic and the liberty enjoyed by Ashkenazi women. The restrictions placed on Sephardi women are even more striking when compared with Dutch women, who were renowned for their exceptional independence and freedom of movement.[31]

The community and its organizations issued many decrees relating to female behaviour, including dress codes. Admonishments to keep order

29 For a description of this incident, see Amsterdam, City Archives 334, 61, pp. 3–4, 8; 9–10-12 Elul 5524 and 4 Ab 5526; p. 4: 'e sendo semellantes liviandades e deshonestidas tao deffendido p. nossa santa ley & contraria a soçiedade humana, se discurio com toda atençao sobre este grave cazo' (and as such immoral behaviour is so much kept at a distance by our Holy Law and is contrary to human society, this serious case is being discussed with complete attention).

30 Amsterdam, City Archives 334, 22, pp. 249–50, 26 Elul 5524. See also the sermon of Haham Salem on 9 Av 5525 (one year later) uttering criticism of the licentious behaviour of certain people, cited in Kaplan, 'Secularizing the Portuguese Jews', p. 107.

31 See Levie Bernfeld, 'Sephardi Women', pp. 177, 182.

at home and run a perfect (and kosher) household were also issued.[32] Moreover, the board particularly tried to restrict the movement of women in open spaces, especially that of unmarried young girls, who were not to go into the streets unaccompanied.[33] As well as this, women were not allowed to visit the synagogue in the early morning or at night, nor to be seen in the area surrounding the synagogue during these hours.[34] Apparently, concrete cases of improper behaviour had led to these decrees. It is well known that the synagogue at the time (Houtgracht) was surrounded by taverns and brothels and known for its lively nightlife.[35] This was not considered the right environment for the entertainment of Sephardi females, whose honour was deemed to be at risk. In all, the communal leadership and other members tried to control the space in which females were allowed to operate. In this way, the western Sephardi lifestyle — the *bom judesmo*, a polite and honourable form of Jewish behaviour (in the eyes of the western Sephardim, at least) — could be imposed on all.[36]

Women certainly did not always stick to the rules, which may have been formulated due to boundary-crossing behaviour. Quite often we find cases where they fought back, striving for more freedom of movement.[37] Eva Cohen Pallache (?1655–?1720) is one example. She was certainly a victim of a heavily guarded private environment. She was a young Sephardi girl from a wealthy cosmopolitan family. As such, she was strictly supervised, yet she managed to breach the system. Punished for frequenting churches and longing to convert, she was ordered by her mother to stay in her room for a couple of months to avoid any further contact with the outside world, including visits to her harpsichord teacher, who was the organist at Delft's New Church, and to her wealthy brother in The Hague, where she had fallen in love with his Christian servant.[38]

On this case, the Portuguese sources are silent. We would not know of Cohen's inner private world, her family life, or her fight for freedom (and thus her right to privacy) if not for the fact that her case was brought before a non-Jewish court. The interrogation of various witnesses brought several issues into the open. In addition, information drawn from Cohen's letters to her mother, written from London after her flight, is to be found in the court file. Cohen's text, written in Dutch between 1680 and 1681, certainly shows

32 See Levie Bernfeld, 'Religious Life', pp. 71–73, 93–95.

33 Levie Bernfeld, *Poverty and Welfare*, p. 101.

34 They were allowed to go to synagogue at night only to listen to the reading of the Esther scroll (*megillat Esther*) or to attend the Day of Atonement (*Kol Nidrei*) and *Tishebe-ab* services commemorating the destruction of the Temples in Jerusalem: see Levie Bernfeld, 'Religious Life', pp. 93–94.

35 Hell, *De Amsterdamse herberg*, pp. 240, 267, 280–81.

36 Kaplan, 'Bom Judesmo'.

37 See Levie Bernfeld, 'Sephardi Women', pp. 182–83; Levie Bernfeld, 'Religious Life', pp. 95–96.

38 On Eva Cohen, see Levie Bernfeld, 'A Sephardic Saga'.

different aspects of privacy and the inner zone. For example, she refers to the private atmosphere in the family circle, including relations with her siblings, which we would otherwise be unable to verify. The letters also reveal aspects of her inner life (the heuristic zone of the soul) and emotions, for example when she admits to joy at receiving her mother's letters. Her warm relations with and care for her brothers and young sister also tell us about her innermost feelings, as these come to the fore in the text of her letters. This also holds true when she writes of her brother Joseph, who had died a few months earlier. Together these disclose different aspects of her inner life, a completely private space.[39]

Moreover, through these letters we get a glimpse of privacy at home: how a girl of her class was educated not only to read and write (in Dutch), but also to play the harpsichord. It shows how she was formed within Jewish tradition in the Portuguese Jewish milieu of the time, which instructed its members to show respect to their parents — in this case, a Sephardi daughter to her mother, who was by then a widow.[40]

The language in Cohen's letters is ambiguous, allowing us to grasp her mental strife. On the one hand, she shows remorse for having caused her mother pain by fleeing her authority and running into the arms of a low-class Christian servant. On the other, she promises to return to the family, under the supervision of her mother and into a closed, protected environment. In this respect, she apparently felt the growing isolation and alienation that could overcome converts on the verge of leaving behind a close-knit family and a familiar environment.[41]

Cohen's case is an example of a woman in a Portuguese milieu allowing herself some freedom of movement, trying to pull down the wall of control, and crossing over from the private into the public. Her case, which demonstrates many aspects of the inner zone, would not have become known if we had only had the sources of the closed and withdrawn community of the Dutch Sephardim on which to rely.

Privacy in Last Wills

The phenomenon of privacy can also be detected in last wills. In general, Jews registered their last wills with non-Jewish notaries, as the profession of notary was not open to Jews in the Dutch Republic. Wills form an important source regarding social, cultural, economic, and religious life. Even though the content of wills can be very pragmatic, they sometimes reveal aspects of the private sphere relating to the inner zone. Therefore, wills are important

39 Levie Bernfeld, 'A Sephardic Saga', pp. 218–19.
40 Levie Bernfeld, 'A Sephardic Saga', pp. 216–17.
41 Levie Bernfeld, 'A Sephardic Saga', pp. 218–19.

WITHDRAWN AND SECRETIVE 183

sources of information, and this is no less true when we are looking into privacy among the Dutch Sephardim. Such data would not be easily extracted from Portuguese Jewish sources.

Let me take the last wills of Isaac and Rachel de Prado (d. 1691 and d. 1708) and their son Josua (d. 1708) as examples.[42] Isaac's father (and Josua's grandfather) Abraham de Prado had a business trading in sugar and tobacco. In 1634 he could be found in Florence under the name of Francisco Fernandes de Mo(u)ra. Upon arrival in Amsterdam in 1641, he changed his name to Abraham de Prado, but he retained his alias for business.[43] At the registration of her wedding in 1656, his daughter Lea stated, in the presence of her father, that she was from Madrid.[44] Therefore, the family probably had its origin in Spain and had moved from there in different directions. Upon the registration of their marriage in Amsterdam in 1644, Abraham's son Isaac and his bride Rachel Gabay Faro stated that they had lived in southern France before making Amsterdam their home.[45] Eventually, the family settled in Amsterdam and became active members of the Portuguese community there.[46]

Isaac and Rachel's last will of 1685 starts with the standard introduction and pragmatic details regarding their burial, legacies to the community and to their offspring, and the continuation of the business and who should be in charge, all formulated in Spanish and Portuguese.[47] In the last part of the will, Isaac and Rachel turn to their six children in a more informal way and thus enter a more intimate zone. First, they specify the names and ages of their children, two girls and four boys: in 1685, their respective ages were forty (Sara), thirty-one (Josua), twenty-two (Esther), nineteen (Joseph), fifteen (Jacob),

42 For the will of Isaac and Rachel de Prado, see Amsterdam, City Archives 5075, 3309, 42, Not H. Outgers, drawn up 13 April 1685, opened 27 January 1691; last will of Rachel de Prado alias Rachel Gabay Faro, widow of Isaac de Prado: Amsterdam, City Archives 5075, 7490, no. 18, Not. J. van den Ende, 12 March 1708; last will of Josua de Prado alias Anthonio de Prado: Amsterdam, City Archives 5075, 7490, no. 19, 12 March 1708, Not. J. van den Ende; addition: Amsterdam, City Archives 5075, 7490, no. 21, 26 March 1708.

43 In Amsterdam, Abraham was assessed by the Portuguese community for the general wealth tax (*finta*) for the maximum amount at that time, i.e. 150 guilders: Amsterdam, City Archives 334, 19, p. 92/177, 26 Nisan 5401; for the amounts involved, see also Amsterdam, City Archives 334, 172, pp. 188–89, 9 Tishri 5402. On the *finta* tax, see Levie Bernfeld, *Poverty and Welfare*, pp. 63, 70. Abraham de Prado immediately became a member of the Amsterdam-based international dowry society Dotar: Amsterdam, City Archives 334, 1143, p. 44/15, 1 Kislev 5401.

44 Amsterdam, City Archives 5001, 683, p. 94, 9 November 1656; see also Pieterse, *Daniel Levi de Barrios*, p. 82.

45 On the marriage of Abraham's son Isaac, see Amsterdam, City Archives 5001, 677, p. 220, 27 February 1644.

46 On their positions in the administration of the Portuguese community, see for example Amsterdam, City Archives 334, 1323, p. 5, 5419 (Abram de Prado); Amsterdam, City Archives 334, 1323, p. 6, 5424 (Isaac de Prado); Amsterdam, City Archives 334, 1323, p. 11, 5459 (Josua de Prado).

47 On the composition of Portuguese Jewish wills, see Levie Bernfeld, 'Caridade escapa da Morte'.

and thirteen (Samuel) (the couple had lost a son by the name of Salomon prior to drawing up the will). Subsequently, they address Judaism: exhorting their children to make punctual religious observances, fear God, and follow the divine commandments. Next, family harmony and ethics are presented: the parents demand from their children unity and sincere friendship with each other, with the younger siblings showing respect towards the older. In this way, they maintain, the children will earn God's blessing. The final paragraph of the will ends with a religious vow applicable to all, expressing the wish that 'God will save all our souls and when we leave this world will collect us in the bosom of his elect'.[48] Thus, through this will we not only learn about attitudes in the communal zone, the relationship between the testators, and the Portuguese community, but also the inner zone: family life, religiosity, and relationships between parents and children.

Twenty-three years later, in 1708, their son Josua drew up his last will, this time written in Dutch. By then he was a childless widower (as he had been since 1698), having lost his two children in 1701 and 1705 respectively.[49] He had apparently been suffering from bad health for a long time, as he leaves a legacy to his two maids as an expression of gratitude for their care for him during his prolonged illness.[50] In his will, Josua continues the path set out by his parents, showing the importance of family harmony by expressing a very warm and emotional attitude towards his mother, to whom he leaves a yearly allowance of six thousand guilders. Besides this financial assistance, he offers her shelter, as she is to remain in his house, where he apparently took her in as a widow in 1706. She is also to have use of all household effects after his death.[51]

48 The original text of the will is in Portuguese, but a Dutch translation was added after the opening of the will on Isaac's death: 'E pedimos ao Sr do mundo salve nossas almas e coando deste mundo forein nolas recolha no Gremio de seus escolhidos'; in the original Dutch translation, 'Biddende aen de Heere des Weerelts dat hij onse Sielen wil behouden om als wij van deese werelt scheyden de selve ontvangen in de schoot van sijne uijt verkoornen'.

49 For the death of his wife Sara Bueno de Mesquita, see Amsterdam, City Archives 334, 421: 11 Sivan 5458; for their marriage, see Amsterdam, City Archives 5001, 692, p. 86/171, 7 March 1681; for the Jewish consecration of their marriage, see Amsterdam, City Archives 334, 407, p. 106, 13 Tamuz 5440; for the deaths of Josua's sons Isaac and Jacob, see Amsterdam, City Archives 334, 422, 2 Hesvan 5462 and 17 Kislev 5466 respectively.

50 Last will of Josua de Prado alias Anthonio de Prado: Amsterdam, City Archives 5075, 7490, no. 19, 12 March 1708, Not. J. van den Ende; addition: Amsterdam, City Archives 5075, 7490, no. 21, 26 March 1708: 'Noch aen zij Testateurs twee Dienstmaegden met namen Anneke en Vrouwtje te samen een somme van vier hondert guldens Bankgeldt eens voor het extraordinaris oppassen, ten dienste van hem Testateur in zijne landuirige siekte gedaen' (also to the two maids of the testator named Anneke and Vrouwtje together a sum of four hundred guilders once, for the extraordinary care of him during his prolonged illness).

51 For more on Josua's mother's residence in his house, see also Levie Bernfeld, *Poverty and Welfare*, p. 191. For the inventory she made upon entering her son's house in 1706, see Amsterdam, City Archives 5075, 3369, pp. 383–93, Not. H. Outgers, 17 January 1706. She sold her own house in the same year: Amsterdam, City Archives 5062, 80, pp. 14v–16v, 4 May 1706.

At the same time, his will stands out in the way it relates to his extended family (siblings, nephews and nieces, parents-in-law, brother- and sisters-in-law), bestowing legacies upon them while also treating the rest of his staff with care and respect, as seen above.[52] Moreover, his connection to the community appears to be as strong as that of his parents and grandparents, as he donates generously to charity and leaves gifts to the poor within his *kahal* (community), as well as to the yeshiva Ets Haim and the dowry society Dotar.[53] The presence of many Hebrew books in his home library also confirms this close connection to Judaism and the Jewish community.[54]

Yet he also takes a more pragmatic approach when he transfers the family capital to the next generation, leaving the biggest legacy to his nephew Isaac, son of his brother Joseph, and his niece Rachel, daughter of his brother Jacob (aged only sixteen and nine respectively at the time). To them he decides to bequeath his house (plus warehouses) — including the inventory, jewellery, gold, and silver — on the explicit condition that they marry each other. Thus, in a will such as Josua's, another aspect of family life comes to the fore, one which was essential in elite circles of the time: marriage was often planned in order to keep intact and even enlarge the family capital.

The will of Josua's mother Rachel from 1708 broadens our perspective on the attitude of a widow and grandmother towards marriage. She tries to soften her son's position regarding the conditional bequest.[55] Besides adding some information as to the legacies granted to her children, she also takes the opportunity to underscore her son's wish for her grandchildren, Josua's nephew and niece, to get married and enjoy their large inheritance. In this respect she once more includes a personal note, allowing us a window into an inner zone: the emotional life of a widow and grandmother. She expresses her personal opinion regarding arranged marriage, insisting it should not be forced upon anybody, but should be accepted by both parties with assent and benevolence.[56] Nor is the religious note absent: as in her will of 1685, she ends with a religious message, expressing a prayer for God's blessing to all.[57]

52 On Josua's loan to the husband of his Ashkenazi maid, see also Levie Bernfeld, *Poverty and Welfare*, p. 116.

53 On Josua's gift to the poor, see Levie Bernfeld, *Poverty and Welfare*, p. 170.

54 For the inventory of Josua de Prado, see Amsterdam, City Archives 5075, 7490, nos 52 and 53, Not. J. van den Ende, 28 September 1708.

55 Rachel's husband Isaac died on 12 Sebat 5451: Amsterdam, City Archives 334, 422.

56 The nephew and niece finally married in 1714: Amsterdam, City Archives 5001, 709, p. 418, 2 November. The groom was twenty-two years old at the time, the bride only fifteen years old. The grandmother's attitude towards arranged marriage stands in clear contrast to that of Eva's mother more than twenty years earlier. The latter did not show such a lenient position and would not depart from her policy of arranged marriages: see Levie Bernfeld, 'A Sephardic Saga'.

57 For the will of Isaac and Rachel de Prado, see Amsterdam, City Archives 5075, 3309, 42, Not H. Outgers, drawn up 13 April 1685, opened 27 January 1691.

Taken together as an example, these wills prove the extent to which such notarial sources reveal aspects of privacy and details about private life, data we would not be able to dig up were we to rely only on the communal records.

Domestic Inventories

More windows into privacy can be opened by analysing domestic inventories made upon death or bankruptcy. These form interesting sources for the study of a population and allow us to reach into people's physical worlds. They inform us of different aspects of material culture, such as people's standards of living, or their prevailing identity and its development over time.

Again, were it not for non-Jewish sources, much less would be known about these aspects of Dutch Sephardim's material culture. An analysis of such inventories can tell us, for example, about remnants of Iberian culture as well as the Sephardim's integration into the world that surrounded them. Besides this, additional information can be retrieved that allows us to draw conclusions about their new identity as Jews.[58]

What do we learn about the physical aspects of Dutch Sephardi privacy from studying such data? In most inventories of the Dutch Sephardim, we find prayer books and other books relating to Judaism in Hebrew and Spanish, a fact which points to a successful return to a normative Jewish lifestyle.[59] The presence of ceremonial objects such as shabbat lamps and *hanukiot* (Hanukkah candelbra) besides scrolls of the Book of Esther (*megillot Esther*) prove likewise. Findings from archaeological research into the former Jewish neighbourhood confirm this supposition, with objects belonging to members of both the Ashkenazi and Sephardi communities dug up from cesspools, including shabbat lamps, Pesach plates, and stamps for kosher slaughtered meat.[60] Pride in their recovered Jewish identity can also be found in the paintings of the newly built Portuguese synagogue, while images of the *Eretz Israel* (Land of Israel) and Jerusalem on the walls of their homes also confirm their connection to Judaism.[61] In addition, objects of Iberian origin described in the inventories, and those dug up in the former Jewish quarter, show the extent to which various families transferred their private belongings along with their culture to their new destination. These objects reveal a strong connection to their country of origin within the private spaces in which they are found.[62]

58 See Levie Bernfeld, 'Matters Matter', especially pp. 195–214.

59 On libraries among Dutch Sephardim, see Swetschinski, *Reluctant Cosmopolitans*, pp. 289–99, 302–08; see also Levie Bernfeld, 'Honen Dalim: A Pawnbank'.

60 Gawronsky, 'Vlooienburg'; Gawronsky and Jayasena, 'De Amsterdamse Jodenbuurt'; Stolk, 'Zeven dagen'; Bakker, 'Eetgewoonten op Vlooienburg'; Bakker 'Koosjer loodjes'; Goffau, 'Shabbatlamp'.

61 Levie Bernfeld, 'Matters Matter', pp. 207–13.

62 Levie Bernfeld, 'Matters Matter', pp. 195–201; Stolk, 'Exploring Immigrant Identities'; Stolk, 'Rattles, Toys'; Stolk, 'Portugees aardewerk'.

Moreover, items representing both Dutch and international culture confirm that Dutch Sephardim — cosmopolitans upon arrival — were well integrated into the environment that surrounded them, and adapted well to the Dutch milieu.[63] The ever-present family portraits serve as further testimonies of a beloved family life, including the especially high esteem in which these Sephardim held their senior loved ones.[64]

Therefore, a study into material culture using domestic inventories and archaeological finds not only highlights the multifaceted identity of the Dutch Sephardim, which was built up from different layers of culture, but also opens for us a window into privacy and the private areas of life at home.

Openness versus Privacy: The Paradox

So far, we have managed to enter quite a few private spaces of Dutch Sephardim, despite the protective attitude of the community and its eagerness to guard those inner spaces. Its leadership tried to control behaviour, drawing boundaries its members were not supposed to cross. These were intended to meld the community into an organic whole and attune it to normative Jewish life. The communal leadership also tried to protect its status in relation to the authorities. Communal records were couched in vague, secretive terms, often withholding details or only being orally transferred.

Some families upheld this image of privacy and withdrew into their private zones. They thus adopted similar attitudes in their own private circles, especially when dealing with the protection of wives and daughters, as related above. Others defied the communal leadership. Quite a few, however, chose the middle way and did not see any conflict between protecting their privacy and being in close contact with the people among whom they lived and worked. Many Portuguese Jews were very keen on openness. They freely went out and about in the neighbourhood and into the world at large, and they were frequently in touch with Jews of other nations as well as their non-Jewish environment.

We also encounter this attitude in the visual arts. Proud of their recovered religious freedom, Dutch Sephardim were eager to show off, inviting guests to their synagogue and opening their homes for them, making them witnesses to various Jewish ceremonies and holiday celebrations, and revealing Jewish life to outsiders eager to learn. Although they kept their inner life to themselves, whereas they had once been hidden and persecuted they now became proud of who they were, striving for freedom of public worship and for status as a tolerated minority.[65]

63 Levie Bernfeld, 'Matters Matter', pp. 201–07, 213–14.
64 Swetschinski, *Reluctant Cosmopolitans*, p. 309; see Levie Bernfeld, 'Matters Matter', pp. 205–06.
65 Swetschinski, *Reluctant Cosmopolitans*. On visitors to the Portuguese synagogue, see for example Kaplan, 'Amsterdam's Jewry'.

The private life of the Dutch Sephardim was therefore not completely isolated. It was also intertwined with the people around them. Quite a few Sephardim, Ashkenazim, and non-Jews worked together, dined together at home or at business banquets, played together in taverns, visited brothels, communicated with each other, were partners in crime, argued, and much more.[66] Therefore, we can say that the secrecy surrounding actions and the protection of privacy were specifically features of official communal records, and were mostly applied when those records dealt with scandals or information not meant for the public. In that respect, privacy was guarded, as the community leaders were conscious of the precious hospitality with which they had been greeted in Amsterdam, and were eager to keep a clean record and avoid confrontation with the non-Jewish authorities. In private, many families, although still protecting the innermost zone, were also keen to connect with the outside world.

Conclusion

The tendency among Dutch Sephardim to protect privacy can be explained as a culture that was part and parcel of Spanish tradition, especially when it came to safeguarding the position of women. Moreover, the desire for privacy, driven by fear, can be traced back to their experiences on the Iberian peninsula, where they had after all been living as a hidden and persecuted group, especially when it came to secret adherence to Jewish tradition. They had been afraid of detection, and they had thus turned inward. Once the Portuguese community was in the Dutch Republic, its protective character was also due to a feeling of insecurity regarding its position as a tolerated minority in the city. The *kahal* tried to keep a low profile, especially in view of the different ordinances issued by the municipality relating to Jews: scandals should not

66 Swetschinski, *Reluctant Cosmopolitans*, pp. 213–14, 216–18. On cooperation on welfare, see Levie Bernfeld, *Poverty and Welfare*, pp. 119–20, 274 n. 30; on the international charitable aspect, see Levie Bernfeld, 'Joining the Fight', pp. 146–52. On the interconnectivity of Jewish culture, specifically the cooperation between Jews from different nations in the Amsterdam printing press, see Ruderman, *Early Modern Jewry*, pp. 99–125; Sclar, 'Books', pp. 227–32; Sclar, 'Sephardi-Ashkenazi Relations', pp. 35–37; Schorsch, 'Kabbalah and Cosmopolitanism', pp. 156–60; Sienna, 'Rabbis with Inky Fingers', pp. 166–74; Schlesinger, 'Four Editions, Four Faces'. For more on the social scene, see Hell, *De Amsterdamse herberg*, pp. 240, 267, 280–81; Pol, 'Amsterdam Jews'. For more on relations between Portuguese masters and their maids, see Levie Bernfeld, 'Masters, Maids and Mistresses'; Levie Bernfeld, *Poverty and Welfare*, pp. 212–13. See also the etchings in Picart's *Cérémonies et Coutumes*, especially those of the celebration of Pesach, Sukkot, circumcision, and the redemption of the firstborn; see also depictions of Portuguese synagogue services showing the visitors in the foreground, especially Emanuel de Witte's 1680 depiction of the interior of the famous Portuguese synagogue, now held in the Rijksmuseum, Amsterdam.

reach the outside world, poverty was to be hidden within the community's own circles, and hostility towards Christianity was to be quashed.

This distanced attitude can also be explained from an ethnic-religious angle. As former *conversos* who had been set apart as the *nação* on the peninsula, and as such closely connected with each other, they distanced themselves from Jews of other nations who came to the Dutch Republic only later. This attitude was also nurtured by the Spanish culture of superiority and aristocratic pretensions.

However, there is a tension at play here. Information from non-Jewish sources offers a more complex impression. While the communal sources reveal a closed atmosphere in which the boundaries of the community were guarded, and scandals and conflicts prevented from becoming public, non-Jewish sources permit us to cross over into a more colourful world, offering more background information and allowing us to enter into the inner zones.

Thus we learn more details about the daily routines of various members of this community, whether at home, at work, at court, or on visits to the notary. We understand the extent to which Portuguese Jews were integrated into their Dutch environment, worked together, socialized together, and welcomed other people not only into their synagogue, but also into their private surroundings.

Non-Jewish sources make us witnesses to moments of joy or misery both inside and outside the family circle, as well as moments of internal mental struggle. The real identity of Dutch Sephardim can thus be revealed as made up of different layers, which became stronger or weaker over time: the new Jewish identity they (re)invented, the Dutch influence they encountered, and the European culture they were part of, with remnants of a Spanish-Portuguese and Catholic background often present too. Therefore, the tension between protected privacy on one hand and openness on the other was a component of life for Dutch Sephardim in early modern Amsterdam.

Epilogue

The tradition of a withdrawn, reclusive Portuguese community has survived through the ages. In 1927, the famous English historian Cecil Roth went to Amsterdam intending to explore the archives of the Portuguese community, which were then still housed in the Portuguese synagogue complex. His explicit purpose was to research the life of Haham Menasseh ben Israel (1604–1657) and his contemporaries. However, he found the doors closed to him, as had happened to many others before him. The custodian told him 'we have nothing in our archives relating to Menasseh ben Israel' and closed the conversation (and the door). Of course, the custodian was not telling the truth. Community records, both those from the archives and those in the library of the famous yeshiva Ets Haim, contain important and extensive source material which could be used to write a book on a famous rabbi such

as Menasseh ben Israel. Perhaps the custodian was ashamed of the fact that one page in the *Livro de Escamot* had been glued together in order to conceal that this rabbi had been put into *herem* (banned) for a day?[67]

At any rate, by preventing Roth from entering, the curator decided to protect the community, its records, and its legacy, and to let privacy prevail. In light of the above, the incident should not surprise us, as the phenomenon of the protection of privacy can be traced back to the seventeenth century, if not earlier. Despite the communal attitude towards privacy, Roth was able to complete his book on the famous rabbi. However, when the book came to be published, Roth had no wish to conceal the incident, because his work would have been more comprehensive had he been allowed to consult these sources. He therefore gave an account of it in the preface to his book.[68] Surprisingly, such remnants of privacy could still be found within the Portuguese community of twentieth-century Amsterdam, for better or for worse!

67 Kaplan, 'Social Functions', pp. 127–28, 153.
68 Roth, *Life*, pp. xi–xii. The preface was written in London in 1932.

Works Cited

Manuscripts

Orobio de Castro, Isaac, *Prevenciones Divinas a Ysrael contra la vana idolatria delas gentes*, Amsterdam, 1668–1675, Manuscript Ets Haim 48 B06

Morteira, Saul Levi, *Providencia de Dios con Israel*, Amsterdam, before 1660, Manuscript Ets Haim 48 A09

Picart, Bernard, *Cérémonies et Coutumes religieuses de tous les peuples du monde* (Amsterdam: J. F. Bernard, 1723–1743)

Archival Sources

Portuguese Jewish Community Amsterdam, Resolutions
Amsterdam, City Archives, 334, 19: 1638–1690
——, 334, 20: 1680–1712
——, 334, 22: 1728–1814

Portuguese Jewish Community, Livros de segredos
Amsterdam, City Archives, 334, 61–62: 1763–1817
——, 334, 973: 1733–1817

Portuguese Jewish Community, Financials Registers
Amsterdam, City Archives, 334, 172: 1639–1646
——, 334, 250 (*Grootboek*): 1758–1767

Portuguese Jewish Community, Administrative Positions
Amsterdam, City Archives, 334, 155: 1639–1795
——, 334, 1323: 'Registro dos Parnassim': 1639–1747

Portuguese Jewish Community, Estate Jacob Mazahod
Amsterdam, City Archives, 334, 736–37: 1721–1865

Portuguese Jewish Community, Dowry Society Dotar
Amsterdam, City Archives, 334, 1143: 1639–1661
——, 334, 1144: 1661–1735

Portuguese Jewish Community, Wedding Registrar: Livro de quetubot
Amsterdam, City Archives, 334, 407: 1673-

Portuguese Jewish Community, Burial Records
Amsterdam, City Archives, 334, 421: 1616–
——, 334, 422: 1616–

Secrete resoluties van de vroedschap
Amsterdam, City Archives, 5025, 161–62: 1663–1725; 1684–1685

Marriage Records City of Amsterdam
Amsterdam, City Archives, 5001, 677, pp. 220, 27 February 1644
——, 5001, 683, pp. 94, 9 November 1656
——, 5001, 709, pp. 418, 2 November, 1714

Notarial Records
Amsterdam, City Archives, 5075, 3309, 42, Not H. Outgers, drawn up 13 April 1685, opened 27 January 1691: Will of Isaac and Rachel de Prado
——, 5075, 3378, Not. H. Outgers, pp. 45v–47, 8 May 1692: Will of Salomon de Lima
——, 5075, 3378, 57, pp. 116v–121, 8 December 1692 Aboab Lopes family
——, 5075, 3378, 116, pp. 220–43, 21 October 1693: Inventory of Jacob Bueno de Mesquita
——, 5075, 3369, pp. 383–93, Not. H. Outgers, 17 January 1706: inventory Rachel de Prado
——, 5075, 7490, no. 19, 12 March 1708, Not. J. van den Ende; addition: Amsterdam, City Archives 5075, 7490, no. 21, 26 March 1708: Will of Josua de Prado alias Anthonio de Prado
——, 5075, 7490, no. 18, 12 March 1708: Will of Rachel de Prado alias Rachel Gabay Faro, widow of Isaac de Prado
——, 5075, 7490, nos 52 and 53, 28 September 1708: Inventory of Josua de Prado

Kwijtscheldingen
Amsterdam, City Archives, 5062, 80, pp. 14v–16v, 4 May 1706: Rachel de Prado

Confessieboeken
Amsterdam, City Archives, 334, 5061, 269–532: 1534–1811

Secrete Confessieboeken
Amsterdam, City Archives, 5061, 533–40: 1618–1810
——, 5061, 534: 1624–1660

Secondary Studies

Bakker, Jan K., 'Eetgewoonten op Vlooienburg: Wat voedselresten ons vertellen', in *Waterlooplein: De buurt binnenstebuiten*, ed. by Kirsten van Kempen and Hetty Berg (Zutphen: Walburgpers, 2020), pp. 44–50
——, 'Koosjer loodjes', in *Waterlooplein: De buurt binnenstebuiten*, ed. by Kirsten van Kempen and Hetty Berg (Zutphen: Walburgpers, 2020), p. 51
Beinart Kaplan, Yael, 'A Bibliography of the Writings of Haim Beinart', in *Exile and Diaspora: Studies in the History of the Jewish People Presented to Professor Haim Beinart on the Occasion of his Seventieth Birthday*, ed. by Aharon Mirsky, Avraham Grossman, and Yosef Kaplan (Jerusalem: Ben Zvi Institute, 1988), pp. 583–98 [in Hebrew]
Bennassar, Bartolomé, *The Spanish Character: Attitudes and Mentalities from the Sixteenth to the Nineteenth Century* (Berkeley: University of California Press, 1979)
Bodian, Miriam, *Hebrews of the Portuguese Nation: Conversos and Community in Early Modern Amsterdam* (Bloomington: Indiana University Press, 1997)

Bruin, Guido de, *Geheimhouding en verraad: De geheimhouding van staatszaken ten tijde van de Republiek (1600–1750)* ('s-Gravenhage: SDU Uitgeverij, 1991)

Bruun, Mette Birkedal, 'The Centre for Privacy Studies Work Method' (Copenhagen, 2019) <https://teol.ku.dk/privacy/research/work-method/> [accessed 24 January 2022]

Caro Baroja, Julio, *Los Judíos en la España moderna y contemporánea*, 2nd edn, 3 vols (Madrid: Ediciones ISTMO, 1978)

Casey, James, *Early Modern Spain: A Social History* (New York: Routledge, 2002)

Defourneaux, Marcelin, *Daily Life in Spain in the Golden Age* (London: Allen & Unwin, 1970)

Gawronsky, Jerzy, 'Vlooienburg: De Jodenbuurt onder de Stopera' <https://openresearch.amsterdam/nl/page/54889/vlooienburg-de-jodenbuurt-onder-de-stopera> [accessed 19 April 2020]

Gawronsky, Jerzy, and Jayasena, Ranjith, 'De Amsterdamse Jodenbuurt archeologisch belicht', in *Waterlooplein: De buurt binnenstebuiten*, ed. by Kirsten van Kempen and Hetty Berg (Zutphen: Walburgpers, 2020), pp. 14–23

Goffau, Lisa de, 'Shabbatlamp', in *Waterlooplein: De buurt binnenstebuiten*, ed. by Kirsten van Kempen and Hetty Berg (Zutphen: Walburgpers 2020), p. 25

Graizbord, David L., 'Religion and Ethnicity among "Men of the Nation": Toward a Realistic Interpretation', *Jewish Social Studies*, 15 (2008), 32–65

Hell, Maarten, *De Amsterdamse herberg 1450–1800: Geestrijk centrum van het openbare leven* (Amsterdam: Vantilt, 2017)

Huussen, Arend H., 'The Legal Position of Sephardi Jews in Holland, circa 1600', in *Dutch Jewish History*, ed. by Jozeph Michman, III (Assen: van Gorcum, 1993), pp. 19–41

Jütte, Daniel, *The Age of Secrecy: Jews, Christians and the Economy of Secrets, 1400–1800* (New Haven: Yale University Press, 2015)

Kaplan, Yosef, 'The Social Functions of the *Herem* in the Portuguese Jewish Community of Amsterdam in the Seventeenth Century', in *Dutch Jewish History*, ed. by Jozeph Michman and Tirtsah Levie, I (Jerusalem: Daf Chen, 1984), pp. 111–55

——, 'Political Concepts in the World of the Portuguese Jews of Amsterdam during the Seventeenth Century: The Problem of Exclusion and the Boundaries of Self-Identity', in *Menasseh ben Israel and his World*, ed. by Yosef Kaplan, Henry Méchoulan, and Richard H. Popkin (Leiden: Brill, 1989), pp. 45–62

——, 'Wayward New Christians and Stubborn New Jews: The Shaping of a Jewish Identity', *Jewish History*, 8.1–2 (1994), 27–39

——, 'The Self-Definition of the Sephardi Jews of Western Europe and their Relation to the Alien and Stranger', in *Crisis and Creativity in the Sephardi World*, ed. by Benjamin R. Gampel (New York: Columbia University Press, 1997), pp. 121–45

——, 'Bom Judesmo: The Western Sephardic Diaspora', in *Cultures of the Jews: A New History*, ed. by David Biale (New York: Schocken, 2002), pp. 639–69

——, *Minotsrim hadashim lejehudim hadasim* (Jerusalem: Zalman Shazar Centre, 2003)

——, 'Secularizing the Portuguese Jews: Integration and Orthodoxy in Early Modern Judaism', *Jahrbuch des Simon-Dubnow-Instituts/Simon Dubnow Institute Yearbook*, 6 (2007), 99–110

——, 'Between Christianity and Judaism in Early Modern Europe: The Confessionalization Process of the Western Sephardi Diaspora', in *Judaism, Christianity, and Islam in the Course of History: Exchange and Conflicts*, ed. by Lothar Gall and Dietmar Willoweit (Munich: Oldenbourg, 2011), pp. 307–41

——, 'Amsterdam's Jewry as Perceived by English Tourists and Other Christian Visitors in the Seventeenth Century', *Frankfurter Judaistische Beiträge*, 40 (2015), 259–83

——, 'Between Religion and Ethnicity: Shaping the Western Sephardic Diaspora', in *Early Modern Ethnic and Religious Communities in Exile*, ed. by Yosef Kaplan (Newcastle upon Tyne: Cambridge Scholars, 2017), pp. 189–207

——, 'The Jews in the Republic Until about 1750: Religious, Cultural and Social Life', in *Reappraising the History of the Jews in the Netherlands*, ed. by Hans Blom, David J. Wertheim, Hetty Berg, and Bart T. Wallet, and trans. by David McKay (London: Littman Library of Jewish Civilization, 2021), pp. 105–71

Levie Bernfeld, Tirtsah, 'Caridade escapa da Morte: Legacies to the Poor in Sephardi Wills from Seventeenth-Century Amsterdam', in *Dutch Jewish History*, ed. by J. Michman, III (Assen: van Gorcum 1993), pp. 179–204

——, 'Sephardi Women in Holland's Golden Age', in *Sephardi Family Life in the Early Modern Period*, edited by Julia R. Lieberman (Waltham, 2010), pp. 177–222

——, 'Matters Matter, Material Culture of Dutch Sephardim (1600–1750)', *Studia Rosenthaliana*, 44 (2012), 191–216

——, *Poverty and Welfare among the Portuguese Jews in Early Modern Amsterdam* (Oxford: Littman Library of Jewish Civilization, 2012)

——, *Dowries and Dotar — an Unbroken Chain of 400 Years: Essay Written on the 400th Anniversary of the Amsterdam-Based Portuguese Jewish Bridal Society Santa Companhia de Dotar Orphas e Donzellas* (Amsterdam: Menasseh ben Israel Institute/Jewish Historical Museum/Dotar, 2015)

——, 'Religious Life among Portuguese Women in Amsterdam's Golden Age', in *The Religious Cultures of Dutch Jewry*, ed. by Yosef Kaplan and Dan Michman (Leiden: Brill, 2017), pp. 57–99

——, 'A Sephardic Saga in the Dutch Republic: The Cohen Pallache Women on Love, Religion and Social Standing', in *Religious Changes and Cultural Transformations in the Early Modern Western Sephardic Communities*, ed. by Yosef Kaplan (Leiden: Brill, 2019), pp. 195–227

——, 'Joining the Fight for Freedom: Redemption of Captives and the Portuguese Jews of Seventeenth-Century Amsterdam', in *Sephardim and Ashkenazim: Jewish-Jewish Encounters in History and Literature*, ed. by Sina Rauschenbach (Berlin: De Gruyter, 2020), pp. 125–53

——, 'Masters, Maids and Mistresses: Aspects of Domestic Life among the Portuguese Jews in the Seventeenth-Century Dutch Republic', in *Sefardische Perspektiven/Sephardic Perspectives*, ed. by Sina Rauschenbach, IV (Leipzig: Hentrich and Hentrich, 2020), pp. 11–40

——, 'Honen Dalim: A Pawnbank for Portuguese Jews in Early Modern Amsterdam, A study in Material Culture, Religiosity and Social Standing', (forthcoming)

Levine Melammed, Renée, *Heretics or Daughters of Israel? The Crypto-Jewish Women of Castile* (Oxford: Oxford University Press: 1999)

Pieterse, Wilhelmina Chr., *Daniel Levi de Barrios als geschiedschrijver van de Portugees-Israelietische gemeente te Amsterdam in zijn 'triumpho del govierno popular'* (Amsterdam: Scheltema and Holkema, 1968)

Pol, Lotte van de, 'Amsterdam Jews and Amsterdam Prostitution, 1650–1750', in *Dutch Jews as Perceived by Themselves and by Others: Proceedings of the Eighth International Symposium on the Jews in the Netherlands*, ed. by Chaja Brasz and Yosef Kaplan (Leiden: Brill, 2001), pp. 173–85

Roodenburg, Herman, *Onder censuur: De kerkelijke tucht in de gereformeerde gemeente van Amsterdam 1578–1700* (Hilversum: Verloren, 1990)

Roth, Cecil, *Het vreemde geval van Hector Mendes Bravo, Nieuw Israelietisch Weekblad*, 67 (7 August, 1931), p. 9

——, *A Life of Menasseh ben Israel-Rabbi, Printer and Diplomat* (Philadelphia: Jewish Publication Society, 1934)

Ruderman, David B., *Early Modern Jewry: A New Cultural History* (Princeton: Princeton University Press, 2010)

Schlesinger, Elad, 'Four Editions, Four Faces, One Book: Printing of the *Shulhan Arukh* in Amsterdam 1661–1708', *Studia Rosenthaliana*, 46.1–2 (2020), 51–70

Schorsch, Jonathan, 'Kabbalah and Cosmopolitanism in Early Modern Amsterdam: The Sephardic and Ashkenazic Producers of *Sefer Raziel ha-Malakh*', in *Sephardim and Ashkenazim: Jewish-Jewish Encounters in History and Literature*, ed. by Sina Rauschenbach (Berlin: De Gruyter, 2020), pp. 155–81

Sclar, David, 'Sephardi-Ashkenazi Relations in Amsterdam Print Houses in the Second Quarter of the Eighteenth Century', *Report of the Oxford Centre for Hebrew and Jewish Studies* (2015), 35–37

——, 'Books in the Ets Haim Yeshiva: Acquisition, Publishing, and a Community of Scholarship in Eighteenth-Century Amsterdam', *Jewish History*, 30.3 (December 2016), 207–32

Sienna, Noam, 'Rabbis with Inky Fingers: Making an Eighteenth-Century Hebrew Book between North Africa and Amsterdam', *Studia Rosenthaliana*, 46.1–2 (2020), 155–87

Stolk, Marijn, 'Exploring Immigrant Identities: The Link between Portuguese Ceramics and Sephardic Immigrants in 17th Century Amsterdam', *EX NOVO: Journal of Archaeology*, 3 (December 2018), 101–20

——, 'Portugees aardewerk en Portugese migranten: Het begin van Joods Amsterdam vanuit archeologisch perspectief', in *Waterlooplein: De buurt binnenstebuiten*, ed. by Kirsten van Kempen and Hetty Berg (Zutphen: Walburgpers, 2020), pp. 39–42

——, 'Rattles, Toys and Miniature Artefacts: Archaeological Insights into Childhood and Children's Identities at Vlooienburg, Amsterdam, ca. 1600–1800', *Kleos: The Amsterdam Bulletin of Ancient Studies and Archaeology*, 3 (2020), 64–81

——, 'Zeven dagen zul je matses eten: Bord uit een pesachservies', in *Waterlooplein: De buurt binnenstebuiten*, ed. by Kirsten van Kempen and Hetty Berg (Zutphen: Walburgpers, 2020), p. 53

Swetschinski, Daniel M., *Reluctant Cosmopolitans: The Portuguese Jews of Seventeenth-Century Amsterdam* (Oxford: Littman Library of Jewish Civilization, 2000)

——, 'Settlement, Toleration and Association until 1639', in *Reappraising the History of the Jews in the Netherlands*, ed. by Hans Blom, David J. Wertheim, Hetty Berg, and Bart T. Wallet, and trans. by David McKay (London: Littman Library of Jewish Civilization, 2021), pp. 38–43

Yerushalmi, Yosef Haim, *From Spanish Court to Italian Ghetto: Isaac Cardoso, a Study in Seventeenth-Century Marranism and Jewish Apologetics*, 2nd edn (Seattle: University of Washington Press, 1981)

JUDITH BROUWER

Private Life in Wartime

Captured Letters from 1672

Prologue

In December 1672, the merchant ship the *Wapen van Hoorn*, which weighed 756 tons and carried more than two hundred crewmembers, lay in wait at the Rede van Texel (the roadstead of Texel, one of the Dutch West Frisian Islands) (Figure 7.1).[1] The ship was sailing in the service of the Vereenigde Oost Indische Compagnie (VOC, East India Company), and its destination was Batavia (modern-day Jakarta). The VOC and its sister firm, the West Indische Compagnie (WIC, West India Company), were key players in the trade and commerce sectors of the United Provinces of the Netherlands. A wide array of foreign goods from east and west, such as spices, herbs, gold, silver, chocolate, and tea, were to arrive in the Dutch Republic.[2] The Rede van Texel was the rallying point for ships from Amsterdam and West Friesland; the VOC and WIC were both equally represented here. As the ships prepared for their voyage, they were stocked with essentials such as food, water, artillery, and ammunition.[3]

* This contribution relies heavily on the first two chapters of my PhD thesis, which appeared in Dutch in 2014: Brouwer, *Levenstekens*. I warmly thank Laura Isherwood for helping me with the translation.

1 Dutch-Asiatic Shipping database (DAS) 1000.1, 1056.2 (Wapen van Hoorn), 1241.4. In the DAS database, each voyage is given a number. The outward voyages run from 0001 to 4789 and the homeward voyages from 5001 to 8401. Each voyage number contains details of the ship, e.g. its name, tonnage, type, etc.

2 Much has been written about the trade of the VOC and WIC. Standard works include Gaastra's *The Dutch East India Company* and Den Heijer's *Geschiedenis van de WIC*.

3 Van Gelder, *Het Oost-Indisch avontuur*, p. 149.

Judith Brouwer works at the Huygens Institute for History and Culture of the Netherlands as the data curator and research data manager for the Department of Data Management.

Private Life and Privacy in the Early Modern Low Countries, ed. by Michael Green and Ineke Huysman, EER 19 (Turnhout: Brepols, 2023), pp. 197–224
BREPOLS ❦ PUBLISHERS 10.1484/M.EER-EB.5.132535

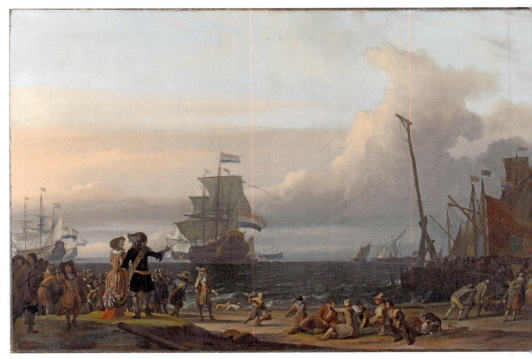

Figure 7.1. Ludolf Bakhuysen, *Nederlandse schepen op de rede van Texel; in het midden de 'Gouden Leeuw', het vlaggeschip van Cornelis Tromp* (Dutch ships at the Rede van Texel; in the middle the 'Golden Lion', the flagship of Cornelis Tromp), 1671. © Rijksmuseum Amsterdam.

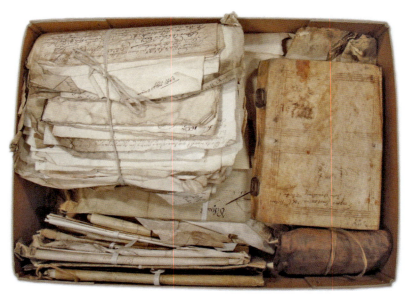

Figure 7.2. A box with ship's papers, procedural documents, ship's journal, ledgers, and a wallet with a French prayer book, captured in the seventeenth century during the Second and Third Anglo-Dutch Wars. Kew, National Archives, HCA 32 / 1845.1. Photo: Erik van der Doe.

By the time the crew of the *Wapen van Hoorn* observed favourable weather conditions for departure, the Republic had already been at war with France, England, and the Bishopric of Munster and Cologne (the Franco-Dutch War, 1672–1678) for eight months. These were exceptional circumstances; it would be the first time the Netherlands was forced to fight simultaneously on so many fronts. The reasons were clear: internal squabbling had marred the unity of the Republic; the swift annexation of cities by the French, and the political murders of the brothers and statesmen Johan (1625–1672) and Cornelis (1623–1672) de Witt, caused panic and fear throughout the land, leaving it vulnerable to invasion. With these disasters all happening in such rapid succession, the year 1672 went down in Dutch history as the *Rampjaar* (Disaster Year). Never before had the Republic found itself facing such truly devastating conditions.[4]

While French troops were plundering Utrecht and planning their advance northwards, the *Wapen van Hoorn* readied itself for departure. On 20 December the ship left the Rede van Texel alongside another ship by the name of *Europa*.[5] At sea the ships were more or less safe, even though enemy ships were always lurking in the distance, on the lookout for an attack. At this point in time, we have arrived at the Third Anglo-Dutch War (1672–1674); the English had declared war on 7 April 1672. Well-known battles from this period include Solebay (1672), Schooneveld (1673, twice), and Kijkduin (1673). While the *Europa* reached its destination of Colombo (Sri Lanka) safely, the *Wapen van Hoorn* was less fortunate, ultimately falling into British hands. About five hundred Dutch ships suffered a similar fate during the Third Anglo-Dutch War.[6]

Capturing enemy ships was common practice in early modern warfare. Different from piracy, it was a legal strategy that set out to cause as much damage as possible to the enemy. Letters found aboard the captured Dutch ships never reached their destinations and intended recipients in overseas colonies. Instead, they were seized by the British, who had no intention of handing them over to the Dutch authorities. Once a ship was captured, the Office of the Admiralty in England was tasked with judging whether the ship had been lawfully seized or not. Documents aboard ships generally included journals, cargo ledgers, accounts, and plantation lists; these documents all served as legal evidence.[7] To this day, more than 38,000 confiscated documents from Dutch ships remain in the National Archives in Kew, London (Figure 7.2). These documents (including records of the interrogations of captured crewmembers) are known in England as the Prize Papers. Thanks to the

4 Brouwer, *Levenstekens*, pp. 18–19.
5 DAS 1240.1.
6 Davis, *The Rise*, p. 51; cf. Van Gelder, *Verslag*, p. 15.
7 For a more extensive discussion, see Brouwer, *Levenstekens*, pp. 22–36.

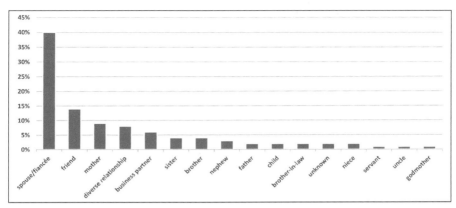

Figure 7.3. The relationship between senders and addressees.

English practice of seizing enemy letters as evidence, cultural historians now have a plethora of invaluable source material at their disposal.[8]

Most of the 195 letters used as source material for this chapter were found aboard either the aforementioned *Wapen van Hoorn* or the *Morgenstar*, another seized ship, which had been headed for Curaçao.[9] The letters had been sent by people residing in the Republic, writing to friends, family, and loved ones who were at sea or already abroad. This source material is unique insofar as many of the writers came from the lower classes, and the majority of them were women.[10] Even though much is already known about these social classes, only a small part of our knowledge is based on source material left behind by the individuals themselves. This is especially the case for women. Never before has so much primary source material been available that can bring such insight into the lives of this previously overlooked class of the population.

Private letters are possibly the most suitable source material to explore the private lives of people during the early modern period. This chapter will

8 There are several European projects on the Prize Papers, which are held in the archive of the High Court of Admiralty (HCA) at the National Archives in Kew, London: Dutch Prize Papers, Huygens Institute for the History of the Netherlands; Gekaapte Brieven, Meertens Institute; Brieven als buit, Leiden University; Scandinavian Prize Papers, Uppsala University and Stockholm University; Prize Papers Portal, Göttingen Academy of Sciences and Humanities. The publisher Brill offers approximately 17,000 interrogations of crewmembers of ships taken during the First, Second, and Third Anglo-Dutch Wars (c. 1652–1674), the War of the Spanish Succession (c. 1701–1733), the War of the Austrian Succession and Seven Years' War (c. 1739–1763), and the American Revolutionary War and Fourth Anglo-Dutch War (c. 1775–1784): Brill, Prize Papers Online <https://brill.com/view/package/ppo?language=en> [accessed 16 February 2021]. For an overview of historiography on the Dutch Prize Papers, see Brouwer, *Levenstekens*, pp. 17–18; 'Selectie van literatuur', p. 1. On the German Prize Papers, see n.n., 'Press & Print' <https://www.prizepapers.de/media/press-print> [accessed 3 March 2022].
9 For a more extensive discussion, see Brouwer, *Levenstekens*, pp. 37–41.
10 Brouwer, *Levenstekens*, pp. 22–23.

PRIVATE LIFE IN WARTIME 201

focus on the question of how to examine private life as it is put into words in the captured letters of 1672. First, I will provide some context regarding the senders and recipients. Then I will take a closer look at methodology by delving into approaches to notions of privacy and the private in early modern sources and verifying those approaches against the captured letters. After that, I will discuss letter-writing rules and the way they were applied in the letters. Subsequently, I will address the tension between public and private. I will finish with some concluding remarks.

Senders and Recipients

Up to forty per cent of the captured letters were written by the wives and fiancées of the intended recipients. The second biggest group of letter writers were mothers, sisters, nieces, daughters, and girlfriends. Most of the men who sent letters to those in service referred to themselves as a 'friend' of the addressee, which is a broad category. The intended recipients were all male, with the exception of Catharina Millandts (d. after 1685) in Batavia, who was the widow of chief merchant Johannes Hartman (d. before 1672).[11] The occupations of the intended recipients included ship hands, skippers, pastors, caregivers, merchants, and managers. There were others who also fit into the category of 'friend', but they do not form a homogeneous group. Besides the authors' and addressees' social backgrounds, their relationship is generally a decisive factor in the content of their letters.

As mentioned above, a large proportion of the writers (and addressees) came from the lower social classes. We do not know much about them except some basic, usually fragmented personal information such as their baptism, wedding, and burial dates, which are recorded by the respective registries.[12] Young men from the lower classes, particularly in cities in sea regions such as Holland and Zeeland (Amsterdam, Rotterdam, Delft, Hoorn, Enkhuizen, Groningen, and Middelburg), tended to volunteer to head either east or west. Consequently, the gender ratio in these social classes shifted significantly, with disproportionately more women than men. Many of such women wrote the letters in question. More than half of all the letters from 1672 were written and sent by this social group of lower class women (Figure 7.3). In their writing, these authors transport us back to Amsterdam, a trade metropolis and a centre of art, culture, and knowledge.[13]

11 Leendert Jansz to Catharina Millandts in Batavia — Alkmaar, 6 November 1672 (HCA 30-1061-2). Information about the dates and occupations of the people mentioned in this chapter is provided when known. However, many of the individuals are hard to trace in the archives.

12 Exceptions are merchants, preachers, and governors, who belonged to the more educated layers of society.

13 Much has been written about early modern Amsterdam. Two standard works are Frijhoff

Ships sailing for (certain) company chambers did not exclusively employ crew who hailed from or around the companies' home cities. It is well known that the VOC employed large numbers of foreigners, most of whom came from Denmark, Sweden, Poland, or Germany.[14] The Dutchmen working for the company in 1672 came from Zwolle, Groningen, and Utrecht. With that knowledge in mind, it is safe to assume that the sailors' families and friends would have wanted to write letters to their loved ones aboard the ships. However, it would have been difficult for them to find a person or network of people on whom they could rely to get a letter to its final destination.

As discussed, the majority of the 195 letters must have come from the *Wapen van Hoorn* (to Batavia) and the *Morgenstar* (to Curaçao). The Batavian post was generally intended for VOC officials in Asia. A large proportion of these officials had already left in 1671. However, some authors had already been separated from family and loved ones for a longer period of time, including Marietje Evers (d. after 1672) from Hoorn. Her cousin Jacop Florissen (d. after 1672) had departed with the ship the *Meerman* in 1667. From 1610 onwards the VOC had a trading post in Batavia, but the city was only definitively conquered in 1619 following a siege led by Governor General Jan Pietersz Coen (1587–1629). From this moment on, Batavia became the headquarters of the VOC in Asia. This was where the ships from Europe docked or departed to other newly acquired ports within Asia. After a period of time, Batavia became the most important staple market for trade in South-East Asia. The castle was the residence of the governor general and council of India (the highest administrative or council body). The most important warehouses and offices were located close by. The demographic make-up of the residents of Batavia can be described as an extreme melting pot of Europeans, Asians, and Eurasians.[15]

Letters sent to Curaçao were addressed to people who had already reached the island or were currently en route aboard ships such as the *Azie* and the *Phenix*.[16] These WIC slave ships had left for Curaçao in October 1671.[17] After being annexed in 1634 by Admiral Johan van Walbeek (1602–1649), the island of Curaçao officially became an important destination for the WIC. In the middle of the seventeenth century, the first immigrants from the Republic

and Prak's *Geschiedenis van Amsterdam: Deel II-1* and *Geschiedenis van Amsterdam: Deel II-2*.

14 Ketting, *Leven, werk en rebellie*, pp. 41–51. On Germans working for the VOC, see Van Gelder, *Het Oost-Indisch avontuur*. On the international character of the VOC and the maritime labour market in general in early modern Europe, see Van Lottum, 'The Necessity and Consequences'; Van Lottum, 'Some Thoughts'; Van Rossum, *Werkers van de wereld*; Van Lottum, Lucassen, and Heerma van Voss, 'Sailors, National and International'.

15 'Belangrijkste gewesten overzee'. See also e.g. Jones, *Wives, Slaves, and Concubines*; Taylor, *The Social World of Batavia*; Niemeijer, *Batavia*.

16 Other ships' names found among the addresses are the *America*, the *Alida*, the *Gouden Kroon* (or *Vergulde Kroon*), the *Jonge Prins*, the *Verstoorde Leeuw*, the *Africa*, the *Rebecca*, the *Juffrouw Margriet*, the *Jonge Prins Willem*, the *St Dominicus*, the *Susanna*, and the *St Franciscus*.

17 Trans-Atlantic Slave Trade Database 44184, 44181.

became free planters, alongside other WIC officials who had already settled there earlier. Curaçao was an important transit station to trade goods with the Spanish colonies. Many shipments of Venezuelan chocolate, tobacco, and pelts were sent to the Republic from this island. Following Curaçao's incorporation into the WIC territories, it became an important point of maritime support. It was considered a strategic location because of its proximity to the coast of Venezuela and the fact that it had several defensible bays, which functioned as deep-water ports. The island also served as an operational base for attacks on the South American mainland as well as raids on the Spanish islands, and as an intermediary station for transport and trade along the Brazilian coast. Most importantly, between 1660 and 1713 Curaçao operated as a slave fort, where slaves were held for shipment to the surrounding Spanish colonies, the most important market of this nature for the whole of the WIC.[18]

Captured Letters as a Source

In 1980, in the UK's Public Record Office (now known as the National Archives), the maritime historian Sipke Braunius was researching military legislation aboard Dutch warships when he stumbled upon a number of boxes full of seventeenth-century Dutch letters. He was the first to draw attention to the existence of these letters, eight of which (from 1664) he included in his publication.[19] Since then, many researchers from various countries and areas of expertise have made use of this truly exceptional source material.

The Prize Papers letters belong to a source genre called 'ego documents'. The Dutch historian Jacques Presser coined the term *egodocumenten* in 1958.[20] He defined these sources as writings in which the 'I', the writer, is continuously present in the text as the person who is describing the subject. Since the 1980s there has been increased interest in ego documents such as letters, journals, and autobiographies. From the perspective of traditional historical writing, these documents were at first considered unsuitable and unreliable. However, as time passed, they received newfound appreciation as 'suppliers of facts' and eyewitness accounts, offering a window onto opinions, mentalities, and mundane experiences, providing supporting information, and reflecting the

18 Den Heijer, *Geschiedenis van de WIC*, pp. 79, 80, 93, 96; see also Klooster, *Illicit Riches*. On the trade with the West Indies, see Meuwese, *Brothers in Arms*; Postma and Enthoven, *Riches from Atlantic Commerce*. Much has been written about the Dutch slave trade, including Brandon and others, *De slavernij*; Balai, *Geschiedenis*; Daalder, Tang, and Balai, *Slaven en schepen*; Nimako and Willemsen, *The Dutch Atlantic*; Balai, *Het slavenschip*; Klooster, *Migration, Trade, and Slavery*; Oostindie, *Dutch Colonialism*; Emmer, *De Nederlandse slavenhandel*.

19 Braunius, 'Het leven'.

20 Baggerman and Dekker, 'De gevaarlijkste', pp. 7–8.

cultural climate of their time.[21] Nowadays, many disciplines use ego documents. They can be used to uncover more information about socio-economic groups that were previously overlooked by traditional historiography, including women, artisans, slaves, and children, to name just a few. Current research in social science and humanities disciplines tends to focus on — among other things — individual experience, conceptions of everyday life and life in general, and especially personal identity. With this in mind, ego documents emerge as a valuable addition to other resources. At the same time, some scholars cast doubt on these studies' approach to chronology, as they focus heavily on the idea of a growing individualism from the Middle Ages onwards. One might question the teleological elements of this approach, as well as the lack of reflection on individuality as a concept, and an underlying Eurocentrism.[22] The historian Michael Mascuch offers an alternative view in *The Origins of the Individualist Self: Autobiography and Self-Identity in England, 1591–1791*. He sees autobiographical writing as a cultural practice and the text as a public showcase for one's identity.[23] Let us keep this in mind when we take a closer look at the letters later on.

When it comes to the *Rampjaar*, there are a considerable number of studies on the subject within the realm of Dutch historiography. They are all based on chronological statements and clarifications concerning the events of 1672.[24] Consequently, many scholars researching this period draw their information from the same sources, most of which are primarily corporate in nature (historical works, minutes, and official letters). On the other hand, the letters captured from ships in 1672 provide insight into (at least a part of) the private daily lives of certain individuals in the seventeenth century. Therefore, they shed light on the private lives of the authors. Their experiences come to life by virtue of the picture they paint in their writing. Regardless of the way in which they choose to write about their personal affairs and feelings, it should be taken into account that these particular experiences represent only a fraction of their lives. One should also bear in mind that the words have been chosen based on the nature of the events foregrounded in the letter and the writer's feelings about that particular subject.[25] The writer's feelings are fleeting, after all, as they pertain only to the immediate situation at the time the letter was written. The time difference between researcher and writer must be kept in mind too. Therefore, the interpretation of these historical experiences must take a contemporary conceptual framework as a starting point.[26] Finally, it is by interpreting and filling in the blanks that one can bridge the gap between

21 Baggerman and Dekker, 'De gevaarlijkste', pp. 3, 9.
22 Blaak, *Reading and Writing*; Baggerman and Dekker, 'De gevaarlijkste', pp. 8–9, 12.
23 Mascuch, *The Origins of the Individualist Self*, cited in Baggerman and Dekker, 'De gevaarlijkste', p. 9.
24 Exceptions are Reinders, *Gedrukte chaos*; Panhuysen, *Rampjaar 1672*.
25 Cf. Dekker, 'Egodocuments', p. 255.
26 Münch, 'Erfahrung', pp. 12–13.

the past and the present. However imperfect or incomplete it may be, this is not only what the letters have to offer to modern-day readers; it was also what they offered their (intended) recipients at the time.[27]

In Search of Private Life

Now, the question is how to examine the expression of private life as it was put into words in the captured letters of 1672. The Danish National Research Foundation Centre for Privacy Studies makes use of two approaches to notions of privacy and the private in early modern sources. The first is terminological and focuses on *priv* words: words with the root *priv*, from the Latin *privatus*.[28] The Dutch *Woordenboek der Nederlandsche Taal*, a historical dictionary describing Dutch words since the sixteenth century, lists the word *privaat* as a noun (in the sense of 'lavatory'), an adjective, and an adverb. Van Sterkenburg's *Een glossarium van zeventiende-eeuws Nederlands*, a glossary of seventeenth-century Dutch, is somewhat more extensive and also lists the word in the sense we use it today.[29] Nevertheless, there are no *priv* words in the captured letters. This might possibly be explained by the nature of the source: in principle, the letters are private messages between two people. Although there might have been some idea of privacy in 1672, a *priv* word did not necessarily have to be used to address topics of a private nature. This assumption is supported by seventeenth-century Dutch newspapers: while they certainly show that *priv* words were actually being used at the time, newspapers differ from letters because of their public character.[30] Furthermore, only four *priv* words are to be found in the Brieven als buit (letters as loot) database, which holds a thousand captured Dutch letters (from the seventeenth to the early nineteenth centuries) from the Prize Papers. They all date from the 1780s.[31]

27 For a more extensive discussion, see Brouwer, *Levenstekens*, pp. 21–22.

28 Bruun, 'Privacy', pp. 46–47.

29 'Particulier, op eigen autoriteit berustend, voor eigen gebruik, privé, eigen, niet openbaar, niet voor iedereen toegankelijk' (private, based on one's own authority, for one's own use, private, one's own, not public, not accessible for everybody). Van Sterkenburg, *Een glossarium*, p. 171.

30 Delpher database.

31 Gerharda Catharina Wirth-Sluijsken to Pieter Sluijsken in Colombo — Amsterdam, 3 December 1780 (HCA 30–336): 'Volgens mijn konsept soude dan nog liever de lesse jnt latijn op de helft vermindere en geeven hem door bekwaame meesters *prevaate lesse* jnt engels ende mateeses' (in my opinion, I would rather reduce the Latin lessons by half and give him *private lessons* in English language and maths); Pieter Philip Jurriaan Quint Ondaatje to Willem Jurriaan Ondaatje in Sri Lanka — Utrecht, 1 December 1780 (HCA 30–317): 'Eindelijk zal haast volgen de ontleedkunst: behalven mijne *privaate huiscollegien*, ook van 't disputeeren' (finally I am about to attend classes in anatomy: besides my *private classes at home*, also [classes in] disputation); Do. Breton Jean de Zoon to Pierre Jacob Le

Perhaps these are early examples of the individualism that was typical of the Romantic era.[32]

The second approach the Centre uses is conceptual. It concentrates on a set of six heuristic zones or circles in order to evaluate notions of early modern privacy: state/society; community; home/household; chamber/alcove/studio; body; soul/mind/self. This represents a spatial construction of privacy in which the zones are not fixed, but fluid.[33] This approach is easier to apply to the captured letters of 1672. Most of the letters share similar substantive characteristics. The authors write about their health, ask about the well-being of the receiver, and hope that he will return soon. Furthermore, they discuss subjects regarding private life and the public events of the war (politics and news). The zones that are particularly applicable in these cases are the household and the sender's self. Domestic life is represented in several different ways, in subjects related to each other. Firstly, there are descriptions of children (growing up, skills, appearance, fatherlessness, child mortality) (Figure 7.4). This is in line with historian Phillipe Ariès's view of the formation of the modern nuclear family as stemming from 'a desire for privacy and also a craving for identity: the members of the family were united by feeling, habit and their way of life'.[34] Secondly, another dominant theme is adversity (financial worries, poverty, sickness, death). Daily work and activities (trade, helping others in need, being helped by neighbours) are generally less prominent. The self is reflected throughout, in all of the experiences, opinions, and emotions of the senders, with regard to both a number of war-related events and the everyday lives they lived — whether affected by those events or not.

Nevertheless, with this specific set of letters, the heuristic approach to understanding notions of privacy is simply not sufficient. Generally, it is safe to say that when early modern sources are explored, one also has to take the specific character of the source into account. As demonstrated, it is

Jolle in Demerara — Amsterdam, 25 September 1780: 'Ik hadde uEd geschreeven, met Captyn Koesfoet, als dat ik uEd met Hyden de assurantie soude bestellen voor de coffy die ik uEd voor myn *privé* wil senden' (I have sent you a letter via Captain Koesfoet, in which I write that I would like to order via Hyden the insurance for the coffee, which I want to send you for me *privately* [for myself]); Jean du Bois to André du Bois in St Eustatius — Amsterdam (HCA 30–342): 'Inmiddels hebbe UEd [...] daarvoor gecrediteerd [...] voor myn ½ aandeel in dieverse goederen als voor myn *Privee Reek[enin]g*' (meanwhile, I have credited you for half of my share in various goods and for my *private account*). Brieven als buit database, all italics mine.

32 Keulen and Kroeze describe the rise of individualism since the early modern period in historiography: Keulen and Kroeze, 'Privacy', pp. 24, 40–41, 48. Baggerman and Dekker point out the criticism of this chronological-teleological vision: Baggerman and Dekker, 'De gevaarlijkste', pp. 8–9.

33 Bruun, 'Privacy', pp. 47–48; Bruun and Koerner, 'Visualizing Privacy'.

34 Ariès, *Centuries of Childhood*, p. 413, cited in Keulen and Kroeze, 'Privacy', p. 26.

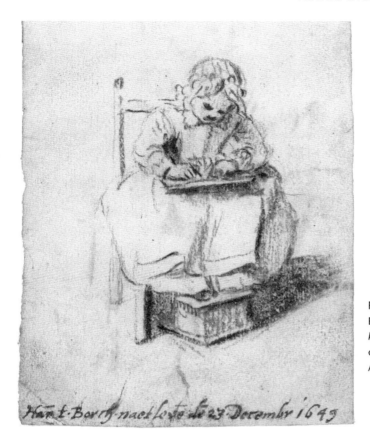

Figure 7.4. Harmen ter Borch, *Tekenend of schrijvend kind* (Drawing or writing child), 1649. © Rijksmuseum, Amsterdam.

possible to recognize heuristic zones in the letters, but it is also important to determine how they work *within* the letters. Therefore, I will combine the heuristic approach with characteristic epistolary mechanisms.

Prescribed versus Written

In order to interpret the letters' content correctly, particularly when it comes to notions of privacy, it is essential to have a proper understanding of epistolary or letter-writing culture. With that context in mind, we can clarify which aspects are standard formulations and which are personal. It is important to consider that there were both written and unwritten rules of letter-writing. The latter appear in patterns that cannot be traced back to a specific source. The former pertain to the important topic of the so-called letter books. In the early modern era, various such books were in circulation; they contained letter theory and instruction manuals. This type of book was fairly common, and there were a lot of variants written in Dutch and intended for a wide

range of people, from amateur to more advanced writers. People used these booklets at school, at home, or as reference works.[35]

The majority of letters were probably based on the popular school manual *Gemeyne send-brieven* (Common Letters) by the Roman Catholic teacher Heyman Jacobi (d. after 1591). This popular booklet, first printed in the 1590s, was intended for novice writers.[36] It had a theoretical part followed by several model letters. The writers of 1672, especially those who belonged to seamen's social circles, tend to apply the prescribed rules quite consistently. According to the epistolary theory, a letter had four parts, beginning with some friendly and familiar words to win over the reader.[37] This is apparent in the 1672 letters in the form of a salutation and information about the writer's health and immediate surroundings, concluding this section of the letter by expressing the hope that the receiver is doing well in their position. After this first section, the writer would make clear in the second section what the letter was actually about.

The distinction between the first and second parts of the letter is not always very clear, at least in the case of the letters discussed in this chapter. As mentioned above, the provision of information about the writer's general well-being appeased the reader and was therefore intentionally placed in the first section of the letter. These habits can be considered formulaic, as they generally rely on — and are virtually always followed by — standard formulas. Indeed, the most important reason why people wrote letters at this time was to inform the reader that the writer was still alive. This was important information in the year 1672. It is safe to say that many of the men stationed abroad had heard about the devastating situation the Republic was facing back home, and presumably would have felt relieved to hear that their friends and family were still 'kloeck ende gesont' (in good health). This was already laid out in the letters' standard formulas, without detracting from the importance of the content or message. Certain letters contained nothing more than formulaic phrases and did not report on the prevailing political situation. A quarter of the letters in the collection do not mention the war or its consequences. Sometimes letters merely contained a couple of sentences referencing a certain fact, such as when a woman notified her husband that she had given birth and was feeling quite well again.[38]

35 For a more extensive discussion, see Brouwer, *Levenstekens*, pp. 56–60. On non-Dutch, early modern letter-writing manuals, see for example Webster Newbold, 'English Model Letters'; Poster and Mitchell, *Letter-Writing Manuals*; Bannet, *Empire of Letters*; Ortner-Buchberger, *Briefe*; Chartier, Boureau, and Dauphin *Correspondence*; Erdmann, *Ars Epistolica*; Kadar, *Model Letters*.

36 Jacobi, *Ghemeene seyndtbrieven*.

37 Jacobi, *Ghemeene seyndtbrieven*, fol. A2r.

38 Neeltje Jackops to Jurriaan Lenderse in Curaçao — Amsterdam, 27 May 1672 (HCA 30-1062-2).

According to Jacobi, writers should use the third section of the letter to indicate the manner in which they were going to write, and should do so by using an edifying biblical comparison.[39] However, this collection of letters contains no such examples. The reason why most writers produced letters in the first place was to inform the reader how they were doing back home. It was not generally deemed necessary to accompany such information with a comparison. Nevertheless, Jacobi's ideas were put into practice in other ways — for example, when letter writers wanted to firmly state their purpose. This was virtually always attributed to God or the Bible, just as Jacobi prescribes in his letter theory.[40] According to the *Gemeyne sendt-brieven*, the sender should dedicate the fourth and last section of the letter to favourable expressions. Sometimes this was to be accompanied by an affable salutation such as 'hondert duijsent goedenachten' (a hundred thousand good nights).[41] These conventions must have offered writers some guidance, since letter-writing was not a daily activity for many of them. They may have learned to write, but they used this skill in everyday life only at the level of compiling grocery lists. Writing letters must have been quite a difficult task for some. When drafting a letter, they could consult the manual to remind themselves of the rules.

Filtering: Public versus Private

As mentioned earlier, there is evidence to support the claim that the prescribed rules were followed fairly strictly. This is particularly clear in the opening and closing sentences of the letters. The next example, with its fixed combinations, can be seen more or less as a template for the 1672 letters:

> Een vriendelijke groetenisse sij geschreven aan mijn seer wel beminde man [naam]. Ick laet u.l. [uwe liefde] weten als dat ick, God sij gelooft, noch kloeck ende gesont ben, verhopende dat het met u.l. oock so is. Ware het anders, het was mijn van herten leet te horen, dat weet God almachtich, die een kenner van alle herte is. Voor[t]s [...] Dese [brief] dient om u.l. te laten weten dat [...]. Hondert duysent goede nachten bij mijn, ULDW [uwe liefde dienstwillige] [naam].

39 Jacobi, *Ghemeene seyndtbrieven*, fol. A2ᵛ.
40 Brouwer, *Levenstekens*, pp. 68–79.
41 Jacobi, *Ghemeene seyndtbrieven*, fol. A2ᵛ. It may seem odd that a person should wish another goodnight rather than good day. The explanation is that in earlier times, it was customary to indicate the time in nights instead of days. In official documents this was the case until the fourteenth century; in the vernacular and in informal correspondence, the custom remained for longer. Philippa, 'Van woord', p. 5; Ter Gouw, *Kijkjes*, p. 35.

(A friendly greeting is written to my very beloved husband [name]. I'm letting you know that, as I praise God, I remain in good health and hoping that you are as well. Were it otherwise, I would be sincerely sad to hear of such a thing, that only God almighty knows, he who knows all hearts. Furthermore this letter is to let you know that [...]. A hundred thousand good nights by me, your willing wife [name]).

In order to explore notions of the sender's private life in this letter, we should particularly consider the middle section starting with 'voor[t]s' (furthermore). We might approach it as a matter of simple subtraction: as we now know the pattern of epistolary theory, and we know we can ignore the sections on politics and news, what remains is the part concerning private life. Actually, however, things are slightly more complicated. Whereas this chapter generally considers the letters' private and public topics to be two separate spheres, most of the letters demonstrate that the line between them was a fine one.

In the course of the year 1672, living conditions worsened, and this is emphasized by the way in which individuals wrote about the war in their letters. In May of that year, the letters mainly demonstrated disbelief that the war had broken out, accompanied by uncertainty about its outcome. By November, the feeling of unpredictability that men and women were facing in their lives had become a common sentiment. In provinces invaded by French forces, people were fleeing their homes, carrying only a few belongings with them. The Republic's economy had ground to a halt, and women could only contribute to the family income by making a concerted effort. In short, both the *public* war and *private* life were a part of everyday life. This is in line with ideas prominent in historical anthropology, which distinguishes an 'outer and inner world' that flow into one another.[42] Furthermore, it aligns perfectly with the zone approach, in which the six different circles overlap. Therefore, we must understand the first circle of state/society — even if it has a public character — as able to influence the other five circles. Past individual or private experiences are embedded in a social context because, as an incorporated or remembered past, they are based on the experiences of others. The Disaster Year letters show that whatever was going on at the time in public or private settings, people's experiences, feelings, and opinions were partially influenced by second-hand information: newspapers, pamphlets, notices from third parties, and of course gossip.[43]

A letter from Brechien Claes (d. *c.* 1700) of Medemblik (a province of North Holland) to gunnery sergeant assistant Aris Diercksen Nuevel (d. after 1672) in Ceylon (modern-day Sri Lanka) illustrates how longing and anxiety (private) were influenced by the war (public). After the standard opening

42 Münch, '*Erfahrung*', pp. 15–18.
43 Brouwer, *Levenstekens*, pp. 179–282.

PRIVATE LIFE IN WARTIME 211

sentences and family news about deaths, sickness, births, and marriages, she informs her husband about the state of the country:

> Ende het staet hier geweldich slecht om met onse lant. Wij benne al 3 peroesijs quijt van onse lant aen de Vransman een gedeelt want hij is selve tegenwooerdich tot Uijtrech, ick segge de koninck selve. Swol, Deventer, Kampen noch meer andere plase die ick niet noeme kan aen bijshop. Hoe het met ons oflope sal is Godt bekent, een swaer oorloch die ons benoudt de Vransman ende Engels man ende 2 bishoppe soo dat het al harde te besoergen staet. Allebert Top [?] heeft sijn handt verloren int oorloch ende Geert Jakop Gevensman sijn been […]. Geen menschen hebbe sulcken oorloch beleeft ende hier is niet te winnen, de see is sloeten daer kan niemant varen soo dat het hier geweldich slecht om staet soo dat wij Godt van harten biedde om help ende bijstant.

> (And the state of our country is terrible. We already lost 3 of our provinces to the French; he — I mean the King of France — is nowadays in Utrecht. Zwolle, Deventer, Kampen and other places I cannot mention are taken by the Bishop [of Munster]. Only God knows what will happen to us. It is a tough war that keeps hold of us; the French, the Brits and 2 bishops, so we have a lot of sorrows. Allebert Top lost his hand during the war and Geert Jakop Gevensman his leg […]. No one ever experienced such a war and there is nothing to gain. The sea is closed, no one can set sail. This means the conditions here are terrible, so we pray to God for help and welfare.)[44]

At the time she wrote this letter (12 September 1672), several wartime events had quickly succeeded one another during the summer: the hostile occupation of several provinces and cities, the murder of the De Witt brothers, and the siege of Groningen. Brechien Claes connects these events to her own circle (Allebert Top and Geert Jakop Gevensman) and her own miserable situation:

> Ick wenchse dat ick bij ul waer want hier is niet dan verdriet ende ick hebbe 2 brieve van ul gekregen, een van 25 een van de 24 vebewaris ende ul gesontheytt was myn seer aengenaem. Dit is 13 brief al die ick al geschreven hebbe, schoudts Vrans daer sult gij wel een brief 3 a 4 by vynde soo gy daer bijkoomt maer gy schrijft mijn harde spys om te verteren […]. Soo gy op een ander jaer selve niet koomt soo sent mijn wat katoen tot hemde tot het kint want onse sooen heeft se van doen […]. Gij wet selve wel wat daer van noede is, hoe gy myn hebbe late sierten doen gij van mij trock. Soo gij een hardt hebbe soo doet baermachticheyt ende stiert myn wat. Voort wenck ick ul de segen des Heren die hoep ick dat ul bewaren ende geve dat gy met gesontheijt weder tuijs kome sult, dat gunne ul de goede

44 Brechien Claes to Aris Dircksen Nuevel in Ceylon — Medemblik(?), 12 September 1672 (HCA 30-1061-2).

hemelse vader ende ick ul huijsvrou [...] wensch [ul] hondert duijsent goede nachte, ul huijsvrou Brechien Claes ul diernaerresse.

> (I wish I were with you, because it is nothing but misery here. I received 2 letters from you, one on 25 and one on 24 February. I was really pleased to hear about your health. This is already the thirteenth letter I have written. You will find 3 or 4 letters with local official Vrans, if you go to him. The content of your letters is hard to digest [...]. If you are not to come home next year, then send me some cotton for the child's undergarments. Our son needs it. [...] You know what we are in need of; you know how you let me down when you left me. If you have a heart, be compassionate and send me something. Furthermore, I wish you the Lord's blessing and I hope He will save you and ensure you will come home in good health, the good Heavenly Father allows you this. I, your wife [...] wish you a hundred thousand goodnights, your wife Brechien Claes, your servant.)[45]

This extract is a clear demonstration of how the writer shares different private sentiments in one letter: longing, misery, happiness, frustration, neediness, despair, and hope. Overall, these are directly linked notions of the private self (the first zone).

When it comes to daily concerns in private life, such as the effects of war, uncertainty appears to be the dominant sentiment pervading all of the letters. Several other emotional grievances can be grouped under this common denominator, including stress, grief, and hope paired with fear (Figure 7.5). Uncertainty was a given for sailors' wives. No one could be certain whether or when their husband would return. A sea voyage was by no means without danger, and once they had landed at their destination, the life of a company officer likewise hung in the balance. For example, tropical illnesses claimed many lives. The absence of and longing for a husband had an immense effect on the daily lives of the women left behind. The impact was felt physically, financially, and emotionally — especially if it concerned the upbringing and care of young children. Such worries about one's husband's safe return were even more acute during wartime. There was a lot of suffering, and many writers were uncertain about their own lives and existences too. Loneliness and anxiety dominated daily life. Against this backdrop, letters came to function as a sign of life.

The physical absence of the husband-sailor is described in a letter from Meijntje Meijndert (d. after 1672), which contains probably the most intimate or private sentences in the 1672 letter collection:

45 Brechien Claes to Aris Dircksen Nuevel in Ceylon — Medemblik(?), 12 September 1672 (HCA 30-1061-2).

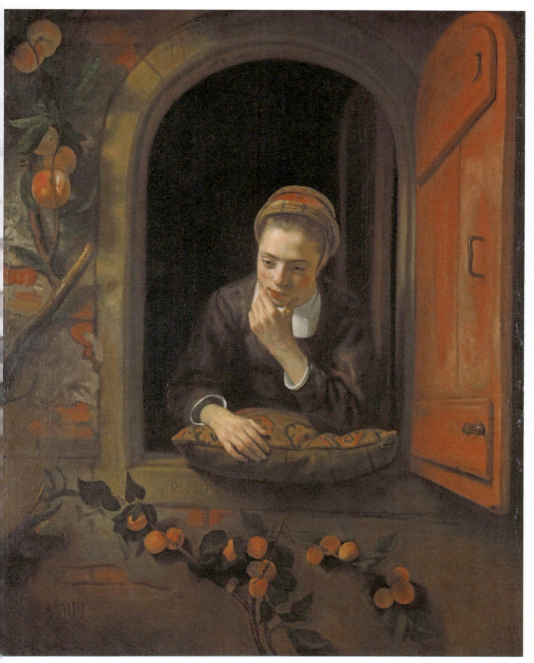

Figure 7.5. Nicolaes Maes, *Meisje aan het venster, bekend als 'De peinzende'* (Girl at a window, known as 'the daydreamer'), 1650–1660.
© Rijksmuseum Amsterdam.

> Ghij schrieft mij dat ghij het kussen ter nacht als ghij in de koeij [scheep-skooi] sijt in de arm neemt ende dat ghij u dan inbeelt of ick bij u mijn alderliefste ben ende dat ick, schrief ghij mij, oock soo moet doen, maer het is als vergeefs gedaen.
>
> > (You write to me that at night, when you're in your cabin, you take your cushion in your arms, thinking it is me. You write to me I should do the same, but it's all in vain.)[46]

This is the only example in the 195 captured letters to refer to the fourth heuristic zone of chamber/alcove/studio. Meijntje Meijndert's husband, quartermaster Willem Luckassen (d. after 1672), had mentioned the sleeping area of the ship he was on in an earlier letter. Apparently, he was not bothered by the lack of a private environment aboard the ship — the lower crew members all slept in the same space — when he embraced his pillow.

Writing Help

Regarding the private character of the letters, it is important to keep in mind that not everybody was capable of writing letters themselves, despite the high literacy rate in the Dutch Republic.[47] Those who could not write but still wanted to send a letter had to enlist the help of a third party. More than a quarter of the letter writers from the Disaster Year did not write the letters themselves, but instead called upon a friend, family member, acquaintance, or professional writer (Figure 7.6) to do the writing for them. These professionals had offices on busy streets.[48] They wrote not only for those who had never attended school or simply could not read, but also for those who could not physically manage the writing process due to old age, the loss of an eye or hand, or some other impairment that made them unable to write a coherent letter. Furthermore, some people sought the help of a public writer even though they knew how to handle a quill themselves, in order to prevent their handwriting from being recognized.[49]

Independent public writers generally remained anonymous. They wrote for others, and therefore did not need to be recognized as an author, only as an intermediary. When the client dictated the text, the role of the public writer was strictly limited to the graphic registration of what was said. It is not inconceivable that people with little or no education lacked the necessary know-how to write a letter in the first place. This type of customer expected

46 Meijntje Meijndert to Willem Luckassen in Batavia — Enkhuizen, 10 November 1672 (HCA 30-1061-2).
47 Weduwen, 'Fear and Loathing', p. 88.
48 For a more extensive discussions, see Brouwer, *Levenstekens*, pp. 97–101.
49 Métayer, *Au tombeau des secrets*, p. 55.

PRIVATE LIFE IN WARTIME 215

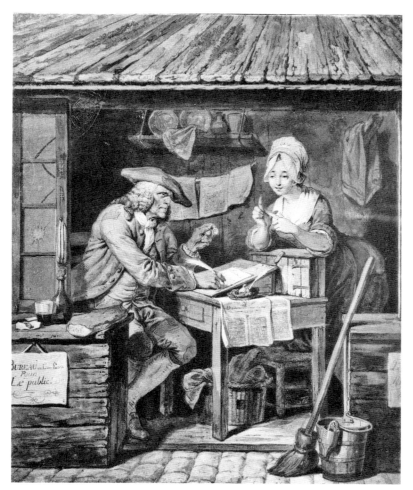

Figure 7.6. Pierre-Alexandre Wille, *L'Écrivain public* (Paris, La Bibliothèque des Arts Décoratifs. 1780). © Reproduced by permission of La Bibliothèque des Arts Décoratifs, Paris.

the public writer to know how to formulate the words on the paper. In short, they expected the public writer to know the rules of letter-writing.[50]

There are various ways to detect whether a sender wrote their own letter.[51] Most importantly, the clues can be found in the material itself. Occasionally, the writing helper refers to his assistance by adding his name somewhere on the page. At the bottom of a letter from 11 November 1672, we read: 'Door

50 Métayer, *Au tombeau des secrets*, p. 55.
51 See also Nobels and Wal, 'Tackling the Writer-Sender Problem'.

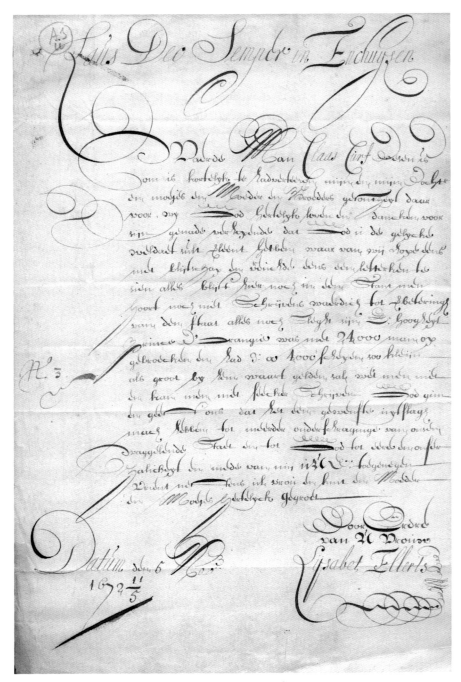

Figure 7.7. Letter of Lijsabet Ellerts to Claas Jansen Curf in Batavia — Enkhuizen, 5 November 1672 (HCA 30-1061-2).

ordre van u vrouw Lijsabet Ellerts' (by order of your wife Lijsabet Ellerts) (Figure 7.7).[52] There are also clusters of letters that are written in one hand but signed by multiple senders. Finally, there are letters that contain two different sets of handwriting, that of the writer and that of the sender. In these cases, the signature belongs to the sender. Another way to establish authorship is to compare the names in the letters against marriage registers and notarial deeds, as these required a signature. Where a person has drawn a cross or circle in an unsteady hand, it is obvious that this person was in fact unable to write.

Another method is to take a closer look at the person's social circles. As mentioned above, if a sender is proficient in writing we can expect them to be a vicar, a shipman's wife, or a teacher. However, it is much more difficult to say the same about the wife of a sailor in a low position on board. The letter from Meinsje Doedes (d. after 1672) is a case in point.[53] Her husband, Jan Sweersz (d. after 1672), was a chef's mate aboard the *Kasteel van Medemblik*, which had set sail in the direction of Batavia. Doedes's letter is written in a flawless and very practised hand. We cannot rule out the possibility that there were indeed women that had a steady hand, even if they were married to 'Jan Compagnie' (Dutch slang for a common man serving the VOC). However, in Doedes's case it is obvious that she did not write the letter herself, because there are three letters from different senders in the same collection, all dated 8 November 1672, that all have the same neat handwriting. Therefore, we can safely assume it was a public writer who wrote them.

It may seem that letters in which the sender refers to the writing process must have been produced single-handedly. But of course, this does not always turn out to be the case. In a letter to her son, Maria Scherius (d. 1675) states how much she misses him: 'Ick had het anders gedacht, met tranen ick dit schrijf' (I had thought otherwise, I am crying as I write this).[54] Aside from the question of whether her grief was real or only a *topos*, she had not taken up the pen in her own hand. Her letter, which is meticulously composed, was in fact written by her husband.[55] There are numerous other letters that close with 'bij [door] mijn' (by me), followed by the name of the sender. This does not necessarily mean they were written by the sender's own hand. At the end of the letter from Elijsabedt Bernaerds (d. after 1672), we read: 'Vo[o] r[t]s soo weense [wens] ick u hondert duisent goede nachten. Bij mijn Elijsabedt Bernaerds, door mij gescreven, Maiike Pieters, ul dochter' (further so, I wish you a hundred thousand good nights. By me Elijsabedt Bernaerds, written by me, Maaike Pieters, your daughter).[56] We see something similar with Lijsbet Ariaens, who hired a professional writer to draft a letter

52 Lijsabet Ellerts to Claas Jansen Curf in Batavia — Enkhuizen, 5 November 1672 (HCA 30-1061-2).
53 Meinsje Doedes to Jan Sweersz. in Batavia — Enkhuizen, 8 November 1672 (HCA 30-1061-2).
54 Maria Scherius to Petrus Duclasel in Batavia — Hoorn, 29 October 1672 (HCA 30-1061-2).
55 Anthonius Scherius to Petrus Duclasel in Batavia — Hoorn, 29 October 1672 (HCA 30-1061-2).
56 Elijsabedt Bernaerds to Pieter Herensen in Surinam — Middelburg (?), 2 April 1672 (HCA 30-1062-2).

to her husband.[57] In this case 'bij mijn' can be interpreted as either 'from me' or 'sent by me'. The fact that third parties — whether a public writer or a neighbour — were involved in the writing process leads us to consider the private nature of the letters. On one hand, the third party offered a solution; on the other, the client might have felt limited by the intervention of the third party. In Aaltje Hendricks's (d. after 1672) letter, we read: 'Het aefweesen van u dat is mijn soo verdrietig dat ick het u niet laete scrijven en kan, en konde ick soo wel [goed] scrijve als gaij, mijn liefs[t]e, ick sou u mijn bedroefde aert wat beter openbare' (your absence has made me so very sad that I cannot bear to let [me] write it to you, and if I was able to write as well as you can, my love, I would be able to express the sadness I feel more openly).[58] Adriaantje Dircks (d. after 1664) wanted to tell her loved one Jan Jaspersen (d. after 1664) about her pregnancy, but because another person was writing the letter for her, she felt she should do so by means of circumlocution:

> Ghij mijn belooefde dat ghij niet langger ut soude blijven als tot Alderheijligen en u maets schrijven dat het wel kermes [met de kermis/Kerstmis] weesen sal, soo dat ick dat niet gedocht hadde en haddet wel anders gewenst, want ghij weet wel waerom, want het tgeen ick teegen u seijde dat is nu soo en ghij kent wel dencken wat mijn daer van overkoomen [gebeuren] sal. Vorders mijn beminde ick verlangge wel, dat weet Godt, dat ghij mocht koomen maer ick hadde noch lijever dat ghij hier waert om reede wille [omwille van de reden] dat ick u niet mach [kan] schrijven, maer kost ghij selver leesen, ick meen ick soude u wel meer schrijven, ghij kent [...] wel verstaen wat ick meen. Ick wenste wel dat ick oock schrijven kost [kon], ick soude u mijn hart wel oopenbaeren doch t en kan anders niet weesen.

> (You promised me you would be away no longer than All Hallows, your mates write this will last until 'kermes time' [the fair/Christmas]. I did not expect this and wished it were different; you know why, because the thing I informed you about is true now. You can imagine what happens further. Moreover, my love, I long for — God knows — you coming home, but I would rather have you here because I cannot write. If you were able to read yourself, I would write to you more extensively, you know what I mean. I wish I could write myself; I would open my heart to you, but that is how it is.)[59]

Dircks could not write, and her loved one could not read. This means that in order to communicate the feelings of one party to the other, the help of two

57 Lijsbet Ariaens to Mattijs Karels in Curaçao — Amsterdam, 26 May 1672 (HCA 30-1062-2).
58 Aaltje Hendricks to Tomes Jansen Weijlandt in Batavia, 1 November 1672 (HCA 30-1061-2). It is unknown where this letter was written, but the destination was Curaçao.
59 Adriaantje Dircks to Jan Jaspersen, 18 September 1664 (HCA 32-1822-1), cited in Dekker, 'Brieven uit zee', p. 128. This letter does not date from 1672, but it can be seen as exemplary.

intermediaries was required: one to write the letter for Dircks, and another to read the letter aloud for Jaspersen. Moreover, the letter might well have been read aloud in a busy section of the ship, where Jaspersen and others would be told what Dircks had revealed to him. We can see in the way the letter is written that she had kindly taken this into account while writing the letter. This letter shows perfectly well how public and private go hand in hand: Adriaantje Dircks reflects on her physical condition (the heuristic zones of the body and the soul/mind/self), but she does so in covert terms because of the presence of intermediaries.

Epilogue

It is only by accident that we have such a peculiar and invaluable source at our disposal as the captured letters of 1672. These letters give us a glimpse into the private lives of people from the lower classes, particularly women in seamen's social circles. However, the question of privacy and private life in this source material is complex. It has become clear that the heuristic zone approach can readily be applied to the captured letters of 1672, where private life is mainly apparent in the domestic lives and selves of the senders. Furthermore, this chapter has demonstrated that private and public should not be approached as two entirely separate spheres, but rather as more fluid. The letters show us that during the course of 1672, public affairs concerning the war significantly affected more and more people in the private sphere.

In addition to using the heuristic zone approach, one should also be aware of characteristic epistolary mechanisms in order to distinguish conventionalism from originality. Letter books constitute the first and most important instrument to make this judgement. To further clarify the tension between theory and practice, one should examine letters written by people from the lower classes: they strictly follow the rules. Letters from senders in the higher classes of society generally appear more declarative, thanks to the elucidation of patterns that cannot be traced back to the letter books. In their own way, these letters demonstrate that certain unwritten letter-writing rules also prevailed.

Although the literacy rate in the Dutch Republic was quite high, not everybody had the means or skill to write a letter themselves. One can only imagine that the presence of a contributing third party would significantly affect the private character of a letter: the sender would probably not always feel completely free to articulate content in the way they might otherwise have done. Moreover, the sender often also took into account that the addressee might not be the letter's first reader; letters could fall into the wrong hands, or they could be read aloud in cases of illiteracy. In that way, the private letters of 1672 were indeed — to cite Mascuch again — public showcases of one's identity. In short, there are many layers to keep in mind when one seeks to uncover private life in personal letters. Nevertheless, whether naturally

formulated or not, and whether written by the sender's own hand or someone else's, the captured letters are the only known primary source material to open a window onto the private lives of those who lived during the Disaster Year, seen through the eyes of a very specific group of citizens living in the Republic.

Works Cited

Manuscripts and Archival Sources

Amsterdam, Huygens Institute for the History of the Netherlands, Dutch-Asiatic Shipping in the 17th and 18th Centuries (DAS) <http://resources.huygens.knaw.nl/das> [accessed 27 September 2020]

Amsterdam, Huygens Institute for the History of the Netherlands, Dutch Prize Papers <https://prizepapers.huygens.knaw.nl/> [accessed 16 February 2021]

Amsterdam, Meertens Institute, Gekaapte Brieven <http://www.gekaaptebrieven.nl> [accessed 10 July 2023]

Brieven als buit <https://brievenalsbuit.ivdnt.org/corpus-frontend/BaB/search/> [accessed 16 February 2021]

Brill, Prize Papers Online <https://brill.com/view/package/ppo?language=en> [accessed 16 February 2021]

Delpher Database <https://www.delpher.nl/nl/kranten> [accessed 16 February 2021]

Göttingen Academy of Sciences and Humanities, Prize Papers Portal <https://www.prizepapers.de/> [accessed 20 September 2020]

Kew, London, National Archives, High Court of Admiralty (HCA), 30–722, 30–1055, 30–1061, 30–1062, 32–274–3

Trans-Atlantic Slave Trade Database <https://www.slavevoyages.org/> [accessed 1 October 2020]

Uppsala University and Stockholm University, Scandinavian Prize Papers <http://prizepapers.se/home/> [accessed 16 February 2021]

VOC-opvarenden <https://www.nationaalarchief.nl/onderzoeken/zoekhulpen/voc-opvarenden> [accessed 27 September 2020]

Primary Sources

Jacobi, Heyman, *Ghemeene seyndtbrieven, seer profijtelick voor die ouders, meesters ende kinderen om te leeren brieven dichten ende oock wel te leven ende ordentlijck te schrijven* (Amsterdam: Ewout Cornelisz Muller, 1597)

Secondary Studies

Ariès, Philippe, *Centuries of Childhood: A Social History of Family Life* (New York: Vintage, 1962)

Baggerman, Arianne, and Rudolf M. Dekker, 'De gevaarlijkste van alle bronnen', *Tijdschrift voor sociale en economische geschiedenis/Low Countries Journal of Social and Economic History*, 1 (2004), 3–22

Balai, Leo, *Het slavenschip Leusden: Slavenschepen en de West Indische Compagnie, 1720–1738* (Zutphen: Walburg Pers, 2011)

——, *Geschiedenis van de Amsterdamse slavenhandel: Over de belangen van Amsterdamse regenten bij de trans-Atlantische slavenhandel* (Zutphen: Walburg Pers, 2013)

Bannet, Eve Tavor, *Empire of Letters: Letter Manuals and Transatlantic Correspondence, 1688–1820* (Cambridge: Cambridge University Press, 2005)

——, *British and American Letter Manuals, 1680–1810* (London: Pickering & Chatto, 2008)

'Belangrijkste gewesten overzee: Batavia' <https://www.voc-kenniscentrum.nl/gewest-batavia.html> [accessed 22 December 2020]

Blaak, Jeroen, *Reading and Writing in Early Modern Dutch Diaries* (Leiden: Brill, 2009)

Brandon, Pepijn, Guno Jones, Nancy Jouwe, and Matthias van Rossum, eds, *De slavernij in Oost en West: Het Amsterdam-onderzoek* (Amsterdam: Spectrum, 2000)

Braunius, Sipke W. P. C., 'Het leven van de zeventiende-eeuwse zeeman: Valse romantiek of werkelijkheid?', *Tijdschrift voor Zeegeschiedenis*, 40–41 (1980), 11–22

Brouwer, Judith, *Levenstekens: Gekaapte brieven uit het Rampjaar 1672* (Hilversum: Verloren, 2014)

Bruun, Mette Birkedal, 'Privacy in Early Modern Christianity and Beyond: Traces and Approaches', *Annali dell'Istituto storico italo-germanico in Trento*, 2 (2018), 33–54

Bruun, Mette Birkedal, and Natalie P. Koerner, 'Visualizing Privacy: Atmosphere and Medium', *Hypotheses*, 10 May 2020 <https://privacy.hypotheses.org/1133> [accessed 16 February 2021]

Chartier, R., A. Boureau, and C. Dauphin, *Correspondence: Models of Letter-Writing from the Middle Ages to the Nineteenth Century* (Cambridge: Polity Press, 1997)

Daalder, Remmelt, Dirk Tang, and Leo Balai, eds, *Slaven en schepen in het Atlantisch gebied* (Leiden: Primavera Pers 2013)

Davis, Ralph, *The Rise of the English Shipping Industry in the Seventeenth and Eighteenth Centuries*, 2nd edn (Newton Abbot: David & Charles, 1972)

Dekker, Rudolf M., 'Egodocuments in the Netherlands from the Sixteenth to the Nineteenth Century', in *Envisioning Self and Status: Self-Representation in the Low Countries 1400–1700*, ed. by Erin Griffey (Hull: Association for Low Countries Studies in Great Britain and Ireland, 1999), pp. 255–85

———, *Egodocuments and History: Autobiographical Writing in its Social Context Since the Middle Ages* (Hilversum: Verloren, 2002)

———, 'Jacques Presser's Heritage: Egodocuments in the Study of History', *Memoria y Civilizacion*, 5 (2002), 13–37

———, 'Brieven uit zee: De correspondentie van en met Nederlandse zeevarenden in de 17de en 18de eeuw', *Spiegel Historiael*, 40.3–4 (2005), 124–30

Emmer, Piet C., *De Nederlandse slavenhandel 1500–1850* (Amsterdam: De Arbeiderspers, 2000)

Erdmann, Axel, *Ars Epistolica: Communication in Sixteenth Century Western Europe: Epistolaries, Letter-Writing Manuals and Model Letter Books 1501–1600* (Luzern: Gilhofer & Ranschburg, 2014)

Frijhoff, Willem, and Maarten Prak, *Geschiedenis van Amsterdam: Deel II-1, Centrum van de wereld* (Amsterdam: SUN, 2004)

———, *Geschiedenis van Amsterdam: Deel II-2, Zelfbewuste stadstaat 1650–1813* (Amsterdam: SUN, 2005)

Gaastra, Femme, *The Dutch East India Company: Expansion and Decline* (Zutphen: Walburg Pers, 2003)

Gelder, Roelof van, *Het Oost-Indisch avontuur: Duitsers in dienst van de VOC (1600–1800)* (Nijmegen: SUN, 1997)

———, *Verslag van een inventariserend onderzoek naar Nederlandse brieven in het archief van het High Court of Admiralty in The National Archives in Kew, Groot Brittanië* (The Hague: Koninklijke Bibliotheek, 2006)

Gouw, Jan ter, *Kijkjes in de oude schoolwereld* (Leiden: A. W. Sijthoff, 1872)

Heijer, Henk den, *Geschiedenis van de WIC: Opkomst, bloei en ondergang* (Zutphen: Walburg Pers, 2013)

Jones, Eric, *Wives, Slaves, and Concubines: A History of the Female Underclass in Dutch Asia* (DeKalb: Northern Illinois University Press, 2010)

Kadar, Daniel Z., *Model Letters in Late Imperial China: 60 Selected Epistles from 'Letters from Snow Swan Retreat'* (Munich: Lincom Europa, 2009)

Ketting, Herman, *Leven, werk en rebellie aan boord van Oost-Indiëvaarders (1595–1650)* (Amsterdam: Aksant, 2002)

Keulen, Sjoerd, and Ronald Kroeze, 'Privacy from a Historical Perspective', in *The Handbook of Privacy Studies: An Interdisciplinary Introduction*, ed. by Bart van der Sloot and Aviva de Groot (Amsterdam: Amsterdam University Press, 2018), pp. 21–56

Klooster, Wim, *Illicit Riches: Dutch Trade in the Caribbean, 1648–1795* (Leiden: KITLV, 1998)

———, *Migration, Trade, and Slavery in an Expanding World: Essays in Honor of Pieter Emmer* (Leiden: Brill, 2009)

Lottum, Jelle van, 'Some Thoughts about Migration of Maritime Workers in the Eighteenth-Century North Sea Region', *International Journal of Maritime History*, 27 (2015), 647–61

———, 'The Necessity and Consequences of Internationalisation: Maritime Work in the Dutch Republic in the 17th and 18th Centuries', in *The Sea in History: The Early Modern World/La mer dans l'histoire: La période moderne*, ed. by Christian

Buchet and Gérard Le Bouëdec (Woodbridge: Boydell & Brewer, 2017), pp. 839–51

Lottum, Jelle van, Jan Lucassen, and Lex Heerma Van Voss, 'Sailors, National and International Labour Markets and National Identity, 1600–1850', in *Shipping and Economic Growth 1350–1850*, ed. by Richard W. Unger (Leiden: Brill 2011), pp. 309–51

Mascuch, Michael, *The Origins of the Individualist Self: Autobiography and Self-Identity in England, 1591–1791* (Oxford: Polity Press, 1997)

Métayer, Christine, *Au tombeau des secrets: Les écrivains publics du Paris populaire, Cimetière des Saints-Innocents, XVIe–XVIIIe siècle* (Paris: Editions Albin Michel, 2000)

Meuwese, Mark, *Brothers in Arms, Partners in Trade: Dutch-Indigenous Alliances in the Atlantic World, 1595–1674* (Leiden: Brill, 2011)

Münch, Paul, ed., *'Erfahrung' als Kategorie der Frühneuzeitgeschichte* (Munich: Oldenbourg, 2001)

Niemeijer, Henk E., *Batavia: Een koloniale samenleving in de zeventiende eeuw* (Amsterdam: Balans, 2005)

Nimako, Kwame, and Glenn Willemsen, *The Dutch Atlantic: Slavery, Abolition and Emancipation* (London: Pluto Press, 2011)

Nobels, Judith, and Marijke van der Wal, 'Tackling the Writer-Sender Problem: The Newly Developed Leiden Identification Procedure (LIP)' (2009) <https://www.let.leidenuniv.nl/hsl_shl/Nobels-Wal.html> [accessed 2 October 2020]

Oostindie, Gert, *Dutch Colonialism, Migration and Cultural Heritage* (Leiden: Brill, 2008)

Ortner-Buchberger, Claudia, *Briefe schreiben im 16. Jahrhundert: Formen und Funktionen des epistolaren Diskurses in den italienischen libri di lettere* (Munich: Wilhelm Fink, 2003)

Panhuysen, Luc, *Rampjaar 1672: Hoe de Republiek aan de ondergang ontsnapte* (Amsterdam: Olympus, 2009)

Philippa, Marlies, 'Van woord tot woord', *Onze Taal*, 54 (1985), 5

Poster, Carol, and Linda C. Mitchell, eds, *Letter-Writing Manuals and Instruction from Antiquity to the Present: Historical and Bibliographic Studies* (Columbia: University of South Carolina Press, 2007)

Postma, J., and V. Enthoven, *Riches from Atlantic Commerce: Dutch Transatlantic Trade and Shipping, 1585–1817* (Leiden: Brill, 2003)

Reinders, Michel, *Gedrukte chaos: Populisme en moord in het Rampjaar 1672* (Amsterdam: Balans, 2010)

Rossum, Matthias van, *Werkers van de wereld: Globalisering, werk en interculturele ontmoetingen tussen Aziatische en Europese zeelieden in dienst van de VOC, 1600–1800* (Hilversum: Verloren, 2014)

'Selectie van literatuur en datasets Prize Papers' < https://www.huygens.knaw.nl/wp-content/uploads/2019/08/Selectie-van-literatuur-en-datasets-Prize-Papers.pdf> [accessed 2 October 2020]

Sterkenburg, Piet G. J. van, *Een glossarium van zeventiende-eeuws Nederlands* (Groningen: Wolters-Noordhoff, 1977)

Taylor, Jean Gelman, *The Social World of Batavia: Europeans and Eurasians in Colonial Indonesia* (Madison: University of Wisconsin Press, 2009)

Webster Newbold, W., 'English Model Letters', *Appositions: Studies in Renaissance/ Early Modern Literature & Culture*, 4 (2011) <http://appositions.blogspot.com/2011/05/w-webster-newbold-rhetoric-fiction.html> [accessed 23 December 2020]

Weduwen, Arthur der, 'Fear and Loathing in Weesp: Personal and Political Networks in the Dutch Print World', in *Negotiating Conflict and Controversy in the Early Modern Book World*, ed. by Alexander Samuel Wilkinson and Graeme Kemp (Leiden: Brill, 2019), pp. 88–106

HANNA DE LANGE

Bibliotheca Furliana, 1714

The Public Sale of a Private Book Collection

In 1691, tragedy struck the linen merchant and Quaker leader Benjamin Furly (1636–1714).[1] Initially it had been happy news that Furly shared with his friend, the English philosopher John Locke (1632–1704). In his letter of 27 February, he wrote that his wife Dorothy had given birth to a daughter. But one month later, Furly reported 'the loss of our dearest Babe, [...] after 8 days of sickness of the mazles'.[2] This was not all. Dorothy herself had not been well, and Benjamin had had to send for a doctor because she had 'a fit of an ague, that her teeth chattered in her head'.[3] It is unclear what exactly she was suffering from, but sadly Dorothy died. It left Benjamin devastated. In his letters he had always spoken affectionately of her, and now he was a widower with five young children. Locke tried to comfort his friend in a letter dated 28 March 1691, after learning of his sorrow.[4] This tragic loss of his wife and baby daughter was one of the rare occasions when Furly shared his personal experience.

This chapter explores Furly's life from a privacy perspective. To do so, it is important to explain how 'privacy' is being understood here. Today, we see privacy in relation to individual human rights and the protection of personal information through the law. But this was not what privacy entailed in the past. Throughout history, the meaning of privacy has never been a fixed concept, but instead has always been subject to change. In the society of the early modern Dutch Republic, various developments can be identified that influenced these changes. Culturally, there was the arrival of individualism and the emergence of a middle class. Their increasing self-direction was reflected

1 I would like to thank Arthur der Weduwen for his comments and suggestions on an earlier version of this chapter.
2 Locke, *The Correspondence*, letters 1363 and 1379.
3 Locke, *The Correspondence*, letter 1364.
4 Locke, *The Correspondence*, letters 1379 and 1386.

Hanna de Lange completed her PhD at the University of St Andrews with a dissertation on early modern book history.

Private Life and Privacy in the Early Modern Low Countries, ed. by Michael Green and Ineke Huysman, EER 19 (Turnhout: Brepols, 2023), pp. 225–246
BREPOLS ☙ PUBLISHERS 10.1484/M.EER-EB.5.132536

in the way people voiced their inner feelings through their correspondence and diaries.[5] Another way to distinguish between the private and the public were the circumstances in which people lived. The middle class used their houses to emphasize their personalities and withdraw from public demands. It became more and more common to dedicate certain rooms to specific functions, such as a library.[6] In the religious sphere, ideas were subject to change under the influence of the Reformation. The collective practice of faith gave way to the idea that each person had an individual relationship with God, based on their own interpretation of the Bible. This required private study of Scripture. A last change that contributed to the private sphere was of a technological nature. Texts — both in scholarly languages and increasingly also in the vernacular — became accessible to a much wider audience than ever before.[7] Throughout Furly's life, we can track these developments. To cope with increasing public claims on his personal life, Furly could withdraw to his own quarters, express his inner feelings in his correspondence with friends, seek comfort in his faith, and satisfy his intellectual needs through his book-collecting practices.

The Centre for Privacy Studies in Denmark has developed a method to investigate the concept of privacy in the early modern period. Mette Birkedal Bruun has defined heuristic zones that can be used as tools of analysis. The zones represent 'the areas in which notions of privacy and the private are negotiated'.[8] These zones are the soul or mind, the body, the chamber or studio, the home, the community, and lastly the state or society. It is when the boundaries of these zones are crossed, or in areas where two or more zones overlap, that we can gain more insight into Furly as an individual. To identify the different zones in which Furly operated, various sources will be inspected. This approach helps us to answer questions concerning Furly's private life. What were the boundaries between his family life and his membership of the Quaker community? How did Furly secure access to his house and his library? How could his library be transformed from an individual collection to public property? Questions such as these are at the core of this chapter.[9]

The principal primary source used in this chapter is the book auction catalogue that was compiled to sell his private library collection after his death. This source will be supplemented by Furly's private correspondence, notarial deeds, marriage contracts, and city registers. Alongside written and printed sources, artefacts and paintings will also help to recreate the private space of Benjamin Furly.[10] Before turning to these sources a concise biography

5 Keulen and Kroeze, 'Privacy', pp. 24–25.
6 Pettegree and Weduwen, *The Library*, pp. 124.
7 Keulen and Kroeze, 'Privacy', pp. 25–27.
8 Bruun, 'Zones of Privacy'.
9 Bruun, 'Towards an Approach', pp. 22–24.
10 Duby, *A History of Private Life*, pp. ix–xiii.

of Furly and the Quaker community in Rotterdam will be given to serve as the foundation upon which Furly's private life can be reconstructed.

The Life of Benjamin Furly

Born on 13 April 1636 in Colchester, Benjamin Furly grew up in the county of Essex in the south-east of England. His father John (*c.* 1590–1673) was a linen merchant, and mayor and alderman of the city of Colchester. All that is known about his mother is her first name: Anna. Benjamin had two brothers, John and Stephen.[11] During his early years, various religious movements and sects started to blossom, looking for an alternative to the Anglican Church. Among them was the Quaker community, founded by George Fox (1624–1691) around 1650. Quaker beliefs were spread by evangelists who travelled around. One of these was James Parnell (baptized 1636, d. 1656), who asked John Furly senior for permission to preach from his hayloft in 1655. The nineteen-year-old attracted a large crowd of around a thousand listeners, many of whom converted to the Quaker movement that same day. Benjamin was one of these converts, and this occurrence would have a profound impact on the rest of his life. The religious and political authorities in England, however, did not endorse the Quakers' approach to the Christian faith. Quakers were persecuted and arrested for their beliefs. Parnell himself met with such a fate. He was sent to jail for spreading his beliefs through his preaching and pamphlets, and he died in prison at the age of twenty.[12]

Many Quakers — including Benjamin Furly — sought refuge abroad. Furly was going to take care of the family business in the Dutch Republic, so he left England to settle there. According to the family's Dutch neighbour in Colchester, Gerard Croese, Benjamin already spoke Dutch.[13] The young English merchant first settled in Amsterdam before he moved his domicile to Rotterdam. Here he lived until his death. The choice of Rotterdam made sense because the city had a substantial English community and was a major gateway port for trade with the rest of Europe.[14]

Benjamin married three times. His first marriage was to Elisabeth Johnson in June 1663. After his first wife died, he married to Dorothy Grainge (?–1691), the daughter of a Quaker from Whitby. With her he had five children who survived into adulthood. This marriage was not listed in the Rotterdam marriage registers, and therefore we have no fixed date. Their first child was

11 Hull, *Benjamin Furly*, pp. 3–11. In a notarial deed in the City Archives of Amsterdam, his brother John is referred to as John minor: Amsterdam, Stadsarchief, Notariële Archieven 1578–1915, 5075, 3658, p. 728; Rotterdam, Stadsarchief Rotterdam, 18_396_92.
12 Davies, 'James Parnell', pp. 1–3.
13 Reijn, 'Benjamin Furly', pp. 219–46. Gerard Croese was their neighbour of Dutch descent, who would later write a history of the Quakers, *Historia Quakeriana*.
14 Bunge and Oudenaarden, 'Rotterdam in de literatuur', p. 7.

Benjohan, born on 6 January 1681. After Benjohan (1681–1738), the couple's sons John and Arent (?–1712) and their daughters Johanna and Rachel were born. No exact dates of birth or death are known for the children other than Benjohan, the eldest. According to the city's burial records, the couple also had children that died at very young ages. One was buried in 1670, one in 1680, and as we saw in Benjamin's correspondence with Locke, a baby girl died in 1691.[15] In December 1693, Benjamin married to Susanna Huis (1644–1707), the wealthy widow of the merchant Jacobus van der Tijt. Marrying Benjamin made her the stepmother of five children under the age of twelve.

Even this concise overview shows that Benjamin Furly had to cope with many personal losses in his life. He outlived all three of his wives, as well as at least three very young, still unnamed children he had with Dorothy. His close friend Locke passed away in 1704, and a grandchild died in 1709.[16] Life dealt him another blow just two years before his own death, when in 1712 his son Arent died in the English army in Spain.

During the fifty-five years that Benjamin Furly lived in Rotterdam, his business prospered and he was able to buy and sell various properties (Figure 8.1). He used these as his family homes, for business and to host Quaker meetings. One address featured on letters that Locke sent Benjamin Furly. A letter dated 26 January 1668 letter was addressed 'for Mr Benjamin Furley, on the Scheepmakers' Haven, in Rotterdam'.[17] During Locke's stay in the Dutch Republic during 1687–1689, he resided at the Furlys' house whenever he was in Rotterdam. He even had his own room there. In his correspondence he gave Furly instructions as to where a particular book was located:

> You need but looke into *Defense des Sentimens de quelques Theologiens*, etc. p. 535, etc. The book is about the bignesse of Lily's Grammar; you will finde it amongst the books in my chamber, bound in vellum.[18]

It was not only Locke who found a welcoming host in Furly, but an abundance of international guests too: Quakers and non-Quakers, exiles and casual travellers.[19] None of these guests had such close access to Furly as Locke did; Locke was in every sense a 'house friend'.

The last property Furly occupied was a house with an associated warehouse on Haringvliet overlooking the Maas river. Benjamin installed his office and his library here. Another exile, nobleman and philosopher Anthony Ashley Cooper, third Earl of Shaftesbury (1671–1713), resided with the family in this house in 1703.[20] Clearly, Furly gave fellow exiles from England access to his

15 Schoor, 'Benjamin Furly in Business', pp. 12–13; Rotterdam, Begraafinschrijving N.n., 9999_14. The children are unnamed: N.N.

16 Rotterdam, Begraafinschrijving N.n., 9999_14.

17 Locke, *The Correspondence*, letter 995.

18 Locke, *The Correspondence*, letter 995.

19 Hutton, 'Introduction', p. 3.

20 Greaves, 'Benjamin Furly', p. 171; Schoor, 'Benjamin Furly in Business', p. 13.

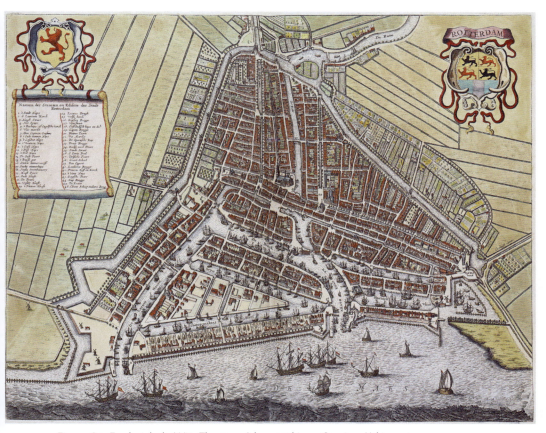

Figure 8.1. Frederick de Wit, *Theatrum Ichnographicum Omnium Urbium et Præcipuorum oppidorum Belgicarum, XVII Provinciarum peraccurate delineatarum*, map 20. Rotterdam, 1698. Photo courtesy of National Library of the Netherlands, shelf mark PPN_145205088.

houses. It is likely he did this because he could empathize with their refugee experience and wanted to make them feel at home.

The Quaker Community

The Quaker movement was an important factor in the life of Benjamin Furly. The convictions that Fox had introduced influenced his decision-making. One critical concept was that the relationship to God was a personal one for each individual. This implied that no interference of any clerical teacher was required and churches were deemed unnecessary. Quakers gathered together in meetings to search for their inner guide or inner light. During these meetings, members could remain quiet, but anyone who wanted to

speak out was allowed to do so, even women and children. Members called themselves 'Children of the Light' or 'Friends of the Truth', which later became 'the Religious Society of Friends'.[21]

In England, Quakers were perceived as a radical movement and a dangerous sect. The 1662 Quaker Act forbade gatherings of more than five people for any religious services other than those of the Anglican Church, making their meetings virtually impossible. Because of the hostile climate in England, many Quakers sought exile abroad. In the Dutch Republic, the authorities were not necessarily more welcoming, but the Quakers were not actively persecuted, as long as members kept a low profile and made sure their beliefs escaped the scrutiny of those in charge. Benjamin Furly became a leading figure, who provided space for meetings of Friends in his own properties, engaged with influential Quakers, disseminated their ideas by spreading and translating Quaker tracts and by publishing his own writings. Furthermore, Furly tried to protect members from threats from outside the community and met with the local magistrates to negotiate. He also defended individual members as an arbitrator at the civil notary, acting as go-between whenever Friends needed help.[22]

In addition to opposition from the authorities, Friends also faced resistance from other sects. One of these was the spiritual movement of Antoinette Bourignon (1616–1680), mystic and prophetess, who believed in the end times.[23] Furly actively engaged in fierce polemics with her. To his 1671 tract *Anthoinette Bourignon ontdeckt, en haar geest geopenbaart* (Anthoinette Bourignon discovered and her spirit revealed), she replied with a counter-attack *tegen de Secte der Quakers* (against the sect of Quakers).[24] Furly continued to keep track of the ideas Bourignon spread, as evidenced by the presence of her works in his library.[25]

As much as the community of Quakers struggled with the authorities and opposing sects, there were tensions within the young religion as well. Partly this was due to one of Fox's own tenets. Without a hierarchical structure, every principle could be questioned.[26] Throughout his life, a development in Benjamin's beliefs can be seen. After his conversion, he was fanatical in his faith. This is evident in the way he defended Quakerism in disputes with state and Church authorities. Saluting others by way of greeting, for instance, was thought of as idolatry, which Friends considered unacceptable behaviour. They strongly believed in an anti-hierarchical, egalitarian society. Furly fervently supported this belief. On the other hand, Benjamin engaged in religious interpretative

21 Ingle, 'George Fox', p. 2.
22 Hull, *Benjamin Furly*, p. 30.
23 Baar, 'Bourignon, Antoinette'.
24 Furly, *Anthoinette Bourignon Ontdeckt*; Bourignon, *Advertissement*.
25 *Bibliotheca Furliana*, lots 19, 184, 249, 291 (containing ten volumes of her complete works), and 547.
26 Ingle, 'George Fox', pp. 2, 3, 7.

debates with his fellow Quakers. Controversies within the community could pressure Benjamin to take sides. Later in life, Benjamin became more lenient. He even refuted some of the strict convictions of his youth.[27]

Guarding the boundaries between the Quaker community, himself, and his family life was not always straightforward. There are two instances I would like to point out in which Benjamin Furly collided with the Quakers over private matters. The first time was when Dorothy, his second wife, died. Benjamin wanted to honour her memory by paying his last respects to her in the local Laurenskerk, with all the manifestations of a Reformed Protestant burial. Within the community this was unheard of, and Benjamin was called to account. Their reaction felt harsh and unreasonable to him. His loyalty was questioned, leaving him disillusioned. From this moment onwards, he seems to have slowly withdrawn from active leadership of the movement. When in 1695 a Rotterdam member of the Friends bought a house dedicated to meetings, Benjamin no longer felt the need to host them in his own home.[28]

The other occasion was when he married his third wife, Susanna. During the meetings of Friends, a marriage could be performed without the involvement of state or Church. Benjamin's first wife Elisabeth and his second wife Dorothy were both Quakers, which explains why neither marriage was registered in the city's wedding registers. With his marriage to Susanna Huis, it was a different matter. Within the Quaker community there was opposition to the marriage, because Susanna was not one of them. On top of that, Benjamin officially reported this wedding to the authorities. Therefore, his 'denomination' indicated on the official marriage certificate is *Stadstrouw* ('civic loyalty').[29] Once more, Benjamin could count on rejection from within the Quaker ranks.

Book Auctions

On 19 January 1688, Locke — at the time residing in Amsterdam — wrote to Benjamin that he should try to get 'the Groeningen catalogue'. Locke had received word that it was an excellent catalogue.[30] One week later, Locke reported that he could obtain the catalogue in Amsterdam. But he had no mind to do so, because:

> The Groeningen Catalogue is to be had here, but you must pay 15 styvers for it. This methinks is not orthodox; and therefore I shall abstain from such undue practice, unless you give me order to the contrary. 'Tis the

27 Hull, *Benjamin Furly*, p. 11; Villani, 'Conscience and Convention', pp. 95–101.
28 Hull, *Benjamin Furly*, pp. 20, 62, 156–57.
29 Rotterdam, Oud Archief van de Stad Rotterdam, 1–01.1060. Quakers were not allowed to marry in a state church.
30 Locke, *The Correspondence*, letter 993.

biggest catalogue I ever yet saw; it has above 600 pages in 8vo, printed as close as Heysius's Catalogue was. I have borrowed one of a friend, who has also promised me a commissioner that is not an author, if I have a mind to have any of the books bought for me.[31]

This book auction catalogue, printed in Leiden, was indeed extraordinary. It listed more than 11,000 books from the library of the late professor of law Jacobus Oisel (1632–1686). The auction would be held in the house of the deceased in Groningen; hence Locke's reference to this northern Dutch city. The catalogue was for sale both locally and abroad, and the auction started on 11 May 1688. Their correspondence indicates that Locke and Furly were very familiar with the phenomenon of the book auction. It underlined their mutual love of books, and they attended sales on each other's behalf.[32]

Buying books at auction was just one means for Furly to collect books. During his lifetime, he built up a considerable library himself. His collection containing *c.* 4500 books would in turn be sold at auction after his death on 21 March 1714, in his house in Rotterdam. An auction catalogue was printed for the event: the *Bibliotheca Furliana*, listing all his books, printed and manuscript, bound and unbound (Figure 8.2). At the end of the catalogue, sixty items or 'curiosities' were added. The surviving copy of the *Bibliotheca Furliana* held by the British Library contains handwritten annotations made by Benjamin's oldest son, Benjohan. In his copy Benjohan added the prices paid for each lot and the names of the buyers that bought them. In an appendix at the end Benjohan noted the revenues and the total amount to be paid per buyer, of which he himself was one. He named one entry 'Books & Curiosities appertaining to My Self'.[33]

Why the heirs of Benjamin Furly decided to part with their father's inheritance remains unclear. In the absence of a will, we cannot be certain what fate Benjamin had envisioned for his books. His children could have had a number of reasons. The collection could have been too big to fit into their houses or they had formed libraries of their own. Another motive could have

31 Locke, *The Correspondence*, letter 995. The guilder (*gulden*) minted by the States of Holland and West Friesland in 1680 was divided into twenty *stuivers*. Each *stuiver* was divided into eight *duiten* or sixteen *penningen*.

32 Pettegree and Weduwen, *The Library*, p. 130; Selm, *Een menighte treffelijcke Boecken*, pp. 25–27. For the *Bibliotheca Oizeliana*, see Book Sales Catalogues Online (BSCO). The catalogue was first printed in Leiden by Jacobus Hackius in 1688. The advertisements appeared in the *Oprechte Haerlemse Courant*, 20 and 27 April 1688.

33 There has been some confusion as to who annotated the copy of the catalogue in the British Library. It was not John but Benjohan Furly who added the names of the buyers and the prices they paid. This copy was scanned and added to the Brill database BSCO. The evidence is in the listing at the end, where the person writing the marginalia mentions the 'Books & Curiosities appertaining to My Self'. Here he states that among others, lot 59 on page 290 is one of his: 'This is a present from Coll. Otway to my Daughter Dorothy'. Benjohan and his wife Martha Wright had named their eldest daughter Dorothy after her grandmother. She was born in 1710.

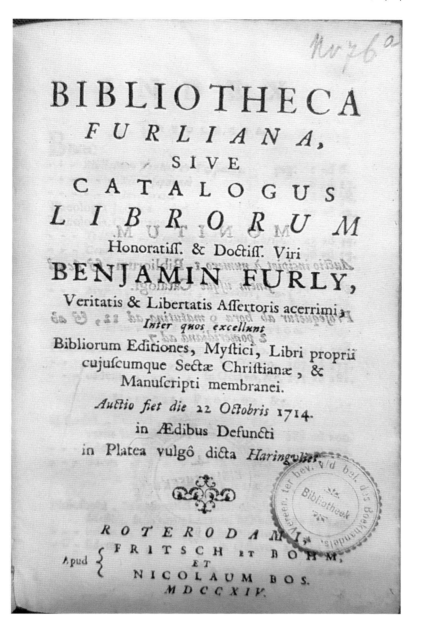

Figure 8.2. *Bibliotheca Furliana*, title page. Fritsch, Bohm, and Nicolaus Bos, Rotterdam, 1714. Photo courtesy of Allard Pierson, University of Amsterdam, shelf mark KVB-NV-76a.

been that selling the most precious parts of the inheritance enabled them to split the proceeds among themselves.[34] One possibility we can rule out is that they felt indifferent. The way Benjohan closely followed the proceedings of the auction and the fact that both he and his brother John bought books at the occasion, reflects the value they attached to their late father's possessions.

The use of book auction catalogues as a historical source is a relatively new phenomenon.[35] The catalogues allow us to reconstruct the intellectual life of the library owner and to research readers' behaviour.[36] In addition, book auction catalogues provide us with valuable information about the production, distribution, and consumption of books. Book auction catalogues were a hybrid form of private and public information. They take us from the hallowed space of a private library to a public auction room. Books that had formerly adorned the shelves of a library could now be bought by total strangers. In this way, a carefully built collection would fall apart at auction, scattering the books far and wide. The library's contents would reflect the personal collecting habits of its owner, while the circulation of the catalogue and the public auction of the library were intended to attract as many potential buyers as possible.[37]

To attract customers to the auction of Benjamin Furly's library, the publishers of the catalogue, Fritsch, Bohm, and Nicolaus Bos, made no fewer than three announcements in the *Gazette de Rotterdam* and at least one in the *Oprechte Haerlemse Courant*.[38] The information was slightly different in each. In the advertisement in the French-language *Gazette*, which was mainly aimed at Huguenots who had found refuge in the Netherlands, the emphasis was on the many Bibles for sale. In the *Oprechte Haerlemse Courant*, the focus of the advertisement was much more on the value, rarity, and physical appearance of the books.[39] The effect of these advertisements was that the name of Benjamin Furly — whether readers had ever heard of him or not — would now forever be tied to his book collection.

The Dutch advertisement also stated that the auction catalogue was for sale in all the prominent cities of the Dutch Republic. Contemporaries who regularly read the newspapers would have had an idea of what this entailed.[40] Another advertisement for an auction scheduled on the exact same date, Monday 22 October 1714, pertained to the sale of four libraries in

34 For more information about collecting practices, see Pettegree and Weduwen, *The Bookshop of the World*, pp. 294–318.
35 See this recently published edited volume dedicated to book auction catalogues: Weduwen, Pettegree, and Kemp, eds, *Book Trade Catalogues*.
36 Duby, *A History of Private Life*, pp. ix–xiii; Champion, 'Fodder of our Understanding', pp. 115–17, 120.
37 Walsby, 'Book Lists', pp. 6–11.
38 Gaspard Fritsch, Michel Böhm, and Nicolaas Bos were all booksellers in Rotterdam.
39 *Gazette de Rotterdam*, 8, 11, and 15 October 1714; *Oprechte Haerlemse Saturdaegse Courant*, 42, 20 October 1714; Lamoen, 'Bibliotheca Furliana (1714)', p. 9.
40 Weduwen and Pettegree, *The Dutch Republic*, pp. 96–97.

Leiden. Here, the towns and bookshops where customers could obtain the sales catalogues were clearly stated. These were in Amsterdam from J. van Oisterwijck's bookshop, in Haarlem from M. van Lee, in The Hague from Aalberts and Gosse, in Delft from Beman, in Rotterdam from N. Bos and the widow Boeckens, in Dordrecht from Van Braam, in Gouda from Endenburg, in Utrecht from Paddenburg, and in Arnhem from Smids. The list ends with '&c.' because there were more sales addresses than could be provided in the advertisement. This shows the dissemination of book auction catalogues within the borders of the Dutch Republic.[41]

Next to the domestic circulation, the *Bibliotheca Furliana* was spread abroad. Today, we know of nineteen surviving copies of the catalogue. Two are kept in Rotterdam and two in Amsterdam. Other copies can be found in Paris, London, Leeds, Cambridge, Oxford, Göttingen, Haverford, Budapest, Copenhagen, New Haven, Philadelphia, and St Petersburg.[42] The distribution reflects the catalogue's public availability, which extended not only far beyond the confines of Furly's office, but also far beyond the country's borders.

The Contents of the *Bibliotheca Furliana*

Not surprisingly, a number of scholars have studied the contents of the *Bibliotheca Furliana*.[43] They have analysed the catalogue from different perspectives, such as Anglo-Dutch literary connections, or Furly's network of influential politicians, scientists, and philosophers. They have focused on the Quaker literature in the collection, or on secular works. Here, I will look at the characteristics that reflect Benjamin Furly's personal preferences. These distinguish the catalogue from others of its time.

The first thing that catches the eye is the mention of material aspects of the books. Usually, the information in book auction catalogues was limited to the title of the book, the name of its author, and the place and year of publication. The descriptions given in Furly's catalogue reflect the special care he gave his books. Detailed information was given regarding how each book was bound, and what type of binding was used for its cover. Whether Furly had all his books bound in his own style, as Samuel Pepys (1633–1703) did, is not known.[44] But he did have his own bookplate with an emblem, dated 1705 (Figure 8.3).[45] Other information that was supplied is whether illustrations were present. 'Fig.' or 'figure(s)' and 'vol curieuse kopere platen'

41 *Oprechte Haerlemse Donderdaegse Courant*, 41, 11 October 1714.
42 *Bibliotheca Furliana*.
43 Golden, 'Benjamin Furly's Library', pp. 16–20; Hull, *Benjamin Furly*, pp. 137–55; Reijn, 'Benjamin Furly', pp. 231–40; Lamoen, 'Bibliotheca Furliana (1714)', pp. 9–23; Champion, 'The Fodder of our Understanding', pp. 120–27.
44 Pepys, *The Diary*, Wednesday 18 January 1664/65.
45 Hull, *Benjamin Furly*, p. 143.

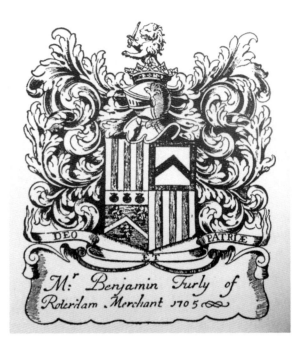

Figure 8.3. Bookplate of Benjamin Furly, in William I. Hull, *Benjamin Furly and Quakerism in Rotterdam*. Pennsylvania, 1941. Photo courtesy of National Library of the Netherlands, shelf mark NL 53 P 8006.

(filled with very fine copper plates) refer to woodcuts or engravings. The size and quality of the paper and the quality of the edition were other material characteristics commented on: 'groot papier' (large paper), or 'beste druk' (best edition). The information about the quality of the books demonstrates that Benjamin Furly spent a lot of time and money on his collection. This is where his personal taste comes to light.

As was to be expected of a Quaker leader, Benjamin Furly owned quite a number of books written by Friends. But Furly also owned a remarkable number of other theological works, including books by established orthodox authors and more controversial religious works.[46] In the *Bibliotheca Furliana*, the extensive category of theological works is subdivided. Its composition matches the broad interests of the owner. Taken together, theology makes up nearly 45 per cent of the total collection, whereas in similar book auction catalogues of the time it is closer to a third. For comparison, up to 65 per cent of the collections of Dutch ministers could comprise theological works.[47] Furly was well acquainted with a number of Quaker authors. He owned nearly thirty works written by Fox, ranging from the unassumingly titled *Several Treatises* (London, 1658 and 1661) to the intriguing *Encouragement to all the*

46 Champion, 'The Fodder of our Understanding', pp. 120–27.
47 Strickland, 'Building a Library', p. 190; Selm, *Een menighte treffelijcke Boecken*, pp. 116–19.

Women's Meetings in the World (S.l., 1676).[48] A compilation of works written by James Parnell, called *Works* (S.l., 1675), had been published twenty years after his death in prison.[49] Other Quaker authors in Furly's collection were William Penn, Robert Barclay (with eleven works), James Nayler, Stephen Crisp, and Isaac Pennington.[50] The last entry in the unbound books section, lot 83, mentions 'Twenty Packets, more of all Sorts of Friends Books'.[51] The precise contents of these packets will forever remain unknown. We do know, however, that the reference to Friends means the packets contained (even more) Quaker publications. To the compiler of the catalogue the precise contents of these packages were of less value than they must have been for their former owner.

As with the works by Fox and Parnell mentioned above, a significant number of the works are listed with no place of publication. For nearly three hundred titles, no location is given. Works of a provocative nature could be printed anonymously. Either the name of the author, the printer, the place of publication, or all three might be missing from the title page. This procedure was a deliberate act to hide the author, printer, or publisher. And this practice was not confined to Quakers. The people involved in the production of the work tried to keep their identities private, invisible to the prying eyes of the authorities. There are many examples of this practice among Furly's books. For the title *Fiat Lux, or a general Conduct to a right Understanding about Religion*, neither the place of publication nor the publisher are mentioned on the title page, and the author is only indicated by the initials J. V. C.[52]

Benjamin Furly relied on this procedure several times for works of his own hand. This was the case with *Copye van eenen brief: Geschreven aen seeckeren vriend* (copy of a letter: written to a certain friend). The title page reveals only his initials: B. F. Despite the title, this is not a handwritten document, but a printed version of the letter. Contrary to the usual practice in print, the place of publication is not mentioned, and in place of the publisher's name the imprint states 'gedruckt voor den autheur' (printed for the author).[53] Scholars have often emphasized Furly's support for freedom of religion and his aversion to dogmatism.[54] But these practices show he was also a pragmatic man, well aware that the authorities might find his work provocative. So he kept the information to himself. By acting cautiously and even secretively he protected himself, his family, and his fellow Quakers.

Another interesting aspect of the contents of the catalogue is language. Benjamin Furly was well known for his language skills. Friends, fellow English

48 *Bibliotheca Furliana*, lots 1074, 1060, and 1022.
49 Davies, 'James Parnell', p. 3.
50 *Bibliotheca Furliana*, lot 1066.
51 *Bibliotheca Furliana*, p. 362.
52 J. V. C., *Fiat Lux*; in the catalogue, lot 761 in octavo in the theology section.
53 B[enjamin] F[urly], *Copye*.
54 Hutton, 'Introduction', p. 6; Lamoen, 'Bibliotheca Furliana (1714)', p. 3.

people, and trade partners relied on him to translate for them. He helped Englishmen based in the Netherlands at the notary's office, and he was an interpreter for William Penn, George Keith, and Robert Barclay on their travels through the Dutch Republic and the Holy Roman Empire.[55] Besides English and Dutch, Furly spoke German, French, and Latin. Despite his linguistic talents, he was modest. He once remarked that his Dutch was inferior to his English.[56] However, Furly's polyglot skills were reflected in his book collection, which contained a range of languages. Even though the dominant languages of the day were Latin and French, he owned no fewer than 1666 books in the English language. Another thirty-five titles were in both English and one or more other languages, such as dictionaries or grammar books. This brings the percentage of English books to almost one third of the entire collection.

Receiving books as gifts was another way Furly's collection could grow. The compiler of the *Bibliotheca Furliana* must have realized that mentioning the donors would increase the publications' value. The theologian John Howe (1630–1705) had presented his work as a gift to Furly. The entry in the catalogue remarks that this is 'a Present from the Author'.[57] The note 'ex Donatione Illustr. Earl of Shaftesbury' appears on two occasions.[58] One of the titles Shaftesbury gave to Furly appears twice in the catalogue; probably Furly already owned a copy of the work. Other donors were John Parkhurst and the lawyer John Freke (1652–1717), both referred to as 'esquire'.[59] As a reminder to himself, Benjamin Furly wrote the donors' names in the respective books. The compiler of the catalogue copied this information. These personal remarks written by Furly represented emotional value, which could explain why his son John bought a number of books that contained his father's annotations. One had been a gift from the treasurer Thomas Micklethwait (1678–1718), and another was from the French Huguenot writer Pierre des Maizeaux (1672/1673–1745).[60]

A last feature I want to highlight here is a hitherto overlooked entry. It concerns 'The Brittish Apollo, or curious Amusements for the Ingenious, 100 Pieces of the first and second Volume'.[61] *The British Apollo* had first appeared as a periodical in London in 1708, and it had gained instant fame. It was aimed at

55 Hull, *Benjamin Furly*, pp. 45–48.

56 Hutton, 'Mercator Theologico-Philosophicus', pp. 149–50.

57 *Bibliotheca Furliana*, lot 799, p. 146: John Howe, *Living Temple*, 2 vols (London, 1702).

58 *Bibliotheca Furliana*, lot 970, p. 156: Whichcot, *Select Sermons* (London, 1698); lot 63, p. 188: Henry Sacheverell, *Tryal before the House of Peers for high Crimes and Misdemeanors* (London, 1710).

59 *Bibliotheca Furliana*, lot 438, p. 221: Thomas Crew, *Proceedings and Debates of the House of Commons* (London, 1707); lot 477, p. 226: Benjamin Hoadley, *Measures of Submission to the civil Magistrate consider'd, in a Defense of the Docttrine deliver'd in a Sermon* (London, 1706).

60 *Bibliotheca Furliana*, lots 417 and 525, p. 209, p. 231. Thomas Micklethwait was a friend of the third Earl of Shaftesbury.

61 *Bibliotheca Furliana*, lot 16. The full title of the periodical was *The Brittish Apollo, or Curious Amusements for the Ingenious: to which are added the most material occurrences foreign and domestick.*

the English market, and readers could ask questions on miscellaneous topics, such as science, theology, mathematics, medicine, customs, or manners. The questions appeared in printed form, combined with answers from the editor, which was a novelty at the time.[62] It was very unusual that printed ephemera, such as newspapers and pamphlets, appeared in auction catalogues. In the case of Furly, a man who had many contacts in his home country, it is not surprising that he had acquired this new periodical. But for what reason did he have one hundred copies of the first two volumes? Was he planning to distribute them among his fellow countrymen, in order to confirm ties within his Rotterdam network? Or did he want to sell them, as his entrepreneurial spirit might suggest? Regardless, we may wonder why he still owned the magazines, considering the time that had passed between the date they were published and the date of the auction. Now they remain silent witnesses to Furly's enduring interest in the latest novelties from England.

Curiosities for Sale

In 1710, the German bibliophile Zacharias Conrad von Uffenbach (1683–1734) visited Furly in his house at Haringvliet. In his travelogue, Uffenbach describes the two rooms he was allowed access to. One was Furly's office, and the other was a room on the south side of the house, overlooking the river. The descriptions are the only source that allow us a glimpse into the private chambers of Furly's house. Much to Uffenbach's astonishment, Furly had transformed his office into a library. He was surrounded by his books in his *comptoir* (cabinet).[63] The German visitor's main interest concerned the books. However, the 'curiosities' mentioned at the end of the auction catalogue were also for sale, and these help us to reconstruct how Benjamin Furly may have decorated his private quarters. There were sixty lots for sale, some containing more than one item. In total they returned the sum of 1367 guilders and nineteen stuivers — the equivalent of roughly 73,680 guilders or €33,430 in 2022.[64]

Of the first five items, three were 'English' or made from 'English' material: a writing desk in walnut, a standing clock, and an example of the newly invented barometer. Did they reflect a craving Furly had for English items, or were they just in vogue? Another desk was East Indian and made from ebony. Next to the standing clock from England was a hanging clock with even more features, showing the position of the moon and containing an alarm. It was made by

62 McGuinness, 'Musical Provocation', p. 333.
63 Uffenbach, *Merkwürdige Reisen*, pp. 278–80. During this same trip, Uffenbach also visited Fritsch and Böhm, the booksellers who would publish the book auction catalogue after Furly's death.
64 *Bibliotheca Furliana*, pp. 347–52; Lamoen, 'Bibliotheca Furliana (1714)', pp. 20–21.

the Englishman Stephen Tracy, who like Furly worked in Rotterdam.[65] The portable barometer was said to have been invented by Daniel Quare, another fellow Englishman and a Friend.[66]

The *Lucerna Magica* or magic lantern was made by 'mister Hartsoecker', who had also made the long telescope or *Maankyker* (moon viewer); these are listed as lots 6 and 7. Had Benjamin bought these instruments from the inventor? Nicolaas Hartsoecker (1656–1725), mathematician and physicist, was also the producer of some of the microscopes contained in an ebony box. There was yet another microscope, made under the supervision of the famous René Descartes, who had given it to Elizabeth of the Palatine. She in turn presented it to Benjamin Furly, probably when they met in 1676.[67] Lots 10 and 11 are described in French as *mirroirs ardents* (burning mirrors), of which one had been a gift from the 'monarch of Sultzbach'.[68] Two mathematical instruments are not further specified, but tools made by Furly's friend Franciscus Mercurius, Baron of Helmont (1614–1699), come with a more elaborate description.[69] He had made a special chair on which a lectern could be attached for sick people and those suffering from gout.[70] Had Helmont custom-made this chair especially for Benjamin Furly, who was ill during the last years of his life? Two lathes, two spinning wheels — one made of palmwood and copper — and a reel for winding thread from the spinning wheel were also made by Helmont.[71] Could these tools have belonged to Benjamin's children, or to his third wife Susanna?

On a pedestal somewhere in the house, perhaps in the hallway, stood a bust of Johan de Witt (1625–1672), grand pensionary of Holland from 1653 to 1672.[72] In the 1660s Furly had supported the Republican faction in the Holland government, which advocated government without a princely stadholder; Johan de Witt had been one of the key proponents. Among Furly's books was *Interest van Holland* (Amsterdam, 1662), written by Pieter de la Court (1618–1685). Johan de Witt had edited the manuscript and contributed Chapters 29 and 30 to the printed version.[73]

65 Leopold, 'Clockmaking', pp. 155–65.

66 *Bibliotheca Furliana*, 'Curiositates', lots 1–6; Radford, 'Daniel Quare'.

67 *Bibliotheca Furliana*, 'Curiositates', lots 7 and 8. The Elizabeth referred to here was Princess Elizabeth of the Palatine (1618–1680), the eldest daughter of Frederick V and Elizabeth Stuart (the Winter Queen). She was a philosopher known for her friendship and correspondence with Descartes.

68 The catalogue does not specify his identity, but the most likely candidate is Christian Augustus, Count Palatine of Sulzbach (1622–1708).

69 Hull describes Helmont as one of Furly's picturesque and adventurous friends. Hull, *Benjamin Furly*, p. 105.

70 *Bibliotheca Furliana*, 'Curiositates', lot 14.

71 *Bibliotheca Furliana*, 'Curiositates', lots 15 and 16.

72 *Bibliotheca Furliana*, 'Curiositates', lot 18.

73 *Bibliotheca Furliana*, lot 386. See Aa, *Biographisch Woordenboek*, pp. 787–88.

Three sets of various utensils and furniture were for use in dressing rooms and must have been tucked away in more private rooms of the house. They contained boxes for hair (wigs?), powder, jewellery, pins, candles, mirror frames, and clothes brushes. Bellows to keep the fire burning were also kept in a box. In the bedrooms, anterooms, and dressing rooms, there must have been more of these objects, because the catalogue lists other powder boxes and various small writing desks made of precious materials, such as shagreen inlaid with mother-of-pearl or walnut.[74] A *Tiktakbort* for playing one of the oldest boardgames in the world, backgammon, was a special piece, inlaid with flowers and adorned with allegorical images. Did Benjamin like to play this game? If so, where in the house did he play, and with whom?

Paintings and images adorned the walls of various chambers in the house. The list includes a picture of a certain David Joris in a black frame, a portrait of Jacob Brill, 'een Moor met een Doodshooft konstig geschilderd, in een vergulde Lyst' (a Moor with a skull artfully painted, in a gilded frame), a map on parchment of Pennsylvania with all its rivers and bays, and a small portrait of the late queen of Bohemia, Elizabeth Stuart (1596–1662).[75] Items we can picture in the dining room are a large oak table and a lacquered cooler. Smaller precious objects may have been either on display or safely kept in cupboards: seven silver *passi-plaetjes*, a Japanese tobacco box, an agate snuffbox, a statue of a sailmaker, a mineral stone, and a red pearl-like gem.

Although his modest but eclectic coin collection was not as extensive as his book collection, he had clearly assembled these too with great care. Among them was a special mock coin, a *Pfaffenfeind-taler* minted by the Duke of Brunswick. There were six exotic coins of the wife of the great Mughal emperor Aurengzeb (1618–1707), and commemoration coins for the sieges of Middelburg in 1572 and Breda in 1625. Worth noting are the two pieces of 'Cromwell money' and the papal *strooi-penningen* (memorial coins to be scattered among crowds). Besides these, he also owned Flemish money found in the bulwark of Veurne, unspecified old coins, antique silvers, and coppers. There is a sequence of 'twenty dito', probably of insufficient value to earn their own separate mentions in the catalogue.[76]

The penultimate entry is for 'book cases for all sorts of sizes of books, very suitable for transportation, without the need to take the books out first'.[77] These clever cases had been invented by Locke and may have proved useful on a number of occasions. Perhaps they were used to import books Locke had purchased in England at Furly's request. Locke may have used them when he moved in with the Furlys, and Benjamin may have used them on one of the many occasions when he moved house. The last entry, similar

74 *Bibliotheca Furliana*, 'Curiositates', lots 19–21.
75 David Joris was an Anabaptist leader in the sixteenth century; Jacob Brill was a mystic.
76 *Bibliotheca Furliana*, 'Curiositates', lots 43–58.
77 *Bibliotheca Furliana*, 'Curiositates', lot 59.

to the packets in the book list, is for package numbers '1, 2, 3, 4, &c'. We will never know what these contained, but according to Benjohan's notes they were sold in forty-eight lots to 'sundry' (that is, to various people) for a total of fifteen guilders and sixteen stuivers.[78]

The list of curiosities is intriguing. It gives us an idea of what the house looked like, the furniture with which Benjamin surrounded himself, and the things he had collected or received over the years. But no matter how fascinating, these items could never have filled the large house at Haringvliet. The clothes he wore, his favourite room, the chair he preferred to sit on — these are all left to the imagination. We can only assume that most of the furniture and household items were distributed among Furly's children, where they remained within the family's private sphere. Another possibility is that they were put up for sale as surplus stock, in which case they would lose their previous emotional value.

Conclusion

Benjamin Furly had to balance very different, often interwoven, sides of his life. He guarded the boundaries between his self, his family and friends, and local and national authorities. His membership and leadership of the Quaker community was a complicating factor. Converting to Quakerism had a huge impact on his personal life. First of all, it forced him to flee from his home country. His first and second marriages were to Quaker women. Furly deemed it unnecessary to share information about these weddings with the state authorities. He hosted meetings of Friends in his personal properties and collaborated with his co-religionists, protecting their practices and ideas from the authorities. Yet he did not always give in to the demands of the Quaker community. On occasion, he let his personal preferences prevail over Quaker doctrines. Even if that meant defending the policy of his host country.

If it was Benjamin Furly's intention to keep his personal affairs to himself as much as he could, we can now say that he succeeded rather well. He left us no diary or will to shed light on his deepest thoughts, feelings, and (last) wishes. It was only in his correspondence with his close friend Locke that he shared moments of joy and grief. Throughout his life Furly continued to maintain strong ties with his roots. This can be seen in his choice of marriage partners, the apprenticeships of his sons Benjohan and John in England and the enlistment of his youngest, Arent, in the English army. It also shows in his extensive network of English friends, scholars and politicians, to whom he opened his doors selflessly. And last, but not least, it is visible in his collection of books. His library contained an overwhelming amount of works in his mother tongue. And, contrary to what was common in book auction catalogues

78 *Bibliotheca Furliana*, 'Curiositates', lot 60.

of his time, the 22 per cent of books produced in the Low Countries were overshadowed by the 32 per cent of the works printed in England.

The book auction catalogue reveals details about Benjamin Furly's private life that he was reluctant to share himself. Furly generously opened his library to his many international friends and fellow Quakers. Whether his wives and children also used the library is not known. He must have been proud of his collection, judging by the way he kept his books close to him in the office of his last house at Haringvliet, He liked to be surrounded by the objects he had so carefully gathered over the years. Thanks to the 'curiositates' list, the house at Haringvliet was the only one of which we have any idea of the objects it housed.

Analysing the *Bibliotheca Furliana* has provided an extra layer of information about Benjamin Furly's private life and the extensive network of friends, Friends, scholars, fellow Englishmen, and the Rotterdam merchant community in which he functioned. Quite a few of the buyers at the auction had known Furly personally. They had been either active in the book trade or fellow Quakers, or both. The books and artefacts he received as gifts represent the variety of people he met during his life, from intimate friends to famous scholars, royalty, and statesmen. As with so many other libraries, Furly's is no longer intact. The bidders who offered the highest prices walked away from the auction with the books and personal items that Furly had collected throughout his life. After the final day of the auction, his legacy would be forever scattered all over Europe.

Works Cited

Manuscript and Archival Sources

Amsterdam, Stadsarchief, Notariële Archieven 1578–1915, archival number 5075, inventory number 3658

Rotterdam, Stadsarchief Rotterdam, Archieven van de Notarissen en daarin opgegane Gemeenten, archival number 18_396_92

——, Begraafinschrijving N.n., archival numbers 9999_14 Begraven 1700–1709

——, Oud Archief van de Stad Rotterdam, archival numbers 1–01.1060

Primary Sources

Bibliotheca Furliana, sive Catalogus Librorum Honoratiss. & Doctiss. Viri Benjamin Furly, inter quos excellunt Bibliorum Editiones, Mystici, Libri proprii cujuscumque Sectæ Christianæ, & Manuscripti membranei. Auctio fiet die 22 Octobris 1714. in Ædibus Defuncti in Platea vulgô dicta Haringvliet (Rotterdam: Fritsch and Bohm, 1714)

Bourignon, Anthoinette, *Advertissement, van Anthoinette Bourignon, Geschreven aen alle menschen die het aengaen mag. Tegen de Secte der Quakers* (Amsterdam: Pieter Arentz, 1672)

Croese, Gerard, *Historia Quakeriana: Sive de vulgo dictis Quakeris, ab ortu illorum usque ad recens natum schisma libri III* (Amsterdam: Henricum and Viduam Theodori Boom, 1695)

F[urly], B[enjamin], *Copye van eenen brief: Geschreven aen seeckeren vriend* (S.l., s.n., 1666)

Furly, Benjamin, *Anthoinette Bourignon Ontdeckt, Ende haeren Geest geopenbaert uyt haere Vruchten, den Geest Godts niet te zijn, klaerlijck bewesen uyt haere eygen Schriften* (Amsterdam: Christoffel Cunradus, 1671)

Gazette de Rotterdam, 8, 11, and 15 October 1714 <https://resolver.kb.nl/ resolve?urn=ddd:010411827:mpeg21:p004 > [accessed 18 September 2020]

J. V. C., *Fiat Lux, or a general Conduct to a right Understanding about Religion* (London?: s.n., 1662)

Locke, John, *The Correspondence of John Locke*, ed. by E. S. De Beer, 8 vols (Oxford: Clarendon Press, 1976–1989)

Oprechte Haerlemse Donderdaegse Courant, 4, 28 January 1681 <https://resolver. kb.nl/resolve?urn=ddd:010759194> [accessed 18 September 2020]

Oprechte Haerlemse Donderdaegse Courant, 16, 20 April 1688 <https://resolver. kb.nl/resolve?urn=ddd:010800923> [accessed 18 September 2020]

Oprechte Haerlemse Donderdaegse Courant, 41, 11 October 1714 <https://resolver. kb.nl/resolve?urn=ddd:011220698:mpeg21:p. 002> [accessed 18 September 2020]

Oprechte Haerlemse Dingsdaegse Courant, 42, 16 October 1714 <https://resolver. kb.nl/resolve?urn=ddd:011220674> [accessed 18 September 2020]

Oprechte Haerlemse (Saturdaegse) Courant, 42, 20 October 1714 <https://resolver. kb.nl/resolve?urn=ddd:011220676:mpeg21:p. 002> [accessed 18 September 2020]

Pepys, Samuel, *The Diary of Samuel Pepys: Daily Entries from the 17th Century London Diary*, ed. by Phil Gyford <https://www.pepysdiary.com/> [accessed 5 March 2021]

Uffenbach, Zacharias Conrad von, *Merkwürdige Reisen durch Niedersachsen, Holland und Engelland*, 3 (Ulm: J. F. Gaum, 1754)

Secondary Studies

Aa, A. J. van der, *Biographisch Woordenboek der Nederlanden*, part 3 <https://www.dbnl.nl/tekst/aa___001biog04_01/aa___001biog04_01_1102.php> [accessed 5 March 2021]

Baar, Mirjam de, 'Bourignon, Antoinette', in *Digitaal Vrouwenlexicon van Nederland* <https://resources.huygens.knaw.nl/vrouwenlexicon/lemmata/data/Bourignon,%20Antoinette> [accessed 6 March 2021]

Book Sales Catalogues Online (BSCO), *Book Auctioning in the Dutch Republic, ca. 1500–ca. 1800* (Leiden: Brill, 2015)

Bruun, Mette Birkedal, 'Zones of Privacy' <https://teol.ku.dk/privacy/research/work-method/privacy_work_method.pdf/PRIVACY_Work_Method_Acces.pdf> [accessed 1 September 2020]

——, 'Towards an Approach to Early Modern Privacy: The Retirement of the Great Condé', in *Early Modern Privacy: Sources and Approaches*, ed. by Michaël Green, Lars Nørgaard, and Mette Birkedal Bruun (Leiden: Brill, 2022), pp. 12–60

Bunge, Wiep van, and Jan Oudenaarden, 'Rotterdam in de literatuur', *Kroniek*, 13 (2017), 6–8

Champion, J. A. I., '"The Fodder of our Understanding": Benjamin Furly's Library and Intellectual Conversation c. 1680–c. 1725', in *Benjamin Furly, 1646–1714: A Quaker Merchant and his Milieu*, ed. by Sarah Hutton (Florence: L. S. Olschki, 2007), pp. 111–48

Davies, Adrian, 'James Parnell', in *The Oxford Dictionary of National Biography*, ed. by David Cannadine (Oxford: Oxford University Press, 2004). <https://doi.org/10.1093/ref:odnb/21387>

Duby, Georges, *A History of Private Life* (Cambridge, MA: Harvard University Press, 1988)

Golden, Samuel A., 'Benjamin Furly's Library: An Intermediary Source in Anglo-Dutch Relations', *Hermathena*, 96 (July 1962), 16–20

Greaves, Richard L., 'Benjamin Furly', in *The Oxford Dictionary of National Biography*, ed. by David Cannadine (Oxford: Oxford University Press, 2004). <https://doi.org/10.1093/ref:odnb/10248>

Hull, William I., *Benjamin Furly and Quakerism in Rotterdam* (Swarthmore: Swarthmore College, 1941)

Hutton, Sarah, 'Introduction', in *Benjamin Furly, 1646–1714: A Quaker Merchant and his Milieu*, ed. by Sarah Hutton (Florence: L. S. Olschki, 2007), pp. 1–10

——, 'Mercator Theologico-Philosophicus: Benjamin Furly Reading', in *Benjamin Furly, 1646–1714: A Quaker Merchant and his Milieu*, ed. by Sarah Hutton (Florence: L. S. Olschki, 2007), pp. 149–70

Ingle, H. Larry, 'George Fox', in *The Oxford Dictionary of National Biography*, ed. by David Cannadine (Oxford: Oxford University Press, 2004). <https://doi.org/10.1093/ref:odnb/10031>

Keulen, Sjoerd, and Ronald Kroeze, 'Privacy from a Historical Perspective', in *The Handbook of Privacy Studies: An Interdisciplinary Introduction*, ed. by Bart van der Sloot and Aviva de Groot (Amsterdam: Amsterdam University Press, 2018), pp. 21–56

Lamoen, Frank van, 'Bibliotheca Furliana (1714): Over het innerlijke licht in "De Lantaarn"', *Jaarboek Nederlands Genootschap van Bibliofielen* (2014), 1–23

Leopold, J. H., 'Clockmaking in Britain and the Netherlands', *Notes and Records of the Royal Society of London*, 43–42 (July 1989), 155–65

McGuinness, Rosamond, 'Musical Provocation in Eighteenth-Century London: The "British Apollo"', *Music & Letters*, 68.4 (1987), 333–42

Pettegree, Andrew, and Arthur der Weduwen, *The Bookshop of the World: Making and Trading Books in the Dutch Golden Age* (New Haven: Yale University Press, 2019)

——, *The Library: A Fragile History* (London: Profile, 2021)

Radford, E. L., 'Daniel Quare', in *The Oxford Dictionary of National Biography*, ed. by David Cannadine (Oxford: Oxford University Press, 2004). <https://doi.org/10.1093/ref:odnb/22942>

Reijn, Johan A. van, 'Benjamin Furly, Engels koopman (en meer!) te Rotterdam, 1636–1714', *Rotterdams Jaarboekje* (1985), 219–46

Schoor, Arie van der, 'Benjamin Furly in Business', in *Benjamin Furly, 1646–1714: A Quaker Merchant and his Milieu*, ed. by Sarah Hutton (Florence: L. S. Olschki, 2007), pp. 11–29

Selm, Bert van, *'Een menighte treffelijcke Boecken': Nederlandse boekhandelscatalogi in het begin van de zeventiende eeuw* (Utrecht: HES, 1987)

Strickland, Forrest C., 'Building a Library in the Dutch Golden Age: André Rivet and his Books', in *Book Trade Catalogues in Early Modern Europe*, ed. by Arthur der Weduwen, Andrew Pettegree, and Graeme Kemp (Leiden: Brill, 2021), pp. 161–92

Villani, Stefano, 'Conscience and Convention: The Young Furly and the "Hat Controversy"', in *Benjamin Furly, 1646–1714: A Quaker Merchant and his Milieu*, ed. by Sarah Hutton (Florence: L. S. Olschki, 2007), pp. 87–109

Walsby, Malcolm, 'Book Lists and their Meaning', in *Documenting the Early Modern Book World: Inventories and Catalogues in Manuscript and Print*, ed. by Malcolm Walsby and Natasha Constantinidou (Leiden: Brill, 2013), pp. 1–24

Weduwen, Arthur der, and Andrew Pettegree, *The Dutch Republic and the Birth of Modern Advertising* (Leiden: Brill, 2019)

Weduwen, Arthur der, Andrew Pettegree, and Graeme Kemp, eds, *Book Trade Catalogues in Early Modern Europe* (Leiden: Brill, 2021)

FREEK SCHMIDT

Sociability and Privacy

*The Eighteenth-Century Extended Homes
of the Amsterdam Elite*

Introduction

Over the four centuries of its existence, Amsterdam's famous canal ring — a
Unesco World Heritage area since 2010 — has changed substantially in
appearance.[1] Created in two phases following council decisions in 1610 and
1660, the district was largely built with rows of houses along the canals,
interrupted by streets or other canals. A unique document records in detail
the streetscapes of approximately 250 years ago: issued in twenty-four
prints in 1768–1771, the *Grachtenboek* is a collection of all the street façades
along the two most fashionable and luxurious canals, the Herengracht and
Keizersgracht.[2] By this time, the canals' seventeenth-century streetscapes
had been largely replaced by eighteenth-century ones.[3] We can distinguish
a wide variety of façades dating from the first 160 years of the district's
existence (Figure 9.1). Early seventeenth-century stepped gables, some still
with cross-frame windows and shutters, alternate with slightly later top
gables, early eighteenth-century neck and bell gables and their ornaments,
and more recent façades with horizontal raised cornices. The majority of
façades with modern sash windows and heightened horizontal cornices date
from the 1720s or later.[4] This makeover of the seventeenth-century canal ring
was accompanied by large-scale renovations and expansions behind the new
façades. While the main structures were preserved, extra floors were added,
and new houses were built in the gardens behind the original houses, with
connecting aisles for new staircases and small skylit courtyards. Within the
restricted plots available, a rich variety was achieved that contrasted with the

1 Abrahamse, *Metropolis in the Making*; Schmidt, 'Architectural Essence'; Kleijn, Kurpershoek,
and Otani, *Canals of Amsterdam*.
2 *Verzaameling van alle de huizen*.
3 Schmidt, *Passion and Control*, pp. 15–16.
4 Levie and Zantkuijl, *Wonen in Amsterdam*, pp. 76–88.

> **Freek Schmidt** is professor of the history of architecture and the designed
> environment at the Vrije Universiteit Amsterdam. He researches the design, use
> and appreciation of the built environment.

Private Life and Privacy in the Early Modern Low Countries, ed. by Michael
Green and Ineke Huysman, EER 19 (Turnhout: Brepols, 2023), pp. 247–272
BREPOLS ⚜ PUBLISHERS 10.1484/M.EER-EB.5.132537

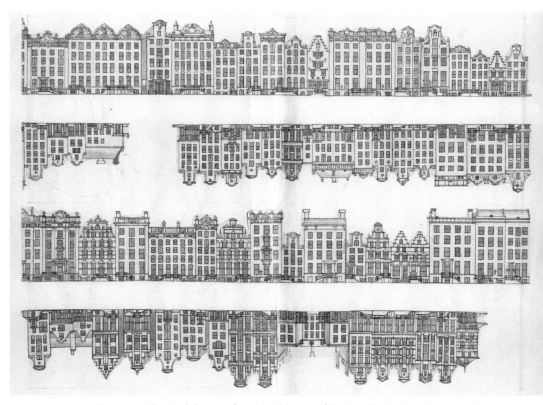

Figure 9.1. 'Original drawing for plate thirteen of the *Grachtenboek* or *Verzaameling van alle de huizen en prachtige gebouwen langs de Keizers en Heere-grachten der stadt Amsteldam* (1768–1771)'. Third row, extreme left is Herengracht 284, with façade created 1728–1733. Like Herengracht 284, the house to the right was originally built in the 1620s but has retained its original façade and fenestration. *Rijksdienst voor het Cultureel Erfgoed, Amersfoort*/129.398. Photo by G. Th. Delemarre, undated. Reproduced with permission.

https://beeldbank.cultureelerfgoed.nl/rce-mediabank/detail/4ad307d8-cb34-0b50-92ad-c40051de911a/media/77a9e284-b67c-b3db-13cf-65a1c2872e2f?mode=detail&view=horizontal&q=herengracht%20284&rows=1&page=30

simplicity of the seventeenth-century canal house and its compartmentalized, more static organization of preferably square rooms. Many of these extended eighteenth-century houses have survived or can be reconstructed on the basis of historical and archival research and building archaeology.

While the Amsterdam houses of the elite had always been richly furnished, this reached new levels in the eighteenth century.[5] By around the middle of

5 De Jong, *Een Deftig Bestaan*, pp. 141–54.

the seventeenth century, especially in Amsterdam, industry and work had already left the house, which was increasingly reserved for dwelling. The extended house offered more representative spaces, pushing beds out of the main rooms and into separate bedrooms on higher floors. In general, this shift and the increase in space are explained as a consequence of a growing demand for representation on the one hand and privacy on the other.[6] However, the evidence for this is not conclusive. Was privacy really at the heart of this reconfiguration of domestic space? Studies of Dutch interiors have observed a shift in decorum in the eighteenth century, which is interpreted as an increased demand for opulence. As Willemijn Fock explains: 'The lifestyle of the ruling elite was reflected in the interior of its houses, and the desire to give expression to one's social position and status left its mark on the layout, function, design and furnishing of the various rooms'.[7] One's own home was the setting for appropriate social behaviour and social contacts that involved food and drink, 'insofar these did not occur in the coffee house or out of doors during one's daily walk'.[8] But it has not been explained how this great increase in space and the differentiation of rooms relates to a growing demand for privacy, rather than simply to the urban elite's apparent desire to display their status and wealth. This chapter looks more closely at the increase in size and interior distribution of the town houses of the ruling Amsterdam elite, situating it in the context of contemporary sociocultural strategies of friendship, distinction, and entertainment. The main sources used here are the buildings themselves, as well as contemporary architectural drawings. Architecture and the built environment require utility or function, and they reflect and structure everyday life. Thus, reconstructing the architecture of the home may inform us about how privacy was translated spatially.[9] It appears that the architectural shape of the house had to undergo substantial transformation to function properly as an instrument of self-fashioning in the daily lives of the eighteenth-century elite. This larger house was not simply a fine building supporting a luxurious lifestyle, but was laid out and operated in specific ways so as to be shared with and displayed to select audiences, affirming one's status and safeguarding one's position both in a network of relations and in society at large. Privacy, understood as an intimacy of relations rather than individual privateness, was one of the determining factors in the use of the extended home.[10]

6 Laan, 'Het décor', pp. 70–74; Pijzel-Domisse, '1700–1750', pp. 184–85; Fock, 'The Décor', p. 105.
7 Fock, 'The Décor', p. 103.
8 Fock, 'The Décor', p. 103.
9 Evans, 'Figures, Doors, and Passages', p. 89.
10 'Privacy', in *Oxford English Dictionary Online* <https://www.oed.com> [accessed 19 September 2020].

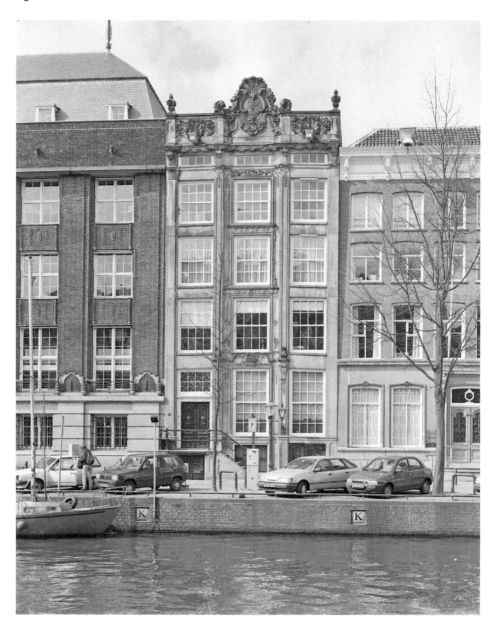

Figure 9.2. 'Façade of Herengracht 284, also known as Huis van Brienen', Amsterdam. *Rijksdienst voor het Cultureel Erfgoed, Amersfoort*/303.562. Photo by A. J. van der Wal, 1994. Reproduced with permission.

https://beeldbank.cultureelerfgoed.nl/rce-mediabank/detail/dc94c3e1-6e73-11aa-1644-12cabc46a081/media/ac0bb5e6-0f8e-adca-2d63-edbe0361c931?mode=detail&view=horizontal&q=herengracht%20284&rows=1&page=6

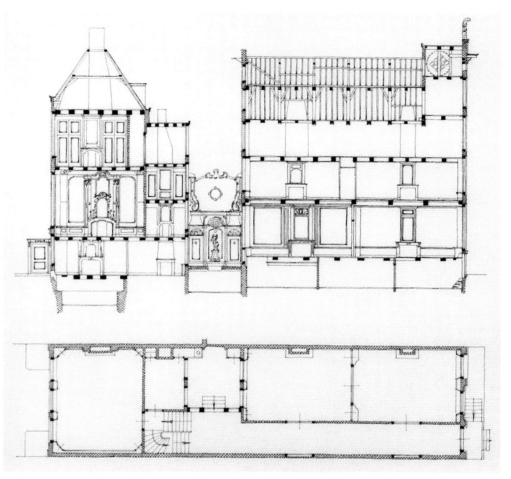

Figure 9.3. 'Section and plan of Keizersgracht 284', in *Collectie Bureau Monumentenzorg: negatiefvellen*. Amsterdam, CAA. Reproduced with permission.
https://archief.amsterdam/beeldbank/detail/1d0700dc-8cf8-843b-318e-874c3bfd4b7d

The Extended Home

In eighteenth-century Amsterdam, the spatial configuration of the typical canal house often changed with the arrival of new occupants.[11] A good and well-documented example of such a makeover can be found at Herengracht 284 (Figures 9.1–9.6). Built in 1620, the house was acquired by David Rutgers (d. 1728) and his sisters Margaretha (d. 1736) and Hillegonda (d. 1743) in 1728. They started a renovation that included a new, almost symmetrical stone façade with a raised

11 For selections of these houses, see Schmidt, *Passion and Control*, ch. 1; Vlaardingerbroek, *The Amsterdam Canals*.

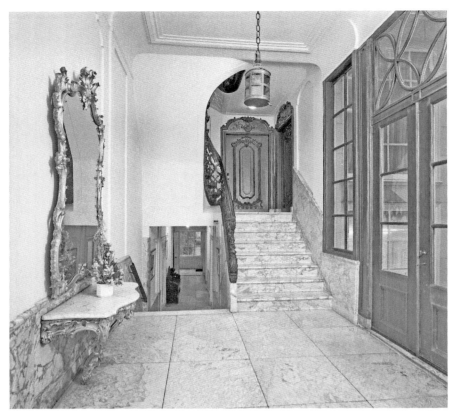

Figure 9.4. 'Interior of Herengracht 284'. Corridor on main floor or *beletage*, leading to interconnecting section with staircase and inner courtyard, and staircase leading to rear house, with flight down to garden and flight up to great salon". *Rijksdienst voor het Cultureel Erfgoed, Amersfoort*/303.574. Photo by A. J. van der Wal, 1994. Reproduced with permission.

https://beeldbank.cultureelerfgoed.nl/rce-mediabank/detail/3160fbe4-0b21-53f0-50b2-b1d26081470a/media/af6f9b37-67b0-8f05-d435-42bec65406bb?mode=detail&view=horizontal&q=herengracht%20284&rows=1&page=41

cornice, a new rear house, and a reorganization of the interiors according to the then-fashionable Dutch Louis XIV style.[12] David soon died, and thereafter the house was occupied by his sisters; Hillegonda lived there until her death in 1743. An auction leaflet from 1781 describes the house in detail.[13] Behind the new façade, which had sash windows and shutters that could be folded away

12 Fock, 'The Décor', pp. 109–14; Schmidt, *Passion and Control*, pp. 17–24; Meischke and others, *Huizen in Nederland*, pp. 261–69; Swigchem, *Huize van Brienen*.
13 'Ma. 14 mei 1781. Willige Verkoopinge van een Capitaal, Hegt Sterk en Weldoortimmerd Koopmans Huys en Erve, staande en gelegen op de Heeregragt, tusschen de Wolve en de Hartestraten'. Cited in Meischke, *Huizen in Nederland*, pp. 267–69.

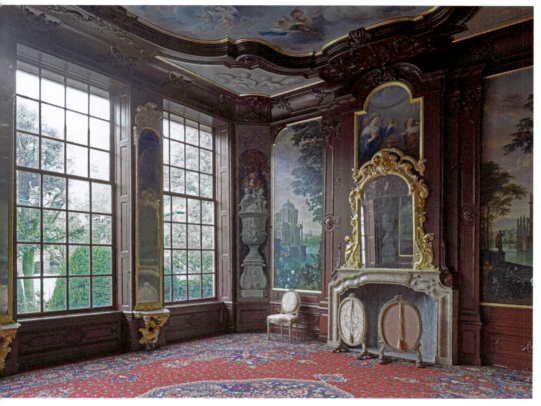

Figure 9.5. 'Great salon overlooking the garden, Herengracht 284'. *Rijksdienst voor het Cultureel Erfgoed, Amersfoort*/18.853. Photo by Sergé Technau, 2017. Reproduced with permission.

https://beeldbank.cultureelerfgoed.nl/rce-mediabank/detail/55095aeb-31df-92fc-17d9-8aa12fa3638c/media/5a69a486-fc0a-6023-b8bd-59f05d31457d?mode=detail&view=horizontal&q=herengracht%20284&rows=1&page=12

completely to provide clear light, every room was decorated as a unit. On the main floor, the raised *beletage* was reached by climbing a stoop in front of the house. While changing the original side room and inner chamber into a suite with a new decorative programme would often suffice, it could also be part of a total renovation and expansion of the house, both exterior and interior;[14] in the case of Herengracht 284, this included a new multilevel wing or back aisle (*achterhuis*), and a complete rear house behind the seventeenth-century

14 In several houses, the location of the staircase was moved, enabling the creation of a room en suite instead of the original *zijkamer* (side chamber) and *binnenkamer* (inner chamber). See for instance Keizersgracht 387 and Herengracht 77, in Meischke, *Huizen in Nederland*, pp. 310, 238.

structure, with a large salon overlooking the garden that was reached from the main entrance via the corridor (Figures 9.3–9.5). Often, a new corridor on the main floor would be combined with a large, open newelled staircase. A special publication, the *Theatrum Machinarum Universale* of 1737, gives us an indication of the popularity of this feature.[15] The Rijksmuseum houses an Amsterdam example of a doll's house (*c.* 1750) that has sixteen spaces, reflecting the gradual increase in spaces, and also includes the corridor and monumental staircase as essential components.[16] Both the corridor and the staircase considerably improved circulation between the rooms of the extended house. As architectural historian Robin Evans puts it, in large houses the entrance or vestibule, hallway, open staircases, passages, corridors, and backstairs all 'coalesced to form a penetrating network of circulation space which touched every major room in the household'.[17] By removing traffic from other rooms, this enabled the spatial and temporal diversification of the order of domestic life. It could also blur boundaries between public and private spaces, which now could be accessed independently, adjusted, and personalized, depending on the time of day and the nature of the activity or social encounter.[18]

In the seventeenth century, the layout of the various reception rooms seems not yet to have followed a coherent system. Apart from the Netherlands' few princely mansions and larger country houses, there is no evidence that the *art de distribution*, which became increasingly popular in France in the late seventeenth and early eighteenth centuries, found serious echoes in the Republic. However, over the course of the eighteenth century, the use of a French vocabulary to describe the spaces of the house increased considerably, most notably *salle* or *salon, garderobe, cabinet (de toilette)*, and *boudoir*. Some of these had already been adopted early in the seventeenth century by the court circles of the princes of Orange-Nassau and the Dutch nobility, among whom French was spoken and used in international correspondence and diplomacy.[19] Unlike the French system of the apartment, in the eighteenth-century Netherlands each room remained independent. A corridor could be introduced into newly built houses, providing access to all the rooms separately or bypassing them.[20] In the seventeenth century, the coupling of separate reception rooms for special occasions had remained an exception, practised by the architect Philips Vingboons on several occasions for prominent Amsterdam burghers.[21] But in the eighteenth century, the *suite* — a large room connected to a second, similar room, with the entrance hall and corridor alongside it — became a

15 Horst and Schenk, *Theatrum Machinarum Universale*; Schmidt, 'The Rise of the Staircase'.
16 Rijksmuseum Amsterdam, 'Grachtenhuis, anonymous', 1760, object number BK-NM-5783 <http://hdl.handle.net/10934/RM0001.COLLECT.250589> [accessed 10 February 2019].
17 Evans, 'Figures, Doors, and Passages', p. 70.
18 Pijzel-Domisse, *Het Hollandse pronkpoppenhuis*, pp. 347–84.
19 Ottenheym, '"Van Bouw-lust soo beseten"'; Fock, '1600–1650', pp. 18–19.
20 Fock, 'The Décor', pp. 106–07.
21 Fock, 'The Décor', p. 107.

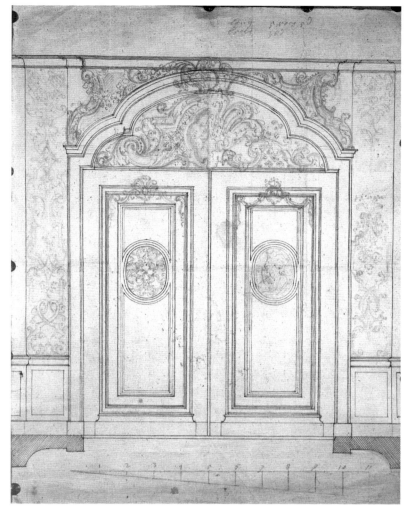

Figure 9.6. '*Porte-brisée* design for room en suite at Herengracht 284', c. 1730. *Rijksdienst voor het Cultureel Erfgoed, Amersfoort*/18.853. Reproduced with permission.

https://beeldbank.cultureelerfgoed.nl/rce-mediabank/detail/285da91c-a7a3-3d9a-1ce2-8c543b481196/media/758bcd36-8c2d-0d51-fd35-30c55469ab95?mode=detail&view=horizontal&q=herengracht%20284&rows=1&page=52

central feature on the main floor of a house. Such a suite can be found in the Rutgers' residence. These spaces could be joined by opening up the *porte-brisée*. This French-sounding term, which was not actually used in France, referred to a set of double doors of extreme width and height, which would transform two rooms into one large, flexible space (Figure 9.6).[22]

22 Fock, 'The Décor', pp. 107–15.

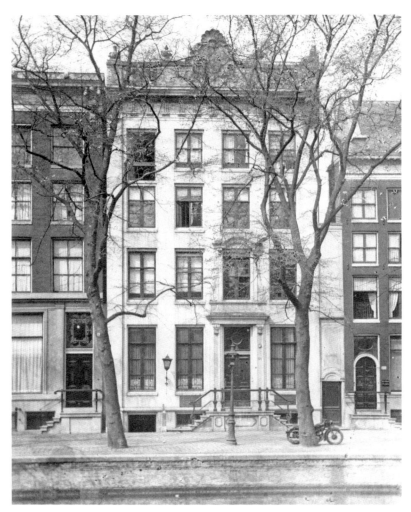

Figure 9.7. 'Façade of Keizersgracht 224, also known as Saxenburg'. Amsterdam, CAA. Photo by E. van Houten, c. 1953. Reproduced with permission.

https://archief.amsterdam/beeldbank/detail/706d4a22-8527-11e4-98f7-03f0f4be13f0

Particularly illuminating is a series of thirty-two drawings attributed to a certain Nicolaas Bruijnesteijn, which reveal the options considered during the creation of such an extended home. Discovered in 1956 and acquired by the Amsterdam City Archive, they are considered to be drawings for the renovation of Keizersgracht 224, also known as House Saxenburg (Figure 9.7).[23]

23 Meischke, *Huizen in Nederland*, pp. 77, 79, 83; Quarles van Ufford, *Catalogus*, pp. 25–27; Koldeweij, '1750–1800', p. 288; Tulleners, *Een pracht van een gracht*, pp. 73–75; Van Eeghen,

Originally built shortly before 1625, the house was probably renovated around the middle of the eighteenth century, judging from the ornamental details of the drawings.[24] Not all of the drawings can be linked to the same building project, and some probably also depict alternatives or designs that were never realized. But taken together, they form a collection of samples that demonstrate a desire to renovate and expand an original seventeenth-century house by adding a new façade, an interconnecting section, and a rear house, thus doubling the house's volume and adding more rooms and passages. Shown here are the designs for the main passages of the staircase and the corridor, and a plan and section of a room combined in one drawing (Figures 9.8–9.10). The drawing technique displayed here, described as the 'developed surface interior' by Evans, was particularly popular in the eighteenth century, and was especially used by architects with domestic commissions.[25] Unlike any other drawing technique, on one sheet of paper it could show all the surfaces of one room or space as a single unit, with its own proportions, openings, and ornamental decorations. Within a total programme of conversion or extension of an existing house, this drawing technique emphasized the individuality of a room that had its own coherent decorative scheme. This type of drawing breaches the hierarchy that traditional architectural plans show in the relational differences between spaces. Representing interior space in detached units emphasizes the specific ways in which the extended home could be used in the eighteenth century: as a collection of individual spaces to be opened and closed, crossed or bypassed at random, depending on the specific occasion and its importance. There was no strict sequence of rooms that would express a clearly defined hierarchy.

'De veertienvoudige restauratie'. On Bruijnesteijn, see also Amsterdam City Archives, 'Beeldbank' <http://hdl.handle.net/10934/RM0001.COLLECT.61691> [accessed 10 February 2019]; Baarsen, *Rococo in Nederland* (Zwolle: Waanders, 2001), p. 20, pp. 91–93 (catalogue no. 24); RKD. Netherlands Institute for Art History, 'Nicolaas Bruynesteyn' <https://rkd.nl/explore/artists/13686> [accessed 10 February 2019]; Bruijnesteijn van Coppenraet, 'Galerie' <http://www.brucop.com/gallery/nederlands/index.html> [accessed 10 February 2019]; Bruijnesteijn van Coppenraet, 'Catalogus a' <http://www.brucop.com/gallery/nederlands/catalogue/a/> [accessed 10 February 2019].

24 From 4 February 1682 the house was in the hands of the family of the Catholic merchant Jean Dutry, before being sold in 1765 to the Mennonite merchant Jan (or Jean) de Neufville (1728–1796). In 1745, on the death of the Catholic Jan Deyman Dutry (1669–1745), his share of Saxenburg had passed into the hands of the couple Dirk Roest van Alkemade (1679–1751) and Geertruid Maria Dutry (1676–1757). The wealth of the family grew enormously under the couple's son, Denijs Adriaen Roest van Alkemade (1715–1791), placing him eleventh on the list of the richest people in the eighteenth-century Republic. Van Eeghen, 'De veertienvoudige restauratie', pp. 102–03; Zandvliet, *De 500 Rijksten*, pp. 270–71.

25 Evans, 'The Developed Surface'.

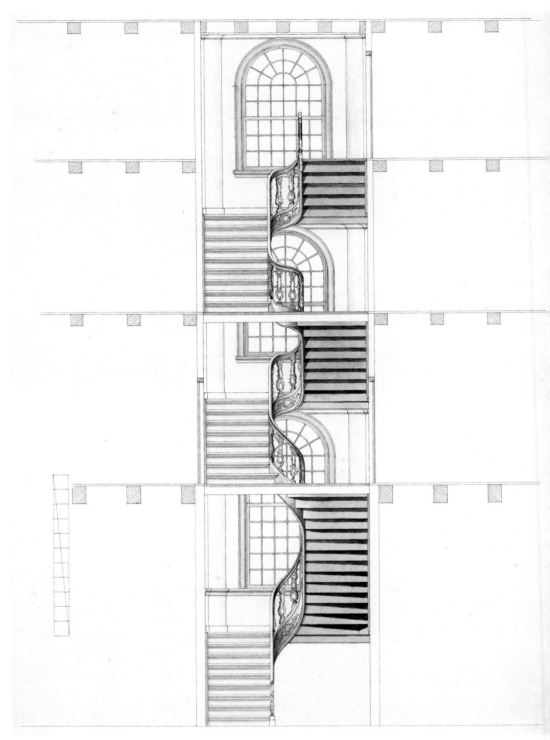

Figure 9.8. 'Staircase design for canal house', c. 1750. Amsterdam, CAA. Reproduced with permission.

https://archief.amsterdam/beeldbank/detail/d3d8b595-432e-d7dc-fb93-08913e6b110d

SOCIABILITY AND PRIVACY 259

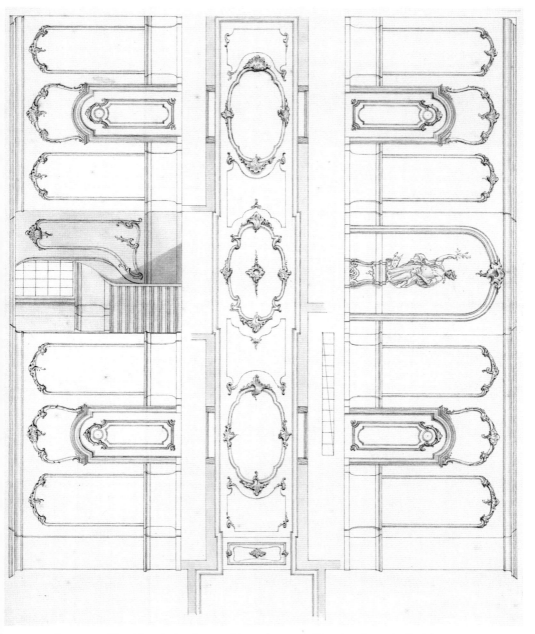

Figure 9.9. 'Corridor design for canal house', c. 1750. Drawing shows both sides of the corridor with niches, sculpture, suggested ornamental decoration, and proposed ceiling decoration, to be executed in plasterwork. Amsterdam, CAA. Reproduced with permission.

https://archief.amsterdam/beeldbank/detail/514c302a-1797-5298-fc55-8c4e8a6eeece

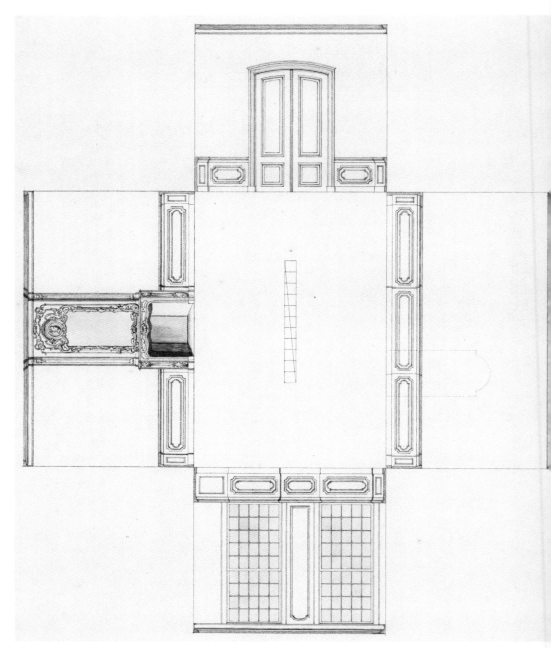

Figure 9.10. 'Drawing, plan, and section of room decoration', c. 1750, in *Collectie Stadsarchief Amsterdam: tekeningen en prenten*. Amsterdam, CAA. Reproduced with permission.

https://archief.amsterdam/beeldbank/detail/86c64633-dbea-d700-8265-a6ec900664a2

Independent Access and Interconnection

Throughout the eighteenth century, these suites of individual rooms with various interconnections were introduced into both new and existing houses. With special furnishings, furniture, and features, they formed the principal setting for the social lives of the owners. Built-in buffets were often installed, indicating the importance of drinking and raising a toast at important social events. Such gatherings are considered typical of the social lives of the eighteenth-century upper crust. But how far these social gatherings stretched spatially to invade the more private areas of the home, and how many rooms could be involved, whether structurally or incidentally, is not entirely clear from the research so far.[26] Of the many activities that took place in the ruling elites' houses, where a large part of everyday life was spent, the architecture reflects only a little. To understand how different spaces were actually used, the remains of eighteenth-century houses combined with archival sources reveal something, but they also leave open the question of how each family organized their daily routine and moved around the house, individually and together. Where the seventeenth-century home had a limited number of rooms in a sequence that required one to move from one room to the next, the eighteenth-century home demonstrates increased connectivity and complexity. In the extended eighteenth-century home, passages tunnelled through the depth of the house on every floor, aided by the staircase as a vertical passage, with doors to all rooms, some of which were themselves also interconnected. Sometimes, separate passages and backstairs were introduced to limit the servants' intrusion into the intimate and private as much as possible.

Why the innovation of independent access should have come about at all is not yet clear. Although Evans suggests that 'it came apparently out of the blue', he also observes that it 'indicated a change of mood concerning the desirability of exposure to company; whether exposure to all in the house, or to just some, was at this point a matter of emphasis'.[27] According to Evans, the division of the house into two domains — 'an inner sanctuary of inhabited, sometimes disconnected rooms, and an unoccupied circulation space' — came with

> a recognizable modern definition of privacy, not as the answer to a perennial problem of 'convenience', but quite possibly as a way of fostering a nascent psychology in which the self was, for the first time, felt to be not just at risk in the presence of others, but actually disfigured by them.[28]

26 Fock, 'The Décor', p. 128.
27 Evans, 'Figures, Doors, and Passages', p. 74.
28 Evans, 'Figures, Doors, and Passages', p. 75. This notion is further developed by Eleb and Debarre, *Architectures*, p. 35.

Observing distance from others was thus a means of self-preservation. In the case of the eighteenth-century extended houses in the Republic, particularly in Amsterdam, this may well have been one of the reasons for the home's new layout, as it provided both independent access and interconnection. The corridor or passage increased the diversity of temporal access to individual rooms as well. It opened up more options — for instance, 'to segregate certain spaces whose conceptual importance coincided with the rarity of their use', as Bill Hillier illustrates in relation to the English 'front parlour'.[29] This room was the least integrated into the main floor of the house, the most rarely used, best furnished, and most highly decorated, but its location close to the door also enabled its main use to support formalized encounters. On the other hand, when it was important to impress a visitor to an elite home in eighteenth-century Amsterdam, such encounters could also involve meeting the guest at the door personally and then escorting them along the corridor or through a sequence of rooms to a deeper, more sacred, but also representative space. Thus, in practice the division between public and private was probably less architectural than temporal, and was dependent on mobility.

The Interior and its Use

For the house to function properly, its architecture should be structured to reflect the daily lives of its occupants. In the context of the elite eighteenth-century household, the domestic interior accommodated the meandering boundary between privacy and publicity. It appears that, depending on the kind of visitor and the nature of the visit, rooms could switch between backstage and front stage, because the functions of rooms could vary within each household. With reference to sociologist Erving Goffman's metaphor of theatrical performance in the presentation of the self in everyday life, the Dutch home has also been viewed as comprising a front stage, where visitors are received, and a backstage, the private domain, where the front-stage theatrical performance is rehearsed, or where the impression fostered by the performance is knowingly contradicted.[30] This idea has been developed in studies of material culture and group behaviour, together with Pierre Bourdieu's investigations of the quest for social and cultural distinction through trends.[31] These studies also take advantage of Thorstein Veblen's notion that respect is gained through conspicuous leisure and consumption, outlined in his 1899 book *The Theory of the Leisure Class*. Goffman defines 'front' as 'the expressive equipment of a standard kind, intentionally or unwittingly employed by the individual during

29 Hillier, 'Space and Spaciality', p. 225; see also Hanson, *Decoding Homes and Houses*.
30 Wijsenbeek-Olthuis, 'Vreemd en eigen', pp. 81, 91; Dibbits, 'Between Society and Family Values', p. 125; Goffman, *The Presentation of Self*, pp. 22, 112.
31 Bourdieu, *Distinction*; Schmidt, *Om de Eer*, pp. 10–11.

his performance'.[32] The setting, with its furniture, décor, physical layout, and background items, supplies the scenery and stage props. In the extended eighteenth-century houses under study here, the setting in fact stretches multiple spaces as part of the performance, depending on the movement of the performer and the audience. Parading through multiple rooms could be an essential part of the performance through the house. A performance and front could even continue in rooms that were only accessible to guests upon special invitation and in the company of the host; at other moments, at least part of the domestic establishment could be reserved for an informality or backstage, normally restricted to the rooms where visitors would never come.[33] The use of curtains, shutters, blinds, screens, and doors could also be operated to this effect. The personal front of the performer, which conveys further signs of their identity, follows the performer around and is expressed in their appearance, manner, clothing, insignia, posture, bodily gestures, facial expressions, and speech.[34] Goffman's metaphor is therefore particularly useful, as it makes us realize that the eighteenth-century elite home in Amsterdam — as a compartmentalized and restricted environment — was organized and used as a social front with relative freedom, to accommodate the individual needs of the occupants.

The separation of working and dwelling that manifested itself in the home culture of the later seventeenth and eighteenth centuries was not accompanied by a straightforward increase in demand for privacy or intimacy, as has often been suggested. Such suggestions ignore the fact that the reception of guests — the public — in this so-called private realm increased, especially in the extended homes of eighteenth-century Amsterdam.[35] Historians of material culture have pointed out this somewhat paradoxical development in the Netherlands during the early modern period: a combination of increasing privatization (with the separation of working and dwelling) and a growing attention to representation and inviting guests into the house, which interfered with the intimacy of family life and opened the house to 'the public'.[36] In studies devoted to relationships between family members and the household's material culture, tensions between the public and private domains have been observed in the context of both 'routine social life' and 'large structural changes'.[37] Thanks to extensive archival research in family archives, notarial documents, probate inventories, and ego documents in particular, we are relatively well informed about the names of the new rooms, the types of furniture and other items placed in them, and their luxurious furnishings with paintings, wall hangings, chandeliers, and so on.[38]

32 Goffman, *The Presentation of Self*, p. 22.
33 Goffman, *The Presentation of Self*, pp. 127–28.
34 Goffman, *The Presentation of Self*, p. 24.
35 Cf. Wijsenbeek-Olthuis, 'Vreemd en eigen', p. 95.
36 Wijsenbeek-Olthuis, 'Vreemd en eigen', p. 95.
37 Schuurman and Spierenburg, 'Introduction', p. 8.
38 Wijsenbeek-Olthuis, 'Vreemd en eigen', p. 95; Pijzel-Domisse, '1700–1750'.

Technical investigations have clarified the materials and techniques used to create the rich variety of surfaces, forms, colours, and furnishings in these refined interiors, which provided each space with its own distinctive character and atmosphere. Stylistic changes have been traced, and specific parts of these interiors have been attributed to individual designers, artists, craftspeople, and the many extremely skilled hands involved. But in tracing the makers and locations of objects in an art historical way, instead of tracing the users who lived in these spaces, we seem to be missing the point. What these studies seldom clarify is how these spaces were actually used, and how they functioned in the larger system and daily life of the household. They do not necessarily help to explain the breakthrough in the new organization of domestic planning, with its elaborate division between inhabited, sometimes interconnected, rooms and unoccupied circulation areas, which replaced its 'corridor-less' predecessor. Of course, there are lots of hints in the archival material, but these often fail to give us a full understanding of what was placed where, how items could move around a room or to other rooms, or how frequently different rooms were used, by whom, and to what purpose. To understand what routines and behaviours among eighteenth-century Dutch burghers required this specific kind of extended home and its display of variety, luxury, and wealth, we have to look beyond interior decoration to the larger architectural configuration. But first, we should briefly look at the life this urban elite was aspiring to lead in class terms, a life that stimulated the rethinking of the home regarding the boundaries of private, social, and intermediate spaces.

The Upper-Class Lifestyle

A large proportion of eighteenth-century society's upper crust, in financial terms, can be considered a 'leisure class'.[39] In the eighteenth century, Amsterdam's bourgeois elite was composed of a number of rich families, which around 1700 had become a stable oligarchy that monopolized offices in the city, the provinces, and the Republic. These families dominated the city council, which formed the basis of economic and political power. Many of the ruling elites in Holland's cities were of non-noble descent, and they imitated a noble lifestyle to emphasize their political power and increase their social standing.[40] This 'process of adopting the lifestyle of the nobility' has been described as 'aristocratization', a term introduced by the historian D. J. Roorda in the 1970s and taken up by elite studies in the 1980s.[41] A growing group who had been amassing fortunes for generations withdrew from the

39 De Jong, *Een Deftig Bestaan*, p. 213.
40 Wijsenbeek-Olthuis, 'Noblesse Oblige', pp. 112–13.
41 Prak, 'Aristocratisering'; Wijsenbeek-Olthuis, 'Noblesse Oblige'; Prins, 'Heren van Holland'; Roorda, 'Het onderzoek'; Jong, Prak, and Kooijmans, 'Wonen Op Stand'; De Jong, *Met goed fatsoen*, p. 186; Kooijmans, *Onder regenten*, p. 10, pp. 205–06; Prak, *Gezeten burgers*, p. 208.

active economic life of trade and invested their money in land, seigniories, and country estates. The urban elite displayed a general desire to extend their town houses, and a growing number also invested in out-of-town houses or country houses.[42] Conspicuous consumption, reflected in the grand life of country estates, coaches, footmen, and coats of arms, could support this appearance of a noble lifestyle.

Ostentation played an important role in the lifestyle of the elite, making 'conspicuous consumption' in Veblen's sense — spending large sums of money on eye-catching status symbols — almost obligatory, as it was instrumental in maintaining and celebrating their special social position.[43] In this daily routine, the house formed the constant backdrop.[44] The more rooms there were available, the more diverse the social and cultural interactions that took place in the house and its sequence of spatial units could be. It could create a new balance between display and retreat, and a shift took place between the public, social, and private spheres. The house should represent more than a self-image of wealth and status to friends and guests. For an elite that strongly depended on sociability and friendship to maintain their position as wealthy families, the transformation of architectural space in the interior was instrumental for enacting or reinforcing their identity, status, and class.

The extended interior was also an environment where a large part of social life took place — informative and sociable relaxation and amusement, to be shared with others. With the rearrangement of rooms, and the creation of suites and extensions, a wide range of activities could take place at home in different spaces ranging from salons to rooms, boudoirs, and cabinets, which were connected by doors, corridors, and stairs. The house became a place to invite guests for all kinds of occasions. Social components of this life included dinner, card games, music, dancing, entertaining, reading, poetry, sharing knowledge, displaying art and other collections (cameos, coins, medals, books, globes, scientific instruments, or *naturalia*), drinking tea, coffee, or chocolate, smoking tobacco, making polite conversation, etc. The increasing space devoted to in-house activities may well have been motivated less by the pursuit of a noble lifestyle, with the house functioning as a status symbol, and more by the increasing importance of sociability as a crucial component in the daily life of the elite, which affected the ways in which privacy found its place in the domestic interior. In friendship networks, the family's houses and country estates played an important part not only as capital, but also as the environment where a large part of social life took place. The interiors of these houses were the most frequented spaces and qualified as important

42 Glaudemans, *Amsterdams Arcadia*; Schmidt, 'Dutch Arcadia'; Schmidt, 'Hollands Arcadië'.
43 Kooijmans, *Onder regenten*, p. 165; Prak, *Gezeten burgers*, p. 207; Veblen, *The Theory of the Leisure Class*, pp. 30–41.
44 De Jong, *Met goed fatsoen*, pp. 222–25; Prak, *Gezeten burgers*, pp. 225–30; Kooijmans, *Onder regenten*, pp. 165–70.

elements in the sociocultural strategy of entertainment and friendship — and as a consequence, in the specific culture and codes of distinction. The interior thus became an important instrument of the self-fashioning of the ruling elite: paying visits and inviting guests into the home functioned as a way to enact identity and emphasize rank, status, and class through interior space.[45]

Friendship and Social Space

In the early modern period, all kinds of calamities were a much greater threat to peoples' lives; these could quickly disrupt the fate of individuals as well as whole families. Much time was spent on safeguarding the family, as life depended on it. As Luuc Kooijmans describes in his book on early modern friendship: 'Surviving was an art, and an essential part of it was the maintenance of friendship'.[46] In the eighteenth century, friendship still played an important part in the way society was organized. It was much less of a private and individually constructed relationship. Friendship was crucial for the promotion of consensus, peace, and solidarity. It was a relationship between individuals on the basis of reciprocal affection and solidarity, expressed in both practical aid and moral support, from which society as a whole profited and ties within a community were strengthened.[47] To this circle belonged relatives, neighbours, and others who were considered crucial for maintaining the social position of an individual. However, there was limited scope to choose one's friends on the basis of individual preference alone, compared with friendship based on kinship. Every individual was required to contribute to the well-being, prosperity, and social position of the family, and 'outsiders' could be serious competitors in the battle for capital, jobs, knowledge, culture, relationships, and reputation.[48] Taken together, these means of existence formed the family's 'social capital'. This notion, first developed by Pierre Bourdieu, has been taken up and developed in Dutch scholarship to signify societal ability, cultural ability, or civility; it can be understood here as the societal potential of the means a family possessed and could administer to maintain their social position and network of relationships.[49] Members of a family controlled and transferred their societal capacities more or less consciously to the next generation.[50]

To safeguard their position, wealthy families strategically deployed their financial, political, and social-cultural abilities. A large network of relationships

45 Baxter and Martin, 'Introduction', p. 3.
46 'Overleven was een kunst, en een elementair onderdeel daarvan was het onderhouden van vriendschap'. Kooijmans, *Vriendschap*, p. 8.
47 Kooijmans, *Vriendschap*, p. 15.
48 Kooijmans, *Vriendschap*, p. 17.
49 Schmidt, *Om de Eer*, pp. 10–11.
50 Schmidt, *Om de Eer*, pp. 193–94. Cees Schmidt prefers to use the Dutch 'societal ability', cultural ability, or 'civility' (*beschaving*), instead of the English translations of Bourdieu's 'social capital' and 'cultural capital', with their materialist associations.

with family and friends was organized and maintained through upbringing, education, marriage politics, public relations, and the use of traditions, customs, and conventions that cemented the group.[51] In the eighteenth-century Republic, before large-scale institutionalization, the stability of society was largely dependent on mutual solidarity, taking care of one's own, and personal ties, with friendship (and kinship) a concept to strengthen those ties. While men were often prepared for trade, finance, law, and governance, and women were prepared to manage the household, both sexes received instruction in the proper form of conduct within their milieu.[52] Men combined outdoor business and visits to coffee houses with working from the house and inviting clients to visit.[53] For women, the interior spaces could acquire an almost theatrical quality as places to entertain, perform identity, and emphasize individuality, in addition to reinforcing social position or authority.[54]

Social interaction was essential in the lives of this ruling elite. The time spent on administrative and political activities was limited, and a large group lived off interest. Power and standing circled within the network of families that comprised the Dutch urban elite. Specific ceremonials were maintained to interact within this group, stimulating regular visits and shared activities whereby families emphasized their distinction from others, and from other classes. In the daily lives of the ruling elite, visits to friends and kin were crucial to maintain and reinforce these social ties, especially in the larger cities. Specific behaviours were greeted with special treatment by other members of the elite. Indeed, they were expected to demonstrate their status.[55] Much time was spent at home, inviting relatives and friends. Special society events, such as births, weddings, and funerals, were singled out in particular to honour and reassert the status of a family, but it appears that everyday life also blurred the boundaries between public and private in eighteenth-century society.[56] Partaking in social life was more than a leisure pastime.[57] Regular interaction provided opportunities to exchange news and gossip, to discuss politics, career opportunities, social relations, expectations, and upcoming events, and also to discuss important business transactions and other topics that required the intimacy of the private domestic domain. To be invited meant that one was part of the network of influential people and their relations, making visits an important part of the daily life of the elite. In these strategies of friendship, the house could perform a number of specific functions that beg the question of

51 Schmidt, *Om de Eer*, p. 10.
52 Kooijmans, *Vriendschap*, pp. 14–17.
53 De Jong, *Een Deftig Bestaan*, p. 144; Kloek and Mijnhardt, *1800*, p. 245; Kloek, *Vrouw des huizes*, pp. 123–27.
54 Baxter, 'Introduction', pp. 6–7.
55 Duijvendak, 'Elite Families', p. 75.
56 Kloek and Mijnhardt, *1800*, p. 100; Zandvliet, *De 250 Rijksten*, p. 275; Jong, *Een Deftig Bestaan*, p. 112.
57 De Jong, *Een Deftig Bestaan*, p. 134.

how public or private the home was, how privacy was defined in this setting, and how it fluctuated depending on the occasion and activity.

Conclusion: Fluctuating Privacy

This gradual transformation of domestic space seems to be intimately linked to the character of sociability among the elite and the way the ruling elite structured their daily lives during these decades. Evidence suggests that privacy as individual seclusion was limited. Much more space seems to have been reserved for privacy as relational intimacy, in the early modern sense of friendship and intimate relations. Rather than arriving 'out of the blue', the extended home and its internal rearrangement arguably came about because of changes in the social behaviour of the Dutch elite. By looking more closely at the transformation of the eighteenth-century Amsterdam canal house in relation to the culture of sociability and friendship, we have seen how competing definitions of privacy contributed to a specific local architectural solution that became a sort of standard in Dutch domestic architecture.

The new extended house enabled flexible usage. With its system of passages and interconnections, it provided ample options in the elite's daily life, in terms of both privacy and sociability. The moving boundary between the two was tailored to often theatrical performances of status, to sustain and support societal ability and capital. The representation of the self was integrated into the elite's strategies of friendship, which unfolded in the different spaces of the extended interior. Indeed, privacy — in the sense of an intimacy of relations — appears to have been a determining factor behind the large-scale interior renovation and extension of the elite house in eighteenth-century Amsterdam's canal district. The increase in rooms and social spaces made possible by large-scale renovation, and the inclusion of a monumental staircase between the *beletage* and the upper floor, suggests that guests were invited deeper into the home and appreciated the extended and spatially varied interiors. The strict division between social and private floors was changing. Even though access could remain restricted, the new interconnected rooms and the open newelled staircase suggest that it became more common to move through the house in company, as a shared experience or an action witnessed by friends, relatives, and other guests.

When the Rutgers siblings commissioned the renovation of their house, the 1620s building was to be enlarged and reconfigured. With the aid of passages such as the corridor, the large staircase, and multiple doors, shutters, and openings, flexibility was built in to provide David, Margaretha, and Hillegonda with both shared and divided social and private spaces. Their home became a multipurpose building that could change from a social convention centre into a private home and back again, with only a few movements and shifts, and without sacrificing comfort or propriety of décor. With the redesign and extension of their home, privacy had become mobile and temporal.

Works Cited

Primary Sources

Horst, Tieleman van der, and Jan Schenk, *Theatrum Machinarum Universale, of Nieuwe Algemeene Bouwkunde, Waar in Op Een Naauwkeurige Klaare, En Wiskunstige Wyze Werd Voorgestelt En Geleerdt, Het Maaken Van Veelerley Soorten Van Trappen, Met Derzelver Gronden En Opstallen* (Amsterdam: Petrus Schenk, 1739)

Caspar Philips Jacobsz, *Verzaameling van alle de huizen en prachtige gebouwen langs de Keizers en Heere-grachten der stadt Amsteldam, van den Binnen-Amstel tot aan de Brouwers-gracht, ten getale van byna vyftienhonderd stuks, tot eene verlustiging voor de bewooners deezer prachtige gebouwen, maar vooral ten byzonderen nutte van architecten, timmerlieden, metzelaars, steen- en beeldhouwers, schilders, smeden, enz. als zynde veelen deezer gebouwen vervaardigd volgens de ontwerpen en teekeningen van beroemde Italiaansche en Fransche bouwkundigen, naar het leven geteekend en in XXIV koperen platen afgebeeld* (Amsterdam: J. B. Elwe, 1768–1771)

Secondary Studies

Abrahamse, Jaap Evert, *Metropolis in the Making: A Planning History of Amsterdam in the Dutch Golden Age* (Turnhout: Brepols, 2019)

Baarsen, Reinier, ed., *Rococo in Nederland* (Zwolle: Waanders, 2001)

Baxter, Denise Amy, and Meredith Martin, eds, *Architectural Space in Eighteenth-Century Europe: Constructing Identities and Interiors* (Farnham: Ashgate, 2010)

——, 'Introduction: Constructing Space and Identity in the Eighteenth-Century Interior', in *Architectural Space in Eighteenth-Century Europe: Constructing Identities and Interiors*, ed. by Denise Amy Baxter and Meredith Martin (Farnham: Ashgate, 2010), pp. 1–12

Bourdieu, Pierre, *Distinction: A Social Critique of the Judgement of Taste*, trans. by Richard Nice (Cambridge, MA: Harvard University Press, 1984)

Dibbits, Hester C., 'Between Society and Family Values: The Linen Cupboard in Early-Modern Households', in *Private Domain, Public Inquiry: Families and Life-styles in the Netherlands and Europe, 1550 to the Present*, ed. by Anton J. Schuurman and Pieter Spierenburg (Hilversum: Verloren, 1996), pp. 125–45

——, *Vertrouwd bezit: Materiële cultuur in Doesburg en Maassluis 1650–1800* (Nijmegen: Sun, 2001)

Duijvendak, Maarten, 'Elite Families between Private and Public Life: Some Trends and Theses', in *Private Domain, Public Inquiry: Families and Life-styles in the Netherlands and Europe, 1550 to the Present*, ed. by Anton J. Schuurman and Pieter Spierenburg (Hilversum: Verloren, 1996), pp. 72–88

Eeghen, Isabella Henriette van, 'De veertienvoudige restauratie voor het Howard Johnson hotel bij de Westermarkt', *Maandblad Amstelodamum*, 57 (1970), 97–106

Eleb, Monique, and Anne Debarre-Blanchard, *Architectures de la vie privée: Maisons et mentalités XVIIe–XIXe siècles* (Paris: Hazan, 1989)

Evans, Robin, 'The Developed Surface: An Enquiry into the Brief Life of an Eighteenth-Century Drawing Technique', in Robin Evans, *Translations from Drawing to Building and Other Essays* (London: RIBA, 1997), pp. 195–231

——, 'Figures, Doors, and Passages', in Robin Evans, *Translations from Drawing to Building and Other Essays* (London: RIBA, 1997), pp. 55–91

Fock, C. Willemijn, 'Werkelijkheid of schijn: Het beeld van het Hollandse interieur in de zeventiende-eeuwse genre-schilderkunst', *Oud Holland*, 112 (1998), 187–246

——, 'The Décor of Domestic Entertaining at the Time of the Dutch Republic', *Nederlands Kunsthistorisch Jaarboek*, 51 (2000), 103–36

——, '1600–1650', in *Het Nederlandse interieur in beeld 1600–1900*, ed. by C. Willemijn Fock (Zwolle: Waanders, 2001), pp. 16–79

——, ed., *Het Nederlandse interieur in beeld 1600–1900* (Zwolle: Waanders, 2001)

Glaudemans, Marc, *Amsterdams Arcadia: De ontdekking van het achterland* (Nijmegen: Sun, 2000)

Goffman, Erving, *The Presentation of Self in Everyday Life* (Garden City: Doubleday, 1959)

Hanson, Julienne, with contributions by Bill Hillier, Hillaire Graham, and David Rosenberg, *Decoding Homes and Houses* (Cambridge: Cambridge University Press, 1998)

Hillier, Bill, 'Space and Spaciality: What the Built Environment Needs from Social Theory', *Building Research & Information*, 36 (2008), 216–30

Jong, Joop J. de, *Met goed fatsoen: De elite in een Hollandse stad: Gouda 1700–1780* (Amsterdam: De Bataafsche Leeuw, 1985)

Jong, Joop de, *Een Deftig Bestaan: Het Dagelijks Leven Van Regenten in De 17e En 18e Eeuw* (Utrecht: Kosmos, 1987)

Jong, Joop de, Maarten R. Prak, and Luuc Kooijmans, 'Wonen Op Stand: De Woningen Van Vooraanstaande Families Te Gouda, Hoorn En Leiden in De 18de Eeuw', in *Wonen in het verleden: Ekonomie, politiek, volkshuisvesting, cultuur*, ed. by P. M. M. Klep (Amsterdam: NEHA, 1987), pp. 207–16

Kleijn, Koen, Ernest Kurpershoek, and Shinji Otani, *The Canals of Amsterdam: 400 Years of Building, Living and Working* (Bussum: Thoth, 2013)

Kloek, Els, *Vrouw des huizes: Een cultuurgeschiedenis van de Hollandse huisvrouw* (Amsterdam: Balans, 2009)

Kloek, Joost, and Wijnand Mijnhardt, with Eveline Koolhaas-Grosfeld, *1800: Blueprints for a National Community*, trans. by Beverley Jackson (Basingstoke: Palgrave Macmillan, 2004)

Koldeweij, Eloy, '1750–1800', in *Het Nederlandse interieur in beeld 1600–1900*, ed. by C. Willemijn Fock (Zwolle: Waanders, 2001), pp. 261–341

Kooijmans, Luuc, *Onder regenten: De elite in een Hollandse stad: Hoorn 1700–1780* (Amsterdam: De Bataafsche Leeuw, 1985)

——, *Vriendschap en de Kunst van het Overleven in de Zeventiende en Achttiende Eeuw* (Amsterdam: Bert Bakker, 1997)

Laan, Barbara, 'Het décor van een voorname levensstijl: Rijke interieurs aan de grachten van Amsterdam 1600–1900', in *Het Grachtenboek: Vier eeuwen Amsterdamse grachten in beeld gebracht; gevels, interierus en het leven aan de*

gracht, ed. by Paul Spies, Koen Kleijn, and Ernest Kurpershoek (Den Haag: SdU, 1991), pp. 68–83

Levie, Tirtsah, and Henk J. Zantkuijl, *Wonen in Amsterdam in de 17e en 18e Eeuw* (Amsterdam: Amsterdams Historische Museum, 1980)

Loughman, John, and John Michael Montias, *Public and Private Spaces: Works of Art in Seventeenth-Century Dutch Houses* (Zwolle: Waanders, 2000)

Meischke, Ruud, H. J. Zantkujl, and P. T. E. E. Rosenberg, *Huizen in Nederland: Architectuurhistorische verkenningen aan de hand van het bezit van de Vereniging Hendrick de Keyser: Amsterdam* (Zwolle: Waanders, 1995)

Ottenheym, Koen, '"Van Bouw-lust soo beseten": Frederik Hendrik en de bouwkunst', in *Vorstelijk vertoon aan het hof van Frederik Hendrik en Amalia*, ed. by Marika Keblusek and Jori Zijlmans (Zwolle: Waanders, 1997), pp. 105–25

Pijzel-Domisse, Jet, *Het Hollandse pronkpoppenhuis: Interieur en huishouden in de 17de en 18de eeuw* (Zwolle: Waanders, 2000)

——, '1700–1750', in *Het Nederlandse interieur in beeld 1600–1900*, ed. by C. Willemijn Fock (Zwolle: Waanders, 2001), pp. 181–259

Prak, Maarten, *Gezeten burgers: De elite in een Hollandse stad: Leiden 1700–1780* ('s-Gravenhage: De Bataafsche Leeuw, 1985)

——, 'Aristocratisering', *Spiegel Historiael*, 23 (1988), 226–32

Prins, Maarten, 'Heren van Holland: Het bezit van Hollandse heerlijkheden onder adel en patriciaat (1500–1795)', *Virtus*, 22 (2015), 37–62

Quarles van Ufford, Carel C. G., *Catalogus van overwegend Amsterdamse architectuur- en decoratieontwerpen uit de achttiende eeuw* (Utrecht: Koninklijk Oudheidkundig Genootschap, 1972)

Roorda, Daniel J., 'Het onderzoek naar het stedelijk patriciaat in Nederland', in *Kantelend geschiedbeeld: Nederlandse historiografie sinds 1945*, ed. by W. W. Mijnhardt (Utrecht: Het Spectrum, 1983), pp. 118–42

Schmidt, Cees, *Om de Eer van de Familie: Het Geslacht Teding van Berkhout 1500–1950, een sociologische benadering* (Amsterdam: De Bataafsche Leeuw, 1986)

Schmidt, Freek, 'Dutch Arcadia: Amsterdam and Villa Culture', in *The Baroque Villa: Suburban and Country Residences c. 1600–1800*, ed. by B. Arciszewska (Wilanow: Wilanow Palace Museum, 2009), pp. 43–58

——, 'Hollands Arcadië: Achttiende-eeuwse Amsterdam buitenplaatscultuur/ Dutch Arcadia: Amsterdam and Villa Culture', *Over Holland: Architectonische studies voor de Hollandse stad*, 10–11 (2011), 173–96

——, *Passion and Control: Dutch Architectural Culture of the Eighteenth Century* (Farnham: Ashgate, 2016)

——, 'The Architectural Essence of the Canal District — Past and Present', in *Amsterdam's Canal District: Origins, Evolution, and Future Prospects*, ed. by J. Nijman (Toronto: Toronto University Press, 2020), pp. 101–17

——, 'The Rise of the Staircase: Motion in Eighteenth-Century Dutch Domestic Architecture', in *Early Modern Spaces in Motion: Design, Experience and Rhetoric*, ed. by Kimberley Skelton (Amsterdam: Amsterdam University Press, 2020), pp. 139–62

Schuurman, Anton J., 'De studie van woonculturen in het verleden als sociaal-economische geschiedenis', in *Wonen in het verleden: Ekonomie, politiek, volkshuisvesting, cultuur*, ed. by Paul M. M. Klep (Amsterdam: NEHA, 1987), pp. 171–87

——, 'Is huiselijkheid typisch Nederlands? Over huiselijkheid en modernisering', *Bijdragen en Mededelingen betreffende de geschiedenis der Nederlanden*, 107 (1992), 745–59

Schuurman, Anton, and Pieter Spierenburg, eds, *Private Domain, Public Inquiry: Families and Life-Styles in the Netherlands and Europe, 1550 to the Present* (Hilversum: Verloren, 1996)

——, 'Introduction: Between Public and Private', in *Private Domain, Public Inquiry: Families and Life-styles in the Netherlands and Europe, 1550 to the Present*, ed. by Anton Schuurman and Pieter Spierenburg (Hilversum: Verloren, 1996), pp. 7–11

Spies, Paul, 'Cieraet deser stede: De grachtengordel bewonderd, bedreigd en beschermd', in *Het Grachtenboek: Vier eeuwen Amsterdamse grachten in beeld gebracht; gevels, interierus en het leven aan de gracht*, ed. by Paul Spies, Koen Kleijn, and Ernest Kurpershoek (Den Haag: SdU, 1991), pp. 15–27

Swigchem, Cornelis A. van, *Huize van Brienen: Beeld van een Amsterdams grachtenhuis uit de 18de eeuw* (Zutphen: De Walburg Pers, 1984)

Tulleners, Hans, *Een pracht van een gracht: 23 monumenten aan de Amsterdamse Keizersgracht* (Amsterdam: Gemeentelijk Bureau Monumentenzorg, 1988)

Veblen, Thorstein, *The Theory of the Leisure Class* (New York: Macmillan, 1899)

Verzaameling van alle de huizen en prachtige gebouwen langs de Keizers en Heeregrachten der stadt Amstseldam, beginnende van den Binnen Amstel en eindigende aan de Brouwers-gracht … : Ruim 1400 … gebouwen … van huis tot huis geteekend en op kunstige koopere plaaten afgebeeld (Amsterdam: Bernardus Mourik, 1768–1771)

Vlaardingerbroek, Pieter, ed., *The Amsterdam Canals: World Heritage* (Amsterdam: City of Amsterdam, 2016)

Westermann, Mariët, 'Wooncultuur in the Netherlands: A Historiography in Progress', *Nederlands Kunsthistorisch Jaarboek*, 51 (2000), 7–33

Wijsenbeek-Olthuis, Thera, 'Vreemd en eigen: Ontwikkelingen in de woon- en leefcultuur binnen de Hollandse steden van de zestiende tot de negentiende eeuw', in *Cultuur en maatschappij in Nederland 1500–1800*, ed. by Peter Boekhorst, Peter Burke, and Willem Frijhoff (Meppel: Boom, 1992), pp. 79–107

——, 'Noblesse Oblige: Material Culture of the Nobility in Holland', in *Private Domain, Public Inquiry: Families and Life-styles in the Netherlands and Europe, 1550 to the Present*, ed. by Anton J. Schuurman and Pieter Spierenburg (Hilversum: Verloren, 1996), pp. 112–24

Zandvliet, Kees, *De 250 Rijksten van De Gouden Eeuw: Kapitaal, macht, verwantschap en levensstijl* (Amsterdam: Rijksmuseum, 2006)

——, *De 500 Rijksten van de Republiek: Rijkdom, geloof, bacht & cultuur* (Zwolle: Waanders, 2018)

FAYROUZ GOMAA AND INEKE HUYSMAN

Balancing between Mother and Wife

The Private Correspondence of Stadtholder Willem IV of Orange-Nassau

Dimanche matin, à 10 heures à La Haie [17??] Hélas, ma chère Annin, que nous simpatisons parfaitement ensemble. J'eu aussi en vous quittant le coeur si serré que je ne pu profferer aucune parole, ni vous exprimer assez le regret que me cause notre séparation. […] Je ne puis te dire d'avantage, car je griffonne encore à un tel point que je ne sçais aranger mes pensée[s] et toutes les fois qu'elle[s] vont vers vous, ma chère âme, elle[s] m'attendrissent si fort que je sens couler mes larmes. Ce matin m'éveillant sans te voir, je ne pu refuser à mon coeur affligé de cette idée une abondance de pleurs. […] Adieu encore, trop aimable Annin, n'oublie point le pauvre Orange, qui ne vit que pour toi. […] Orange.

(Sunday morning, 10 a.m. in The Hague [17??] Alas, my dear Annin, how perfectly do we understand each other. When I left you, it was with such a heavy heart that I could not utter a word, nor express to you well enough the regret that our separation causes me. […] I cannot tell you more, for I am still scribbling in such a way that I cannot arrange my thoughts, and every time they are directed to you, my dear soul, they move me so strongly that I feel my tears flowing. This morning, waking up without seeing you, I could not deny an abundance of tears to my heart, which was so saddened by this. […] Farewell again, too sweet Annin, do not forget poor Orange, who lives only for you. […] Orange.)[1]

1 The Hague, RC, A30-VIa-1, Willem IV of Orange-Nassau to Anne of Hanover, undated.

Fayrouz Gomaa completed her research master's degree in History at Utrecht University in 2021. Her thesis analysed the meanings attributed to sexual perversions in the early twentieth century in the Netherlands.

Ineke Huysman is a senior researcher at the Huygens Institute for History and Culture of the Netherlands. She manages the digital editions of the correspondence of Constantijn Huygens, Johan de Witt, and stadholders' wives.

Private Life and Privacy in the Early Modern Low Countries, ed. by Michael Green and Ineke Huysman, EER 19 (Turnhout: Brepols, 2023), pp. 273–304
BREPOLS ❧ PUBLISHERS 10.1484/M.EER-EB.5.132538

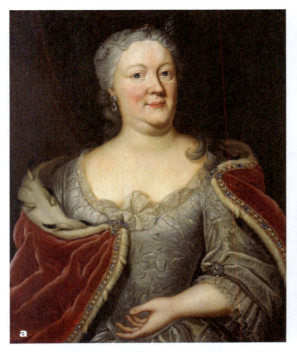
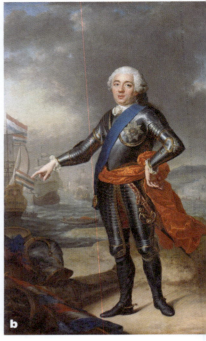
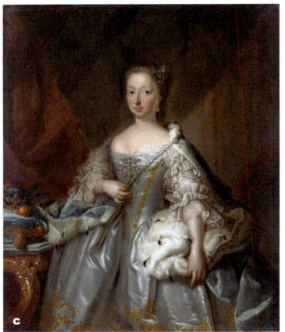

Figure 10.1. a: Johan Philipp Behr, *Maria Louisa of Hesse-Kassel*, c. 1720–1756; b: Jacques-André-Joseph Aved, *Willem IV, Prince of Orange-Nassau*, 1751; c: Johann Valentin Tischbein, *Anne of Hanover*, 1753.
© Rijksmuseum Amsterdam.

Introduction

How were emotions expressed in early modern correspondence?[2] In starting this article with an exemplary love letter from stadtholder Willem IV (1711–1751) to his wife Anne of Hanover (1709–1759), we seem to have set the tone. However, can we address the issue using new methods? We will examine this question by conducting a pilot study: on the basis of selected examples, and by applying Transkribus's text recognition tool and Bruun's method of heuristic zones, we will investigate how Willem IV expressed his personal feelings in letters to his wife Anne, and to his mother, Maria Louise of Hesse-Kassel (1688–1765). Through the stadtholder's private letters, we hope to catch a glimpse of the inner life of a prince whose public life has to date received more attention.

Letters provide particularly good opportunities to express emotions.[3] They can reveal complex family relationships and determine how expressions of identity and emotion are influenced. Furthermore, while the historiography of the Dutch stadtholders has focused strongly on their relationships with public institutions, international rulers, and military campaigns, their personal lives remain under-studied. This is especially true of stadtholder Willem IV, who has been regarded a weak statesman of little historical interest. According to Pieter Geyl, Willem IV was in no way comparable to his predecessor, the great stadtholder-king William III (1650–1702), who became king of England, Scotland, and Ireland as a result of his marriage to Mary Stuart (1662–1695). Geyl argued that Willem IV was hesitant, indecisive, and entirely lacking in vigour. Willem the prince, wrote Geyl, was a mixture of over-the-top idealism, which made him look decent, and cynicism inspired by his strong-willed wife Anne, who made him fatalistic.[4] This bad reputation has never really left Willem IV, even though Fred Jagtenberg presents him in a very different light as a good and reliable statesman.[5] We hope to supplement this particular portrait with an extra nuance, paying attention to the personal side that Willem IV expressed in the private letters he sent to his mother and wife.

In his work on the French 'age of absolutism', *The Court Society*, Norbert Elias asserts a distinction between the public and private lives of monarchs in early modern Europe. For monarchs, there was a clear intrusion of what we would consider public life into the private. According to Elias, the aristocracy had no professional life as we would understand the term today, as a large part of court life fell into the public sphere, and consequently there was almost no distinction between public and private.[6] This also applied to the

2 We would like to thank Margriet Lacy, Joshua Dixon, and Jean-Marc van Tol for their comments.
3 Broomhall and Van Gent, *Gender, Power and Identity*, p. 1.
4 Geyl, *Willem IV en Engeland*.
5 Jagtenberg, *Willem IV*.
6 Elias, *The Court Society*, p. 32.

physical condition of princes, which is relevant when we consider Willem IV, although every effort was made to keep his poor health hidden from the public.[7] Nonetheless, in this chapter we will focus on aspects within the stadtholder's private sphere, paying attention to the way in which he expressed his thoughts and feelings.

By using Transkribus, a comprehensive platform for the digitization, artificial-intelligence-powered recognition, transcription, and searching of historical documents, we created two data sets containing fully searchable texts of Willem's correspondence, to be used for this pilot study.[8] In this chapter, we will compare these two sets of letters, addressed to his wife and his mother respectively. By doing so, we hope to demonstrate the usefulness of modern analytical methods for investigating notions of privacy in early modern correspondence.

Notions of privacy can be very broad. Although there is no fixed definition of privacy, this chapter will adopt the approach initiated by the Danish National Research Foundation Centre for Privacy Studies concerning terminology, heuristic zones, and semantic mapping, in order to analyse these notions in the letters.[9] By investigating how men and women in that era understood what we know nowadays as 'privacy' and 'private', the extent to which such notions were shared among family members, and how these concepts and practices may have differed in individual experience, we are adopting Bruun's method.[10] Of course, there are numerous interesting concepts regarding privacy that could be studied using these letters, but because of the specific health problems that Willem IV faced, as we will explain below, we have chosen to study cases concerning his emotional and physical state, how he experienced these, and how he reported them to his mother and wife. More specifically, we will analyse these cases with regard to his physical health, his wife's pregnancies, and their children. These cases bring us closest to the first of Bruun's heuristic zones, as will be explained below. Furthermore, this will give us an insight into the way in which family relations influenced the expression of such notions of privacy.

There are a number of limitations to our study, the most important of which is that, due to the limited time available for the research, we looked solely at the letters written by Willem IV, and not at those sent by his mother or wife. Furthermore, we are interested in using a gendered approach specifically with regard to feelings and emotions, as these are often wrongly identified as 'feminine'.[11] The letters of Maria Louise and Anne would be a suitable

7 Jagtenberg, *Willem IV*, pp. 134–35.
8 For Transkribus, see <https://readcoop.eu/transkribus> [accessed 31 January 2021].
9 Bruun, 'Privacy'.
10 Bruun, 'Privacy'.
11 Billing and Alvesson, 'Questioning the Notion', p. 144.

BALANCING BETWEEN MOTHER AND WIFE 277

subject for a follow-up study, as would the letters these women exchanged with other correspondents.

Another limitation of our study is that we have excluded all other correspondents, only analysing the letters Willem sent to his mother and his wife. These (we infer) were the people to whom he was the closest, and we are interested in ascertaining whether he did indeed share his private affairs with them. Willem had an older sister, Amelia (1710–1777), but the family regarded her as mentally unstable.[12] His father, Johan Willem Friso (1687–1711), had died before he was born, and he only rarely came into contact with other relatives. Furthermore, we have to rely on the reports of emotions that Willem put on paper. Of course, it is possible that he kept his most private feelings and emotions to himself, or that he only communicated them orally.

This chapter will proceed as follows. We will first take a look at the historiography of expressions of the private sphere in early modern correspondence and provide a context for our main actors, Willem IV of Orange-Nassau, Maria Louise of Hesse-Kassel, and Anne of Hanover. Next, we will elaborate on Transkribus and Bruun's approach, and apply them to our study. Finally, we will make some concluding remarks on our analysis and evaluate the method used.

Historiography

In Europe, letter-writing increased dramatically in the early modern period. Literacy levels rose due to the increasing availability of printed material, postal infrastructures improved, and most correspondence exchanged Latin for local vernaculars.[13] The capacity of letters to document the lived experiences of social interactions has been demonstrated by James Daybell in his study of women's writing in Tudor England.[14] He even goes so far as to state that there is no other medium as potentially illuminating as letters, as they can constitute the most private and direct form of writing.[15] This makes letters incredibly effective for studying notions of privacy, as correspondence was employed for a flexible range of intimate and introspective uses.[16]

Carolyn James and Jessica O'Leary have pointed out that epistolary sources can reveal how the expression of emotions has changed over time, including the ways in which feelings and emotions were put on paper, and how relationships could be developed via post, rather than offering direct access to how someone was feeling.[17] Most noteworthy in this field are the works by

12 Jagtenberg, *Marijke Meu*, p. 115.
13 James and O'Leary, 'Letter-Writing and Emotions', p. 257.
14 Daybell, *Women Letter-Writers*.
15 Daybell, *Women Letter-Writers*, p. 6.
16 Daybell, *Early Modern Women's Letter Writing*, p. 2.
17 James and O'Leary, 'Letter-Writing and Emotions', p. 257.

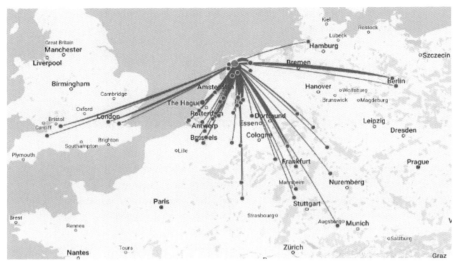

Figure 10.2. Routes of letters from Willem IV to his mother, Maria Louise of Hesse-Kassel, written from various European cities. Source: Nodegoat.

Rosenwein, Ruppel, and Broomhall.[18] However, within the study of (noble) family experiences in the past, emotional expression in correspondence is still an under-studied field. As well as learning why they were used, different forms of emotional expression within family ties can provide us with insights into family history in general and socio-hierarchical relationships between or within communities.[19]

Naturally, letters written in the early modern period were shaped by their cultural, political, and religious contexts. According to James and O'Leary, it is therefore important for historians to take into account how certain phrases were used and understood within these contexts.[20] A correspondence could be initiated because of physical distance, and although such letters often contain pragmatic, day-to-day interactions, they can clarify how social relations were managed across distances, and how distance created other ways to relate to family members or friends. In his study of vernacular correspondence between 1500 and 1700, Gary Schneider argues that face-to-face interaction enabled clearer communication than interaction via letters.[21] This is especially important to acknowledge, as letters lack direct interaction's non-verbal communications, such as facial expression, tone of voice, and overall body

18 Rosenwein, 'Worrying about Emotions'; Ruppel, *Verbündete Rivalen*; Broomhall, 'Emotions in the Household'.
19 Broomhall and Van Gent, 'Corresponding Affections', p. 144.
20 James and O'Leary, 'Letter-Writing and Emotions', p. 261.
21 Schneider, *The Culture of Epistolarity*, p. 22.

language. Emotions were not easily transferable onto paper, so one had to think about the way in which one's words might be received. This sheds light on the formal expectations letter writers had of one another, and how they influenced each other through their letters.[22]

In their study of early modern Nassau family correspondence, Broomhall and Van Gent argue that letter-writing also created and sustained emotional bonds between family members who were geographically dispersed all over Europe, and who were related to one another through the various marriages of their respective parents. Broomhall and Van Gent analyse the strict behavioural codes the Nassau family used when corresponding with one another. According to the authors, the family were very much aware of hierarchies — as was expected of a noble family — and always observed hierarchical codes whereby family members carefully chose the relatives to whom they wanted to express their emotions.[23] The study of this complex relationship between letter-writing, emotions, and family bonds in early modern Europe is a fairly new scholarly field.

Actors

As a rule, from the sixteenth to the eighteenth centuries, the Republic of the Seven United Netherlands appointed *stadhouders* (stadtholders) as their official representatives. Although the States-General had official decision-making power in the Republic, the stadtholder was de facto head of state: as captain-general of the army and admiral-general of the fleet, he was the highest government official. After stadtholder-king William III died childless, most provinces elected not to choose a successor, and so the second 'stadtholderless' period (1702–1747) was announced.[24] The only exception was the province of Friesland, where Johan Willem Friso of Nassau-Dietz, the father of Willem IV, was stadtholder during this time. In 1711 he drowned when a ferry he had taken to cross Hollands Diep capsized in bad weather. This caused Friesland to appoint his widow, Maria Louise of Hesse-Kassel, as regent for her son, Willem IV, who was born on 1 September 1711, seven weeks after his father's death.[25] Until Willem came of age, Maria Louise would fulfil his duties as stadtholder.

Maria Louise, daughter of landgrave Charles of Hesse-Kassel (1654–1730) and Maria Amalia of Courland (1653–1711), was a pious woman, having had a thorough Protestant upbringing.[26] After her marriage to the stadtholder

22 James and O'Leary, 'Letter-Writing and Emotions', p. 257.
23 Broomhall and Van Gent, 'Corresponding Affections', p. 148.
24 The first stadtholderless period was 1650–1672.
25 Jagtenberg, *Het korte leven*, p. 21.
26 Jagtenberg, *Marijke Meu*; Barthels, 'Maria Louise van Hessen-Kassel'. Johan Willem Friso had also a solid Calvinist upbringing, see: Green, 'Educating Johan Willem Friso'.

and her move to Leeuwarden in 1709, she quickly adapted to her new life in the Frisian capital. She was warmly welcomed by the people of the province and praised for her overall friendliness (see Figure 10.3).[27] When she became regent for her son during his minority, Maria Louise was not prepared for the governmental tasks that required her attention, as she had been in the Dutch Republic for less than two years. As multiple parties laid claim to the titles and possessions of William III, she had to deal with matters relating to his inheritance, as well as with a weak financial budget and a large debt.[28] After Willem came of age and was appointed stadtholder of Friesland in 1731, she led a quiet life in Leeuwarden. The untimely deaths of her son in 1751 and her daughter-in-law in 1759 made her regent once again from 1759 until her own death in 1765, this time for her underage grandson, later stadtholder Willem V (1748–1806). Maria Louise was known as Aunt Maria (Maaike Muoi in Frisian, or Marijke Meu in Dutch), which illustrates her popularity among the people of Friesland. Throughout her life she maintained a large network of correspondence, comprising nearly 10,000 letters in total, which are all currently being digitized as part of the Huygens Institute for the History of the Netherlands' Dutch and Frisian Stadtholders' Wives Project.[29]

Willem IV grew up at the Frisian court in Leeuwarden and studied (Dutch) history, theology, rhetoric, law, mathematics, languages, logic, philosophy, politics, and geography at the universities of Franeker and Utrecht.[30] When he came of age, the regency of his mother ended, and he was officially appointed stadtholder of Friesland by the States of Friesland. In the meantime, the provinces of Groningen (1718), Drenthe (1722), and Gelderland (1722) had also acknowledged him as stadtholder; the senior branch of the Nassau family, that of the Orange dynasty, had officially ended with the death of stadtholder-king William III in 1702. From that moment on, Willem IV was not only the highest-ranking nobleman but also the highest-ranking official in these provinces. It was not easy to achieve the position of stadtholder of the entire Republic, as the States-General — specifically the provinces of Holland, Zeeland, and Utrecht — were opposed to appointing a new stadtholder. Nevertheless, he became stadtholder of the entire Dutch Republic in 1747.

To secure the continuation of the Orange-Nassau dynasty, male successors were important. After years of marriage negotiations, a bride for the young stadtholder was found in 1733: Anne of Hanover, eldest daughter of the British king George II (1683–1760). Although their alliance was not born out of love, their correspondence testifies to the deep affection that existed between them. The marriage resulted in five children, three of whom were stillborn or died

27 Baker-Smith, *A Life of Anne of Hanover*, p. 33.
28 Barthels, 'Maria Louise van Hessen-Kassel'.
29 The project can be found at Early Modern Collections Online <http://emlo-portal.bodleian.ox.ac.uk/collections/?page_id=2756> [accessed 30 January 2021].
30 Jagtenberg, *Willem IV*, pp. 196–98.

Figure 10.3. Carel Frederik Bendorp after Jan Bulthuis, *Stadhouderlijk Hof in Leeuwarden*, 1786–1792. © Rijksmuseum Amsterdam.

shortly after birth. In 1743, Carolina Wilhelmina (1743–1787) was born in Leeuwarden, and in 1748 a healthy son followed, the later stadtholder Willem V.[31]

Willem IV's health was poor from an early age, although the cause of this remains debated. Whereas his biographer Jagtenberg, as well as general historiography, attribute it to an unfortunate fall from a carriage at the age of five, Veronica Baker-Smith argues that this is very unlikely, as a fall from a height of (at most) one metre would not have affected an active child so badly.[32] Even if he had been unlucky enough to receive a permanent injury to his back, this would have resulted in instant paralysis rather than a gradual deformity, as was the case with Willem. In Baker-Smith's view, the deformity of his back and chest indicates a chronic condition. She argues that Willem could have been born with part of a vertebra missing, as this would show no sign of deformity until the combination of gravity and growth took effect. A second possibility is a tubercular condition attacking the spine, as Willem's adult medical history reveals frequent attacks of pleurisy.[33] Although the true cause of his poor health remains unclear, his poor health was always a

31 Lantink, 'Anna van Hannover'; Baker-Smith, *A Life of Anne of Hanover*.
32 Jagtenberg, *Willem IV*, pp. 135–36; Baker-Smith, *A Life of Anne of Hanover*, p. 36.
33 Baker-Smith, *A Life of Anne of Hanover*, p. 36.

worry to Willem's mother. With more than the usual motherly attentiveness, Maria Louise was overly concerned about his well-being, especially since he was the only heir to the title of Prince of Orange, and therefore the only person able to continue the dynasty. Although at the time it was standard for correspondents to exchange information about their health, Maria Louise obsessively interrogated her son regarding his well-being in almost every letter, and she would always urge him to spare himself any strenuous activity and give his body enough rest.

Methodology

The letters under discussion are preserved in the Royal Collections in The Hague, and are digitally available thanks to the Huygens Institute's Stadtholders' Wives Project. The project focuses on the correspondence of leading women in the United Provinces at the Orange and Stuart courts in The Hague (Holland) and Leeuwarden (Friesland) during the sixteenth to eighteenth centuries. Within this corpus, 1100 letters from Willem IV are addressed to his mother (see Figure 10.2).[34] All were written in French, which was the lingua franca for the aristocracy of the Low Countries. Willem wrote his first letter in 1719, when he was almost eight years old. The last letter was sent a week prior to his death in 1751. In contrast, a total of 134 letters were sent by Willem to his wife.[35] Given that they spent a lot of time together as husband and wife, the corpus of letters to Anne is understandably considerably smaller. The first was sent in 1733, just before their marriage in 1734, while the last was sent a month before Willem died.

After digitization, the letters were uploaded to Transkribus (see Figure 10.4). By using this tool, we were able to train a model to recognize Willem's handwriting in order to transcribe all his letters automatically, a method called handwritten text recognition (HTR). The results of the model far exceeded our expectations, showing a mere three per cent margin of error (the 'character error rate') for the entire corpus. After completion of the HTR, we decided to use a word-counting tool to determine which words appeared most frequently and to uncover words that stood out in Willem's letters.

In letters to his mother, Willem used approximately thirty thousand different words (a total of more than 250,000 words or three thousand pages). In the letters to Anne, the number of different words used is around 2500 (a total of more than ninety thousand words or four hundred pages). Subsequently, for our research we had to select words relating to health and emotions, as these were the notions of privacy in which we were most interested. As Willem wrote extensively about his physical condition, we were keen to find

34 The Hague, RC, A28, 6–11.
35 The Hague, RC, A30-VIa-1.

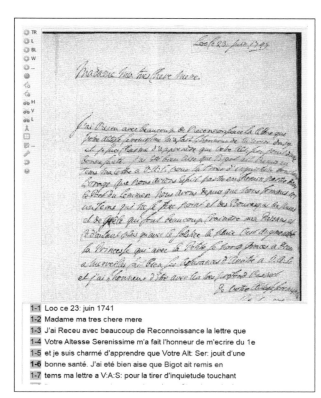

Figure 10.4. Letter from Willem IV to his mother, Maria Louise of Hesse-Kassel. Royal Collections, The Hague, A28-11. Source: Transkribus.

out whether he described his well-being to his mother differently compared with the expressions he used to his wife. Normally, the health of a prince would be a matter of public interest, but in Willem's case he and his private circle went to great efforts to keep his condition away from the public eye, as they did not want to cause public unease.

In order to get an impression of Willem's writing style, we first conducted a qualitative study, examining one hundred letters from Willem to both his mother and his wife for keywords used in relation to his feelings. Subsequently, using lists of words from the digitized texts, we were able to generate two alphabetical lists showing word frequency. From these lists we then selected the keywords which in our opinion had the strongest affinity with feelings and which also occurred the most frequently. With the words already noted from our qualitative research alongside the list-based selection, we then surveyed the corpus, which allowed us to implement the working method proposed by the Danish National Research Foundation Centre for Privacy Studies. In her article, Mette Birkedal Bruun presents an analytical approach and a set of common markers to guide scholarly efforts.[36] These markers serve as

36 Bruun, 'Privacy'.

investigative tools for the analysis of early modern sources. The first concerns terminology; the second concerns the areas in which notions of privacy are negotiated; the third is about the semantic realms relating to privacy.[37] For our study, the first and second markers were tested, and the second proved to be the more promising.

According to Bruun, searches for words with the root *priv** generate insights into notions of privacy, as this root captures a broad array of meanings within the realms of privacy.[38] Adopting this method, we used Transkribus to search for *priv** in Willem IV's 1100 letters to his mother. Unfortunately, this did not accomplish the result we were aiming for: *priv** appeared forty-eight times in the letters. In most cases (forty-four), the sender was using the French verb *priver*, meaning 'to deprive'. In the other four cases, *priv** referred to a private adviser. Additionally, Bruun argues that it might prove useful to broaden the terminological search by including cognate terms.[39] In early modern French sources, this applies to words such as *intime* or *particulier*.[40] *Particulier* was found thirty-four times in the letters sent by Willem. In all of these cases, the context of the letters proved that Willem was using the word to mean 'particularly' or 'in particular'. The root *intim** appeared only twice in all 1100 of the letters, in both cases with regard to a close friend or friendship. In his correspondence with Anne, *priv** appeared twenty times: seventeen times in the French verb *priver*, and three times to refer to a private adviser. *Particulier* and *intim** occurred twelve and four times respectively, the results being the same as in Maria Louise's case: they meant 'in particular' or related to a close friend or friendship. As this method did not achieve the intended results, we did not pursue the terminological first marker any further.

The second marker, which concerns the areas in which notions of privacy are negotiated, proved to be more fruitful. In her article, Bruun states that early modern sources often lack *priv** words, which is why a heuristic set of zones is defined that represents early modern areas of theorizing, regulation, and practice relating to privacy.[41] Because this approach is not solely reliant on terminology, it enables scholars to make use of a wide range of different sources. The zones concern 1) soul/mind/self, 2) body, 3) chamber/alcove/studio, 4) home/household, 5) community, and 6) state/society. For this study, we were primarily interested in the way in which Willem IV wrote about his emotional and physical health. For this reason we mostly addressed the first two zones, although the other zones were present in the correspondence as well, as we will show. We would like to point out, however, that the 'zoning' of words can be problematic. First of all, the researcher's (subjective) interpretations can

37 Bruun, 'Privacy', p. 46.
38 Bruun, 'Privacy', p. 46.
39 Bruun, 'Privacy', pp. 46–47.
40 See, for instance, Merlin, 'La cour et la ville'; Merlin, *Public et Littérature en France*.
41 Bruun, 'Privacy', p. 47.

cause confusion: many words have multiple meanings or change meaning over time, and they can also have different meanings depending on the intended addressee. Furthermore, we are well aware that the meaning of the concept of privacy in the eighteenth century was different from its meaning today. What we now consider 'private' may have been seen differently at the time.

Bearing this in mind, we selected fifty-five keywords for our analysis.[42] Nineteen of these related to physical health, and thirty-six to emotions. Next, in order to obtain a contextual overview, we organized the words into the following categories: 1) Maria Louise's health; 2) Willem's health/recovery/ treatment; 3) Anne; 4) the children; 5) politics/news; 6) trips/mail; 7) worries; 8) death; 9) gratitude; 10) other family members/acquaintances. For example, the word *triste* (sad) occurs eighteen times and fits into six different categories.

The results will be further elaborated in the analysis section of this chapter. However, an important caveat is that we looked exclusively at instances where the selected words occurred verbatim. A certain word — for example, *grossesse* (pregnancy) — may not appear in every letter that is about a pregnancy, as it may already have been used in a previous letter. Nevertheless, where such a word was used, we considered it an indication that we should pay attention to the surrounding letters.

Analysis

Writing Style

When describing important political topics, Willem's letters to his mother and wife can be as long as four pages; but when he is writing about his well-being, the letters tend to be short messages of half a page. Even though both women receive letters in French, the texts are sporadically interrupted by the occasional sentence in English or German, or a word or two in Dutch. However, according to Jagtenberg, that is where the similarities end.[43] Comparing the letters to his mother with those to his wife, Jagtenberg stresses Willem's difference in style. The letters to Anne not only contain many particular details about his life in the army camp and at the front, but also constantly testify to his playful spirit and lively narrative style.[44] The couple call each other by their nicknames — Annin and Pepin or Pip — and discuss all sorts of topics in their correspondence: political news, family affairs, and personal affection in equal measure. This is in sharp contrast to Willem's correspondence with his mother. Her son dutifully satisfies her desire to receive a weekly sign of

42 See Appendices 1 and 2.
43 Jagtenberg, *Willem IV*, p. 383.
44 Jagtenberg, *Willem IV*, p. 383.

life. As a result, Willem's letters to his mother are to some extent written in a rigid format, full of standard expressions and predictable formulations. Yet Maria Louise's own health, and Willem's reaction to her concerns regarding his well-being and treatments, are recurring themes. His letters often do not transcend daily concerns, although he regularly writes to his mother about political matters too.

In the following, we analyse and compare three notions of privacy in Willem's correspondence with his mother and wife: 1) his physical health; 2) Anne's pregnancies; 3) their children, Willem and Carolina. These notions bring us closest to Willem's physical and emotional state in relation to both women. In addition, they provide us with useful parameters to compare his relationships with his mother and his wife, as he writes to both about these subjects but in different ways. We would like to emphasize that the three topics we discuss below are only examples and are not exhaustive. To obtain a complete picture of Willem's handling of his emotions and the way in which he expresses them, further research is required.

Physical Health

Willem was often ill and took cures, including baths, in order to heal, which was not uncommon for aristocratic families in Europe.[45] He visited spas in several European cities, such as Spa (Belgium), Bath (Great Britain), and Aachen (Germany). The cures or treatments usually involved both drinking and bathing in spring water, in order to relieve his fevers, reduce the aching in his limbs, and regain his strength. As his mother often had to cope with small ailments too, she also underwent regular treatments.

When Willem went to a spa, or when he was travelling, he informed his mother and his wife about the events of the day, the progression of his treatment, and how he was feeling. In total, Willem wrote to his mother seventeen times on this subject. The most common topics are his treatment (seven) and Maria Louise's own baths (three). Once or twice the advice of a doctor is mentioned, or he refers to someone else in the family visiting the baths. To Anne, he wrote nineteen times about the baths — proportionally more often than in the letters to his mother, bearing in mind that Willem's letters to Anne total only 10 per cent of the number of letters to his mother. In total, 14.2 per cent of the letters to Anne mention this subject, compared with only 1.5 per cent of the letters to his mother. This is striking, as his mother was extremely concerned about his physical state. It indicates that he did not want to share the full details with her, and also that he wrote to Anne in a more open and private way than to his mother.

45 Tubergen and Linden, 'A Brief History of Spa Therapy'; Gianfaldoni and others, 'History of the Baths'.

The heuristic zones relating to privacy can shed light on this matter: Anne was privy to his personal and private feelings. With regard to Willem, she had access to the first identified zone — soul, mind, and self — whereas Maria Louise was kept informed of his physical health but nothing more, which indicates that she was allowed into no sphere of intimacy beyond that of the body. The topics of his letters confirm this: in his letters to Anne, he is more explicit about his hopes for healing, his experiences at the baths, and his treatment schedule. In September 1751, when he was in Aachen for three weeks undergoing treatment, he wrote to Anne (see Figure 10.5):

> J'ai commencé hier avec bains de l'Empereur la cure des bains et de la dousse et a eu juger par l'expérience du jour d'hier j'ai tout sujet d'en bien espérer, j'ai eu les jambes incomparablement plus minces déjà que depuis tout le tem[p]s que je suis ici, & surtout j'ai mieux dormi cette nuit que depuis très longtem[p]s, les bains ne me donnent pas le moindre mal de tête.

> (I started the treatment at the imperial baths and showers yesterday and, judging from yesterday's experience, I have every reason to have high hopes; I already have incomparably thinner legs since I have been here, and above all I slept better last night than I have for a very long time, [and] the baths do not give me the slightest headache.)[46]

In the correspondence with his mother, Willem uses the word 'cure' forty-five times. Of these, twenty are with regard to Maria Louise's own treatment. The others refer to Willem's health and recovery (eighteen), or the health of another individual (seven). When writing about his own treatments, Willem is usually quite brief. He writes either that he is continuing them, or that they have ended successfully as he was cured. In his letters, Willem is always more concerned about his mother's welfare than about his own health. He always asks in detail how she is, whereas his own ailments are mentioned only briefly at the end of the letters, before his goodbye. This shows us again that he did not want to share his inner thoughts and feelings (the first privacy zone) with his mother. Rather, he mostly wanted to give her good news, as he constantly told her that his treatments were working successfully.

According to Baker-Smith, Willem's habit of writing to his mother two or three times a week affected his marriage to Anne, who did not have a good relationship with her mother-in-law. In all of his letters, he sent Anne's regards to Maria Louise, but Anne rarely wrote to her personally. Baker-Smith argues that it was difficult for Anne to share her husband with an overprotective mother-in-law, and that she resented the correspondence he maintained with her. Since she realized that he would not neglect his duty to his mother, she could only stubbornly distance herself from it.[47] Willem was always a mediator between the two, and it speaks in his favour that he

46 The Hague, RC, A30-VIa-1, Willem IV of Orange-Nassau to Anne of Hanover, 24 September 1751.
47 Baker-Smith, *A Life of Anne of Hanover*, p. 64.

Figure 10.5. Letters from Willem IV to Maria Louise of Hesse-Kassel (above) and Anne of Hanover (below), Aachen, 4 September 1751. Royal Collections, The Hague, A28–11, A30-VIa-1.

refused to allow his love for his strong-willed wife to deflect him from the duty he felt towards his mother.

How did this precarious family dynamic influence the way in which Willem wrote to both women? In September 1751, a month before he died, when he was undergoing treatment in Aachen, he wrote to Anne almost every other day — seventeen letters in total. At the same time, he wrote to his mother every week — a total of five letters in the same period — and these letters followed the same pattern every time: good wishes for her health, updates about his treatment, and any other news he had heard.[48] The letters to Anne in September 1751 are much longer than those sent to his mother, which normally occupy a single page. They are on average two to three pages long, and Willem's handwriting is much smaller, meaning that there is considerably more information on each page. In contrast to the letters to his mother, those to Anne contain a comprehensive report of his day-to-day activities, his treatment, his meals, his experiences, and any members of the European aristocracy he has met at the spa. Besides these, Willem's affection for Anne and their children is also a standard topic. The letters also contain a great deal of political news that he wanted to share with Anne.

This comparison confirms that Willem shared much more about his private feelings with Anne than with his mother; in other words, she had more access to his mind. The letters to his mother were mostly to keep her politely informed, but the letters to Anne were expressions of his inner thoughts and feelings.

Pregnancies

When Willem informed his mother of his own condition, he usually reported on Anne's health too, especially when there was a baby on the way.[49] In general, noblewomen felt a constant pressure to have children and produce a male heir, even to the point where they sometimes believed themselves to be pregnant when they were not.[50] This was the case with Anne's first apparent pregnancy. Unfortunately, when Anne thought she was nearing labour in April 1735, the pregnancy turned out to be false.[51] On one of the rare occasions when Maria Louise was allowed into a sphere of intimacy beyond that of the body, Willem wrote her a literally tear-stained letter:

> Je ne puis sans émotion le communicquer à V[otre] A[ltesse] S[erinissime] qu'il [l'accoucheur] ne la croioit pas grosse d'un enfant. [...] Ce n'est pas qu'elle n'accouche point ou ne fait pas grosse qui me fait de la peine, nous

48 The Hague, RC, A28–11, Willem IV of Orange-Nassau to Maria Louise of Hesse-Kassel, 4 September 1751.

49 Willem also corresponded with physicians about Anne's pregnancies. Jagtenberg, *Willem IV*, p. 430; RC, A30, 185.

50 Broomhall and Van Gent, *Gender, Power and Identity*, p. 105.

51 Baker-Smith, *A Life of Anne of Hanover*, p. 58. Jagtenberg, *Willem IV*, pp. 394–95.

sommes jeunes tous les deux, et si ce n'est pas cette année, nous osons espérer pour une autre fois [...] mais ce qui me fait de la peine c'est l'abbattement de la princesse et l'affliction ou cela l'a plongé.

> (I cannot tell you this without emotion, but the obstetrician did not think that she was with child. [...] It is not the fact that she will not give birth and is not pregnant that saddens me; we are both young, and if it is not this year then we dare hope for another time [...] but what does make me sad is my princess's despondency and the profound distress this has caused her.)[52]

In 1736, an unnamed stillborn daughter followed. In the months leading up to this tragic event, the news of the pregnancy was ever-present in the correspondence, and both Anne and Willem were healthy in body and mind. In November they were expecting the birth 'any day now'.[53] However, on 19 December 1736 he had to write to Maria Louise about the stillbirth. At first, there seemed to be no complications: the start of the delivery was very encouraging. But (Willem wrote) God had other intentions. In a letter the following day, he told his mother of how the little princess had had to be sacrificed to keep Anne alive.[54] In 1739 Anne became pregnant again, but once more the child was stillborn.

In Willem's letters to his mother, instances of *(ac)coucher* — a verb that means 'to sleep' (forty-seven) as well as 'to give birth' (eighteen) — occur sixty-five times (see Figure 10.6). In total, the root *grossess** appears five times. An alternative keyword, *enceinte* (pregnant), does not appear. In most cases, Willem was expressing his worries regarding Anne. It might have been comforting and troubling at the same time for him to share his feelings about Anne's pregnancies and miscarriages with his mother, especially because he knew she was impatiently waiting for an heir. Willem's letter dated 16 March 1745 is another example of Maria Louise being allowed within Willem's first privacy zone, that is, his mind. Anne had been losing a lot of blood, and she was also losing weight. The midwife inferred a miscarriage, but Willem summoned the famous physician Gerard van Swieten (1700–1772), later the personal physician of Maria Theresia of Austria (1717–1780), to examine Anne.[55] Van Swieten disagreed with the midwife and prescribed rest. Two weeks later, however, he had to admit that the midwife had been right: Anne

52 The Hague, RC, A28–8, Willem IV of Orange-Nassau to Maria Louise of Hesse-Kassel, 19 April 1735.

53 Jagtenberg, *Willem IV*, p. 413.

54 The Hague, RC, A28–8, Willem IV of Orange-Nassau to Maria Louise of Hesse-Kassel, 19 December 1736.

55 The Hague, RC, A28–10, Willem IV of Orange-Nassau to Maria Louise of Hesse-Kassel, 16 March 1745.

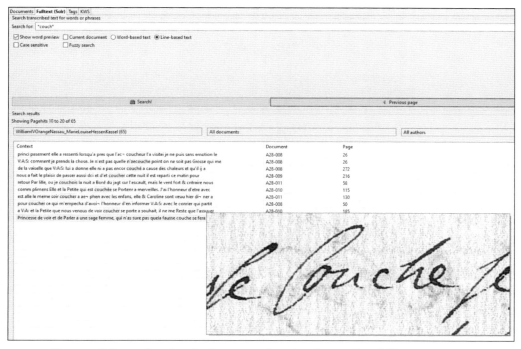

Figure 10.6. Screenshot showing instances of *coucher*. Source: Transkribus.

had miscarried.[56] When Willem told his mother about this, his relief that Anne was feeling better prevailed.[57]

In Willem's correspondence with Anne, *couch* in the sense of giving birth is found three times; the keyword *grossess* is found twice. In these letters, he is mostly concerned with Anne's health and well-being during pregnancy. In August 1734, he wrote to her from Freiburg:

> Ma première occupation à ce matin au sortir de mon lit est de m'entretenir avec vous, ni ayant point de plus grand soulagement dans mon absence pour moi, que le plaisir de vous écrire, ma chère Annin, […] je pense que vous continué à vous bien porter, car je ne puis vous hier que j'étois dans de grande inquiétude, vu les mauvais bruits qu'on avoit répandu touchant l'état de votre santé et que votre grossesse étoit passée. Dieu soit loué que ses bruits s'en sont allez en fumée et que les gens qui se sont fait un plaisir de les divulguer avec empressement en Hollande, n'auront que de la confusion en partage.

56 Baker-Smith, *A Life of Anne of Hanover*, p. 92.
57 The Hague, RC, A28–10, Willem IV to Maria Louise of Hesse-Kassel, 16 March 1745.

> (My first occupation this morning when I got out of bed was to talk to you, as there is no greater relief for me during my absence than the pleasure of writing to you, my dear Annin, […] I think you continue to be in good health, and I could not [tell] you yesterday that I was in great anxiety because of the bad rumours that had been spread concerning the state of your health and that your pregnancy was over. Praise be to God that these rumours have gone up in smoke and that the people who were so happy to eagerly disclose them in Holland will have nothing but confusion to share.)[58]

This fragment indicates that there were rumours throughout the country about Anne's pregnancy and even a possible miscarriage. This was also the case when she was pregnant in 1736. The news of a possible Orange heir also fired up a fierce discussion regarding where the child should be born. As The Hague symbolized the seat of central government, the republicans wanted at all costs to prevent the child from being born there, whereas the Orangists — who were in favour of the stadtholder — strongly advocated that city as the child's place of birth.[59]

Anne's pregnancies were also 'shared' with the States of Friesland, as the succession of the stadtholder was a matter of great importance for the province. For instance, at the request of Willem himself, the States of Friesland allowed four delegates to be present (for a quarter of an hour each) at the (still) birth on 21 December 1739.[60] Above all, what this illustrates is that Anne's pregnancies — including the miscarriages — were common knowledge, and everyone had their own opinions about them. It also demonstrates that this aspect of privacy — sharing updates about the pregnancy of the stadtholder's spouse — was not limited to the first (mind), second (body), third (chamber), or fourth (family) zones; rather, the information had a wide circulation that included the community (fifth zone) and the state (sixth zone). Significantly, in January 1745, Maria Louise wrote that she had heard rumours that Anne might be pregnant again, and she felt offended because the general public had known about it before she did. Willem confirmed the news and warned that the pregnancy was still at a very early stage, but as Baker-Smith aptly puts it, 'by February, it had become the secret of the whole world'.[61]

Even though there were always rumours about possible pregnancies or miscarriages, they entailed no ill will among the general public, especially the people of Friesland, who were always hoping for an heir. In the case of a

58 The Hague, RC, A30-VIa-1, Willem IV of Orange-Nassau to Anne of Hanover, 10 August 1734.
59 Baker-Smith, *A Life of Anne of Hanover*, p. 55.
60 Jagtenberg, *Willem IV*, pp. 447–48.
61 Baker-Smith, *A Life of Anne of Hanover*, p. 91; The Hague, RC, A28–010, Willem IV of Orange-Nassau to Maria Louise of Hesse-Kassel, 4 February 1745.

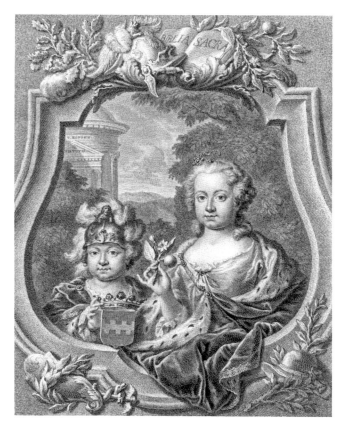

Figure 10.7. Pieter Tanjé after Gerard Sanders, *Willem V and his sister Carolina of Orange-Nassau*, 1751. © Rijksmuseum Amsterdam.

stillborn or deceased child, the family shared their grief with the people of Friesland by publicly displaying the baby in a small coffin.[62]

The Children: Willem and Carolina

The need for an heir was ever-present, but it was not until 1743, after they had been married for almost a decade, that Anne and Willem produced a healthy child: Wilhelmina Carolina. A male heir followed in 1748: Willem Batavus, later Willem V (see Figure 10.7). On the day of his son's birth, Willem wrote to his mother that he could not express on paper the joy he was feeling.[63] From that moment on, the children — who occupy the fourth privacy zone of home/household — were always mentioned in his letters to his mother. Usually, a short sentence at the end of each letter informed Maria Louise

62 Baker-Smith, *A Life of Anne of Hanover*, pp. 63, 77.
63 The Hague, RC, A28–10, Willem IV of Orange-Nassau to Maria Louise of Hesse-Kassel, 8 March 1748.

that they were doing well, or that Willem had learned a new word, or that Carolina missed her *groote mama* (grandmama): 'Caroline m'a recommandé ce soir par trois foi[s] de faire bien ses complimens à Groote Mama en te vraegen: "Hoe de lieve Groote Mama vaert, en ook Broertjes complimenten te maeken"' [Carolina asked me three times this evening to pay her compliments to Grandmama and to ask how dear Grandmama is, and also to convey her little brother's compliments].[64]

Their health was also often mentioned. When they were ill, Willem informed his mother in detail. For instance: 'Le petit Guillaume, qui est après à faire ses dents oeuillaires, a eu la fièvre depuis lundi jusqu'à hier à différents accès mais Dieu-merci il ne l'a pas eu cette nuit, ainsi nous espérons que cela n'aura pas de suite' [Little Willem, who has been teething, had a fever several times from Monday until yesterday, but thank God he did not have one last night, so we are hoping that it is over].[65]

In total, Willem mentions 'Guillaume' (the young Willem) 140 times to his mother, while Carolina is mentioned 199 times. In letters to Anne, these numbers are significantly lower: eighteen mentions for Guillaume and thirty-five for Carolina. Proportionally, however, the children are mentioned more frequently in the letters to Anne. In total, 13.4 per cent of the letters to Anne mention Guillaume and 26.1 per cent mention Carolina, whereas in the letters to his mother only 12.7 per cent mention Guillaume and 18 per cent mention Carolina. Furthermore, in his letters to Anne, he expresses his concerns about the children more openly. He often worries about Guillaume's health and hopes for improvement. This is explained by the fact that whenever he wrote to Anne, he had been absent from her for some time in order to fulfil his duties as stadtholder. The love he had for his small family is strikingly visible in every letter, as he reassures Anne constantly how important they are to him.

If we compare Willem's reports of his children's illnesses, Willem was more comfortable sharing his concerns with Anne than with his mother, to whom he only gave the facts and the news that they had recovered. This again indicates that he was more private with Anne and gave her access to the heuristic zone of the soul, mind, and self, whereas Maria Louise was kept out of his thoughts and concerns most of the time.

64 The Hague, RC, A28–11, Willem IV of Orange-Nassau to Maria Louise of Hesse-Kassel, 23 January 1750.
65 The Hague, RC, A28–11, Willem IV of Orange-Nassau to Maria Louise of Hesse-Kassel, 28 June 1749.

Conclusion

Our research has focused on how the expression of emotional and physical health was practised in the correspondence of an aristocratic family. Primarily, this study has been explorative, in that it has tried to adopt new methods and tools as a first step towards unpacking a large corpus of unedited letters. In addition, we would like to underline that this type of research, if applied, must be seen as a starting point and an aid, and that more in-depth human research still remains to be done.

Our pilot study has proved that early modern (private) correspondence can indeed function as a significant primary source for the study of the history of emotions. Thanks to the HTR tool Transkribus, a large number of digital sources were quickly made readable and — more importantly — searchable. In this particular case, we unlocked 1300 letters in just a few weeks, and we found many significant keywords relating to the subject of feelings. However, this is where the usability of such a tool for this kind of research currently ends. We should be aware that specific keywords are not always used verbatim, since a writer — in this case stadtholder Willem IV — may often describe their private affairs in a very modest and concealed manner, something that cannot automatically be extracted with such a tool. His wife, and even his mother, will often have needed only half a word to understand what he meant between the lines. Incidentally, Transkribus can also be used to tag sections of text to which keywords can then be applied manually. Although this is very laborious and time-consuming, it could be applied in future research.

For our pilot study, the second marker of Bruun's method for the study of privacy, which concerns the heuristic zones in which notions of privacy are negotiated, was the most interesting. We searched for keywords that applied to these zones, in order to analyse the letters in which these words were used. We would like to note in particular that on the basis of the few cases we researched, it was difficult to draw any conclusions. We remain cautious about the applicability of this method in general, since the danger of anachronism is always lurking. Firstly, as we pointed out in our introduction with regard to privacy in relation to sovereigns, contemporaries understood and used the very concept of 'privacy' differently. Even so, Willem IV's 'privacy zones', insofar as they can be defined, will have been different in his correspondence with his mother when he was eight years old compared with his correspondence at the age of thirty. Lastly, it is important to note that these heuristic zones are not rigid or fixed; it is possible that they overlap. For example, Willem would often keep his mother in the second zone when it came to the expression of his feelings, but he made an exception when his wife had miscarried. This indicates that Willem would weigh up his feelings, deciding what he wanted to share with his mother and what he did not want to share, although these could differ depending on the issues at stake.

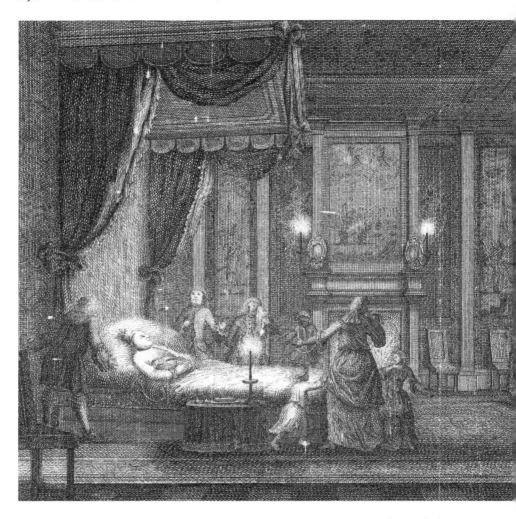

Nevertheless, our research has provided us with new insights and ideas. Looked at from our modern perspective, Willem's correspondence with his mother and his wife has revealed an empathic, affectionate man who was quite able to express his feelings on paper, especially when addressing his wife. Although he had a physical disability, he coped with his health to the best of his abilities. In terms of the heuristic zones of privacy, he admitted his wife Anne into the first zone, his mind, while Maria Louise remained in the second zone, which concerned his body and physical health - except when he wrote about Anne's pregnancies, as he would then give his mother access to his inner thoughts. This all accords with the expected pattern, since Anne, as his wife, was evidently much more involved in his private life - indeed, she largely *was* his private life. His affection for her in his letters clearly shows this; we only need to recall the letter we quoted at the start of this chapter.

Figure 10.8. Anonymous, *Death of Willem IV*, 1751. © Rijksmuseum Amsterdam.

Both Maria Louise and Anne became widows fairly young. For future research, it may prove illuminating to compare their letters with regard to the ways in which they coped with the loss of their respective spouses and how they expressed their emotions to their families in London and Kassel. Within the scope of this research, it was not possible to carry out a comparative study of the 231 letters that Willem's father, Johan Willem Friso of Nassau-Dietz, sent to his mother, Henriette Amalia of Anhalt Dessau (1666–1726). However, this correspondence is likewise eminently suitable for further research.[66] In the context of the boundaries between public and private, a further qualitative investigation of the correspondence about Anne of Hanover's pregnancies

66 The Hague, RC, A26a–002.

and miscarriages would be ideal, as there was significant public interest in these, as well as deep emotional family involvement. Ultimately, although Willem's letters to his mother predominate in quantity, his letters to Anne definitely deserve their own full consideration, as they are qualitatively better suited to reveal more about Willem IV's private life.

Epilogue

After his last treatment in Aachen in September 1751, Willem continued to struggle with his health: he had a sore throat and was exhausted. Instead of returning straight home, he first had to have an audience with the cardinal and prince-bishop of Liège, Johann Theodor of Bavaria (1703–1763).[67] It was a few more days before he could finally go home to see his wife and children.[68] He wrote to his mother that he was still feeling a little weak, but that this was normal when returning from the baths. He expected to recover after a few days' rest.[69] But when he returned home, his condition deteriorated, and he had a throat infection, high fever, and headaches. He then suffered a stroke, and on 22 October 1751 Willem IV of Orange-Nassau passed away at the age of only forty (Figure 10.8).

67 Jagtenberg, *Willem IV*, p. 806.
68 Jagtenberg, *Willem IV*, pp. 806–07.
69 The Hague, RC, A28–11, Willem IV to Maria Louise of Hesse-Kassel, 12 October 1751.

Appendix 1: Keywords in the Correspondence Between Maria Louise of Hesse-Kassel and Willem IV

Keyword	Health/ emotions	Categories
accident	health	Willem (3) worries (5) children (2) other (2)
affliction	health	other (2) death (1) children (1) Willem (1) Maria Louise (1)
bain(s)	health	trips/mail (1) other (2) Maria Louise (3) children (2) Willem (9)
chagrin	emotions	Maria Louise (10) children (1) death (1)
charme	emotions	Maria Louise/gratitude (10)
coeur	emotions	gratitude (4)
colique	health	other (3) Willem (6) Maria Louise (3)
coucher	health	Anne (4)
cruellement	emotions	Willem (5)
cure	health	Maria Louise (20) other (4) Willem (20) children (1)
curieuse/x/osité	emotions	politics/news (6) other (10)
danger/eux/euse	emotions	politics/news (9) other (8) gratitude (4)
dent(s)	health	Children (23) Willem (2)
désordre	emotions	politics/news (3) other (2)
douleur(s)	health	death (2) Anne (4) Willem (7) Maria Louise (12) other (1)
doux	emotions	politics/news (13) other (2)
embaras*	emotions	Maria Louise (1) other (10) Willem (4)
émotion	emotions	politics/news (2) other (2) gratitude (1)
en dout	emotions	worries (1)
fache	emotions	Maria Louise (50) other (10) politics/news (36) trips/mail (4)
facheuse	emotions	politics/news (3) worries (1) death (4) Willem (7)
fatiguant	emotions	trips/mail (4)
fatigue	health	Willem (9) trips/mail (15) Maria Louise (11) politics/ news (8) other (3) children (8)
gorge	health	Anne (1) Willem (2) Maria Louise (2)
grossesse	health	Anne (5)
honte/eux/euse	emotions	worries (4) other (2)
humeur(s)	emotions	children (5) other (5) Maria Louise (2) Willem (4)
incertitude	emotions	trips/mail (4) worries (2) Maria Louise (1)

Keyword	Health/ emotions	Categories
incommodite/é	emotions	Maria Louise (12) children (6)
indifférence	emotions	politics/news (2)
indisposé/e	health	Maria Louise (17) Willem (10) other (3)
inquiétude(s)	emotions	Willem (1) Maria Louise (5) trips/mail (2) other (2)
joie	emotions	children (7) Maria Louise (17) politics/news (2) other (2)
jolie	emotions	Maria Louise (5) other (5) children (3)
malad(i)e	health	other (11) Willem (4) Anne (6) Maria Louise (7) children (6) politics/news (3)
malheur(eusement)	emotions	politics/news (12) worries (12) death (6) trips/mail (4) other (4)
mauvais/manvais	emotions	politics/news (57) Willem (6) Maria Louise (5)
mécontentement	emotions	politics/news (2) Willem (1) other (2)
médecin(e)	health	politics/news (8) Willem (18)
mélanc(h)olie	emotions	Maria Louise (3)
misérable	emotions	politics/news (3) Willem (3)
mort(i)fié/e	emotions	Maria Louise (33) politics/news (4) other (6) trips/ mail (3) Willem (10)
mort	health	other (45) Willem (1) Maria Louise (1) politics/news (15) worries (8)
néglige	emotions	politics/news (7) Maria Louise (10) other (2)
pénible(s)	health	trips/mail (5) politics/news (6)
peur	emotions	politics/news (2) Maria Louise (3) other (3) children (2) trips/mail (1)
ravi/e	emotions	Maria Louise (44) other (2) Willem (18) children (1)
regret(tes)	emotions	trips/mail (3) other (7) Maria Louise (21) death (11) politics/news (3) children (5) trips/mail (2)
rhume	health	Maria Louise (13) Anne (4) Willem (11) children (5) trips/mail (1) other (3) politics/news (2)
rougeole	health	Children (2) Anne (1) other (1)
sensible	emotions	Maria Louise (22)
souf*/rir	health	children (1) Willem (6) Maria Louise (2) politics/news (3)
stérilité/e	health	politics/news (14)
terrible	emotions	politics/news (16) trips/mail (3) Willem (4)
triste	emotions	other (2) Maria Louise (2) children (3) death (2) politics/news (9)
violences	emotions	other (1) politics/news (16) Maria Louise (13) Willem (9) children (2) death (1)

Appendix 2: Keywords in the Correspondence Between Anne of Hanover and Willem IV

Keyword	Health/ emotions	Categories
accident	health	politics/news (2) trips/mail (2), Anne (1)
affliction	health	other (1)
bains	health	trips/post (4) Willem (15)
chagrin	emotions	Anne (4) trips/mail (2) worries (1)
charme	emotions	politics/news (10) Anne (15) children (5)
coeur	emotions	Anne (133)
colique	health	Willem (1) other (1)
coucher	health	other (28) trips/mail (1)
cure	health	Willem (10) Other (1)
curieuse/x/osité	emotions	politics/news (9)
danger/eux/euse	emotions	politics (3) worries (1)
dent(s)	health	children (3) Willem (2)
désordre	emotions	politics (1)
douleur(s)	health	Willem (3)
embaras*	emotions	other (4) politics/news (6) worries (2)
fache, fach, facheuse	emotions	Trips/mail (3) Anne (7) other (2) children (2) politics/news (6)
fatiguant	emotions	politics/news (1) trips/mail (2) Anne (1)
gorge	health	death (1) Willem (2)
grossesse	health	Anne (2)
honte/eux/euse	emotions	trips/mail (1) politics/news (2)
humeur(s)	emotions	other (3) Anne (3) Willem (3)
incommodite/é	emotions	children (2)
inquiétude(s)	emotions	worries (2) Anne (3)
joie	emotions	Anne (9) politics/news (3) other (3) trips/mail (5)
jolie	emotions	other (6) children (2)
malad(i)e	health	trips/mail (3) other (3) politics/news (7) children (3) Anne (1) Willem (1)
malheur(eusement)	emotions	politics/news (3) other (3) trips/mail (4) Anne (2)
mauvais/manvais	emotions	politics/news (9) other (7) Willem (4) Anne (3) children (1)
mecontentement	emotions	politics/news (1)

Keyword	Health/ emotions	Categories
médecin(e)	health	Willem (6) trips/mail (2)
mélanc(h)olie	emotions	other (3) Willem (1)
misérable	emotions	other (1)
mort(i)fié	emotions	other (1) politics/news (3)
mort	health	politics/news (10) Anne (4)
néglige	emotions	politics/news (4) Anne (1) children (1) worries (3)
pénible(s)	health	Willem (1)
peur	emotions	other (9) worries (1) Anne (3)
ravi(e)	emotions	other (3) Anne (1) trips/mail (1) Willem (2) children (4)
regret(tes)	emotions	Anne (2) trips/mail (1) worries (3) death (1) politics/ news (1)
rhume	health	Willem (7) other (2) children (2)
sensible	emotions	other (4) Anne (2) Willem (1)
souf*/rir	health	children (1) Willem (3)
terrible	emotions	trips/mail (1) Willem (3) other (1) politics/news (3)
triste	emotions	Anne (3) Willem (1) other (2)
grossesse	health	Anne's (2) desire for a good pregnancy (1)

Works Cited

Manuscript and Archival Sources

The Hague, Royal Collections, Archive Anna van Hannover, A30-VIa-1
——, Archive Maria Louise, A28, 6–11

Secondary Works

Baker-Smith, Veronica, *A Life of Anne of Hanover: Princess Royal* (Leiden: Brill, 2005)
Barthels, Marjo, 'Maria Louise van Hessen-Kassel', *Digitaal Vrouwenlexicon van Nederland* (2016), <http://resources.huygens.knaw.nl/vrouwenlexicon/lemmata/data/HessenKassel> [accessed 31 January 2021]
Billing, Yvonne Due, and Mats Alvesson, 'Questioning the Notion of Feminine Leadership: A Critical Perspective on the Gender Labelling of Leadership', *Gender, Work and Organization*, 7.3 (2000), 144–57
Broomhall, Susan, 'Emotions in the Household', in *Emotions in the Household, 1200–1900*, ed. by Susan Broomhall (Basingstoke: Macmillan, 2007), pp. 1–37
Broomhall, Susan, and Jacqueline van Gent, 'Corresponding Affections: Emotional Exchange among Siblings in the Nassau Family', *Journal of Family History*, 34.2 (2009), 143–65
——, *Gender, Power and Identity in the Early Modern House of Orange-Nassau* (Abingdon: Routledge, 2016)
Bruun, Mette Birkedal, 'Privacy in Early Modern Christianity and Beyond: Traces and Approaches', *Annali Istituto storico italo-germanico/Jahrbuch des italienisch-deutschen historischen Instituts in Trient*, 44.2 (2018), 33–54
Daybell, James, *Early Modern Women's Letter Writing 1450–1700* (Basingstoke: Macmillan, 2001)
——, *Women Letter-Writers in Tudor England* (Oxford: Oxford University Press, 2006)
Elias, Norbert, *The Court Society* (New York: Pantheon, 1983)
Geyl, Pieter, *Willem IV en Engeland tot 1748* (The Hague: Nijhoff, 1924)
Gianfaldoni, Serena Georgi Tcherney, Uwe Wollina, Maria Grazia Roccia, Massimo Fioranelli, Roberto Gianfaldoni, and Torello Lotti, 'History of the Baths and Thermal Medicine', *Open Access Macedonian Journal of Medical Sciences*, 5.4 (2017), 566–68
Green, Michaël, 'Educating Johan Willem Friso of Nassau-Dietz (1687–1711): Huguenot Tutorship at the Court of the Frisian Stadtholders', *Virtus – Yearbook of The History of the Nobility*, 19 (2012), 103–24.
Jagtenberg, Fred, *Het korte leven van Johan Willem Friso: 1687–1711* (Amsterdam: Uitgeverij de Bataafsche Leeuw, 2011)
——, *Marijke Meu 1688–1765: Stammoeder van ons vorstenhuis* (Gorredijk: Bornmeer, 2015)
——, *Willem IV: Stadhouder in roerloze tijden 1711–1751* (Nijmegen: Van Tilt, 2018)

James, Carolyn, and Jessica O'Leary, 'Letter-Writing and Emotions', in *The Routledge History of Emotions in Europe: 1100–1700*, ed. by Andrew Lynch and Susan Broomhall (Abingdon: Routledge, 2019), pp. 256–68

Lantink, Frans Willem, 'Anna van Hannover', *Digitaal Vrouwenlexicon van Nederland* <http://resources.huygens.knaw.nl/bwn1780-1830/DVN/lemmata/data/AnnavanHannover> [accessed 31 January 2021]

Merlin, Hélène, 'La cour et la ville, ou la question du *public* au siècle de Louis XIV', *Les cahier de Fontenay*, 2 (1983), 91–103

——, *Public et Littérature en France au XVII siècle* (Paris: Les Belles Lettres, 1994)

Rosenwein, Barbara H., 'Worrying about Emotions in History', *American Historical Review*, 107.3 (2002), 821–45

Ruppel, Sophie, *Verbündete Rivalen: Geschwisterbeziehungen im Hochadel des 17. Jahrhunderts* (Cologne: Böhlau, 2006)

Schneider, Gary, *The Culture of Epistolarity: Vernacular Letters and Letter Writing in Early Modern England, 1500–1700* (Newark: University of Delaware Press, 2005)

Tubergen, Astrid van, and Sjef van der Linden, 'A Brief History of Spa Therapy', *Annals of the Rheumatic Diseases*, 61.4 (2002), 273–75

Index locorum

Aachen: 286, 287, 288, 289, 298
Aarschot, duchy of: 129, 130, 136
Aarschot, castle of: 138
Amsterdam: 17, 21, 22, 27–57, 86, 87, 173, 174, 175, 179, 183, 188, 189, 190, 227, 231, 235, 247–272
Antwerp: 125, 147
Arnhem: 42, 235
Asia: 202

Batavia: 197, 201, 202, 214, 215, 218
Bath: 286
Beaumont: 122 (castle of), 126, 127, 130, 132, 133, 136, 138
Belgium: 286
Bierbeek: 136
Breda 147, 241
Bruges: 64, 125, 134, 135
Brussels: 121, 129, 130, 131, 133, 134, 136, 137
Budapest: 235

Cambridge: 235
Ceylon: 210, 211, 212
Chimay: 128, 130, 136, 137, 138
Colchester: 227
Cologne: 199
Colombo: 199, 205
Comines: 126, 128, 129, 131
Copenhagen: 235
Curaçao: 200, 202, 203, 208, 218

Delft: 201, 235
Den Bosch: 152
Denmark: 202, 226

Deventer 211
Dordrecht: 235
Drenthe: 280
Duisburg: 52
Dutch Republic: see United Provinces of the Netherlands

England 199, 204227, 228, 230, 239, 241, 243, 277, 286
Enkhuizen: 201, 214, 216, 217

Florence: 183
France: 183, 199, 211
Freiburg: 291
Franeker: 280
Friesland: 197, 280, 292, 293

Gelderland: 280
Germany: 286
Gouda: 235
Göttingen: 235
Groenlo: 152
Groningen: 201, 202, 211, 232, 280
Haarlem: 36, 37, 235
Hainaut: 126, 136
Halluin: 128, 129, 130
Hamburg: 179
Haverford: 235
Heverlee: 130, 134 (castle of), 135, 137, 138
Holland, Province of: 16
Hollands Diep: 279

Iberian Peninsula: 122, 173, 174, 188
Israel, Land of: 186

INDEX LOCORUM

Jakarta: 197
Jerusalem: 186

Kampen: 211
Kew: 198, 199, 200
Kijkduin: 199

Leeds: 235
Leiden: 49, 147, 152, 161, 232, 235
Leuven: 130, 135, 168
Leeuwarden: 280, 281, 282
Leyden: *see* Leiden
Lille: 135
London: 199, 200, 235

Madrid: 183
Middelburg: 201, 217, 241
Mulheim: 52
Munster: 199, 211

New Haven: 235
North Holland: 210
Nurnberg: 49

Oxford: 235

Paris: 156, 235
Poland: 202
Philadelphia: 235

Rede van Texel: 197, 198, 199
Rotselaar: 129, 130, 136
Rotterdam: 201, 227, 228, 231, 232, 235, 240, 243

Schooneveld: 199
Sint-Joost-ten-Node: 133, 134, 136, 137, 138
Solebay: 199
Spa: 286
Spain: 183
Sri Lanka: 199, 205, 210
St. Petersburg: 235
Stade: 147
Surinam: 217
Sweden: 202

Terheijden: 147
The Hague: 42, 145, 147, 148, 149, 152, 153, 155, 160, 161, 162, 165, 181, 235, 273, 282, 292

United Provinces of the Netherlands: 182, 188, 189, 197, 199
Utrecht: 199, 202, 205, 211, 235, 280

Venezuela: 203
Venice: 147, 148
Veurne: 241
West Friesland: 197
Whitby: 227

Zeeland: 201, 280
Zwolle: 50, 202, 211

Index nominum

Aalberts: 235

Aarschot, Duke de: *see* De Croÿ, Charles III

Abenasar, David: 176 n. 14

Aboab Lopes, family: 178 n. 24

Alberti, Leon Battista: 68, 69, 71 n. 35, 72 n. 40, 42, 74, 78, 83, 84 n. 78 90 n. 96, 97

Amalia van Solms: 111

Amelia of Nassau-Dietz: 277

Anne of Hanover: 22, 273–302

Arenberg, Alexandre d' 124

Arendtsen, Arend: 297

Ariaens, Lijsbet: 217, 218

Aristotle: 65, 69, 72, 88, 90

Asser, Moses Salomon: 30

Aureng Seb, Great Mogul: 241

Baerle, Jan van: 149

Baerle, Susanna van: 21, 145, 146, 149, 150, 151, 152, 158, 161, 166, 167

Barlaeus, Caspar: 151

Barclay, Robert: 237, 238

Barzilay, Jacob Jessurun: 179, 180

Bassan, Eleasar: 176 n. 14

Beck, David: 42

Beeckman, Isaac: 71 n. 33

Beman 235

Ben Israel, Menasseh, Haham: 189, 190

Bentinck, Hans Willem (William), the earl of Portland: 54

Berckhout, Pieter Teding van: 110

Bernaerds, Elijsabedt: 216

Bicker Raye, Jakob: 30, 48

Boeckens, widow: 235

Bos, Nicolaus (N.): 234, 235

Bosse, Abraham: 113

Bourignon, Antoinette, 230

Boutens, Elisabeth: 47

Braam, van: 235

Bratbaard, Abraham Chaim: 30

Braunius, Sipke: 203

Brill, Jacob: 241

Brimeu, Marie de: 125, 128

Bruijnesteijn, Nicolaas: 256

Brunswick, Duke of: 241

Bueno de Mesquita, Jacob: 178 n. 24

Burgh, Jacob van der: 151

Campen, Jacob van: 160

Carolina Wilhelmina, Princess of Orange-Nassau: 281, 286, 293, 294, 298, 299, 300, 301, 302

Cats, Jacob: 63, 64, 69, 71, 72 n. 40, 79 n. 60, 83 n. 71, 167

Charles II, King of England, Scotland and Ireland

Charles V, King of Spain: 127

Charles landgrave of Hesse-Kassel: 279

Claes, Brechien: 210, 211, 212

Coen, Jan Pietersz: 202

Cooghen (Koghen), Leendert van den: 37

Cooper, Anthony Ashley, 3rd Earl of Shaftesbury: 228

Court, Pieter de la: 240

Crisp, Stephen: 237

Croese, Gerard: 237

INDEX NOMINUM

Croÿ, Charles III de: 121–139
Croÿ, Dorothée de: 125
Croÿ, Guillaume de: 127, 130
Croÿ, Philip III de: 21, 122, 129, 136
Curf, Claas Jansen: 216, 217

Desmaizeaux, (Des Maizeaux)
 Pierre: 238
Desargues, Gerard 113
Descartes, René: 160, 167, 240
Dircks, Adriaantje: 218, 219
Doedes, Meinsje: 217
Dorp, Dorothea van: 158
Drebbel, Cornelis: 162
Duclasel, Petrus: 217

Eelkens family: 42
Elizabeth of the Palatine,
 Princess: 240
Ellerts, Lijsabet: 216, 217
Endenburg 235
Engelen, Steven: 31
Euclid: 88
Evers, Marietje: 202

Faro, Rachel Gabay: 183, 185
 (*see also* Prado, Rachel de)
Florissen, Jacop: 202
Fox, George: 227, 236, 237
Frederik Hendrik (Frederic
 Henry), Prince of Orange: 148,
 149, 150, 152, 158, 161, 167
Freke, John 238
Fritsch & Bohm: 234
Furly, Anna: 227
Furly, Arent: 228, 242
Furly, Benjamin 22, 225–243
Furly, Benjohan: 228, 232, 234, 242
Furly, Johanna: 228
Furly, John (senior, father of
 Benjamin): 227
Furly, John (junior, brother of
 Benjamin): 227

Furly, John (son of Benjamin):
 228, 234, 242
Furly, Rachel: 228
Furly, Stephen: 227

Gamis, Jacob: 179
George II, King of England,
 Scotland and Ireland: 280
Gevensman, Geert Jakop: 211
Goeree, Willem: 69, 73, 78, 82 n.
 69, 70, 83 n. 74, 85, 88
Goltzius, Hendrick: 102, 104, 106,
Gosse: 235
Gouge, William: 101
Grainge, Dorothy 225, 227, 228, 231
Grebber, Pieter Fransz de: 104
Grotius (De Groot), Hugo: 79 n. 60

Haan, Madame de: 52
Hack, Philip: 53
Halluin, Jeanne d'128
Halmael, Sara van: 36
Happe, Regina Maria: 51–52
Hartman, Johannes: 201
Hartsoecker, Nicolas: 240
Hendricks, Aaltje: 218
Henriette Amalia of Anhalt
 Dessau: 297
Herensen, Pieter: 217
Hermans, Alida: 51, 55
Hermans, Jan Hendrik: 32, 49–56
Heuvelingh, Petronella
Hooch, Pieter de: 63, 64, 68, 69
Hoefnagel, Jacob: 147
Hoefnagel, Susanna: 147
Hooft, Pieter Cornelisz. 151, 154,
 160, 167, 168
van Hoogstraten, Samuel: 68
Howe, John: 238
Huis, Susanna 228, 231
Huygens, Catharine: 147
Huygens, Christiaan: 147, 149
Huygens, Christiaan jr. 152

INDEX NOMINUM

Huygens, Constance: 147
Huygens, Constantijn 13, 21, 72 n.
 40, 145–168
Huygens, Constantijn jr. 152
Huygens, Elisabeth: 147
Huygens, Geertruyd: 147
Huygens, Lodewijk: 152
Huygens, Maurits: 147, 149
Huygens, Philips: 152
Huygens, Susanna: 152

Isabella of Portugal: 134

Jacobi, Heyman: 208, 209
Jansz, Leendert: 201
Jaspersen, Jan: 218, 219
Johan Willem Friso: 277, 279, 297
Johann Theodor, Cardinal and
 Prince-Bishop of Bavaria: 298
Junius, Jacobus: 148
J.V.C.: 237
Johnson, Elisabeth: 227, 231
Joris, David: 241

Kampen, Engbertus van: 51 n. 70
Kannegieter, Barta: 49, 50, 54, 55
Kannegieter, Engberta: 51 n. 70
Kannegieter, Fenna: 51 n. 70
Keith, George 238
Klein, pastor: 53
Koghen, Dirck van der: 32–39, 43
Kolm, Jan Sijwertz (Siewertsz):
 30, 40

Lairesse, Gérard de: 113
Laura: 151
Lee, M. van: 235
Lima, Salomon de: 178 n. 24
Locke, John: 22, 225, 228, 241
Luckassen, Willem: 214
Lumbrosa, Sara: 177 n. 15

Maria Amalia of Courland: 279
Maria Louise of Hesse-Kassel: 22,
 273–302
Marnix de. St. Aldegonde, Philips:
 147
Marolois, Samuel: 113
Mary Stuart II, Princess of Orange,
 Queen of England, Scotland and
 Ireland: 275
Mauritz (Maurice), PMauritsrince
 of Orange: 64, 147
Mazahod, Jacob: 178 n. 21
Meersch, Arent van der: 27, 30,
 43–49
Meersch, Petronella van der: 46
Meijndert, Meijntje: 212, 214
Mercurius, Franciscus, baron of
 Helmont: 240
Merkendorp, Arend: 51 n. 70
Micklethwait, Thomas 238
Millandts, Catharina: 201
Monconys, Balthasar de: 110
Montigny, Adrien de: 126
Mostart, Daniel: 154, 168
Mo(u)ra, Francisco Fernandes: 183
 (see also Prado, Abraham de)

Nayler, James: 237
Neufville, Maria de: 42, 48
Nuevel, Aris Diercksen: 210, 211, 212

Oisel, Jacobus: 232
Oisterwijk, J. 235
Orange-Nassau, princes of: 254,
 279, 282
Ostade, Adriaen Jansz. van: 41, 42
Ovid: 101

Paddenburg: 235
Pallache, Eva Cohen: 181, 182
Pallache, Joseph Cohen: 182
Palladio, Andrea: 69, 74, 76, 83

INDEX NOMINUM

Parkhurts, John: 238
Parnell, James: 227, 237
Pels, Andries: 104
Penn, William: 237, 238
Pennington, Isaac: 237
Pepys, Samuel: 235
Petrarch: 151, 166
Philip II, King of Spain: 127, 129
Philip III the Good, King of
 France: 130
Pieters, Maaike: 217
Prado, Abraham de: 183 (*see also*
 Mo(u)ra, Francisco Fernandes)
Prado, Anthonio de: 184 n. 50
 (*see also* Prado, Isaac de [son of
 Abraham])
Prado, Esther de: 183
Prado, Isaac de (son of Abraham):
 183
Prado, Isaac de (son of Joseph): 185
Prado, Isaac de (son of Josua): 185
Prado, Isaac de (father of Josua de
 Prado): 183
Prado, Jacob de: 183
Prado, Jacob de (son of Josua): 184
 n. 49
Prado, Joseph de: 183, 185
Prado, Josua de (see also Prado,
 Anthonio de): 183, 184, 185
Prado, Lea de: 183
Prado, Rachel de (see also Faro,
 Rachel Gabay): 183, 185
Prado, Rachel de (daughter of
 Prado, Jacob de): 185
Prado, Salomon de: 184
Prado, Samuel de: 184
Prado, Sara de: 183
Puteanus, Erycius: 168

Quare, Daniel: 240

Rapin-Thoyras, Paul: 54
Richard, Mr.: 54
Rijn, Rembrandt van: 100, 101, 103,
 104, 105, 107
Roth, Cecil: 189, 190
Rutgers, David: 252, 253, 255, 268
Rutgers, Hillegonda, 252, 253, 255,
 268
Rutgers, Margaretha, 252, 255, 268

Salem, Salomon, Haham: 179
Scherius, Maria: 217
Scherius, Anthonius: 217
Smids: 235
Socrates: 73
Staveren, Johannes van: 51
Stevin, Hendrick: 64 n. 9, 66, 70,
 77, 78, 81, 82, 89
Stevin, Simon: 20, 63, 64, 65, 66,
 67, 68, 69, 70, 71, 72, 73, 74 n. 51,
 77, 78, 79, 80, 82, 83, 84, 85, 88,
 89, 90, 91
Sultzbach, monarch of: 240
Sweersz, Jan: 217
Swieten, Gerard van: 290

Tijt, Jacobus van der: 228
Tracy, Stephen 240
Tydeman, Gerrit: 108

Uffenbach, Zacharias Conrad von:
 239

Venne, Adrian van der: 100
Vermeer, Johannes: 63, 100,
 109–117
Verbeeck, Barta: 43
Verbeeck, Hermanus: 32, 39–43
Verbeeck, Maria: 43
Vingboons, Philips: 63, 64, 69, 78,
 82 n. 70, 85, 86, 87, 88, 254

INDEX NOMINUM 311

Vitruvius: 69, 74, 75, 79, 80, 85, 89
Vondel, Joost van den: 154, 168
Vries, Hans Vredeman de: 110, 113

Walbeek, Johan van: 202
Weijlandt, Tomes Jansen: 218
William (Willem) I, Prince of
 Orange: 147
William (Willem) III, Prince
 of Orange, King of England,
 Scotland and Ireland: 275, 280
Willem IV, Prince of Orange: 22
Willem V, Prince of Orange: 280,
 286, 293, 294, 298, 299, 300, 301,
 302
Witt, Cornelis de: 199, 211
Witt, Johan de: 199, 211, 240
Woodstock, Henry Bentinck,
 Viscount of: 54

EARLY EUROPEAN RESEARCH

All volumes in this series are evaluated by an Editorial Board, strictly on academic grounds, based on reports prepared by referees who have been commissioned by virtue of their specialism in the appropriate field. The Board ensures that the screening is done independently and without conflicts of interest. The definitive texts supplied by authors are also subject to review by the Board before being approved for publication. Further, the volumes are copyedited to conform to the publisher's stylebook and to the best international academic standards in the field.

Titles in Series

Sociability and its Discontents: Civil Society, Social Capital, and their Alternatives in Late Medieval and Early Modern Europe, ed. by Nicholas Eckstein and Nicholas Terpstra (2009)

Diseases of the Imagination and Imaginary Disease in the Early Modern Period, ed. by Yasmin Haskell (2011)

Giovanni Tarantino, *Republicanism, Sinophilia, and Historical Writing: Thomas Gordon (c. 1691–1750) and his 'History of England'* (2012)

Writing Royal Entries in Early Modern Europe, ed. by Marie-Claude Canova-Green, Jean Andrews, and Marie-France Wagner (2013)

Friendship and Social Networks in Scandinavia c.1000–1800, ed. by Jón Viðar Sigurðsson and Thomas Småberg (2013)

Identities in Early Modern English Writing: Religion, Gender, Nation, ed. by Lorna Fitzsimmons (2014)

Fama and her Sisters: Gossip and Rumour in Early Modern Europe, ed. by Heather Kerr and Claire Walker (2015)

Understanding Emotions in Early Europe, ed. by Michael Champion and Andrew Lynch (2015)

Raphaële Garrod, *Cosmographical Novelties in French Renaissance Prose (1550–1630): Dialectic and Discovery* (2016)

Languages of Power in Italy (1300–1600), ed. by Daniel Bornstein, Laura Gaffuri, and Brian Jeffrey Maxson (2017)

Performing Emotions in Early Europe, ed by Philippa Maddern, Joanne McEwan, and Anne M. Scott (2018)

Women and Credit in Pre-Industrial Europe, ed. by Elise M. Dermineur (2018)

Emotion and Medieval Textual Media, ed. by Mary C. Flannery (2019)

Luxury and the Ethics of Greed in Early Modern Italy, ed. by Catherine Kovesi (2019)

Memories in Multi-Ethnic Societies: Cohesion in Multi-Ethnic Societies in Europe from c. 1000 to the Present, I, ed. by Przemysław Wiszewski (2020)

Historiography and the Shaping of Regional Identity in Europe: Regions in Clio's Looking Glass, ed. by Dick E. H. de Boer and Luís Adão da Fonseca (2020)

Wojtek Jezierski, *Risk, Emotions, and Hospitality in the Christianization of the Baltic Rim, 1000–1300* (2022)

Inter-Ethnic Relations and the Functioning of Multi-Ethnic Societies: Cohesion in Multi-Ethnic Societies in Europe from c. 1000 to the Present, II, ed. by Przemyslaw Wiszewski (2022)

Legal Norms and Political Action in Multi-Ethnic Societies: Cohesion in Multi-Ethnic Societies in Europe from c. 1000 to the Present, III, ed. by Przemyslaw Wiszewski (2022)